THE TECHNIQUE
of
DOCUMENTARY FILM
PRODUCTION

THE LIBRARY
OF COMMUNICATION TECHNIQUES

THE TECHNIQUE OF FILM EDITING
Karel Reisz and Gavin Millar

THE TECHNIQUE OF FILM ANIMATION
John Halas and Roger Manvell

THE TECHNIQUE OF FILM MUSIC
John Huntley and Roger Manvell

THE TECHNIQUE OF FILM AND TELEVISION MAKE-UP
Vincent J-R. Kehoe

THE TECHNIQUE OF TELEVISION PRODUCTION
Gerald Millerson

THE TECHNIQUE OF THE TELEVISION CAMERAMAN
Peter Jones

THE TECHNIQUE OF THE SOUND STUDIO
Alec Nisbett

THE TECHNIQUE OF DOCUMENTARY FILM PRODUCTION
W. Hugh Baddeley

THE TECHNIQUE OF SPECIAL EFFECTS CINEMATOGRAPHY
Raymond Fielding

THE TECHNIQUE OF TELEVISION ANNOUNCING
Bruce Lewis

THE TECHNIQUE OF EDITING 16MM FILMS
John Burder

THE TECHNIQUE OF THE MOTION PICTURE CAMERA
H. Mario Raimondo Souto

THE TECHNIQUE OF THE FILM CUTTING ROOM
Ernest Walter

THE TECHNIQUE OF

DOCUMENTARY
FILM
PRODUCTION

by

W. HUGH BADDELEY, F.R.P.S., M.B.K.S.

with a preface by
PAUL ROTHA

Second Revised Edition

COMMUNICATION ARTS BOOKS
Hastings House, Publishers
New York

© FOCAL PRESS LIMITED 1970

REVISED EDITION © 1969

8038 - 7021 - 3

First published 1963
Second Impression 1964
Third Impression 1966
Fourth Impression 1967
Fifth Impression 1968
Second Revised Edition 1969
Seventh Impression 1970

Printed photolitho in Great Britain
by Ebenezer Baylis and Son Limited
The Trinity Press, Worcester, and London
and bound by W. & J. Mackay and Co. Ltd
Chatham, Kent

CONTENTS

PREFACE *by Paul Rotha* 7

INTRODUCTION 9

1. PREPARATION OF THE SCRIPT 13
 The Film Treatment 13
 Subject Research 15
 The Shooting Script 16
 Script Terminology 17
 Scripting the Unpredictable 20

2. THE BREAKDOWN SCRIPT 29

3. BUDGETING A DOCUMENTARY FILM 32
 Cost of Materials 35
 Travelling Expenses 37
 Music Royalties 38
 Hire of Equipment and Facilities 38
 Insurance 39
 Production Time 40
 Overheads 41
 Margin of Profit 42
 Submitting the Quotation 42
 Checking the Cost 43
 A Typical Budget 43

4. PLANNING A DOCUMENTARY 46
 Colour or Monochrome 48
 Lighting 48
 Personnel 50
 Obtaining Outside Services 53
 Hiring Actors 54
 Costume 55
 Wigs, Beards and Moustaches 55
 Make-up 56
 Studios, Sets, Furniture and Props 56
 Hiring Commentators 57
 Library Material 58
 The Shooting Schedule 59

5. CHOICE OF CAMERA EQUIPMENT AND FILMSTOCK 62
 35 mm. or 16 mm. 62

Choice of Filmstock 64
Negative or Reversal? 64
Choice of Camera 66
The Continuous Reflex Camera 66
Cameras for Use in the Field 70
Choice of Lenses 71
Focal Lengths 72
Aperture 73
Selecting Filters 75
Filters for Colour 76
Filters for Black-and-White 79
Polaroid Filters 81
Exposure Meters 82
Tripods 84
The "Spider" 87
Reflectors 87
Other Accessories 87

6. SHOOTING 89
Rules and Conventions of Film Assembly 90
Division of Subject-Matter into Separate Shots 91
Sequence of Shots 92
Planning Camera Angles 95
Continuity Between Shots 97
Condensing Time 98
Directing People 99
Liaison During Production 101
Conventions of Movement 102
Overlapping Action 103
The "Cut-Away" 104
Breaking the Rules 106
Dope Sheets 108
Exposing the Film 110
Choice of Lens 111
Camera Angle and Viewpoint 111
Use of the Tripod 112
Camera Jams 113

7. SHOOTING A DOCUMENTARY OVERSEAS 114
Production Hazards to be Considered 115
Customs Requirements 117
Health Considerations 118
Dispatching Rushes 118
Safeguards Against Tropical Conditions 119
Problems of Extreme Humidity 120
Budgeting a Film Overseas 121

8. LIGHTING ON LOCATION 123
Four Types of Lighting 123
Lighting Contrast 126
Use of Reflectors 127

Light Units and Their Use 127
Overrun Photographic Lamps 129
Tungsten-halogen Lamps 129
The Problems of Mixed Light 129
Filming with Very Limited Light 131
Working on Remote Locations 132
Achieving Colour Balance with Artificial Lighting 133

9. SOUND RECORDING 135
Development of Sound-Recording Methods 136
Magnetic Sound Recording 137
Problems of Synchronizing Magnetic Tape 137
Perforated Magnetic Film 140
Mixing Sound Tracks 140
Recording on Location 142
"Wild" Recordings 143
The Problems of Extraneous Sounds 144
Placing the Microphone for Synchronous Shooting 145
Problems with Acoustics on Location 146
Assessing Acoustic Qualities 148
When Acceptable Results are Impossible to Obtain 149
Choice of Microphone 149
Recording Speech 151
Recording Music 152
Single-Microphone and Multi-Microphone Techniques 153
Methods of Synchronizing Sound Recorded at the Same
 Time as Picture 154
Recording Synchronous Sound with an Independent
 Recorder 156

10. ARTWORK AND ANIMATION 157
Titles 157
Filming Titles 158
Superimposing Titles 158
Adding Fades and Dissolves 160
Stop Action and Animation 160
Cartoon-style Animation 161
Simple Animation 164
Stop Action 166
Filming Stills, Drawings and Paintings 167
Camera Movement as a Substitute for Animation 169

11. EDITING 171
Obtaining a Work-Print 171
Footage Numbers 172
First Assembly 174
Screening the Rough Assembly 175
Assembling Picture and Synchronous Sound 176
Marking Up the Work-Print 179
Marking Up for Opticals 180
Master Matching 181

Preparing the Master for Opticals 183
A and B Roll Assembly 183
"Chequer-Board" Printing 186
Cueing for Release Printing 187
Leaders 188
Marking Up for Printing 189

12. THE SOUND TRACK 190
The Commentary Script 190
Writing Commentary to Picture 191
Basic Rules of Commentary Writing 192
Style in Commentary Writing 193
Blending Commentary with Visuals 194
Integrating the Commentary and Visuals 197
Recording the Commentary to Picture 197
Cueing the Commentator 198
Cueing the Work-Print 199
Cueing by Footage 200
Placing of Commentary in Relation to Picture 201
Avoiding Paper Rustle 203
Dealing with "Fluffs" 203
The Commentator's Style 205
Need for Rehearsal 205
Handling the Recorded Commentary Track 206
Post-Synchronous Recording of Dialogue to Picture 206
Recording to Picture Loops 207
Laying the Commentary 207
Using the Synchronizer with Track Reader 209
Bringing the Commentary and Picture into Precise
 Synchronism 210
Cutting in Retakes 211
Running Double-Headed 212
The Music Track 212
Library Music 213
Laying Magnetic Music Tracks 214
Mixing Music from Discs 215
Music Royalties 217
Effects 217
The Sound Effects Library 219
Mixing the Various Sound Tracks 219
Sound Loops 221
Simpler Methods of Mixing 221
Checking Synchronism During Mixing 222
Producing the Optical Track 223
Characteristics of Optical Tracks 224
Cueing for Printing 225
Blooping Joins in Optical Tracks 226
Checking Track Quality in the Print 227

13. OBTAINING PRINTS 228
Checking the Grading 228

Checking Colour Quality 229
Joins in Release Prints 231
Sound Quality 232
Obtaining Release Prints 233
Printing from Dupe Negatives 233
35 mm. Colour Release Prints 235
16 mm. Colour Release Prints 236
Comparative Costs of Different Methods 237
Fragile Emulsions 238
Release Prints on Both 35 mm. and 16 mm. 239
Magnetic Sound Prints 240
8 mm. Sound Prints 241
Spooling Up 241

14. DISTRIBUTION 243
Cinema Distribution 243
Selling Films to Television 244
The Non-Theatrical Market 247
Distributing the Sponsored Film 247
Setting Up the Sponsor's Own Library 248
The Sponsored Film in Education 249

15. CONCLUSION 250

GLOSSARY OF TERMS 252

INDEX 259

PREFACE

Having just finished making a feature film, it seems odd to be writing a piece to preface a manual of documentary film production. Yet on reflection the two genres of cinema have much in common: it is wholly the matter of approach, and even this can have common interests. Some years back I drew the close parallels between Flaherty's magnificent documentary Louisiana Story *and De Sica's equally fine so-called fiction film* Bicycle Thieves. *What has happened since then to make cinema really alive and exciting again is that the most perceptive of makers of feature films have learned ever more deeply from documentary cinema in the pursuit of the "creative interpretation of reality".*

Mr. Baddeley's manual, and he makes this most clear, is not concerned with the aesthetics and/or social approach to the documentary film. He does not deal with the poetic, the humanistic or the sociological attitude of the documentary film-maker. His is a book—and to my mind a most useful and valuable one—about what we may call the craft of film-making, if you can apply that term to a highly-industrialized and mechanized medium. I find his work all embracing and, I am sure, most accurate.

In the past year or two, some European, British and American film-makers of what is pretentiously called the nouvelle vague *have, it would seem, cast aside the technical niceties and skills of our medium in an effort to become more "free". They have rebelled, as the Italian neorealists and British documentary movement did before them, against the confined restrictions of the studio-made film. They have let their cameras and microphones roam the streets and houses of today's life and, aided by recent technical improvements of film stock, light portable movie-cameras and magnetic sound-recording, have given some exciting work far closer to pure cinema than anything from the conservative commercial entertainers.*

Personally I much welcome and applaud this freedom—it has a fine freshness to it—but at the same time it has often shown a disrespect for the craft of film-making about which I am not happy. Somewhere between the two must lie a middleway in which freedom of technical means can be equated with the skill of fine craftsmanship. Out-of-focus shots, a wavering hand-held camera and sound-recording in which the dialogue is inaudible are the privilege of the rank amateur. Film-making is a professional task.

In commercial cinema, on the other hand, due I fancy mainly to the frustration of being compelled to make worthless subjects dictated by the

7

industry's ideas of "entertainment", many talented film-makers have become fascinated by the perfections of the technique per se, thus film after film is a hollow shell of glittering technique. Such striving after perfectionism is, however, very expensive and is one reason—but not by any means the only one—for the high cost of commercial film production today in England and America.

To those of us who started in thirty odd years ago with the documentary world, Mr. Baddeley's book is obviously alarming. In those days, mainly due to the sheer lack of money with which to obtain good technical facilities, we had to make do with the most primitive equipment, a minimum allowance of film-stock and public transport was the rule for travel. Imagination and improvization were our saviours.

But I am not one of those people who believe that an artist must triumph over the poorest of tools and materials, especially in a medium like the film which depends so greatly on mechanical instruments, but I do believe that an over-abundance of technical aids can confuse the film artist's direction of purpose. I once recall watching a distinguished documentary director, who had been given an elaborate camera-velocilator to use for the first time, spending all morning in deciding how to shoot a simple "insert" of a map pinned to a wall. Without the many variations made possible by this intriguing piece of equipment, I am sure this director would have shot the map perfectly adequately in five minutes. The results would have been just as good.

Nevertheless, in spite of my reservations, all kinds of film production have become infinitely more complicated—and more expensive—since the war years. Thus it becomes more and more important for the film-maker—whatever his particular talent as a director, cameraman, editor or so on—to know and master the tools of his craft before he can afford to take risks and discard them. To this end, Mr. Baddeley's book will be a tremendous help, and it may lead its readers perhaps on to a more specialized study of works devoted to the various branches of production.

At the same time, I must record that I still believe that knowledge is best gained by the hard way of trial and error in practical experience: but even here this book can have its place of reference.

February, 1963 PAUL ROTHA

INTRODUCTION

THE WORD "documentary" to describe a type of film was introduced by John Grierson in the late twenties. It derived from "*documentaire*", a term used by the French for their travel films. Grierson first applied "documentary" to Robert Flaherty's *Moana*, an account of events in the daily life of a Polynesian boy. Later he defined it as the "creative treatment of actuality".

Today the term has come to refer to a far wider range of films than its originator intended. The purists rebel and remind us of the original definition. But language is a live, changing thing, and when a word becomes popularized and used by all and sundry no power can stop it subtly changing and acquiring, as in this case, a wider meaning. "Factual film" is a more correct description of many of the films described today as "documentary". But the miilions have taken over the word and are convinced that *they* know what a documentary film is. Undoubtedly the word fulfils a need and describes something for which no better one exists.

So, however it may offend the purists, I am going to succumb to popular usage and use "documentary" in this broadened form.

The motion picture has had three phases in its development. It began as a novelty; it grew into a worldwide medium of entertainment; and in its third phase it became a tool – an instrument with a thousand serious jobs to do. This instrument is the factual or documentary film. It is called upon to tell us about the world we live in; to present us with its myriad different faces; to show us our fellow men spread about the six continents; to show us nature, inanimate and living, in all its moods.

The film has become an instrument of teaching, opening a window on the world to the schoolbound youngster. It helps to train scientists, biologists, doctors, mechanics, soldiers and astronauts. The film can record, storing the movements of the countless instruments in a space rocket, bringing back to earth for study by waiting scientists pictures of the world beneath and the heavens above. The film can analyse: the high-speed camera records movement

and slows it down a thousand times, enabling the precision of mechanical parts to be examined and faults which the unaided eye could not see to be corrected; or the stop-action camera speeds up action so that the movement of crowds, vehicles, shoppers and factory operatives can be studied and improvements in layouts and methods effected. The motion-picture camera has become an integral part of the equipment of expeditions, recording man's attempts to overcome nature in remote and formidable places. The film can sell – consumer goods or capital equipment – by demonstrating convincingly or by sheer hard plugging. The film can win our sympathy for causes of all kinds. And the film carries the power of making all things clear, by magnifying, diminishing, speeding up, slowing down or interpreting with the help of cartoon animation.

And no longer is the film, when made, confined to the fire-proof projection box in the public cinema. It has broken out – into our homes, into schools, churches, factories, hospitals and exhibitions. Today also film is flung through the air by means of television, one of whose most versatile and invaluable tools it has become.

This huge development of the "film with a job to do" has caused the birth of a new industry, one devoted to the production of factual films dealing with countless thousands of subjects. It is with these films, a large proportion of which are never intended to see the inside of a cinema, that this book is concerned. And because a great many of these films are essentially practical productions, this will be an essentially practical book.

While many of the processes of production are the same whether the film deals with fact or fiction, there are many special problems to be encountered in the field of the factual film – problems concerned with filming everyday life, with capturing the unpredictable, with filming in ordinary surroundings as distinct from filming in a studio where everything is under the producer's control. These are the problems that this book attempts to deal with: problems of organization and planning, of equipment and materials, of the handling of people and subjects.

It has been said that the art of making films is the art of successful improvisation. This is certainly true of documentary production. But, improvisation or not, there are many basic rules that must be understood – even though there may sooner or later come occasions for breaking each one of them!

Whereas most people will be ready to grant that a tremendous amount of skill is necessary to make a piece of pottery from clay, play a musical instrument or design a motor-car, there is a curious

10

and widespread conviction that anyone can make a film. The traveller will take up a motion-picture camera and set off to make a film of an expedition in faraway places with practically no preparation whatever, confident of bringing back a masterpiece that the television networks will be delighted to transmit. Or a still photographer will gaily change his Rolleiflex for a cine camera overnight and set about making a sales film for his firm, convinced that it will be just as effective as others made by experienced specialists. If this book should fall into the hands of one of these optimistic folk I hope it will persuade him that film making is in fact a combination of many hard-won skills, most of them calling for experienced judgment and much practice.

Today, documentary films are produced either on 35 mm. film or – a great and increasing proportion – on 16 mm. The majority of the problems I shall discuss are common to both film sizes. Where there are essential differences in the techniques required for the two gauges these will be dealt with separately. In endeavouring to cover so wide a field as the complete production of documentary films, which differ so much in style and subject-matter, it is impossible to go exhaustively into the artistic or aesthetic considerations of all the departments concerned. But there are other books which deal individually with such aspects as film editing, camera work, film music, make-up and so on.

The practical problems and normal trade procedures of each department of production are explained, as is the manner in which their specialized operations are woven together to produce a harmonious whole. To make the coverage as helpful as possible, I have gone beyond the pure technicalities of film and referred to such matters as hiring actors and costumes, budgeting, insurance, the ordering of prints and other non-technical but relevant aspects.

Although much of the book is purely practical, there are frequent reminders that imagination remains the most important ingredient in production, in almost any kind of film. I have approached numerous documentary film producers, directors and scriptwriters and have incorporated their views, ideas and suggestions. Where appropriate, I have quoted from shooting scripts, commentary scripts, cameramen's "dope sheets" and so on, all such quotations relating to actual productions.

I should like to place on record my personal appreciation of the very willing help given by the many people I have approached for information, advice and collaboration. My thanks are particularly due to the following: Edgar Anstey, David Attenborough, B. J.

11

Davies, John Davies, R. F. Ebbetts, Thorold Dickinson, R. W. Fountaine, John Grierson, L. B. Happé, Forsyth Hardy, Kodak Ltd., The Public Relations Officer and Films Officer of the East African Railways & Harbours Administration, and John Waterhouse.

I am also greatly indebted to Dr. Leslie Knopp, M.B.E., for his invaluable contributions to Chapter 9, SOUND RECORDING.

I would also like to express my sincere thanks to Brian Watkinson for his great help and the innumerable practical contributions he made as editor of this book.

1

PREPARATION OF THE SCRIPT

THE SCRIPT is the blueprint from which a film is made. Ideally, it is a precisely worded document describing the visuals scene by scene, with details of the accompanying sound track. It contains all the instructions to enable the technical team and the actors to bring the script-writer's ideas, complete in almost every detail, to the screen.

In the production of fictional films, such scripts are the accepted thing – it is very difficult to make a story film without a very detailed plan of action. But in the making of a documentary, dealing as it so often does with the real world around us, we cannot always be so precise. Sometimes the subject is under our control and then we can plan our sequences, shot by shot, with reasonable confidence that our plan can be carried out. More often, however, we cannot be sure in advance what we shall have to deal with at the shooting stage. Perhaps we require scenes of people going about their ordinary business; maybe our script calls for shots in streets and public places: in these cases neither the people, the weather nor the lighting are under our control. The script of a documentary film, therefore, cannot always be precise; it must often allow the director and cameraman considerable latitude to deal with the unpredictable and the uncontrollable.

Documentary scripts vary greatly with the type of film to be produced. But whether every scene can be planned in advance or not, there are many things that the script can and must indicate to the producing team. There are three principal stages in the development of a script. The first is the preparation of the treatment; the second is the carrying out of research on the subject to be filmed; the third is the writing of the shooting script itself.

The Film Treatment

The treatment is the "story" of the film, presented in straightforward, plain language, uncluttered with technical jargon. The

object is to enable everyone concerned to study the project, whether they have knowledge of film terminology or not, and then give their opinion on the style, emphasis, mood and shape of the film as it will finally emerge. This manner of presenting the subject has many advantages. It is far easier to grasp the idea of the film as a whole from a concise treatment in plain language than it is from a shooting script, embellished as it must be with instructions to camera crew, sound recordists, film editors and so on. And when suggestions for alterations are received – as they are very likely to be – the labour of rewriting is so much less. If the film is for a commercial organization, client or sponsor, the producer's proposals are far more likely to be understood in this simple form.

At the treatment stage far more than the subject-matter of the film has to be decided. The treatment must be sufficiently detailed to indicate the method of presentation – the style of the film. Will it have spoken dialogue or commentary, or both? Will music be used as an important ingredient in its own right? Will the subject be presented factually, impressionistically, or will it be dramatized? Will the mood be serious or light-hearted? And how long will the film be?

But before these points can be decided it is necessary to answer two vitally important questions: What is the purpose of the film and for what audience is it intended? It is surprising how many films are embarked upon without their objective being precisely defined, particularly those varied productions made under the guise of "public relations" and the more nebulous category of documentaries "with a social purpose". Even in the case of films made to instruct, too little thought is sometimes given at the outset as to the probable age-group and mental capacity of those to be instructed, and to how many instructional points can, in fact, be put over effectively in one film. Whatever the type of film, it cannot be too much emphasized that the most important initial step is to establish without any doubts *exactly* what its purpose is and who it is aimed at. It is very seldom possible to produce a successful film for more than one type of audience.

A film treatment may evolve slowly and develop stage by stage. The first treatment may be no more than a paragraph presenting the outline in summary form. This may pass through various phases of amplification as the idea crystallizes – which is one reason why it is better to start with a treatment than with a detailed shooting script.

There are no hard and fast rules for the presentation of treatments. Sometimes the sound track and the picture are described

14

separately in alternate paragraphs, as in the extract given below. This film was to be a historical documentary reconstructing the building of a railway in Africa at the turn of the century.

TREATMENT: PERMANENT WAY [1]

We open with a shot of the East African landscape, wild, rugged and without a sign of human habitation. We dissolve through a series of introductory scenes showing East Africa as it was, untouched by any civilizing hand – empty plains, wide expanse of bush, the Rift Valley, the rolling highlands, and then Uganda, green and fertile.

> The commentator begins: "East Africa at the end of the nineteenth century. A land without history. In these vast tracts of land, today was the same as yesterday. And yesterday was the same as it had been for centuries. Time stood still." The commentary continues to point out that in those days what is now known as Kenya was a scarcely populated, barren region, arid in the east, rising up to a high plateau inhabited by only a few nomadic tribes. In fact, the idea that it should be settled, populated and farmed had not yet entered anyone's head. It was regarded as no more than the route to Uganda . . . for Uganda was known to be green and fertile, a land with great potentialities.

Then we see, coming through the bush, a slave-train. The slaves, their heads bowed down by heavy wooden halters, plod on, driven unmercifully by their captors.

> The commentary refers to the blot of slavery on this land – a scourge that was now condemned by the European Powers but by no means suppressed.

Subject Research

When the treatment has been agreed and approved more detailed research into the subject-matter can proceed. Naturally, investigations will have been made already; but now, all the information that the film is to present must be systematically gathered together and checked for accuracy. Wherever possible, locations should be visited, contacts established with those persons the crew will have to work with, camera angles planned.

If the film is to deal with a technical subject a considerable amount of effort may be required to master the principles and techniques to be presented. No sources of information, however small their contribution, should be neglected. In the case of technical films, an expert on the subject can often be induced to write a description of a process, or a summary of his field of work, and this can provide invaluable background information. Books, magazine articles, even sales leaflets, all help to build up that fund of information that will be so useful when writing the shooting script – particularly where a detailed commentary is called for.

It may be that the budget does not allow all the locations to be

[1] Produced for Caltex (Africa) Ltd., and East African Railways & Harbours Administration.

visited – if some of them are overseas not only cost but also time may preclude a preliminary reconnoitre – but it is still possible to find out a great deal in advance. While the resulting shooting script cannot be as watertight as one where a detailed examination of every location has enabled each camera set-up to be planned, we shall see later that much can nevertheless be achieved.

The Shooting Script

Let's consider, first, the case where a full and detailed shooting script can be produced. What information should it contain?

The ideal script should describe the visuals, shot by shot, and provide the following information:

The shot number.

Whether exterior or interior.

The location.

The time of day – whether day or night, unless some more specific time is important to the script, such as "Dawn" or "Twilight".

The area to be seen by the camera, described as
Long Shot (L.S.)
Medium Long Shot (M.L.S.)
Medium Shot (M.S.)
Medium Close Up (M.C.U.)
Close Up (C.U.)
Big Close Up (B.C.U.)

If the camera angle is other than a normal eye-level view, a further description must be given such as *Upward angle*, *Downward angle* (sometimes called a *Top Shot*).

The subject and the action, if any, that will take place.

Any camera movements called for within the shot, such as *Pan left*, *Tilt upward*, *Track in*, etc.

All this sounds very complicated, but an example will show that it is, in fact, quite straightforward.

Shot
32 *Exterior. Beside a river close to an African village (Madinare); Day.*
L.S. A sweep of country with the river on the left. An African, the Chief of the village, enters right of frame and walks left. The camera pans with him and centres on a group of men who are waiting beside the river.

If the next shot follows chronologically and is to be shot on the same location, there is no need to repeat the description of the place and time, thus:

33 *M.S. The leader of the group greets the Chief and they shake hands.*

16

. It is normally accepted that one shot will be joined to the next by a straight cut unless instructions are given to the contrary. If a dissolve is called for this is stated between the shots:

36	M.S. The Chief and the leader of the group. The Chief points across the river to the land on the other side and speaks.
	Dissolve to
37	*Exterior. A clearing in front of the Chief's hut. Madinare Village; Day.* M.L.S. The Chief is seated on an old, but imposing dining-room type chair; around him, sitting on the ground, are the village elders.

The sound track is described in a separate column alongside the visuals. It is usual to place the visuals on the left of the page and the sound on the right. Adding the sound to the above example, the following would be a typical layout:

36	M.S. The Chief and the leader of the group. The Chief points across the river to his land on the other side and speaks.	*Fade music to background* *Commentator:* "Beyond the river is my land," said the Chief. "If you come and work there you must work hard and quickly."
	Dissolve to	
37	*Exterior. A clearing in front of the Chief's hut. Madinare Village; Day.* M.L.S. The Chief is seated on an old but imposing dining-room type chair; around him, sitting on the ground, are the village elders.	A few days later the project went a stage further. At a meeting of the Tribal Elders, known as the Kgotla, the Chief put forward the plans and asked for the co-operation of everyone in the village.

It is customary in script-writing, just as it is in play-writing, to underline all instructions to distinguish them from descriptions of the action and dialogue or commentary. Here, these underlined passages are in italic type.

Script Terminology

Script terminology varies slightly with individual script-writers, but it may be helpful at this stage to summarize the most common terms used, and define them.

PICTURE

EXTERIOR. Any scene shot in the open air.

INTERIOR. Any scene shot indoors, usually with the aid of artificial lighting, but not necessarily so. It may be useful, as an aid to subsequent planning, to add in the script an indication as to whether artificial light will be required or not. In feature film production, INTERIOR would usually indicate a studio scene shot on a set with, of course, lights.

CAMERA SET-UPS

LONG SHOT (L.S.). A full general view of the subject.

MEDIUM SHOT (M.S.). Part of the scene photographed from nearer than a long shot.

CLOSE UP (C.U.). A close view of an object or some detail in a scene. In the case of human subjects, the head only.

BIG CLOSE UP (B.C.U.). A very close shot taking in a very small area. In the case of human subjects, part of a head or face only, e.g., the eyes or the mouth.

Further sub-divisions are frequently made, such as MEDIUM SHOT (halfway between a long shot and a medium shot), MEDIUM CLOSE UP (halfway between a medium shot and a close up), and so on. The phrase TWO SHOT, referring to a shot just framing two persons – probably head and shoulders only – is a useful and concise description. Some writers prefer CLOSE SHOT (C.S.) to CLOSE UP, but such variations are purely personal and are easily understood.

CAMERA INSTRUCTIONS

PAN. An abbreviation of the word "panorama", meaning to rotate the camera horizontally.

TILT. A movement of the camera in the vertical plane, the direction usually being indicated: TILT UP or TILT DOWN.

TRACK (or DOLLY). To move the camera forward, sideways or backwards, using a "dolly" – a camera support on wheels. Sometimes the term is changed to TRUCK, i.e., TRUCK IN or TRUCK OUT.

ZOOM. To operate a zoom lens on the camera to bring the subject optically nearer or farther. Thus ZOOM IN or ZOOM OUT, sometimes amplified still further to ZOOM FROM MEDIUM SHOT TO CLOSE UP.

SHOT-LINKING INSTRUCTIONS

DISSOLVE (or MIX). The merging of one scene into the next.

FADE. The gradual darkening of a scene until the screen becomes black (FADE OUT) or the transition from a black screen to a normal picture (FADE IN).

WIPE. A line moving across the screen "wiping" off one scene and revealing the next. In practice the line can be straight or any shape, vertical, horizontal or at any angle in between.

These effects are all known as "opticals" because they are often inserted at the printing stage by means of what is known as an "optical printer" – although nowadays many such effects can be introduced in ordinary printing. But these are technicalities that will be gone into more fully later.

Dissolves are most often used to bridge time or a change of scene from one place to another, when a quick, smooth transition is required. Fades, although they are also used to carry us to another time or place, separate two scenes much more decisively. They must, therefore, be used more sparingly.

18

Wipes provide a quick, slick link, but they are rather a "gimmick" and can soon become irritating if they are used frequently.

In the case of the sound track, the terminology is less complicated. In addition to the commentary and dialogue, the only instructions usually relate to the handling of music and effects. The following terms are commonly used:

SOUND INSTRUCTIONS

SYNCHRONOUS SOUND (or SYNC SOUND), indicating that the sound is to be recorded at the time of shooting.

WILD SOUND (or WILD TRACK), indicating that the sounds, usually effects or background noises, are to be recorded non-synchronously – that is, not at the same time as the shots were taken, or not with a sound system linked to the camera.

MUSIC, MUSIC TO BACKGROUND LEVEL are self-explanatory.

MUSIC OUT or MUSIC IN are the same as FADE-OUT MUSIC and FADE-IN MUSIC.

It will already be clear that the preparation of a detailed, water-tight script is no small undertaking. If the film is a commercial one, or has been commissioned by a client, the script will represent a sizeable item in the budget, and the amount of work involved in its preparation must not be underestimated.

It is also obvious that the script-writer must have a sound knowledge of the principles of film production. He must understand the rules of camera movement, the proper length of shots, the variety of angles and camera viewpoints required by the film editor, and when to use "opticals" – dissolves, fades and wipes. He must be able to suggest how the various ingredients of the sound track – dialogue, commentary, music and effects – can be blended together to support and reinforce the visuals.

Script-writing is not merely telling a story or presenting a subject in a filmic form. It is the creation of a plan of action whereby a team, consisting of a director and his technicians, can bring their subject effectively to the screen. The breakdown of the subject into separate shots and the selection of camera angles are not, in documentary work, a matter merely for the whim of the particular script-writer. In the production of fiction films everything will normally be under complete control. The angle that the script-writer considers to be most effective from an artistic point of view can be contrived. The art director can no doubt so design his set that, however unusual the requirement, that particular camera angle can be made possible. The documentary team, on the other hand, are usually dealing with reality. What they are intending to film probably already exists and

19

cannot be altered merely to suit their purpose. That is why the preliminary research before the script is written must be much more than a survey of the subject-matter. It must also be an examination of the locations with the practical object of deciding the best camera positions that are *physically* possible. It is useless to suggest a downward angle for a shot of a large machine tool if the problems of getting the camera into the elevated position visualized are going to dislocate the factory.

It is important that the camera angles described in the script are well thought out and practicable. When the crew arrive to shoot the scenes their work will proceed smoothly only if the camera set-ups suggested are feasible without a great deal of rearrangement. For if one of the suggested set-ups turns out not to be possible, discussions are necessary, alternatives must be compared one against the other, and a great deal of time is wasted. And there is always the danger that a changed camera position for one shot will upset the proper transition of that shot to the subsequent one. Hasty adjustments of the camera viewpoints called for in the script may result in pictures that the film editor later finds difficulty in assembling smoothly.

Scripting the Unpredictable

So far we have considered the case where it is possible to prepare a detailed script of the whole film. In documentary work, by no means all subjects lend themselves to being fully scripted in advance. It is obvious that films containing sequences to be shot newsreel fashion – such as a film of a motor race, for instance – cannot be planned in very great detail. Films that observe life, using "candid camera" techniques to film life as it happens, must remain only loosely planned, at least as regards the sequences where the subject is not under the director's control. But it is always vitally important to prepare as detailed a script as the subject-matter permits – and in many cases more can be planned and presented on paper than might be imagined.

The best approach to the problem is to divide the scenes under two headings, those which are under your control and those which are not. The former can be scripted, the latter cannot. The script will then take the form of a framework, with the predictable items acting as the pegs upon which to hang the remainder. The unpredictable portions can then be inserted in plain language, in a style similar to that employed in writing the treatment.

In most documentary films the opening and the ending are the

20

most difficult parts to write. If a film tells a story, the story itself – if it is a good one – has a ready-made beginning and end. But a documentary film is very often a slice of life, and life flows on in a continuous stream. Some moment must be selected, arbitrarily, as the beginning, and another moment as the end. A good opening sequence is full of anticipation; it captures the interest at the outset and gives promise of interest to follow. The conclusion is equally important and should have an air of finality and completeness. Even if the bulk of a film is unpredictable and cannot be scripted in detail in advance, at least try very hard to script the beginning and end. Beginnings and ends don't happen naturally; they have to be contrived.

Let's take some specific examples of "filming the unpredictable" and see how they were achieved and how much scripting in advance was carried out. A very popular television series was David Attenborough's ZOO QUEST. In these programmes he is seen travelling in distant and remote parts of the world, usually in search of some rare or elusive zoological specimens. From one expedition he frequently brings back five or six half-hour television programmes, describing stages in his journey and the people and animal life he encountered. For example, in one series he was in search of the Bird of Paradise. In the sixth and final episode he showed the successful end to a long search and rounded off the series with some remarkable shots of the bird performing its mating dance.

It is obvious that there are innumerable problems to be overcome before a successful series of this kind can be secured. First of all, although there may be a theme running through all the programmes – in this case, the finding and filming of a rare bird – each episode must be complete in itself. Each one must contain a story with a climax and a reasonably satisfying conclusion, and this must be achieved five times before we are brought to the final, sixth, climax that rounds off the whole series. And it must be remembered that these six rounded episodes must be obtained with the minimum of advance knowledge of what will be encountered. It is all very well to set out with the intention of filming a Bird of Paradise. Supposing such a creature refuses to allow itself to be discovered and photographed! It is clear that the whole expedition must be organized with the maximum flexibility and a readiness to seize any likely opportunity and turn it to advantage. If no Bird of Paradise can be located, something else must be found instead – in fact, Mr. Attenborough did not usually go on an expedition with any very set plans in mind, because it might have proved impossible to carry them out. As he explained at the time:

"I have no plans whatsoever as to what we shall film before setting out. I merely try to do as much research as possible both on the anthropology and the zoology of the area. Obviously I have certain animals that I am particularly interested in, but that is all. As to the actual story, this is certainly not in any way thought out, for our trips are all told in the first person and anything that happens is almost entirely *as* it happened and minimally engineered. What frequently happens is that we run into something and I secure what I tend to call good shots – for example, a marriage ceremony, a Bird of Paradise displaying and so on. We then tend to work both backwards and forwards around this, shooting the things that will turn these good shots into a complete story. Indeed, I might go so far as to say that very often, although I spend a long time looking for some animal, I will not bother to cover the build-up approach material until I have *got* the shot of the animal, thereby saving both labour and film.

"However, I do find it necessary at regular intervals throughout the trip to go over the notes I have made each evening on the material that has been shot, to try and devise some method of piecing together the mosaic that we have got so far into some continuous picture; and try to visualize what the missing fragments are. Having done this, we then try to cover them.

"Often we find that episodes have to be juggled about so that often what reaches the screen is by no means in chronological order. This is fairly obvious; on, for example, our Pacific trip we went first to Tonga, then to the New Hebrides and finally to Fiji. In the event, for geographical simplicity, we made this a journey from the New Hebrides through Fiji to Tonga."

In this case, the film grew out of the expedition and the script was created out of what was encountered on the way. A rather different approach was used in the production of the United Nations film *Power among Men*. Thorold Dickinson, the producer, described the development of the basic idea in these words:

"We built it up without a script. As our basis we had the idea of human survival; we wanted to present four anecdotes, each dealing with an entirely different sort of people in entirely different parts of the world, that would make the audience feel 'Yes, this world *is* worth living in! It is an achievement worth preserving.' We decided to link these anecdotes with compilation sequences showing the negative side – the destructive side of life. In our four episodes, man was creative, and in the links man was destructive. And we would, in the end, reach the hydrogen bomb.

"Now, how can you show a hydrogen bomb explosion effectively? No hydrogen bomb has blown anything up yet; it has so far merely created fall-out in the air. We were given a shot by the American Air Force of an H-bomb explosion, a unique shot. A beautiful thing to look at – but without scale. Nothing to give you an idea of its immensity. All it did was to turn night into day, and then, for a whole minute, the night steadily returns. That's all it did. So we decided that each episode in this film would be followed by a bigger and bigger explosion.

"The first one was a chance explosion of a hand-grenade which killed a peasant. The second, a controlled explosion blasting rock in the course of building a road. The third was blowing up a mountain during the building of a dam in British Columbia. Then, the fourth one – a ten-megaton bomb. By that time the audience would know what they were in for and would be chilled to the marrow.

"To create the four sequences in the various countries we took a writer with

the team. I refused to try and write the script in advance – although I was very strongly pressed to do so. It would, of course, have been quite impossible. In each case, the director, the writer and myself went ahead and found our location, without the rest of the crew. When we had broken the ice with the people involved, decided on our subject and visuals, we would *begin* our scripting – not before.

"At this point it is important to script in detail, in order to introduce discipline and avoid overshooting. We were not working in the Flaherty-Eisenstein way – shooting thousands of feet and relying upon assembling it later into some shape and form. You can't really take up the time of people who are not actors and who are just 'behaving' for the camera. It's almost an insult, after all, to shoot a lot of stuff on them which you're not going to use. It's very wasteful of their time and your resources. So we would script and while we were scripting we would ask the rest of the unit to come and join us.

"In Haiti we reconstructed in six weeks a piece of community development that had taken six years. This *had* to be scripted – you couldn't shoot it in six weeks otherwise."

It is possible to see, in both these examples of a producer's approach to planning and scripting, the conflict that is always present when approaching a factual subject – the conflict between planning and scripting in advance on the one hand and keeping an open mind and the maximum flexibility on the other. This is brought out yet again in these comments by John Waterhouse, director of *Men at Work* (British Productivity Council):

"Very much depends upon what sort of film you are making. If, for instance, you are using a hidden camera technique you can obviously have only a general idea of what you are going to get as you are aiming at the unexpected detail. If, on the other hand, you are reconstituting an event either with actors or with amateurs, I believe in scripting as tightly as possible, but in keeping a very open mind when shooting. So often, ideas come from the actual working out of a scene which are very much better than anything one could have imagined beforehand.

"The prior preparation, on the other hand, is important, as it means that most of the basic problems have been worked out in advance, thus leaving the director's mind free to embroider and improvise. In any activity which has a creative element it is important *not* to let ideas become crystallized too early, as this inhibits half the creative process. There are, of course, practical limits. The undecided director who continually changes his mind demoralizes both unit and actors."

This striving to ensure that ideas do not get crystallized too soon was taken to great lengths in the British Transport Commission film *Terminus*. The producer, Edgar Anstey, describes how this film grew out of an initial suggestion and was allowed to develop, to mature, over a very long period and then continuously throughout the shooting:

"The first germ of the idea came from John Maddison of the Central Office of Information, who said to me one day 'Why don't you make a documentary of a night at King's Cross Station?' It was, of course, an interesting subject,

23

but seemed likely to prove depressing on the screen. After all, King's Cross was old, inadequate and due for rebuilding. So I did nothing about it. Perhaps I was influenced, too, by the fact that we had already made a film called *This is York* and somehow we had lost the human story amongst the mechanics of station operation.

"Some time later I was looking at some candid-camera material showing the handling of parcels at King's Cross – film taken as a time-and-motion study to help us analyse parcel and luggage handling, in relation to the layout and general efficiency of the station. In these pictures members of the general public were seen, as well as railway staff. We were fascinated by the material. Quite apart from its purpose as a study of procedure, the actions of the people – quite oblivious of being shot – were extraordinarily interesting. John Taylor had been responsible for making the scenes and over a drink after seeing the rushes an idea occurred to us – could we introduce actors in amongst the live people and use this as the basis of a film? The actors would set up dramatic situations; we could have someone having an argument, pretending to be drunk, to have lost something, to be quarrelling with his girl, and so on. We could see the reactions of the ordinary people round about to these scenes played by the actors and film the whole thing with a concealed camera.

"There the idea rested perhaps a couple of years. Then John Schlesinger came to me to make a film. We discussed various ideas and then he said he would like to make a film of a day in the life of a railway station. Someone mentioned Waterloo. Waterloo has two important advantages. It's modern and light enough for unlit candid-camera shooting; and when I remembered Charles Potter, my administrative assistant, had once suggested a film about how the signalmen in the Waterloo box preside each day over the fortunes of hundreds of trains and hundreds of thousands of passengers, the decision had made itself. The film at last was on.

"How would it relate to British Transport's policy? Two things, it seemed to me, might be put over in such a film: that British Railways *still* have a vital national job to do and if you sit at a London terminus throughout a day, you see enough vital things happening to prove it; and secondly the film could show the staff were human, warm-hearted people, trying to do a good job.

"Both these things seemed very much worth saying, and Schlesinger agreed that they were not in conflict with his personal (rather than public relations) approach.

"It was obvious that we must be strictly honest. If we were not, the audience (which knows about stations) would not believe any of it. This meant showing some unattractive aspects of the life of a station.

"It was time to begin scripting. The script consisted simply of a series of impressions chosen by Schlesinger to be integrated into an account of the life of the station. This kind of thing:

Flying high above London and the Thames. The Houses of Parliament on our left.
Insistent notes of the harpsichord suggest the time, 8 a.m.
We are now hovering over Waterloo, featuring the enormous acre of glass that covers it.
Titles – *Terminus*, etc., etc.
Various angles on the glass roof under titles.
From the mouth of the station – trains are running both ways.
Inside, the rush to the city is beginning.
The signal box – the dots of the indicator run towards the station. Intent old faces. Silence. "Give me 23, George." Levers are pulled. Kettles steam with the Houses of Parliament in the background. Harpsichord.
The business train from Guildford rattles past the box – swift pan to a

cat looking down from the top of the internal telephone exchange in the signal box.

The men in the business train pack up newspapers, take down their umbrellas, bowlers, brief cases – "See you on the 5.45" etc. etc., and join the march.

Outside the station, the cars and their executive occupants drive away – The Lion and the insignias of War and Peace over the archway gaze down at them.

Public gazing at train arrival board. The destinations change like magic. A special notice indicates the arrival of boat train from Southampton. Australian line.

On 11 – the people who are meeting the train gather. Curiosity at whom they are meeting. The Salvation Army man – elderly foreign-looking woman – a young girl with a bunch of flowers.

Bill, the porter, sits on some scales. He whistles, the pointer on the scales registers the rhythm.

The officials of Cooks, Dawson's, Poly Tours join the group.

Black Homburg, and top hat – the insignia of the Station Master. Phone conversation about delay of boat train.

On 11 – they wait. Their voices perhaps tell us whom they are meeting. A married sister, a prodigal son returning after ten years, a comrade from the Salvation Army. An ambulance at the ready on the concourse – Nurse in evidence.

On the boat train from Southampton – bronzed creatures from the Antipodes. Paraphernalia of travel, the last exchange of addresses – "You will promise to phone me – we could have dinner together. . . ."

The end of shipboard acquaintance – apparently durable.

The landscape of blackened houses gives way to Clapham Junction – Virol signs and huge posters for the London Palladium.

Wheels. Steam. Red dots along the indicator. "Give me 97, George."

Reunion. Frantic embraces. Snatches of conversation ". . . so high when I last saw you."

Bill foraging for luggage in the guard's van.

Hubbub at the sorting-point. The girl with the flowers looks in vain for someone. She seems particularly alone amongst the crowd exchanging their first rather trivial conversation.

The invalid is helped to the ambulance. Bill is paid off as he loads his customers into a taxi.

He rejoins his line of porters.

The girl with the flowers sits down to wait on the station bench – already thronged with people – reading – sleeping – watching aimlessly – a man with an earring counting what looks like the remains of his dole, the boy avidly consulting the racing forecast, feeding himself like a robot with potato crisps.

"Racing Kempton Park" . . . Bookies at the special ticket office. They carry their stands, like musicians, wrapped in a variety of cases. The train, entirely masculine, filled with unmistakable habitués of the race-course . . . "6 to 4 the field", etc., on the sound.

Lifts – luggage vans. Cattle offloaded – half-wrapped new motor-cycles – babies' perambulators –

A van is unlocked – inside, a coffin. Bill helps to load it on the station hearse. It is wheeled through the station with the undertaker following.

Rapidly back to the hubbub of the station. Bookstalls and tea bars.

Departure sign reads – Exeter – Plymouth – Okehampton – Launceston. Clock at 12.30. More passengers.

A procession of vehicles on to the concourse. Black bus sandwiched

between two Jaguars (old type). Police materialize. Several stand by a carriage at the front of the train. Special signs on windows – "Reserved for Party." Black-suited men, too thuggish to be City types, out of the cars. Men in raincoats and hats materialize. No urgency – cigarettes – chatter – glimpses of faces at bus window.

Joint in the galley is basted – vegetables tested with fork. Clock at 12.45 – "City" men consult watches.

Doors of special coach unlocked by police.

Out of the black bus – twenty convicts for Dartmoor, eight years P.D. – handcuffed in pairs.

Public held back on platform – more through barrier. "Send my love to Auntie" – Mother to her children farther back on the train. . . . "Enjoy yourselves."

"The train from Platform . . . calling at . . ." the announcer's voice, smooth.

Whistles. Steam. Waves from Mother. More formal acknowledgment from police on platform to warders inside locked coach.

Lost Property Office. Woman enters. "I left an umbrella on the train from Alton – you couldn't miss it, it's one of those knobbly kind."

Stacks of knobbly caned umbrellas in the store – rows of coats – box upon box of hats, gloves. A library to be proud of – an excess of copies of "Lolita". Another ride into the bowels of the station. Knobbly caned umbrellas on a trolley – down into a dungeon lined with faded, commonplace treasure, all unclaimed though charted.

Cartoon laughter – Donald Duck from the News Cinema. Cardboard faces from our childhood stare at us. Public going in – kids – the girl from the boat train – neon lights, candy, girls with torches. We could be in Leicester Square. A small movement will reveal the station below – still crammed.

A child is crying alone. Policeman goes over to her. Through her sobs . . . "Mummy told me to wait here, and she isn't back yet. . . ."

Station Master's Office. The genial clerk, Mr. Allen, is trying to cheer the child up.

Cakes – cups of tea. The office typewriter is the greatest attraction of all – particularly when the secret of the bell is discovered.

The clerk makes a simple paper boat and the child sails it happily up and down the typewriter.

Details of the child are phoned up to the announcer's box. . . . "Here is a special announcement. . ."

A few people listen *en passant* – but the name announced is not theirs, and the incident ceases to be of concern to them.

More concerned with tea. Tea from the Automat – or the old-fashioned urn in the Long Bar.

Bill the porter is to be found in the staff canteen under the station.

The little girl leaves the Station Master's Office gripping tightly the hand of a parent.

The occupants of the bench have changed again. Now predominantly coloured people are waiting. At the entrance to the platform are fourteen more of them. Some dressed like highly coloured spivs, others with bowler, waistcoat, watch and chain.

"The boat train from the West Indies is arriving at . . ." Tea for the announcer.

Mambos – sambas – West Indian rhythms.

Shrieks of uncontrolled joy at reunion. Some bewildered, dressed in frilly things with a guitar round the shoulder, and a roughly painted case – optimistically – K. Gerald, U.K.

Dolls seem whiter and more blonde than ever in the arms of children.

Social workers and police mingle with the single spivs who are waiting to show the joys of a bedsitter in Ladbroke Grove to the female immigrants with no one to meet them.

Life is busy in the Long Bar. City men putting off the agony, sailors just starting their evening out. Railwaymen, a trip up from Weymouth safely over.

The evening rush continues – a waistcoat blacks out the camera.

Night . . . Theatres out. Music, laughter, applause. The sound is suddenly cut, as the lights on the Theatre Booking Office go out.

The Long Bar is empty now, chairs on tables – sweeping in progress.

As each train comes in, passengers off, the lights on the platforms are extinguished.

"Good night" to the ticket collectors.

Train indicator almost a blank.

Activity by the Automat still. Humanity with no place to go, huddled together – last train missed.

Rubbish under the benches, covered with sleeping forms.

Paper bags, half-eaten sandwiches, a bunch of withered flowers, a crumpled paper boat.

Cheerful whistling from somewhere – mingled with the sound of the harpsichord.

High above the station roof again. Glimmer of light through it. The whistling – electrically multiplied – echoes. London in the distance.

"Most of these items had emotional content that we could emphasize and develop. Emotion is needed in an awful lot of films – if you can touch the emotions of the audience you can reach their minds; they become involved. In *Terminus* we would be able to capture the real emotion of ordinary people in our scenes, but we always had our 'planted' actors who could be brought in to act the more complex parts, and give point and emphasis to the more difficult sequences.

"Our story would start before dawn, and carry on right round the clock. This theme has been used many times before, of course, so long ago as Cavalcanti's *Rien que les Heures* and Ruttman's *Berlin*. In fact, it is a classical documentary formula but Schlesinger wasn't much bothered by that and I suppose I regarded it as a definite advantage – provided the treatment was good.

"We shot the film largely by a newsreel technique, with a hand-held camera operated by a television cameraman who had real genius for capping the sudden drama of the moment. People today are so used to being photographed with 16 mm. and 8 mm. cameras that they were rarely bothered – this was 35 mm., but that was all the same to them. Those who were aware of anything unusual were put at their ease by Schlesinger's enthusiastic explanations and carried on quite naturally. Often we would ask permission – group saying good-bye to friends, for instance, and drinking a parting sherry together; they immediately agreed to be filmed. It was rarely necessary (or possible) to hide the camera.

"Among all these people we planted our actors. They each had a part to play, among the ordinary passengers. One was a man who was late and just missed his train – both morning and evening – and retired frustrated to the bar. Then the little lost girl was 'planted', although the later tears were genuine enough. The whole thing proved rather much for her. Among the other 'planted' actors were, of course, the prisoners on their way to Dartmoor – we shouldn't have been allowed to film real prisoners and reveal their identity.

"These controlled episodes did of course provide an opportunity for more complete shot-to-shot continuity, but in general there was no shooting script

for *Terminus*. More than that, I don't suppose the director looked at this treatment more than once or twice during the shooting. Hugh Raggett, the editor, used it as a guide to the kind of film being made, but he was not inhibited by it in his assembly of shots. A film like this should go on growing beyond the written word. You look at the 'rushes' and new ideas come to you. Some things you see are disappointing, others are surprisingly effective – better than you expected. So you develop some things and curtail others.

"In such a film you can edit and shoot in parallel. You roughly edit a sequence, look at it, and then go back, shoot more and edit it again. Of course, this situation is unusual. We had a subject that was on our doorstep and we could do this. Much more often you have returned from a distant or expensive location and you have to complete a film with what you have got. Your series of rough assemblies have to exist in your imagination as you shoot." [1]

This, of course, is one particular type of documentary film making. There are plenty of occasions – when shooting a film with a strong story line, when it is intended to be instructional, or when a large crew is employed – where a detailed script is necessary. But our examples have shown something both of the great variety of documentary work now being carried out and of the individual approach of some of its exponents. It is clear, too, that this is an art for which it is very difficult to lay down precise rules.

[1] Terminus. *Produced by British Transport Films. Producer, Edgar Anstey. Director, John Schlesinger.*

2

THE BREAKDOWN SCRIPT

HOWEVER DETAILED the shooting script, a film of any complexity cannot easily be shot from this alone. If a film calls for scenes on many different locations, some breakdown of the scenes under various headings is desirable. If a film also contains artwork, animation, close-up "inserts", and perhaps library material (scenes obtained from a stock-shot library or from other films) and some special techniques such as photomicrography as well, the need to sub-divide the shooting script becomes even more pressing.

The "breakdown script" is the accepted method of presenting a complicated film in such a way that the work can be allocated to the various members of the team (or some portions "farmed out" to specialists outside the organization). A breakdown script consists simply of all the material in the shooting script now rearranged under various headings.

All the shots on one location are grouped together. It may be that the film returns to the same location two or three times at various points in the unfolding of the narrative. Irrespective of their position in the shooting script, all these shots are placed together under the same heading. This has several practical advantages. It is much less likely that shots will be overlooked during production than it would be if the director had to thumb through a whole shooting script to make sure that he had secured all the shots on that particular location. It is much easier to plan the shooting, since all the work to be done at a particular place is summarized under one heading. It is, likewise, easier to brief both technical crew and actors. Costing, also, is simplified.

The breakdown script should draw attention to the special requirements of any scene. Any cast required should be listed, as should the dress they should be wearing if this is important. Where dress varies from scene to scene this is also indicated. "Props" required are also shown and any special requirements regarding

background or the set, if it is a studio scene, are specified. But the subject or the action is described in summary form only; it is not intended that the scene should be shot from the breakdown script, which merely needs to refer the director and crew to the relevant portion of the shooting script. For easy reference, the pages on which the scenes are to be found in the shooting script are usually quoted, and the total number of shots involved. A portion of a breakdown script would look like this:

BREAKDOWN SCRIPT

Film: The Trust of a Child[1]

INTERIORS WITH CAST REQUIRING LIGHTING
Location: National Children's Home, Harrogate
Scene: Interior Living-room; Sister Edith's House

Shot Nos.	Summary of Action	Page in Shooting Script	Costume Notes	Props
33 to 38	NIGHT Robert is brought in front door by a Minister and greeted by staff.	6 and 7	Minister and Robert: outdoor clothes (over-coats). Others: normal indoors.	Robert's school satchel.
	CAST Minister Sister Edith Sister Mary Robert 5 other children.			
Total: six shots.				
42 to 51	MORNING Robert arrives down to break-fast, but is too shy and upset to stay. He runs out of the room.	7	All: indoor clothes, chil-dren as for school.	Breakfast on the table.
	CAST Robert Sister Mary Sister Edith 9 other children.			
Total: ten shots.				

The headings under which the scenes should be listed depend upon circumstances. If a film is a complex one and the team working on it fairly large, a considerable number of headings may be helpful.

[1] An extract from the commentary script of this film is reproduced in Chapter 12, The Sound Track.

In our example our heading was INTERIORS WITH CAST REQUIRING LIGHTING. This makes it clear to the production manager that he has to lay on lights and a crew to operate them. Another page of the breakdown script might be headed INTERIORS WITH CAST NOT REQUIRING LIGHTS. Other useful sub-divisions are:

INTERIORS WITHOUT CAST REQUIRING LIGHTS
INTERIORS WITHOUT CAST NOT REQUIRING LIGHTS
EXTERIORS WITH CAST
EXTERIORS WITHOUT CAST.

Then again, if some interiors are to be shot on the actual location and others are to be staged in a studio, appropriate indication and separate lists may be helpful.

Many films contain detail shots, often close ups or big close ups, that can most conveniently be shot separatèly from the main scenes. A list headed INSERTS will help to ensure that none of these is forgotten. Other useful sub-divisions are:

TITLES
ARTWORK
ARTWORK - ANIMATION. ,

Some films will require still further headings. It may be that "library material" will be required, or there may be sequences calling for special techniques, such as stop-action, high-speed photography or photomicrography.

The breakdown script can be used as a set of general instructions to the various specialists, whether inside the film unit or not. If the relevant pages are issued to the artist, the animation specialist and so on, these individuals will be able to see at a glance the contribution that is required from them.

I am not suggesting that every documentary film requires a breakdown script. Many straightforward subjects will not call for such elaboration. The breakdown script is a product of the feature film studio where long and complicated story films are produced by large teams employing dozens of technicians and involving the use of·many actors. To obtain the co-ordination of so many people on a project calling for the closest attention to detail requires much paper work and an elaborate system. Nevertheless, since documentary films vary from a specialist film produced by one technician to a large and expensive television series, involving resources comparable with those of a feature studio, we must be ready to borrow any methods that may assist us in a particular assignment.

31

3

BUDGETING A DOCUMENTARY FILM

THE ingredients of a film are many, and they all cost money. Many of them are invisible when the film is complete. To estimate in advance what a given film is likely to cost is, even to the experienced expert, no easy task. The unpredictable factors are many; the time required to carry out the various tasks, many of them creative in the highest degree, is hard to forecast. What will be the ratio of the film shot to the finished length of the picture? How much extra time should be allowed for adverse weather? What will be the average output per day in terms of finished length? These are just a few of the imponderables. Such questions we cannot answer. But we can, by considering the experience of many producers, analyse some typical budgets.

Film production costs fall into three main categories: Cost of Materials, Time, Overheads. By way of a beginning, let us list the items likely to appear under these three headings.

In a documentary, the MATERIALS, or "prime", costs can include any or all of the following:

Hire of camera equipment.
Raw filmstock.
Processing of raw filmstock.
A work-print (known also as a rush-print or cutting copy).
Film leaders and "spacing".
Actors' fees.
Cost of any studio sets.
Studio properties.
Travelling expenses.
Living and accommodation expenses while shooting, etc.
Studio hire.
Hire of lighting – or the depreciation of your own lamps and lighting equipment.
Commentators' fees.
Hire of sound recording and mixing facilities.

Magnetic film or tape.

Optical track – the final photographic sound track, usually made, nowadays, from a magnetic original.

Processing the optical track.

Music royalties.

Music fees – fees for the use of music recordings (disc or magnetic film or tape) or, in more ambitious productions, the cost of commissioning a musical score, the fees of musicians and the cost of facilities for recording it "to picture".

Laboratory charges for the first approval (or "answer") projection print, plus the cost of "opticals" – that is, the dissolves, fades, superimpositions, etc.

The hire of projection facilities for viewing "rushes" (the film as exposed in the camera immediately after processing and printing) and the various edited versions; and finally, the first approval print.

Insurance.

In the second category, TIME, we have to provide for the hours spent on any or all of the following:

Subject research.

Writing the treatment.

Conference on the treatment.

Writing the shooting script.

Preparing the breakdown script.

Shooting time – including travelling to and from locations.

Viewing the rush-prints as they come from the laboratory.

Editing the work-print – that is, the material selected from the rush-prints.

Preparation of titles and artwork (if not done externally).

Shooting titles and artwork.

Matching the negative or colour master to the edited work-print.

Editing live sound to work-print (dialogue or sound effects – and occasionally music – recorded synchronously at the time of shooting).

Writing the commentary (usually a matter of rewriting the shooting-script version of the commentary) to fit the edited picture.

Recording commentary to picture.

Laying (editing) the commentary track to fit picture accurately.

Selecting recorded library music to provide background music, or commissioning a musical score.

"Laying" effects to picture – that is, synchronizing specially recorded or library effects to picture.

Recording the musical score – or re-recording the selected library music – to picture.

Mixing the music and effects recordings.

Mixing the music and effects sound track with the dialogue or commentary track.

Timing the music used and preparing a "royalties" clearance cue sheet.

Transcribing the final mixed magnetic track to optical track.

Cueing the optical track and the edited picture negatives for printing.

33

Checking the approval print.

Conferences at various stages of production.

Typist's time preparing treatment, shooting script, breakdown script, commentary script, etc.

Journeys to and from laboratories.

Difficult though it may be to estimate the time required for all the various items above, the items in our third category are even harder to calculate and allocate to a particular film. Under this third heading, OVERHEADS, we have the following:

Premises: rent, rates, light, heat, power, telephone, postage, building maintenance and renovations.

Clerical staff.

Stationery.

Vehicles: taxation, insurance, maintenance, repairs and depreciation.

Depreciation of equipment: camera and ancillary equipment, editing, sound recording, projection, etc., including depreciation of lamps, valves and consumable components, depreciation of magnetic film and tape that is used repeatedly.

Advertising and publicity.

If the organization producing the film is a commercial one there must be a margin, after all the above have been met, which is usually termed the "profit". In fact, of course, in a forward-looking organization the so-called profit has to meet still further items without which no progress could be made. It is not enough to cover, as we have done above, the depreciation of equipment and premises. New equipment and fresh techniques are continually presenting themselves and a sizeable proportion of the final margin or profit must continually be ploughed back in acquiring, testing and adapting them for future use.

Finally, there is an extra category, CONTINGENCIES. Film production must always remain largely unpredictable, and however close our estimates under the many detailed headings above may be, estimates they remain. Unexpected problems, the need for retaking scenes for any of a dozen reasons – perhaps criticism on artistic lines, or a legitimate change of mind on the part of director, sponsor, or client – may increase the cost of any item. Every good budget, therefore, includes provision for "contingencies". Often this contingency figure·is based upon a percentage of the total costs involved.

Having broken down our costs, let's consider what helpful advice can be given for estimating some of them individually.

Filmstock

Among our materials, some at least will bear a more or less close relationship to the finished length of the film. It should, for instance, be possible to calculate the consumption of raw filmstock within fairly close limits. However, the ratio of stock consumed to the length of the finished film is not a constant; it depends upon the type of shooting that is involved. If sound is to be shot synchronously with picture, the wastage will be far higher than if the sound is to be added afterwards. It is difficult to quote figures for types of production, and standards of performance vary greatly. Synchronous sound shooting, involving characters speaking a script from memory, will rarely result in a raw-stock to finished film ratio of much less than 4 or 5 to 1 – and the ratio may go as high as 8 or 10 to 1 or higher. The likelihood of trouble arising when both picture and sound are being recorded together is not twice that for picture alone; it appears to follow the law of squares! And because the sync shots are usually longer, there is normally much greater wastage due to ends of reels which are just too short for a repeat or the subsequent shot.

For shooting picture without sound, a good average raw-stock to finished picture ratio is 3 or $3\frac{1}{2}$ to 1. But here again it is dangerous to generalize. Occasionally units have worked successfully to a ratio as low as $1\frac{1}{2}$ (or even less!) to 1. At one time the B.B.C. allowed its news cameramen a ratio of no higher than this, yet a very acceptable standard of news reporting was achieved. Of course, news pictures, though often difficult to secure, can usually only be obtained once – you can't have a retake, for the incident has happened and that's that – and this tends to keep the wastage comparatively low.

News work apart, film wastage during shooting is often closely related to the amount of planning carried out at the script-writing stage. A tightly planned script, with camera angles fully described, will usually result in a much lower raw-stock to finished length ratio than will a loose and badly conceived script. Guided by a tight script, a sequence may be covered smoothly in very few shots. If the script has not been well thought out, if the camera angles suggested are not feasible in practice, or if a rough treatment only has been provided instead of detailed shots, it may be necessary for the director to shoot twice as many to cover himself so that he can be sure that the scenes will edit together smoothly. All this adds up to higher wastage.

Of course, as I mentioned earlier, there are some films that cannot

35

be planned in advance. It is often necessary, on such assignments, deliberately to shoot a great deal of footage to be sure of an adequate coverage, and to leave it to the film editor to select what to include and what to reject at the editing stage. Among films that fall into this category are those recording subjects as they happen – the film of a car rally is one example; another is the film taken by members of an expedition in the field – *The Conquest of Everest* and the films of the Trans-Antarctic Expedition are two that come readily to mind.

Another film-consuming type of assignment is the documentary that records the progress from start to finish of some large engineering project, such as the building of the London to Birmingham motorway or the construction of the Kariba Dam in Rhodesia. A shooting script may be prepared with the close co-operation of the engineers on the project, but the final shape of the film must be subject to considerable amendment. Some stages look more filmic than was anticipated; the engineers on the spot press for some pet technique to be shot after all, although it hadn't been thought of at the scripting stage; or maybe the unexpected happens. The Kariba Dam was nearly swept away by the flooding of the mighty Zambesi, for instance, providing a magnificent spectacle that could hardly have been foreseen. The only way is to shoot plenty of footage and select later. Ratios on such films may often reach 14 or 15 to 1 or more.

Under the heading of filmstock there is one more factor that affects the costing and that is whether the film is to be shot in black-and-white or colour. Colour stock costs on average between two and three times more than black-and-white, but this is by no means the whole story. Processing costs are similarly higher. The work-print may not entail any greater outlay because it is possible to obtain a black-and-white work-print from most colour camera stocks, but if it is desirable to have a colour work-print, this will naturally be more expensive. Again, the first approval print of the finished picture will cost two or three times more in colour than in black-and-white. If extra colour negatives – usually known as inter-negatives – are required for producing numerous release prints, these will be considerably more expensive. Should a special colour process such as Technicolor be used, the initial cost of producing the colour masters for release printing will constitute a very sizeable additional item in the budget. It must be added, however, that when a large number of colour release prints are required the high cost of the masters may be more than offset by the lower cost of each print.

Quite apart from the additional costs connected with colour filmstock – whether camera stock, work-print or release prints – there is likely to be an increase in the bill for lighting. Even today, when fast colour emulsions are available, considerably more light is usually required for colour filming. There are also problems of obtaining a correct colour balance and the special measures to be taken when dealing with mixed light – as for instance when daylight and artificial light are both present. Such difficulties may increase the time spent in shooting, so that labour costs may also be increased.

Generally speaking, if a film is to be shot almost entirely out of doors by daylight the extra cost of shooting in colour will not be very high. Only a few items in the budget will be affected, and the increase may be no more than 15 to 20 per cent overall (this, of course, refers to production costs, and does not take into account the higher price of release prints). But if a film involves a high proportion of interior shooting with lights the cost may be raised very appreciably. By how much it is difficult to say – it may be 40 or 50 per cent – or perhaps even more.

Sound Track

The item among the materials that bears the closest ratio to the length of the finished picture (apart from the first print itself) is the sound track. The usual procedure is to make a magnetic track first, and only when this has been approved is the photographic optical track made from it. The magnetic material can be erased and used again. There is thus very little waste of consumable materials.

The fees of first-class commentators, contrary to what many people imagine, are usually most reasonable having regard to the experience and skill that most of them bring to the job. On the other hand, it must be borne in mind that well-known personalities can sometimes command fees several times those of the ordinary professional commentators. Naturally, the same is true of actors – big names may expect to be paid a great deal more than their lesser-known but (for commentary purposes) none-the-less competent fellows.

Travelling Expenses

It is often an excellent thing, when a film is being produced for an outside sponsor, to quote travelling, living and accommodation expenses as a separate item, to be charged at net cost. Such expenses are often hard to estimate – you may not be able to forecast accurately how long your crew will have to stay in a given locality. If

you try to estimate these costs so as to include them in your overall quotation you will be forced to provide yourself with a good margin against any contingency. This may substantially raise the figure and, if the job is competitive, could lose you the contract. Nevertheless, it is helpful to the sponsor to be given some idea of what the expenses are *likely* to be, even though you will eventually be charging him at cost.

Music Royalties

If you use library music – that is, ready-made discs or magnetic recordings from which you select appropriate portions – you are liable to pay royalties, as well as a fee to the company who made the recordings. The royalties are based upon the length of each "use" – that is, the passage re-recorded on to your sound track; on the regions of the world in which you intend to show the film; and on the type of audience to whom it will be shown. If your documentary is for non-paying audiences, the royalties are usually less than for paying audiences. As a rule television incurs a higher rate than either cinema or non-theatrical distribution. The rates are often higher for *direct* advertising, as distinct from the public-relations type of film. In many countries there is a central bureau empowered to fix rates and collect fees for its members, who include composers, arrangers, publishers and musicians as well as the recording companies.

It may be that your film is being produced not to order but speculatively, in which event you may not know what type of distribution it will receive – if any. You may aim at television, but fail to obtain a contract and issue it through the cinemas instead. When the eventual form of distribution is in doubt, it is usually possible to clear the copyright provisionally at the lowest permissible charge for the type of film. You then pay the difference later if your exploitation is successful and your film is accepted for a form of distribution subject to a higher rate.

Hire of Equipment and Facilities

Some film units make a practice of owning very little equipment, hiring what they require for the various stages of production as they arise. Other units own a more or less complete set of equipment for the shooting stages only; some are equipped for all stages of production. Whether it is more economical to hire or to own is a matter for the individual producer to calculate. Probably the best course is to own equipment that you can keep *continually* in use, but to hire special or additional items that you require only occasionally. It is

38

not economic to have capital tied up in gear that will be in operation for only a small percentage of the time.

The same may be said on the question of providing facilities for carrying out the various post-shooting stages like editing, sound recording, artwork and animation. All such facilities can be hired. Obviously, to invest in the necessary equipment and premises is economic only if the annual costs of so doing are less than would be the cost of hiring them.

Insurance

Adequate cover is important for the peace of mind of all concerned. It is usual to insure equipment and film against all risks for use anywhere in the country in which the unit is based, and to arrange extensions for temporary and occasional location work overseas. However, if the unit does a lot of work abroad, permanent world wide insurance should be considered, since it may be more economical in the long run.

Insurance on individual productions takes several forms. It is possible to take out "negative all risks insurances" and these may include what is known as "daily take" cover. This insures the actual film during the period of production and until a master negative is struck. Such a policy provides an indemnity to the producer against losses sustained as a result of damage however arising to the film or sound track, including "faulty manipulation and fogging". Normally the basis of settlement would be the cost of re-shooting the scene or scenes that have been lost. It is customary for the policy to contain an exclusion of all losses arising from faulty raw-stock, unless there is proof that the stock was tested and found satisfactory before use. It is therefore advisable to make a test exposure on a length from each batch of film and have this developed before the production begins.

Bad weather can vitally affect a production and it is possible to obtain a limited amount of cover against this contingency. Weather cover is expensive, however; it is normally keyed to the rainfall in a given area, so that the cost may vary considerably with the location.

There is what is known as a "film producer's indemnity policy" which covers production costs that may be incurred and subsequently rendered abortive due to an accident or illness affecting one of the stars. This is primarily intended for feature producers, but it can be made to apply to the director as well, and in this form it may be useful to documentary producers.

Insurance of the members of the technical crew is usual on overseas assignments, very often in the form of "personal accident, sickness and life" policies. Cover is frequently taken out in favour of both the producing company and the individual, and is usually extended to actors taking part in a production overseas, as well as the crew.

Sets and properties, of course, can also be insured. When equipment is hired for location work it is as well to study any contracts or agreements entered into, for these often contain insurance requirements. Similarly, care must be taken over such special properties as vintage cars, which may or may not be insured for use on public roads.

When working overseas, it has to be remembered that many countries have Workmen's Compensation Acts; these should be borne in mind when engaging additional labour on the spot.

There are, of course, those basic items of insurance such as "employers' liability" and "public liability" and the usual fire and burglary cover.

It is possible to over-insure and one must try to strike a careful balance between adequate cover and cost. There are insurance brokers who specialize in the types of insurance required by film producers and since brokers make no direct charge for their services it is well worth while to seek their expert advice. Another reason for consulting a specialist broker is that only a few insurance companies are able to offer every type of insurance that a film unit ought to have.

Production Time

A word of warning is desirable on the matter of estimating and costing the time that will be taken on production tasks. Almost all the stages involved in film production are creative and the time that they will take is hard to judge. Most people occupied in this kind of work tend to be too optimistic when they are asked to estimate how long they will need to complete a certain job. It is as well to add a percentage to all such estimates and to bear in mind that many of these tasks may have to be done more than once before they are artistically acceptable.

It is easy to underestimate the time required for subject research and script-writing. Conferences and discussions will occur, not only in the scripting and planning stages but also during the final editing and sound-track "laying", and an adequate time allowance has to be made for these. In fact, at all stages of production, there are

liable to be delays because of small details that were not envisaged. Only quite lengthy experience in your own type of work can arm you with the foreknowledge that will enable you accurately to budget for all the items under this important heading. Time will, almost certainly, be the biggest single item in your costing. By keeping an accurate record of time consumed on each production you will gradually assemble the data that will enable you to bring your budgeting within fine limits of accuracy in the future.

Overheads

Assessing the overheads that should be allocated to a given production is beset with two main difficulties. The first is that you may have several productions in hand concurrently, which gives you the far from easy task of deciding how much should be charged to each of them. The second snag is that while your overheads may remain fairly constant from year to year, your output of films will probably vary. If output drops, the cost of overheads per film – or per finished foot – will rise; if output increases, your overheads per film will be reduced. I make no apology for stressing the obvious – costing is not one of the film industry's strongest points!

In the calculation of overheads, your book-keeping system as a whole is put to the test. Your trading account should show, at the end of your financial year, an analysis of your various costs which will enable you to work out an average weekly figure of overheads. It may be possible to divide this weekly figure between the films you expect to have in production at any one time. This is not as easy as it sounds, because film production programmes have a habit of not working out as planned. Clients change their minds, the weather does not follow the seasonal pattern, unexpected jobs crop up – all these things make it difficult to anticipate how many films you will have on hand at any one time in the future.

It is helpful to have some general figures which will provide you with a yardstick. It should be possible to calculate how many finished reels you completed in the last financial year and divide them into the year's overheads. (A reel, when speaking of finished film, is accepted throughout the film industry as 10 minutes – approximately 1,000 ft. of 35 mm. or 400 ft. of 16 mm.). You can be more precise and calculate an average overhead cost per finished foot. Such figures must be used with caution, because it is obvious that some films will take longer to make than others and therefore their share of the overheads should be larger. Experience will show how much various types of film vary from the normal.

Margin of Profit

What margin should be added to the materials-plus-time-plus-overheads figure is a matter upon which it is very difficult to give advice. Do not forget that, although depreciation on equipment, fittings and premises may have been included in the figure for overheads, it is out of the profit margin that new equipment and extensions to premises must come. In an industry such as film production the mere replacement of a worn-out camera by a similar one is rarely the answer. By the time a camera requires replacing, new, more versatile and more expensive equipment will probably have become the standard article and the cost of replacement will be far in excess of the cost of the old one. Although this applies to all branches of the business, it has been particularly true in the department of sound recording. The change-over in recent years to magnetic recording for all but the final stage has brought about the introduction of entirely new types of recording equipment, rendering the bulk of the previously used systems completely out of date. And this process shows signs of continuing. All this has to be borne in mind when fixing the percentage of so-called "profit" margin with which each production is to be loaded.

Submitting the Quotation

A sponsor or client is entitled to know certain things, when he receives a quotation for the production of a film, over and above the cost of the film. He should be told the cost at which subsequent copies of the film will be supplied to him. He should also be told, if the film contains copyright music, for what territories and for what types of distribution the music has been cleared; it is quite a good method to quote the music clearance as a separate item, adding the additional cost that he will incur if he subsequently wishes to clear for any additional distribution that you have reason to think he may have in mind. A quotation, should, furthermore, be for a film of stated length and running time. This is a safeguard, both to the sponsor and the producer. It is not always easy to anticipate the finished length of a film with absolute accuracy, even when the subject allows a detailed shooting script to be prepared.

When producing a film for a sponsor it is quite usual to ask for progress payments. A common arrangement is one-third of the total quoted upon acceptance of the shooting script and the beginning of shooting, one-third when the edited work-print has been viewed and agreed, and the balance upon delivery of the first projection print.

It is also common for a contract to be exchanged between the sponsor and the producing unit before production starts. On the other hand, a great many films are produced without any contract. In practice, of course, the most important factor is the integrity of the parties involved. A sponsor of high integrity will see that justice is done, contract or not; a sponsor without integrity may well find a way of taking advantage of any difficulties that arise, even if there is a contract. Nevertheless, if a production is undertaken without a contract, care should be taken to see that both parties clearly understand what is expected of the producer. Apart from such matters as the length of the finished film, the item that most often leads to disagreements is the time that may be taken up in shooting. Bad weather may cause delays and result in the unit's remaining on a location far from base for much longer than was anticipated. It may be as well to agree in advance the maximum time that can be allotted for such shooting, and fix an additional sum to be charged should shooting be extended beyond that time for any reason outside the unit's control. This agreement can be worded to cover delays caused by the sponsor himself, should shooting be dependent upon his providing certain facilities or subjects without which work could not proceed.

Checking the Cost

It is good business for a commercial film unit to have some means of checking that its actual cost is keeping closely in step with the quoted cost. Time sheets recording the hours spent by various technicians on each production, together with a record of the materials consumed, should enable this to be done.

A Typical Budget

A specimen budget will illustrate many of the points we have discussed. That given on p. 44 is based on an actual production, though the actual cost of the various items has been converted to percentages.

It is interesting to note that filmstock, including processing and work-print, represented only 11 per cent of this whole budget. In many productions the figure might be even less. This film was shot entirely on location and no actors were employed. Naturally, the percentages added to costs for overheads and margin will vary greatly from one film unit to another, depending upon the type of organization of which it is a part. In the case of internal units set

43

A TYPICAL BUDGET. The cost of producing a film may be divided into four main categories:

MARGIN to cover new equipment, extensions to premises, investments in new ventures, provisions for unforeseen contingencies and profit.

OVERHEADS such as wages of clerical and office staff, rent, rates, electricity, heating, telephone, stationery, postage, depreciation of equipment, advertising.

TIME. Salaries and wages of production staff.

MATERIALS AND SERVICES including filmstock, processing, work-prints, magnetic and optical sound stock, fees of artists and commentators, musicians, music copyright clearance, hire of outside facilities and travelling expenses.

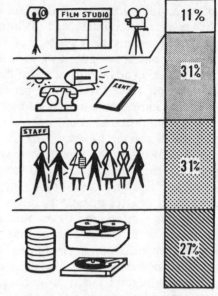

A producer quoting to produce a film based on the above budget would have to add approximately 72 per cent on to the TIME and the MATERIALS AND SERVICES figures to cover the other two items, MARGIN and OVERHEADS.

up by an industrial concern or television network it may be unnecessary to provide for an overall margin and the figure for overheads may be minimized or omitted altogether. Even so, a wise management will calculate and allow for these factors; otherwise it will be impossible to judge whether a real saving is being effected by running its own unit, as compared with the alternative of farming the work out to a specialist firm of film producers.

A SPECIMEN BUDGET

MATERIALS AND SERVICES	%	%
Filmstock	5·9	
Processing	2·2	
Work-print	2·9	
Titles	·5	
Sound track: magnetic	·7	
Optical: transcription charge, stock and processing	·8	
Commentators' fees	1·5	
Music royalties	.5	
Insurance	2·0	
Travelling expenses, meals and accommodation	10·0	27·0

TIME: SALARIES AND WAGES

Scripting, research, planning		3·6	
Shooting on location		7·0	
Shooting artwork		1·0	
Editing picture work-print		10·0	
Sound: Laying live			
dialogue	·3		
Recording commentary	·8		
Music selection and dubbing	·8		
Laying effects	·9		
Mixing tracks	2·3	5·1	
Matching master to work-print		1·3	
Typing scripts, etc.		·6	
Office administration, etc.		1·0	
Messenger (to and from labs., etc.)		·1	
Screening with clients, conferences		·5	
Sundries		·8	31·0

OVERHEADS

Wages of clerical and office staff		
General overheads, rent, rates, electricity, heating, telephone, postage, etc.	26·2	
Depreciation of equipment	4·8	31·0
MARGIN	11·0	11·0
		100·0

It is often helpful to calculate the cost of a film per finished foot. This figure, although it will vary with different types of production, forms a very useful yardstick when considering new films or discussing overall costs with clients.

In the specimen budget shown the unit owned the equipment used and possessed its own premises in which editing and sound recording were carried on. If this had not been so, a large portion of the item labelled "overheads" would have come under a heading of "hire of equipment and services".

4

PLANNING A DOCUMENTARY

PLANNING A FILM begins from the moment the first idea is born in someone's mind. The TREATMENT is an extension of that plan which is carried a stage farther in the SHOOTING SCRIPT.

In preparing the shooting script, the ideas have been thrashed out and marshalled into a plan of action. If the script-writer has been able to visit all the locations and has written his script from first-hand investigation, the plan should be firmly founded. If he has not done this, it is desirable for the person responsible for directing the film to visit the locations to see whether it will be feasible to carry out the shooting in accordance with the script, and to check local facilities.

A large unit will have a production manager, or an assistant director, who can lift the practical problems off the shoulders of the director. These problems are many: travel arrangements have to be made; if the unit must stay away from base, living accommodation must be organized; if interior shooting is called for, lighting has to be provided, and an assessment made of the light power required to illuminate adequately the area to be filmed. A check must be made to see whether electricity will be available, at the voltage required and the amperage needed to supply lights of the power decided upon. If such electricity supplies are not available, arrangements to hire generating equipment must be put in hand if the budget will permit.

Colour or Monochrome

At a very early stage the decision has to be made between black-and-white and colour. At one time films for television were always shot on black-and-white but now that colour television is so widely available all this has changed. The vast majority of programmes are now shot on colour film even though the immediate requirement may be for black-and-white transmission.

Television apart, there are two other factors to be considered

when making this decision. The first is the additional cost of colour. As I mentioned when referring to budgets, the amount that cost is increased by using colour varies with the type of production, but filmstock does not make up a large proportion of the total budget. A black-and-white work-print can be taken from the colour camera stock without any difficulty and so there need be no increased cost here. There is, however, a big increase in the cost of release prints. On average, colour prints are two to three times as expensive as black-and-white (but this ratio must be used with some caution, because the final figures are dependent upon the method of printing employed).

If very few prints will be required, the higher cost of colour will still not, therefore, be a major consideration. If a great many will be called for, on the other hand, it may be decisive.

Lighting

The second factor that affects the decision is whether, from the shooting point of view, colour is practicable. If the film is to be shot entirely out of doors there will probably be no problem. If the film contains interiors two points must be considered. The first and more obvious one is whether you will be able to provide enough lighting to illuminate the areas you will have to photograph. If you have large interior scenes, a great deal of light will be required to enable an adequate exposure to be obtained for colour film. And this will not be a matter of area only; the amount of lighting required will depend greatly upon the reflective properties or otherwise of the surroundings. Of course, colour films of much higher speeds than previously are available today and even faster ones will undoubtedly follow. On the other hand, these fast films tend to be rather grainy and many cameramen prefer to limit their use or avoid them altogether in the interests of picture quality.

Before you can decide how much light you will need you must also consider the depth of focus that is desirable in your scenes. If the zone of sharp focus in your picture has to extend from objects in the foreground to a distant background, very much more light will be required than if you can keep the whole of your subject in the same plane.

The second point to be considered when planning the lighting of interiors – sometimes a more serious problem – is that artificial light and daylight very seldom mix satisfactorily on colour film. Artificial light calls for a type of film balanced specially for it. Our problem arises when daylight is present but is not bright enough for filming.

47

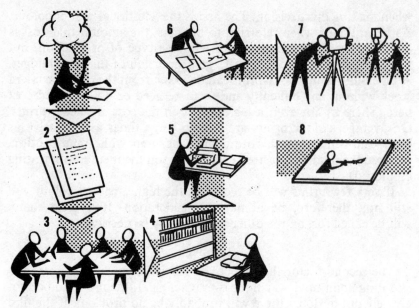

STAGES IN THE PRODUCTION OF A TYPICAL DOCUMENTARY
1. The idea is born.
2. A Treatment is prepared.
3. It is discussed, amended and developed.
4. Research is carried out.
5. A Shooting Script is prepared.
6. The production is planned and a schedule drawn up.
7. Shooting begins, and at the same time . . .
8. artwork such as titles, animated diagrams or cartoon sequences is prepared and filmed.

If we can exclude it and use artificial light exclusively, all is well. But if we cannot exclude it, as is so often the case in large buildings, it will mix with our artificial light and upset the colour rendering. Generally speaking, there is no lens filter that will correct matters; the daylight will almost certainly be unevenly distributed – stronger near the windows and progressively weaker in the areas farther and farther away from them.

This difficulty will be dealt with more fully later when we consider the technical problems of lighting on location. Our present concern is with planning – deciding in advance how we are going to cope with the situation. Briefly, there are two possible solutions. We can use a type of artificial light that is similar in colour range to daylight and which will therefore mix with it. Arc light has a colour temperature that is near enough to be acceptable. But will the budget run to the expense of arcs, which normally require a high-amperage direct

48

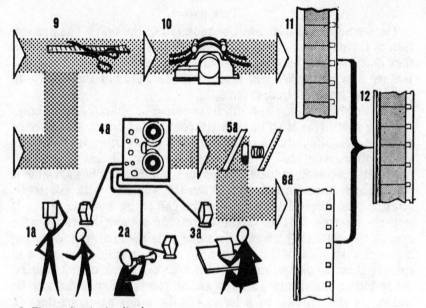

9. The work-print is edited.
10. The master is matched to the edited work-print while, at the same time, work is going ahead on the sound.
1a. The "lip-sync" dialogue is laid to picture.
2a. The music and sound effects are recorded and laid.
3a. The commentary is written and recorded.
4a. All the tracks are mixed to produce a master magnetic track.
5a. The master magnetic is transcribed to an optical track 6a.
Finally the matched master picture 11 is printed with the optical track 6a to make the "married" projection print 12.

current and in most cases, consequently, a special generator to provide it? The second solution is to cover all the windows with gelatine sheets specially coloured to convert the daylight so that it matches the light from our normal tungsten lamps. Sometimes this is quite practicable, but all too often the windows – and perhaps skylights as well – are too big, or too numerous, or too high.

This problem of interiors where the daylight is not sufficient by itself for colour filming (and indoors it rarely is), and yet cannot be excluded, may well be the deciding factor in the choice between colour and black-and-white. If the difficulties are too great it may be more satisfactory to shoot in monochrome.

We must, of course, set against these purely practical considerations the question of whether the subject *needs* colour, and whether a modern audience will expect it. Having made – or been forced to make – our decision, let's turn to the next planning problem.

49

Personnel

How many technicians will be required in the unit? The production of factual films, covering the vast field it does, is undertaken by film units varying between one man and a crew as numerous as a feature film outfit. We will begin with the needs of the small unit producing the small-budget film.

Can one man, single-handed, be expected to undertake the shooting of a film? If it is to be shot entirely out of doors, this may be possible. But difficulties arise as soon as lighting or sound recording are involved. Admittedly, they *can* be overcome. I know of one unit, producing excellent industrial films on a commercial basis, which is run by one man. He refuses to "burden himself" with assistants, quoting a number of advantages to be gained by working alone. It is perfectly true that as director and cameraman he can obtain exactly the material he wants. Handling his own lighting, directing his own cast, he has the maximum control over his subject, and since he does his own editing and even speaks his own commentaries, the resulting film displays a unity and singleness of style that can be lacking in the product of a team. On the other hand, he does in practice obtain a great deal of assistance from his clients and their staff in the shooting stage, at least. Help in such matters as the handling of lighting units, provision of electric power and so on, is always forthcoming. Perhaps his films therefore are not one-man jobs in the strictest sense.

Documentary has produced the technician known as the director-cameraman. This hybrid fellow is, for many types of work, an excellent invention. Given one general assistant, there is a great deal that he can achieve, and for certain types of work he is perhaps unexcelled. To produce films recording life as it is happening, a speed of decision is called for that may defeat your separate director and cameraman. Various films fall into this category. Films of expeditions, mountain climbing, exploring distant lands, wild game – in all these the majority of the incidents must be captured the moment they occur. Second chances are rare. Even where the subjects are human beings who might be asked to repeat an action or an incident, the spontaneity may have gone out of it by the time it is staged again in front of the camera. And spontaneity is the essence of films like these.

The same applies to films of sporting events, public occasions and any subject involving shots of people going about their ordinary affairs. By the time the director who is not his own cameraman has given directions it is usually too late.

50

Good director-cameramen, however, are not easily found. A great deal of skill has to be wrapped up in one person. An absolutely thorough photographic knowledge is the basic essential, for the technical matters of setting up the camera and dealing with film loading, exposure, focus, filters, and the rest must be second nature so that the larger part of the mind is free to deal with handling of the subject. The director-cameraman must also have a complete knowledge of film editing, for he must create a series of shots that will assemble into a smooth flowing narrative later.

For many subjects, therefore, a director-cameraman is an excellent answer. He will need an assistant to help with the transport of the lighting, to calculate or check exposures, to measure where focusing is critical, and to help control both the people in front of the camera and those who need to be kept out of the scene.

The limitations of the director-cameraman begin to be felt when people appearing in the film need to be directed. As soon as actors are involved, whether professionals or merely people acting their everyday jobs or occupations for the benefit of the film, it becomes desirable to separate the task of director from that of cameraman.

And if live sound is required, to be recorded synchronously with the shooting and involving a larger crew, a director with no other responsibilities is much to be preferred.

The personnel we shall require for shooting therefore may be summed up as follows:

A director-cameraman with one assistant may prove to be the ideal team for certain subjects involving the recording of life as it happens.

A director-cameraman with two assistants can tackle many subjects involving simple interior lighting, provided not very much acting on the part of subjects to be filmed is called for.

A director and separate cameraman can tackle straightforward scenes involving actors, although an additional assistant will be helpful. If simple interior lighting is also involved, an electrician is essential.

Of course, everything depends upon the budget. The budget of documentaries varies so much that there are no rules, and not even very many standard practices. It *is* possible for two people to tackle the shooting of scenes with actors, and handle live sound and lighting as well. But it will be very hard work.

Larger commercial units doing work involving actors, lighting, and sound may well have a team on the lines of the following:

Production Manager
Director
Assistant Director – his job is to assist in handling the cast; check that props are to hand; act as liaison between director and the crew and cast;

check travel facilities, hotel accommodation and the availability of meals; check that all is ready on the location so that shooting can commence promptly; and generally act as Jack-of-all-trades.

Cameraman – who, on a large production, may be called Director of Photography. He will be in charge of the lighting of interiors as well as the camera.

Assistant Cameraman or focus puller – or both.

Electricians—responsible for connecting up the lights to the power supply, placing them under the direction of the cameraman or director of photography and operating them.

Sound Recordist – responsible for sound recording generally, the positioning of microphone, etc.

Assistant Sound Recordist – he will actually operate the sound equipment.

Sound Engineer – responsible for the maintenance and working of the sound equipment.

Boom Operator – his job is to manipulate the microphone boom so that the microphone remains as near to the character who is speaking as possible and yet does not come within the camera's field of view. (Neither must it cast a shadow within the picture area!)

Clapper Boy (or Operator) – his job is to hold the "clapper board" or "slate" in front of the scene at the beginning of each "take". The clapper board has the scene and take number chalked on it (and the name of the production and any other relevant information). If sound is being recorded synchronously with picture, the clapper operator calls out the shot and take numbers so that they are recorded on the sound track. He also brings the hinged portion smartly into contact with the body of the board. The sharp sound so made is easily recognized on the sound track afterwards. When it is placed side by side with the frame of picture in which the hinged portion is seen to have just met the board, picture and sound are in synchronism. Often the clapper boy also loads the camera and is known as a "clappers-loader".

Floor Secretary or Continuity Girl – her job is to check continuity from shot to shot as well as recording the scenes taken and any other useful data.

The list can be extended still further; to it can be added the art director, set-builders, set-dressers, wardrobe mistress, and many others. But to return to our planning, it is clear that the size of our crew can vary within wide limits. It can be anything between one – a director-cameraman – and all the people referred to above, and more. The type of film, and the budget, will decide.

Just to emphasize how flexible are the crew requirements in this kind of work, let's consider one actual case. Thorold Dickinson describes the team he used to shoot *Power among Men* as follows:

"I was the producer, but I went along with the unit. We had a director, a cameraman, often a second cameraman, or an assistant who could use a hand-camera, and a sound man. And we took our writer with us so that we could work out our line of continuity and script on the spot. Most important, we had a manager who arranged the transporting of all the gear, travelled with it, got

it unloaded and stored at the location, and then was responsible for the physical well-being and economics of the unit – he paid all the bills and so on. We found that if we concerned ourselves with that we were really wasteful of our own time. Certain labour we would hire locally if we needed – say, a carpenter and people to hump things around."

Obtaining Outside Services

You may have within your organization facilities for the many stages subsequent to shooting, such as editing, sound recording, sound track "laying" (that is, in effect, sound editing), sound mixing, projection facilities for viewing the material at all stages of assembly, titling, artwork and animation. If, on the other hand, you have to farm out some of these operations, or hire facilities that you or your staff will use, it is as well to check that these services will be available when you are ready for them. Certain aspects of the work may take some time and it may be essential to get them started even before you begin the shooting. Animation, for instance, can be a lengthy business and a complicated animated sequence may take as long as the whole of the remainder of the shooting plus the editing. If possible, therefore, such animation should be put in hand first.

Background Music

Another time-consuming item is the preparation of a specially written musical score. Unfortunately, the composer cannot usually proceed very far until the picture is edited, as he will need to work to an accurate timing. There are a few cases where the music is written and recorded first and the picture fitted to it afterwards – this is frequently true of cartoon films – but it is much more usual for the composer to wait until the picture editing is complete.

This must be borne in mind in planning the timetable. The sooner the edited work-print can be shown to the composer, the sooner he can start work. He will probably require a detailed, timed shot-list to guide him. It may be that while the composer is at work on his score a number of other finishing processes can proceed. The matching of the negative to the edited work-print, recording of commentary and the laying of commentary or dialogue tracks, the drawing and shooting of titles – all these can go forward. But the composer will have to be called upon to give an estimate of the time he will require both for writing and recording and he will have to be kept to this if the whole production is not to be held up.

Much of the film industry relies upon hiring the facilities of production. There are many companies that do not own any

equipment or production facilities at all. It is possible to hire everything that is needed for every stage of film making. Cameras, tripods, "dollies" on which the camera can be moved about, lenses of all kinds, lighting; studios, sound recording equipment and the crews to work them; viewing theatres for screening the material at all stages, editing rooms, sound recording studios, titles – all these things are available, many of them at set rates. But there is a lot to be said for owning basic equipment – a cameraman becomes familiar with his own camera, knows its condition, and appreciates its capabilities and its limitations better than he will a piece of hired equipment. On the other hand, some facilities are offered so economically that it is cheaper to hire unless you have a large and steady output. The service for shooting titles, for instance, particularly in the case of 35 mm., is so competitive that it is rarely worthwhile shooting them yourself.

Hiring Actors

The bulk of documentary work is concerned with presenting real life and most of the documentary producer's "cast" are real people in their natural surroundings. But there are quite frequent occasions when the professional actor is called in, for there are limits to what the ordinary person can be expected to do naturally and unselfconsciously in front of the camera. This is particularly true when live sound is being used. Most people can be encouraged to behave naturally, when doing the things they are used to doing, provided that they are not called upon to speak pre-planned dialogue. A speaking part, entailing the memorizing of lines, is another matter altogether. Very few people can sound natural and convincing unless they happen to have gained experience as public speakers. Unless the whole essence of your theme depends on absolute reality, or you are very sure that you can find someone who will not let the film down, it is as well to consider calling in an actor to perform the speaking parts.

Even if the sound problem does not arise, there are other occasions when your ordinary man-in-the-street may be unable to cope. While people are being called upon to act their everyday routines, they can probably appear at ease. If, however, you wish them to act a dramatic part – to express emotion of one sort or another – you will have to be lucky in your choice for the result to be convincing. Here again the use of the professional actor may be the best course.

If your filming involves the frequent use of actors it is good practice to keep a file in which details can be recorded: each actor's

name, address and phone number, the title of the film in which he appeared, the part played and the fee he was paid, plus a photograph. This is not only an aid to memory but also useful information to have when discussing a new film with a client or colleague. If the actor's measurements are added to his file-entry, a costume can be ordered for him without the bother of calling him up to obtain them.

Of course, theatrical agencies will endeavour to solve your casting problem for you. One advantage of dealing with them, instead of with the actor direct, is that should your actor be unable at the last minute to appear, they will probably be able to find you a substitute. And agents, having larger files to draw upon, will be able to find you particular types or people with special talents or experience that you may require. They will loan you photographs from which you can make your initial selection.

Costume

The feature-film producer is constantly dealing with actors, the hiring of costumes, wigs, set furniture and props. The documentary producer, on the other hand, may need them only rarely, so a few words on the subject may be helpful. Let's begin with costumes and wigs.

The requirements of film and stage differ considerably. Costumes worn on the stage are often deliberately exaggerated and fanciful. Accuracy in historical dress is often sacrificed to theatrical effect. For film work, it is better to deal with those concerns who regularly supply film studios and to state that the costumes to be hired are for film use. Theatrical costumiers have varying reputations and some have certain special fields. A good costumier may well be quite a historical expert and able to supply a wide range of period costumes and give advice on the clothing and accessories worn in any given era. It is accepted that clothing may have to be adjusted to fit individual actors and time should be allowed for this to be done. The accepted procedure is for costumes to be ordered by the film producer, the actor then being instructed to call at the costumiers for a fitting. Naturally, it helps if the actor's principal measurements can be given with the order so that only minor adjustments are called for when he appears.

Wigs, Beards and Moustaches

Some costumiers can provide wigs and beards, but it is better to deal with a wig specialist. Wigs can be hired; beards must usually be made up specially and purchased outright. Compared with the

stage, the requirements of the film in the matter of wigs, beards and moustaches are obviously much more difficult to satisfy. The camera is so much closer than the theatre audience that the greatest effort is called for to ensure realism. Some actors are expert at applying their own moustaches and beards, but a make-up expert is well worth his fee.

Make-up

Apart from wigs, beards and moustaches, make-up is too large a subject to permit more than a few generalizations here. It can, however, be said that the non-actor who constitutes the largest proportion of documentary subjects will usually appear perfectly natural if photographed without make-up. Modern filmstocks, both black-and-white and colour, reproduce flesh tones well. In any case, where the general public are filmed going about their business, or large numbers of factory operators are seen doing their daily jobs, make-up is obviously out of the question. And if actors are to be called upon to mix with them it will be most undesirable for them to use make-up when everyone else appearing is not using it.

Where all the characters are under the control of the producer it is obviously desirable to employ a make-up expert if the budget will allow. If this is not possible, it may still be as well to consider applying a small amount of make-up to the women. They do, after all, normally use make-up anyway, but it may not be the kind that photographs well. For instance, when shooting in black-and-white ordinary lipstick will often be reproduced too light in tone. If a dark shade, preferably with a tinge of brown, is applied it will photograph better. In the case of colour, flesh tones may appear too pale and an application of light brown powder may improve matters. In the case of men, make-up applied in the absence of an expert can be troublesome. It is easy to make a man look effeminate if make-up is applied unskilfully. If a make-up expert cannot be included in the crew it is usually safer not to make the men up at all.

Of course, period costume scenes are another matter and so are those in which a character's normal appearance has to be changed. Most professional actors can be relied upon to apply basic and straight-forward make-up themselves, but it will obviously be an advantage to have a make-up expert available when actors are called upon to play period or character parts.

Studios, Sets, Furniture and Props

There are times in documentary work when it is necessary to forsake the genuine background for a studio-built set. Studios of all

56

sizes can be hired by the day. The word "studio" is, strictly speaking, the term for the whole building, the actual area on which the shooting is carried out being known as a stage. A given studio may have several stages of different sizes for hire and the dimensions and area of each will be quoted on application. The very small stage, suitable for very compact sets or for such things as interviews in which one person talks to the camera (frequently called for in television material), is usually known as an "insert stage".

The rates quoted for studio hire generally include the use of standard camera and sound recording equipment and lighting, but exclude materials, electricity and crew, these being charged for separately. The use of dressing-rooms, make-up rooms and wardrobe rooms is normally included. Usually, two daily rates are quoted, the full rate which applies to shooting time, and a lower rate for the "building and striking period" – in other words, the time required for scene building and dismantling.

The provision of scenery, or "sets" to use the trade term, may be undertaken by the staff of the studio or it may be farmed out to specialists – in both cases, of course, at the hirer's expense. When the set design has been agreed and the construction details thrashed out, an estimate of the time taken to build and strike the set will be given which will guide the production manager in deciding for how many days the studio should be booked.

Furniture and props have now to be considered. The larger studios may have property rooms and they may be able to hire suitable items from their stock. Failing that, there are film and theatrical furnishing establishments which specialize in hiring out such items. The basis of charging is often a percentage of the value of the articles hired, and for an extra fee delivery to the studio and subsequent collection can be arranged.

Hiring Commentators

The choice of a commentator whose voice will be appropriate to the style, mood and character of a film is as important in a documentary as the casting of a leading rôle in an entertainment feature. Fortunately, in these days of widespread radio and television services, plenty of trained voices are available. As with actors, it is an excellent thing to compile an index of the commentators you use and keep, for reference, a short recording of each one on magnetic tape or film. Many professional commentators have tapes of their voices, demonstrating the styles of work they do, which they are happy to loan and they are usually only too pleased for these sample

recordings to be re-recorded for future consideration by anyone likely to require their services. A library of voices can soon be compiled that will be invaluable both for making your own decision and for playing to sponsors who may wish to make the selection themselves.

Professional commentators are expert at adapting themselves quickly to the mood or style that is required of them. All the same, it is good planning to send them a copy of the commentary they will be called upon to read, a few days before the recording session. Many commentators like to spend a short time alone with the script, studying it and marking it up – some have their personal systems of indicating pauses, inflections and words that require emphasis. The final recording is likely to be better if adequate time has been allowed for this, and the required concentration is not always possible while preparations are being made in the studio. A sight of the script beforehand also provides time for verifying the pronunciation of unusual words, technical terms and so on. It may also allow grammatical imperfections that might have gone unobserved until too late to be detected and put right.

Library Material

There are some shots that it would be impossible, or at least ridiculously expensive, to secure yourself. A single shot of the New York skyline, in a film that was otherwise to be shot in England, for instance, would hardly be worth crossing the Atlantic for. Newsreel companies usually run a special department which will supply copies of extracts from newsreels for many years past, and most large producing companies have a library department in which what they call "stock shots" are filed away. Copies of such scenes, which will usually be supplied for a fee, are described in the script as to be obtained "from library".

The range of library material is very wide, and there may be no difficulty in getting hold of, say, scenes of Arctic exploration, the Sahara Desert, an atomic explosion or the Eiffel Tower. All the same, if a scene that is to be obtained from library is *vital* to the theme of the film it is important to make sure, during the early stages of planning, that it is, in fact, available. Although there are optimists who seem to believe that almost anything can be obtained from library if one searches long enough, this is far from the truth. For a film on fire control, for instance, it was assumed that plenty of newsreel material depicting large industrial fires would be available. In fact, the right kind proved to be extremely rare. The scenes

needed had to show fires in single-storey factories. Such fires have seldom been covered by the newsreels for the very simple reason that the really spectacular – and hence newsworthy – fires are those in multiple-storey buildings. And these were no use for the film in question.

Moreover, it is not enough to ensure that the required scenes exist. They must be available on the kind of filmstock on which the rest of the film is being produced – or must be capable of being duped on to it. Obviously, if the film being planned is in colour, included library material cannot be on black-and-white stock (unless it is being cut in as a newsreel insert, with no attempt to suggest that it is an integral part of the film). If the film being planned is on 35 mm. and the library material is available only on 16 mm., a check must be made to see that a 35 mm. blow-up will reach the required standard of quality. If the library material is on 35 mm. colour negative and it is required for cutting in to a film being shot on 16 mm. colour positive stock, the necessary stages to secure the right kind of dupe must be investigated and checked with the laboratory concerned. In 16 mm. work also, care must be taken to ensure that the resulting dupe will have the emulsion on the same side as the rest of the master material. (In 35 mm., the side on which the emulsion occurs in the printing negative has been standardized, but for various reasons this is not so in 16 mm.)

Library material obtained from commercial sources is usually paid for at so much per foot plus a search fee, the rate varying with the purpose for which the scene is required. The laboratory charges for making dupes are added to these charges. The accepted procedure for ordering a dupe of a section of the film is to view a print and "paper up" the section selected. This is done by wrapping paper round the print at the beginning of the required section and at the end, then drawing arrows on each piece of paper pointing inwards towards the chosen scenes.

The Shooting Schedule

We have prepared our treatment, the shooting script and the breakdown script, visited the locations, prepared our budget, selected the crew, checked on the outside facilities we shall require, booked our actors and commentators, and decided on our sources of music and artwork. We should now be in a position to plan our shooting schedule.

If the film is a simple one, this may entail no more than advising the technical crew when shooting will begin and how long it is

expected to take; the rest will follow on automatically. If the film is complex, it may be necessary to prepare a detailed time schedule – this will certainly be the case if a number of locations are necessary, involving hotel reservations, train or plane tickets, and the use of

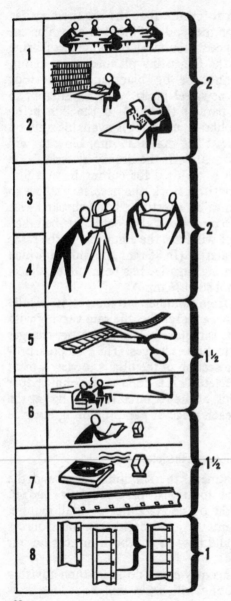

PLANNING A PRODUCTION. A typical production schedule covering eight months. Conferences and the preparation of the Treatment occupy two weeks; research and the preparation of the shooting script the next month and a half. Shooting occupies two months and picture editing one. Agreeing the picture assembly with the sponsor and making adjustments: two weeks. Agreeing the final commentary and recording it and laying the commentary track: two more weeks. The seventh month is taken up with recording or dubbing music and sound effects and laying them to picture. The various stages of mixing are then carried out, and the master magnetic transcribed to optical track, which is then processed and cued for printing. The last month sees the master graded, the answer print made and checked and the first batch of release prints run off.

hired vehicles. It is no easy task to estimate the time that will be required to secure a number of scenes on a given location, particularly if many of them are exteriors and so dependent upon the weather. Experience alone will be the guide and it is as well to discuss these estimates with the crew concerned, seeking their agreement that the proposed schedule is in fact reasonable and possible. If actors have been booked to play in scenes at different places, it will be more than ever necessary to plan a realistic schedule – and keep to it. In fact, much of the efficiency of a film unit or producing company is dependent upon accurate planning of working schedules. To let the various stages of production drop behind the timetable may cause chaos as regards services that have been booked in advance, whether equipment to be hired, travel and hotel accommodation or the booking of cast. And personnel concerned with the later stages of editing, sound recording, musical scores and so on will either be kept idle or have to turn to other work sooner than they expected, so upsetting yet another schedule.

It will often be found that technicians will be over-optimistic in the estimates that they give for completing a certain job. It is perhaps human nature to assume that the next job will go smoothly, even though the last one struck many snags. Yet unexpected problems and hindrances turn up all the time in film production. The experienced producer will consider all estimates offered as being on the optimistic side and add a percentage for those hold-ups that are almost certain to occur.

I have not referred to the planning of the equipment for various types of documentary work; this warrants a chapter of its own.

5

CHOICE OF CAMERA EQUIPMENT AND FILMSTOCK

AT ONE TIME all professional film making was done on 35 mm. Today, the production of documentary films direct on 16 mm. has become an industry. The world's largest manufacturer of filmstock now sells more 16 mm. than 35 mm. The first decision of the documentary producer is which of these gauges shall he shoot on – assuming, of course, that he is not going in for one of the super-standard wide-screen formats.

35 mm. or 16 mm.

If the film is primarily intended for normal cinema distribution there is no room for argument – the right gauge is obviously 35 mm. But if the film is intended for any of the other large fields that exist today – television, industry, sales promotion, education – the matter requires careful consideration. Television consumes vast quantities of 16 mm. While many television programmes are on 35 mm., an increasing number are on 16 mm. – indeed, there are many stations in various parts of the world that can handle 16 mm. only. Some television organizations have standardized their advertising commercials on 35 mm., among them being those in Britain, but in other countries commercials on 16 mm. are accepted, and in some of them preferred. At one time the B.B.C. News was presented on 35 mm.; today it is largely 16 mm. Many documentary programmes shot specially for TV, such as the BBC TV "Look" series, and many others, are shot on 16 mm.

To sum up, if you are aiming at television you can use either gauge of film – unless you are producing an advertising "spot", in which event the requirements of the station or network for which it is intended should be sought.

If the film is intended for industry, sales promotion, education, staff instruction or any of the other fields outside the cinema, 16 mm. prints will be required. But even if 16 mm. prints only are needed, it

does not necessarily follow that the film has to be shot on 16 mm. You can shoot on 35 mm. and produce 16 mm. prints by reduction printing – indeed, this was the invariable method before an industry grew up shooting direct on 16 mm. and it is still a perfectly normal procedure. Many and long have been the arguments and discussions as to which is the better method: to shoot direct on 16 mm. or shoot on 35 mm. and then reduce. There was a time not so many years ago when it could be said that the facilities for production on 35 mm. enabled more polish to be obtained. Today there is not a great deal to choose between the facilities offered on either gauge.

Production on 16 mm. naturally tends to be cheaper. The camera equipment is lighter and more portable and the filmstock much less bulky: these are great advantages in many types of documentary work.

On the other hand, there are many technicians who, brought up in 35 mm., prefer to work with the equipment they know so well. And there are a few who still tend to decry the narrow gauge. Among 16 mm. workers a similar attitude is tending to grow up with regard to 8 mm., now that this gauge is growing in popularity and beginning, with the advent of magnetic stripe sound prints, to be used for the screening of sales and instructional films. This is human nature. No one in his right mind would really argue that 35 mm. is not capable of producing a picture that is sharper, and under cinema conditions brighter, than 16 mm., or that the 35 mm. sound track is not capable of handling a wider frequency range and therefore capable of producing superior sound quality. These things are accepted fact and to debate them serves no useful purpose.

The best advice is: shoot on the largest gauge on which you intend to show the film. If your release prints are to be 35 mm., shoot on 35 mm. If your release prints are to be solely 16 mm., there is a strong case for shooting on 16 mm. If you require prints on both gauges, shoot on 35 mm. and have your 16 mm. prints made by reduction printing. The only exception to the latter rule is where, although *almost* all the release prints will be required on 16 mm., there may be a need for just one or two on 35 mm. – as, for example, when a special première in a cinema is planned but the main distribution is to be in the non-theatrical (and hence 16 mm.) field. If your budget is too small to permit 35 mm. to be used, or it is vital to use 16 mm. because of the need for the utmost portability of camera equipment, it is possible to shoot on 16 mm. and obtain the necessary 35 mm. versions by what is known as "blow-up" printing. The quality of these 35 mm. prints will not be quite so good as if the

master were 35 mm., but if the 16 mm. original is of a high standard a very acceptable result can be obtained. Quite a number of films seen in the cinema on 35 mm. prints started life on the smaller gauge. Such well-known productions as the Walt Disney nature series were shot on 16 mm. to secure the advantage of light and portable cameras. Other productions that will be remembered were *The Conquest of Everest* and *The Kon-Tiki Expedition*.

Choice of Filmstock

The type of filmstock to be used, apart from a personal preference for a particular brand, is largely a matter of selecting an emulsion with the most suitable speed for the kind of work you are going to tackle. In black-and-white films, a tremendous range of speeds is now available. However, the old rule that "the faster the emulsion the coarser the grain" is still valid, and for this reason it is advisable to use the slower filmstocks wherever the light permits. Where the high-speed stocks are particularly useful to the documentary producer is in enabling him to capture factual scenes under natural light when extra lighting would either destroy the realism or be impossible to provide on a particular location.

In colour, some very fast filmstocks are now available, some of them approaching the speed of the faster black-and-white emulsions. But the problem of grain is greater than in the case of black-and-white and even quite moderately fast colour films reveal a coarseness of grain that is unpleasant. The rule, therefore, that a fast filmstock should be selected only when the lack of light makes its use imperative is even more important in colour work. Some types of colour film can be boosted in processing – in other words, they can be exposed at a faster speed-rating than normal and compensated for this by the laboratory. Experiment with such films is essential before undertaking an important assignment, so that you become familiar with the characteristics of a particular stock and know how much boosting is practicable.

It is advisable to be consistent in your use of brands and types of film, rather than chop and change. It is much better to work with emulsions you know, so that you become familiar with their capabilities under a variety of conditions, using one normal-speed and one faster-speed film for the bulk of your work.

Negative or Reversal?

In the case of 16 mm. black-and-white, there is the choice of negative or reversal stock. Cameramen coming to 16 mm. for the

first time, having worked for a long time on 35 mm., often assume automatically that negative is to be preferred, simply because it is always used on the larger gauge. In fact, there is a considerable argument for the use of reversal as the master material in 16 mm. black-and-white work. One reason is that joins in a reversal master are much less noticeable than joins in a 16 mm. negative, unless "chequerboard" assembly is used, a method that is described in the chapter on editing. Again, minute dust particles on the master are a problem in printing and, since the smaller the film the larger they appear in the print, dust is therefore a greater problem in 16 mm. Dust on a negative appears in the form of white "sparkle" in the print; dust on a reversal master, on the other hand, appears black in a reversal copy and is much less noticeable on the screen.

If many prints are required from a master, reversal has yet another advantage. From a reversal master an inter-negative can be made in one stage. From this, the release prints can be produced. The master is thus preserved and from it further inter-negatives can be made when the first shows signs of wear. If a dupe negative is required from an *original negative*, however, it is usually necessary to make a fine-grain print first, and then from this make the dupe negative from which further prints are taken. Losses in quality by this method will almost certainly be greater; since every additional stage of duplication tends to introduce some deterioration, two stages will naturally have a worse effect than one. The use of reversal film, then, cuts out one stage of duplication. For all these reasons, it deserves serious consideration when choosing the type of film for black-and-white 16 mm. work.

This is not to say that 16 mm. negative is unable to produce excellent results. In fact, if poor lighting conditions are likely to be encountered, it may be the better choice. Negative film has a greater latitude than reversal, which calls for consistently accurate exposure, and with reversal the amount of correction that can be applied in printing to scenes that have been differently exposed is much less. All these factors have to be weighed up before the final choice is made.

Colour Reversal

In the case of 16 mm. colour work there is a camera negative stock available, although reversal colour stocks are still more popular. Kodachrome, once so widely used, has now largely been superseded for professional purposes by Ektachrome Commercial, a reversal film designed to produce copies. Kodachrome was intended

for projection, not for making copies. It was used professionally because there was very little choice, but the copies produced from it were markedly inferior to the original. Ektachrome, on the other hand, produces an image with softer colours. It is a film with a very soft emulsion, quite unsuitable for projection and requiring careful handling on the editing bench, but it produces copies that are much more faithful reproductions of the original, particularly when it is printed on to the newer Kodachrome copying stocks.

Choice of Camera

For most documentary work, mobility is of first importance and the camera must be truly portable. In addition to weight and bulk, another important consideration is motive power. Spring-driven cameras have always been extremely popular, as no problems of power supply arise and there are no leads or cables to get in the cameraman's way, or batteries to carry around. On the other hand, the length of scene that can be shot on one winding of the spring is a limiting factor. There is always the danger that the spring will run down in the middle of a vital scene – or that some unrepeatable incident will occur before the cameraman has had time to rewind.

Electric drive, therefore, has advantages. Any length of shot can be taken; there are no moments when the camera is out of action because the spring has run down; shots can be taken one after the other as quickly as the subject demands. But there are disadvantages too. Batteries, although quite small and efficient today, add weight to the outfit. Leads from battery to camera, however short, can get in the way. Batteries need replacing or recharging and in very remote places this can present serious problems. Clearly, the decision rests upon where you will be shooting. If you will always be close to civilization, there is much to be said for the electrically driven camera fed from small portable batteries. If you are going into the middle of the African bush or the Arctic wastes, and you are travelling light, without a generator of any kind, then a spring-driven camera is the safer answer. Of course, there are many locations to which it is possible, and advisable, to take one camera of each type.

The Continuous Reflex Camera

One of the most useful revolutions in camera design in recent years is the development of the continuous reflex motion-picture camera. In the non-reflex camera the viewfinder is separate from the taking lens system and must always be liable to error. Since it must

66

be physically separate from the taking lens, and therefore at a distance from it, it views the subject from a slightly different angle. If it is otherwise accurately aligned, this small difference will not be noticeable at distances of 5 ft. or more. But at closer distances the error begins to matter until, in the case of big close ups of small objects, it becomes very serious indeed. Although a correction for this "parallax" error is usually provided, absolute accuracy over the shorter distances is difficult to guarantee. And making the adjustment for parallax is one more task to be carried out by the cameraman, and so subject to human error or forgetfulness like everything else. The great advantage of the reflex camera is that the operator looks at the scene directly through the taking lens. There is no parallax error to compensate for, and focusing can be done visually through the lens when the occasion demands.

Furthermore, when changing lenses, whether by rotating a multilens turret or fitting a separate lens, the reflex viewfinder needs no attention. In the non-reflex type of camera the viewfinder lens will have to be changed as well – yet another job for the cameraman – unless the camera is one of those with a mechanical link between turret and viewfinder so that the finder is automatically adjusted to suit the taking lens being used.

The reflex camera, therefore, is a boon to the cameraman; it removes the danger of the viewfinder failing to see the same picture area as the taking lens; it lessens the danger of out-of-focus shooting and assists critical focusing of near objects. Reflex cameras are more expensive, but they are no longer the sole prerogative of the more lavishly equipped units only, for they are available in the medium price-range of equipment also. To sum up, a continuous reflex type camera is strongly to be recommended, particularly when speed of operation is called for or when accurately framed close-ups are important.

In fact, the nearer to the subject it is necessary to work the more vital it becomes to use a reflex camera. As the distance from the subject becomes really small depth of field is greatly reduced too. When an extremely small object is to be filmed the problem of maintaining accurate focus becomes almost as great as that of keeping it in the centre of the frame. The extreme case is that of cine-macrophotography – that is, taking larger than life photographs with ordinary camera lenses – and tackling such work nowadays without a reflex camera is almost unthinkable. Continuous viewing through the taking lens while the camera is running is achieved in two ways: (1) by reflecting the image from the taking lens into the

67

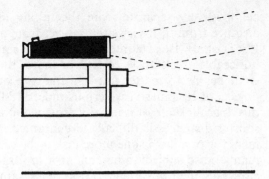

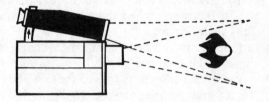

VIEWFINDERS 1. In the non-reflex camera the viewfinder is liable to error since it views the subject from a slightly different position compared with the camera lens. Compensation for this "parallax error" is usually provided but absolute accuracy in the case of extreme close-ups is difficult to guarantee.

VIEWFINDERS 2. The earliest method of solving the problem of providing an accurate viewfinder was to look at the back of the film itself. Naturally, provision had to be made so that the film would not be fogged when the eye was not covering the viewfinder. Unfortunately the introduction of filmstocks with dark, anti-halation backing and multi-layered colour stocks made it difficult to see the image on the back of the film.

VIEWFINDERS 3. The reflex camera solves the problem of providing an accurate view-finder by enabling the cameraman to see through the taking lens itself. One way of achieving this is by incorporating mirrors on the shutter, which is mounted at an angle to the optical axis of the lens. While the frame is being exposed, as in 1, all the light falls on the film. As soon as the shutter moves in front of the film 2, the light is deflected into the viewfinder.

The only drawback to this system is that should the camera happen to stop with the mirrored shutter *not* in front of the film nothing can be seen in the viewfinder until it has been moved into the viewing position by means of an inching knob.

VIEWFINDERS 4. Another method of providing a reflex viewing image is to introduce a double prism 1 between the taking lens and the picture gate. Some of the light is deflected at right angles into the viewfinding system 2, the remainder passing straight through the prism and exposing the film.

The advantage over the mirror-shutter reflex system is that an image is seen in the viewfinder at all times, whether the camera is running or not. A slight disadvantage is that some light that would have been available for exposing the picture is lost in the viewfinder and a small increase of exposure is necessary to compensate.

69

viewfinder by means of mirrors mounted on the shutter blades; or (2) by inserting a very thin piece of glass behind the lens and in front of the shutter to reflect a small percentage of the light into the viewfinder. The first method has the slight disadvantage that, unless the camera stops with one of the shutter mirrors in the right place, no picture will be seen until the shutter is inched by hand into the correct position. The second method gives a picture in the reflex viewfinder all the time, but the small amount of light deflected into the viewfinder is not available for exposing the film. To compensate for this, therefore, it is necessary to open up the aperture a trifle. However, the required increase of exposure amounts to no more than a quarter or a third of a stop and is a very small price to pay for the great advantage gained.

While these methods of obtaining a continuous reflex picture have been developed fairly recently, it is interesting to recollect that many years ago absolute accuracy of viewing while shooting could be obtained on certain cameras by the simple method of looking at the back of the film, with the aid of prisms, as it passed through the gate. Naturally, the viewfinder had to be closed when the eye was not in position to prevent light entering and fogging the film. Nevertheless, this was an excellent method giving 100 per cent accuracy because one actually looked at the picture framed in the camera gate. Unfortunately, the introduction of filmstocks with an anti-halation backing, usually dark in colour, made it impossible to see the image on the back of the film. Colour films, also, carried too many layers of emulsion for an image to be seen. The method also had the drawback that, when working at a small aperture, with faster filmstocks, the image was very dark and difficult to see. These disadvantages do not occur with continuous reflex cameras.

Cameras for Use in the Field

Most portable motion-picture cameras are straightforward instruments. Features such as single-frame exposure, wide speed variation, variation of shutter timing and so on are only occasionally called for when shooting on location. It is as well to think about the facilities you will require for the work you are undertaking before deciding upon the type of camera you will use. The more features a camera possesses the more danger there is of its going wrong under the rough conditions of working in distant places. Cameras in documentary work travel around for most of their lives and experience proves that as much, if not more, wear and tear occurs in

continuous travel as in actual use. Vibration, jolting and dust can play havoc with delicate mechanisms. For jobs involving much travel and shooting under all conditions in all weathers, choose a robust camera with no more mechanical complications than you will actually require.

There was a time, in 16 mm. work, when the ability to produce optical effects such as fades and dissolves in the camera was valuable, and the more complex cameras that provided these facilities were most useful. Nowadays, with the great advance in printing techniques, this is seldom necessary. Fades and dissolves can be added in the final release printing stage with much greater accuracy and at a small cost. In 35 mm. work it has always been the practice to add such "opticals" afterwards at the laboratory.

Choice of Lenses

The range of lenses available for motion-picture cameras has increased greatly during recent years. The most remarkable development has been that of the "zoom" lens, the lens that can change its focal length during the taking of a shot to enable the subject to appear to draw nearer or farther away. Such lenses are obviously very attractive to the documentary producer. While they do not produce precisely the same effect as "tracking" – moving the camera bodily nearer or farther from the subject – the effect is very similar. But tracking calls for a smooth-running camera dolly, and this in turn requires rails of some kind to be laid down unless the location has an unusually smooth floor. Zooming, on the other hand, can be achieved from a static camera by the mere operation of a lever.

Quite apart from its ability to bring the subject optically nearer or farther while the camera is running – an effect that should only be used once or twice in the course of the average film – the zoom lens has another important advantage. In one unit, it offers all the focal lengths of a whole battery of normal lenses. A zoom lens covering the range of, say, 25 mm. to 250 mm. on 35 mm. film can be set to any focal length between these to cover exactly the area required, and then used, without further movement of the zoom lever, to produce a static shot.

The question can now be asked whether it is any longer necessary to have a number of normal lenses giving different fields of view. The answer is that, at the present time, the zoom lens has not superseded normal lenses – although for certain types of work it is on the point of doing so. It is now common practice to mount a zoom lens

on the front of a newsreel camera or a camera used for synchronous sound recording and use nothing else. Modern zoom lenses are available that will provide a range of focal lengths as great as 20:1 (for example, from 12 mm. to 240 mm. in the case of a 16 mm. lens.) At one time zoom lenses were not available with apertures much larger than $f3.5$ but even this limitation is now being removed and models are marketed that will open up to $f2.2$. Nevertheless, zooms do have their limitations. If an extremely wide angle or a very long focus lens is required it is still necessary to turn to the normal type of lens and the same applies when an exceptionally wide aperture, such as $f0.95$, is required.

To sum up, therefore, if we wish our camera to remain fully versatile we must still turn to the wide range of normal lenses available to us. Furthermore, zoom lenses must, by their very nature, be an optical compromise. Good though the definition of a modern high-quality zoom lens can be, the resolving power will vary slightly over its range of focal lengths. And it is a somewhat delicate instrument, usually provided with its own reflex viewfinder, and this can get out of adjustment, making critical focusing no longer possible. Quite apart from the foregoing, therefore, for mere quality of picture, reliance is better placed on conventional lenses.

In other words, a zoom lens is a most valuable *addition* to the cameraman's outfit. The occasional zoom, used for a carefully planned purpose, can be very effective. But we still have to consider our normal lens requirements.

Focal Lengths

The choice of focal lengths is naturally dependent upon the work to be undertaken. Very-long-focus lenses will be of limited use – say above 100 mm. on 35 mm. film, or 50 mm. on 16 mm. film – and are seldom called for. Of course, for subjects requiring high magnification, such as wild life or close shots of sportsmen in the middle of a playing field, they may be essential. But for everyday shooting there is much more use for the less extreme focal lengths. A point that must always be borne in mind is that the longer the focal length the smaller the depth of field at a given distance and aperture. Furthermore, camera shake is much more apparent with a long-focus lens and extreme steadiness is called for. Altogether, long-focus lenses are much more difficult to use.

In any set of lenses, there is one that is regarded as the "normal" lens – the lens that is said to cover the normal field of view. In 35 mm., this is often the 50 mm. lens; in 16 mm. the most common focal

LONG AND SHORT FOCAL LENGTH LENSES. The same scene viewed by lenses of different focal lengths. A short focal length (wide angle) lens tends to exaggerate depth. A lens of long focal length (a telephoto) has the opposite effect.

length is 25 mm. In a great deal of documentary work lenses with wider angles than these are extremely useful. When filming in small interiors, to be able to cover a wide field is often essential; indeed, for ordinary work there are a great many situations where wide-angle lenses are far more valuable than long-focus ones. In 35 mm., a wide-angle lens with a focal length of 24 mm. or 32 mm. is a very important addition to an outfit. In 16 mm. work, 15 mm. or 12.5 mm. lenses are similarly important.

It must be remembered, however, that there are limiting factors. Just as the very-long-focus lens brings with it problems of accurate focus, so very-wide-angle lenses bring problems of distortion. Lenses of the order of 24 mm. or 20 mm. or less (35 mm. cameras) will tend to distort verticals – in other words, upright straight lines at the sides of the picture area will bow outwards. In the case of such lenses as the 18.5 mm. and 14.5 mm. now available this will be even more pronounced. Their equivalent in 16 mm. – the 12.5 mm. and 10 mm. lenses or less – will do the same. While the effect will usually be acceptable while the camera is static, if the camera is moved during shooting – either panned or tilted – the distortion will become disturbingly apparent. If such lenses are to be included in an outfit they must be used with care.

Aperture

Extreme wide-angle lenses have one great advantage, however. "The shorter the focal length the greater the depth of field" is one of the laws of optics, and our very-wide-angle lenses will give us a very great depth of field – so much, in fact, that a 10 mm. lens for use on 16 mm. cameras may require no focusing at all. Objects from about 3 ft. to infinity will all be in focus, assuming an aperture

73

no larger than $f2$. Of course, the basic rule that smaller apertures tend to produce sharper pictures still applies and at $f2$ it would be unwise to expect the foreground to be quite as sharp as it would be at $f8$. But this depth of field is a very useful feature of such lenses and reminds us of the advantage enjoyed by the 8 mm. camera user; he has such a large depth of focus, even with his normal lens, that his focusing problems are very few indeed.

Long-focus lenses are not usually made with particularly wide apertures. It is when we are considering normal-field and wide-angle lenses that the question whether to select a very wide aperture arises.

A lens with a very wide maximum aperture can be most valuable when it is necessary to film in very poor light. On the other hand, the wider the aperture the smaller the depth of field. At $f1.4$ the depth may be awkwardly small, particularly if the subject is rather near the camera. The new wide-aperture lenses now on the market, with apertures of the order of $f0.95$, for instance, may be very useful at times, but focusing is a very critical matter when the diaphragm is wide open.

All these factors have to be borne in mind when a set of lenses is being selected for a given job. The answer must be, as in most things in life, a compromise.

It might be helpful to suggest some typical outfits for normal working.

For 35 mm. cameras, if three lenses are to be selected, a good outfit would be: 32 mm.; 50 mm.; 100 mm. If a fourth is to be added, preference might be given to an 18 mm. or 20 mm. If a fifth is to be added, a 150 mm. or 200 mm.

For 16 mm. cameras, three lenses: 15 mm.; 25 mm.; 50 mm. Addition of a fourth: 12.5 mm. or 10 mm. Addition of a fifth: 75 mm.

As I have already said, for some types of work nowadays a zoom may do the work of a whole series of normal lenses. There are factors to be borne in mind when choosing a zoom for a particular purpose. A 10:1 zoom may sound most attractive – a zoom, that is to say, in which the longest focal length is ten times greater than the shortest. But such a lens will inevitably be quite bulky. Do you really need such a range of focal lengths? If a six-to-one gives you all you want, you will be very much wiser to settle for that. You will economize on bulk, weight and money. Can the zoom lens you have in mind be blimped for synchronous sound shooting? Has it a wide enough aperture? All these factors need to be carefully weighed.

Selecting Filters

A large proportion of film production today is in colour. Although filters are used in an entirely different way in colour work from black-and-white, they are still frequently necessary. Whether a film is to be in colour or black-and-white, therefore, filters will be required. But before considering the types of filters that will be most useful under various conditions, we must discuss the practical question of how the filters that we decide upon are going to be mounted on the lens.

As I have said, it is still very likely that, despite the advent of the zoom lens, you will be using a camera with a lens turret accommodating a number of normal lenses of various focal lengths. You are at once faced with a problem of providing a full range of filters for all of them and fitting them quickly and easily in place. The most common solution is the matte box, a combination of lens hood and filter holder mounted in front of the taking lens in such a way that it can be moved to accommodate lenses of any normal length. The advantage of a lens hood needs little emphasis. If you have occasion

THE MATTE BOX. A matte box performs the double function of shielding the camera lens from the direct rays of the sun or lights and acting as a filter mount. The best types permit one of the filters to be rotated about its axis, a feature that is most useful when Polaroid filters are being used.

to shoot towards the sun (or towards the lamps if artificial light is being used), it is obviously important to shield the lens lest any rays enter it directly and cause fogging or a veiling of the picture. As a filter mount the matte box has the great advantage that only *one* filter is used for all the lenses on the turret – or, for that matter, any others you may fit. As you bring a lens into the taking position the filter in the matte box is there in front of it.

This gets over the problem that lenses of different focal lengths often require filters of different sizes. If you have four lenses you may require four different filters of every type. This not only increases the bulk and cost of your filter outfit, but it also consumes a lot of time, since you must fit the same type of filter to all the lenses you are likely to use on any location. Should the lighting conditions change suddenly, you are then faced with the need to change all the filters in a hurry. A matte box saves all this bother – one filter taking care of all the lenses.

In colour work an ultra-violet filter is regarded by many cameramen as an essential for outdoor shooting. It is often left permanently in place throughout shooting. Another type of filter that is often left permanently on the lenses is the daylight correction filter that is required with various types of colour film when filming in daylight. It is a good idea to fit either of these filters to the lenses themselves by means of the filter ring that is usually provided and to leave them there. This has two advantages. It leaves the matte box vacant for the additional filters that may be required, while the permanent filters screwed into the lenses protect the lens surfaces from dust that may damage the bloom.

To sum up, then: a matte box is most suitable for filters that may have to be changed to suit certain conditions or to obtain certain effects; but there is still a case, with filters of a more permanent nature, for mounting them directly on to the individual lenses.

Filters for Colour

In colour work two main types of filters are normally used. The first is the type already mentioned – the filter required to enable colour film intended for use in artificial light to be used in daylight, and vice versa. Such filters are known as conversion filters. Colour film that is balanced to give a correct rendering in artificial light can be made to give an acceptable rendering in daylight by using a conversion filter such as the Wratten 85 or 85B. This is regularly done with films such as 35 mm. or 16 mm. Eastman Colour, and 16 mm. Ektachrome Commercial. Both are balanced for artificial

light and it is standard procedure to use them in daylight with either of these filters, applying an increase of exposure of about two-thirds of a stop.

It is also possible, in theory, to use colour film that is balanced for daylight in artificial light, with a conversion filter such as the Wratten 80B. In practice, this is not desirable. The conversion filter requires an increase of exposure of about one stop – in other words, the effective speed of the film is cut by half – and on location under artificial-light conditions, where the power of the lighting may already be barely sufficient, this can be a serious limitation. In any case, the blue filter required for this purpose is likely to produce a less accurate colour rendering than would be obtained with an artificial-light type of film. This procedure is only recommended in cases of emergency, therefore.

The second type of filter required for colour work is the colour-compensating filter. These are very pale filters which are useful for making slight corrections to the rendering of scenes when the light falling on them has a colour bias. All colour film is balanced to give the best results under certain light conditions. If the temperature of the light falling on the scene is not the same as that for which the film is balanced, the colour in the resulting picture will be distorted. For instance, most colour film is balanced to give the best colour rendering outdoors in sunlight (with the appropriate conversion filter in the case of artificial-light film). If the sun is not shining it will not, therefore, give an ideal colour rendering; the resulting picture will appear rather cold – that is, a trifle more blue than it should be. A very pale yellow filter, such as the Kodak CC 05 Y or CC 10 Y, will hold back a little of the blue and produce a picture that is a little warmer and therefore more acceptable. A whole range of these colour-compensating filters is available, including, in the Kodak range, six different colours, each in six strengths.

Of this range the most useful for normal outdoor colour photography are the yellows and blues. The red filter, also, can be used for warming up the overall tones of a scene that is too blue. The blues can be helpful when filming early in the morning or in the late evening. Colour film gives the most natural results from about two hours after sunrise until about two hours before sunset, and scenes photographed earlier or later tend to be very warm in tone, because the light at these times contains more yellow and red. A very pale blue filter (such as the Kodak CC 10 B or CC 20 B) will go a long way to correct this effect. A Wratten 82A pale blue filter is also recommended for this purpose.

It is important to use the filters specially manufactured for colour films. They are very pale in hue and are nothing like the strong-coloured filters used in black-and-white work. It must also be remembered that the amount of correction that can be obtained – even by using the strongest filters in the range, the yellow CC 50 Y or the blue CC 50 B – is limited. If the sun is almost setting it is very unlikely that any filter can so correct the scene as to make it look as though it were taken at noon. Similarly a scene shot on a dull, cloudy day cannot be made to look like one shot in bright sunshine. Some degree of compensation, and hence some improvement, can be achieved, but there is no substitute for bright sun and the proper time of day.

Deciding what filter to use for particular conditions is largely a matter of experience. Colour temperature meters are available and it is possible to purchase certain types complete with a large range of filters to be used in conjunction with them. In practice, however, a colour temperature meter is a tricky instrument to use. It can be affected not merely by the colour of the light falling on the subject, but by the colour of the subject itself or reflections from neighbouring objects. Some cameramen like to use such a meter, after careful tests and experiments. Many others prefer to rely upon the judgment of their own eyes plus experience gained under a variety of conditions.

One important filter is the ultra-violet haze filter. Distant landscapes, mountain views, sunlit snow scenes or scenes over water frequently acquire a blue cast when photographed on daylight colour film. This is because a high proportion of ultra-violet radiation is present in such scenes and this records on the blue-sensitive emulsion layer of the film, giving an excessively cold result.

An ultra-violet haze filter will considerably improve matters, since it will absorb a large proportion of the ultra-violet. It will also penetrate, to some extent, any visible haze that may be present. A very popular representative of this type is the "Kodisk" haze filter. This is a colourless solid glass filter. In the same range is the Wratten No. 1A (Skylight) filter, which is faintly pink. Scenes in open shade exposed through either of these filters will appear slightly warmer in tone. This is quite a desirable effect, since colour film, balanced as it is for sunshine, tends to render scenes in shade slightly too blue.

When using artificial-light film in daylight with the aid of a conversion filter, an ultra-violet haze filter is unnecessary. The conversion filter itself will cut down the ultra-violet.

78

A useful set of filters for outdoor colour work on either 35 mm. Eastman Colour or 16 mm. Ektachrome Commerical would be:

For each lens (to be left in position)
 Artificial to Daylight Conversion Filters (Wratten 85 or 85B)
One of each only for use in the matte box
 Colour Compensating Filters:
 Yellow: Kodak CC 10 Y; CC 20 Y; CC 30 Y.
 Red CC 10 R.
 Blue CC 10 B; CC 20 B; CC 50 B; Wratten 82A.

Not all filters used with colour film are intended to produce the most natural colour balance. Occasionally they are used to produce a deliberate distortion, perhaps the most common example being the shooting of "night" shots. To obtain a night effect in daylight, a Wratten 81EF filter may be used and this will produce the predominantly blue cast that is required. This filter would be effective with either Eastman Colour 35 mm. film or Ektachrome Commercial 16 mm. film, and would be used in daylight *instead* of the Wratten 85 or 85B conversion filter. The filter factor of the Wratten 81EF is the same as that for the 85 and 85B.

When shooting under artificial light there is the alternative of filtering the lamps instead of the camera lens. A blue filter such as the Pinewood CT ½ B would be suitable or, in the case of white-flame carbon lamps, the Pinewood CT ½ O.

Another class of filter used when filming in artificial light is the "light balancing" filter. These are intended for use over the camera lens to increase or decrease the colour temperature of the light reaching the film. For instance, studio tungsten lamps, photoflood lamps, fluorescent tubes and carbon arcs all produce light of different temperature and in some cases filters are necessary to give the best results. It is doubtful whether a cameraman would require to carry a range of such filters permanently in his kit, so this subject will be dealt with in the chapter on "Lighting on Location".

Filters for Black-and-White

The purpose and use of filters in black-and-white photography is generally better understood than in the case of colour, largely because black-and-white film is a far older product. A brief survey of the requirements of the average cameraman will therefore suffice.

The most common filters in use are the yellows, oranges and, less frequently, the reds and the greens. The purpose of using filters in black-and-white work is, of course, quite different from that in colour, where the aim is to produce the best and most natural colour

rendering. In black-and-white, the aim in most instances is to emphasize the contrast between the various colours in the monochrome rendering. In a country scene, for instance, a large area of green grass and foliage may surround a red-brick building and we may feel that the building will not stand out sufficiently boldly against the background. With the aid of a filter, we can ensure that it does.

A coloured filter will freely transmit light of its own colour to the film and, to a greater or lesser extent, absorb the remaining colours of the spectrum. In a black-and-white photograph, a coloured object will appear as a light tone if photographed through a filter which transmits light of the same colour as that object, and as a dark tone if the filter absorbs this colour. If we photograph our red-brick building through a red filter, therefore, it will appear light in tone and the filter will hold back the green of the foliage and render this dark. Conversely, if we use a green filter, the foliage will appear light and the building dark. In either case, the contrast between the building and its surroundings will have been increased.

In practice, it might be inadvisable to be so drastic as to use a red filter, for the final renderings might be so changed as to make the scene appear unnatural. A yellow or orange filter would hold back some of the green, but allow sufficient to pass for the scene to retain its natural appearance.

We are also very much concerned by the fact that whereas colour film will usually record skies quite faithfully, black-and-white film, unaided by a filter, will not. Most emulsions have a high sensitivity to ultra-violet and blue light (in this respect their sensitivity is dissimilar to that of the human eye) and blue and violet objects often appear to be too light in the black-and-white print. For this reason there is a lack of contrast between white clouds and a blue sky. This is where our yellow, orange and red filters perform a most useful function by holding back some of the blue light from the blue areas of the sky, making it appear darker than the white clouds which then stand out clearly.

A brief summary of the effect of the most commonly used filters in black-and-white work may be useful:

YELLOW – Acts as a general correction filter with panchromatic films; helps to make white clouds stand out clearly against a blue sky.

DEEP YELLOW – Darkens the sky still more. Penetrates the haze in distant landscapes, increases the brilliance of snow scenes.

RED – Gives a very striking, dramatic effect when recording light colours – clouds, cliffs, stone buildings – against a blue sky, which is rendered dark in tone.

GREEN – A general correction filter for panchromatic film with tungsten light. Also useful outdoors for taking shots of flowers, and for close-up head and shoulder shots against the sky.

Naturally, the exposure must be increased to compensate for the filter – how much the lens diaphragm must be opened depends upon the filter factor and the effect that is desired.

Most filter and filmstock manufacturers issue comprehensive lists of filters and data concerning their use, and these are well worth studying. From the practical point of view, it cannot be too strongly stressed that tests should be made before using any filter for serious work if you are not familiar with it. Different filmstocks reproduce colours in different ways. It follows that a filter may produce a different result with one type of black-and-white film than with another. It is not merely that the tonal rendering may differ; overall exposure may also be affected. Every filter has a factor *in relation to a particular type of film* – it may be slightly different with another type of film. Make tests, and afterwards be consistent. Become familiar with a particular range of filters and do not chop and change either these or your brand or type of filmstock.

A good working filter kit for black-and-white would be as follows:

One of each, for use in a matte box:

Colour	Filter Factor Daylight	Filter Factor Tungsten Light
YELLOW	2 to 2½	1½ to 2
ORANGE	2 to 2½	1½ to 2
RED	5 to 8	3 to 4
GREEN	4 to 5	3 to 4

(The filter factor refers to the amount by which a given filter will cut down the overall exposure. A twice times filter will require twice the exposure – in motion-picture work this usually means opening the diaphragm one stop – to produce a picture of the same density as would have been obtained without a filter at all.)

Polaroid Filters

One type of filter we have so far ignored is the Polaroid filter. Polaroid filters can be used with either black-and-white or colour film and they are helpful for cutting down reflections from surfaces such as polished wood, glass, water and paint.

A Polaroid filter may be likened to an optical slit which only transmits light vibrating in the plane of the slit. Light normally vibrates in every direction, but under certain conditions it becomes "polarized" – that is, it vibrates mainly in one particular plane.

There are two common sources of polarized light in nature, light reflected from smooth surfaces and light from a clear blue sky. A Polaroid filter, if rotated into the right plane, can be made to control the intensity of polarized light. In this way, reflections can be diminished or even eliminated, according to the degree of rotation of the filter and the angle at which light is being reflected into the camera.

In addition to controlling reflections, Polaroid filters can be used to darken skies in black-and-white photography without affecting the rendering of the landscape. In colour work they offer the only known means of modifying sky brightness, and can be used to avoid excessively blue skies under certain conditions. In the case of reflections on glass or water, these can be subdued to show detail beyond or below the surface.

The method of use is to view the scene through the filter, rotate it until the maximum (or desired) effect is obtained, and then place it over the camera lens with the same orientation. A well-designed matte box will have provision for rotating a filter for this purpose – a point to bear in mind when selecting your matte box.

Pola-screens can be placed over lights as well as the camera lens and they then give complete control of reflections when copying paintings, prints, murals or posters or any surface showing specular or other troublesome reflections.

Polaroid filters do not affect the colour, being neutral grey, but they do cut down the light reaching the film. The average density is 0.4, necessitating an increase of $1\frac{1}{2}$ stops – but care should be taken to check the precise factor of the filter you are using.

Exposure Meters

There was a time when exposure had to be judged by eye with the help of a table produced by the filmstock manufacturer. For many years after the invention of cinematography no easily used instrument for measuring light could be bought. When the photo-electric exposure meter first became generally available there was still a prejudice against it among experienced cameramen, who regarded the use of such an instrument as rather unprofessional. It was probably the introduction of colour film, which required much more accuracy of exposure than black-and-white, that finally broke down this conservatism. Nowadays few if any cameramen will deny themselves the useful information that a meter, intelligently used, will provide.

There are two principle types of exposure meter in general use today; the reflected-light type and the incident-light type. The former is more popular, but both have their advocates.

The reflected-light meter records the light that is reflected *from the subject*. At first sight this appears to be the obvious type to use, but an examination of the two systems will show that there are certain conditions under which each of them has particular advantages.

In normal circumstances, the reflected-light type meter pointed at the subject will give an accurate reading. It is important, however, that the area from which the meter is receiving light is approximately the same as the area to be photographed. If this is not so, the meter may be reacting to light outside the picture area and be giving an incorrect reading – a fault particularly liable to occur when the picture includes the horizon and an area of sky. If the meter is pointed so as to include too much sky the reading may be too high, producing under-exposure. If it is pointed too low the reading may be too low, tending to produce over-exposure. This problem can be surmounted by taking care to hold the meter at the correct angle, bearing in mind the camera field.

This angle is quite critical. It is usually possible to approach close to the subject, so that the area "seen" by the meter is the same as that covered by the lens. If this is not possible – because a long-focus lens is being used and the subject is very distant, or because the subject is too high up or unapproachable because of some barrier between you and it – the problem may have to be tackled in a different way. One answer is to carry a card with a surface of average colour – a mid-grey, for instance. From experience and tests you know that this represents an average subject – average, that is, from the point of view of its light-reflecting properties. Then, provided this card is held in the same light as the subject which you intend to film, pointing the exposure meter at it will give you the right answer. This is, of course, always assuming that *the subject itself* is an average one.

The incident-light type of meter does not measure the light reflected from the subject, but the strength of the light falling on it. It is argued in favour of this system that the important factor in judging exposure is the amount of light *falling on* your subject – *not* the light reflected by the subject.

In point of fact there is an equally good argument for both types of meter and neither is infallible. The lesson to be learned is that the readings given by *all* meters must be interpreted intelligently. The

83

reading should not be blindly accepted. Just as in the case of the reflected-light meter I made the point that it is important to take care not to include too much or too little sky, so it is important with the incident-light meter to make an allowance for the type of subject. Your meter is telling you how much light is falling upon it. If the subject is very dark and contains no light areas you must open up the lens diaphragm a little. If the subject is very bright all over – a close view of a whitewashed cottage or a long-shot of a wide sandy beach – you must close the aperture slightly.

Which type of meter you choose is a matter of personal taste, therefore. Both, in the right hands, are equally good. As in the case of all apparatus, the user must become familiar with it. Serious work should *never* be undertaken with new equipment until tests have been made and the results carefully analysed. The successful cameraman is usually the one who has a trusty camera that he has worked with for a long time, uses one or two brands of filmstock consistently so that he knows their speeds and contrast range, and intelligently interprets, on the basis of experience, the readings of whatever exposure meter he selects.

I have referred to the types of exposure meter in most general use. The well-equipped cameraman may well possess one of each, knowing that there will be occasions when one or other has a marked advantage. These meters will be all that is required for normal work, but one other type must be mentioned because it is sometimes useful for certain kinds of filming. This type is exemplified by the S.E.I. Spot Photometer, an instrument of extreme accuracy designed to record the amount of light being reflected or given off from a single small area (or spot, hence its name). To check the exposure required for a small area to be photographed at a distance (inside a furnace, for instance, or, in medical photography, inside the mouth or an incision during an operation – subjects that could not be approached closely with an ordinary meter) this instrument is invaluable. It is quite expensive and not very speedy to use, however, and as it will only rarely be required it does not figure in the normal cameraman's everyday outfit.

Tripods

The documentary film maker makes special demands upon his tripod and careful thought should be given to the type to be selected for particular assignments.

It goes without saying that a motion-picture camera tripod must be fitted with a pan-and-tilt head, a device to enable the camera to

be moved either horizontally or vertically by means of a handle on a long arm. This head must be capable of producing a *smooth* movement in any direction. This is not easy to achieve, but the smallest variation in speed will reveal itself on the screen. There is a type of tripod known as a "gyro" tripod which enables extremely smooth panning to be done by means of a gyroscopic mechanism consisting of a heavy flywheel that is set in motion by gears when the panning handle is pushed. By its very nature it is a heavy piece of equipment. It is therefore unsuitable for many types of documentary work where equipment has to be carried any distance. But for studio work, or scenes where transport is available right up to the location and adequate crew is available to move it and set it up, a gyro tripod is strongly recommended.

When buying a light non-gyro type of tripod, several points should be borne in mind. The panning handle should not be too short – for the longer the handle the easier it is to obtain a smooth movement. The best types have a telescopic handle that can be extended where space permits, and yet can be shortened for shooting in confined spaces where there is very little elbow-room. The pan-and-tilt head must be well balanced, so that the camera is not trying to fall forward or backward when tilting. It must be capable of being locked firmly in any position, so that when the framing of a static shot has been decided upon it can be relied upon to stay in position.

The tripod legs must be strong enough to be rigid, and yet the whole thing must be light enough to be easily carried. The documentary cameraman's tripod must be sufficiently robust to stand continual travelling. I have found from long experience that many tripods come to grief under the stresses of being transported by all kinds of conveyance. Vibration during long journeys in cars and aircraft causes nuts, bolts and screws to become loose and drop off. When placed with other luggage or freight in an aircraft, a tripod may be at the bottom of a pile and have to take a great deal of weight which will tend to break or bend the legs. Tripods with wooden or composition legs are most susceptible to such damage – probably models with light metal alloy legs are the best. Wooden legs, if robust, may be strong when new but they tend to dry and become brittle with age. Strength in relation to weight in tripod legs is a vital matter.

Another consideration is the range of heights attainable. It should be possible to extend a tripod so that the camera is just *above* eye-level. This will enable downward angles to be obtained, even though it may be necessary to find something to stand on before you

85

can look through the viewfinder! It is just as important that the legs can be telescoped to provide a very low angle. The best tripods have detachable legs, which either leave very short stumps in place for ground-level shots or permit very short substitute legs (known as "baby legs") to be fitted instead.

There is one more facility that is worth looking for. The best designs of tripod have the pan-and-tilt head fitted to the tripod itself by means of what might be termed a "floating bowl" – that is, a device that enables the complete head to be rocked through several degrees in any direction and locked in any position. By this means the camera can be brought into the horizontal position quickly and easily when setting up. Without this device it is necessary to move the feet to different positions on the ground, or lengthen or shorten one or more of the legs, to obtain a horizontal set-up – and either procedure can be time consuming.

A good stout bag into which the tripod can be packed for travelling is a useful asset.

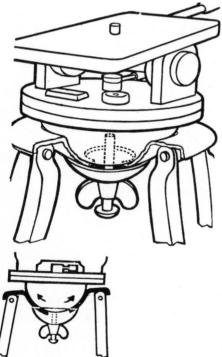

LEVELLING THE TRIPOD. A most useful device to look for when selecting a light-weight tripod: a head that can be rocked through several degrees in any direction and locked in position. This avoids moving the feet or varying the length of the legs to achieve a horizontal set-up. A spirit level attached to the tripod head is also helpful.

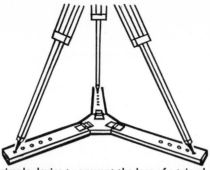

THE "SPIDER". This simple device to prevent the legs of a tripod slipping on a smooth surface is called a "spider". It consists of no more than three pieces of wood with holes drilled in them to take the tripod feet. They are hinged to the centre piece so that they can be folded for transporting.

The "Spider"

There is another item associated with the tripod that is most useful, known as a "spider". It is an extremely simple gadget, consisting of no more than three strips of wood radiating from a centre piece. Each strip has a number of holes in it. One of the spiked feet of the tripod can be inserted into an appropriate hole in each strip. This will prevent the tripod legs slipping on a smooth surface. In practice, the three perforated strips of the spider are hinged to the centre piece so that it will fold up for transporting.

A variation of this device, less commonly met with, is the "triangle". A triangle of wooden strips is assembled with a socket at each corner into which one foot of the tripod can be inserted. The tripod is thus held rigid. Advantages over the spider are that the triangle can be mounted on wheels so that camera and tripod can easily be moved around, and even with the legs at their shortest and spread-eagled for a low camera position, the tripod is perfectly stable. On the other hand, the triangle cannot be collapsed so easily as the spider to make it portable.

Reflectors

Folding reflectors, small enough to be carried around, are another accessory that many cameramen like to include in their kit. They are most useful for directing light into dark areas and filling in shadows. They will be referred to in more detail in Chapter 8.

Other Accessories

Every cameraman collects items which he has found, from experience, to assist him when working in the field. Some of these are extremely important.

A measuring tape is certainly essential, and the 25 ft. or 50 ft. tapes used by builders are the best. Even though the camera being used may be a reflex model providing for visual focusing through the lens, there are frequent occasions when accurate measurement is preferable. Indeed, it is essential when the depth of field is critical and one has to know the distance of objects nearest and farthest from the lens.

A changing bag is most useful. With spool-loaded film, it is possible to fog several layers when loading or unloading in bright daylight where there is no shade. The description "daylight loading" applied to spools is, in fact, an exaggeration, and fogging can ruin shots at the beginning or end of a reel unless a changing bag is used. Moreover, there are bound to be occasions when a camera jams and the cause has to be investigated on some location far from home. If there is a director and cast impatient to continue or some never-to-be-repeated incident unfolding relentlessly despite the fact that you are out of action, you may be very glad that you have a changing bag in your kit.

A camera gate brush, lens-cleaning tissues, a spare take-up spool in case you come upon a bent one – these things may appear too obvious to deserve mention, but I have known them to be forgotten. A check list of all the equipment usually taken on location pasted to the lid of the camera case provides a most useful reminder.

Sound equipment for location work has not so far been mentioned. This has a chapter to itself later on.

6

SHOOTING

THE VARIOUS ASPECTS of production are so closely interwoven that it is impossible to separate one completely from another; there are no watertight compartments in film making. Shooting, for instance, is so tightly bound up with editing that the two stages cannot be discussed separately. At the shooting stage we are fashioning the pieces of the jigsaw puzzle which the film editor must later assemble to create the complete picture. Unless these separate pieces are made to fit together, the editor cannot do his work.

Physically it is possible to join any one piece of film to any other. In practice, however, film audiences have come to expect certain rules to be obeyed and certain conventions to be observed. The scenes recorded in the motion-picture camera must be such that it is possible for them to be assembled in conformity with these rules and conventions.

The still photographer takes a series of individual pictures. Generally speaking, each of them is a separate entity, telling its own story, capturing a single moment of time; and he is not concerned, when he presses the shutter release, with the picture that went before or the one he will take next. The motion-picture cameraman, on the other hand, must *always* have in his mind the previous shot in the script and the shot that will follow, for these and the one he is working on at the moment are going to appear consecutively on the screen. It must be possible for the film editor to assemble them so that they flow smoothly from one to the other.

In the case of the feature film, where everything is under the control of the director, he, alone of the crew, takes responsibility for creating a series of shots that will edit together. In practice he is assisted by a floor secretary or continuity girl to watch for small details, but it is the director who decides when to start the camera and when to cut, how much to overlap the action at the end of one shot with the beginning of the next, and so on. In this kind of filming

it is not necessary for the cameraman to understand all the complexities of picture editing. It may be useful if he does – but he will not be called upon, off his own bat, to create shots that will be capable of subsequent assembly.

In documentary work, however, the situation is very different. Some sequences and some complete films may involve scenes where everything is under control and a director takes charge of the whole set-up. Other sequences may involve shooting scenes of real life where little or nothing is under control. It may frequently be necessary for the cameraman to shoot without direction – to be, in effect, his own director. Much documentary work is similar to newsreel work, in that incidents are happening which must be recorded as they occur. A newsreel cameraman is really a director-cameraman, selecting his own angles, deciding when to shoot and when to cut, responsible for securing material that can be put together on the editing bench in a smooth-flowing way. A cameraman shooting such scenes must obviously have a complete grasp of the rules and conventions of film assembly.

Rules and Conventions of Film Assembly

Let's consider what these rules are, bearing in mind that in our kind of filming they are the concern almost equally of the director, cameraman and film editor, all of whom must work in harmony if an effective and technically good result is to emerge.

Some of the rules and conventions are purely mechanical; some are matters of careful individual judgment, and some of purely artistic appreciation. How long should a given shot last? What is the best composition within the frame for a given scene? Is this an occasion for using a steep upward angle to give a shot emphasis and strength? At what juncture will a track-in give point to a significant detail? All such questions can be decided only by the individual according to his own feelings and the conception that he carries in his mind's eye of the finished film. The ability to visualize a sequence of shots as they will appear after assembly is an essential quality for both the director and cameraman. Only when each has developed this ability can he make those decisions, often in an instant, that enable him to capture some fast-moving event that may never be repeated – and capture it in such a way that the various separate shots will fit together to flow smoothly yet vividly on the screen.

The artistic aspects of camerawork cannot be taught. Each individual must develop his own talents and feelings by concentra-

90

tion and practice. The only advice that can be given is that before this ability can be developed all the factors involved in shot assembly must be analysed and fully understood. Every shot in a film has a number of ingredients. Composition, camera angle, camera movement (if any), movement or action on the part of the subject, duration: these are the most important of them, plus one more which is vitally important – the manner in which the shot will link with the one before and after. (I have left out those other factors that may or may not be under control, such as lighting, mood and accompanying sound.) In creating these component pieces of our jigsaw, therefore, we have a host of variable factors, each one capable of almost infinite variation according to the judgment and feeling of the director or cameraman taking the decisions at the time.

I have said that many of these artistic aspects of shooting cannot be taught. They are matters of individual feeling. What can be taught are the basic rules and conventions that audiences have come to expect. Let's descend to less aesthetic levels and consider what they are.

Division of Subject-Matter into Separate Shots

First, there is the question of the changing viewpoint of the camera. Why do we break a sequence down into LONG SHOT, MEDIUM SHOT and CLOSE UP, for instance, instead of recording all the action taking place on one location as a single shot? The best way of answering this fundamental question is to consider how we use our eyes in real life. Do we, in fact, see life as a continuous scene? If we are not ourselves in motion, do we see the scene around us in the form of one continuous long shot taken from the same viewpoint as might at first seem to be the case?

Let's analyse an everyday situation. Suppose we are sitting in a restaurant quietly eating lunch. Perhaps we glance up as the room becomes crowded and casually observe the complete scene. We are certainly looking at it in long shot so far, for we take in everything after a fashion – the crowded tables, the people around us, the newcomer looking for a vacant seat. But let's imagine that someone nearby raises his voice above the general murmur of conversation. We look to see who it is. We study this character and notice that he is rather agitated. Now we have forgotten all the other people round about – we are studying one man. We are looking in medium shot, for the human eye, coupled to the human brain, is an incredibly flexible instrument, capable of taking in a wide scene or concentrating on one small area to the exclusion of everything else.

91

The man is pointing and we look to see what he is pointing at. He is pointing first to the menu and then to his bill – these two articles we study quickly in close-up, excluding, mentally, even his face. His companion makes a remark and we look for a moment at him – another close-up. Then the first character calls for the waitress. We look back to him as he does so. We note the direction in which he is looking and we then follow his glance. We cut to the waitress – in medium long shot – across the other side of the restaurant.

All this we have done without moving from our seat. There should be no need to pursue this simple example any further. If you still doubt whether we do, in fact, concentrate on one part of a large scene to the exclusion of the rest as intently as I have suggested, I think I can convince you by asking a question. Can you not remember, at one time or another, observing something with such concentration that a friend stopping near you has been unnoticed, startling you with his proximity when finally you realized he was there?

I said that, at one point, we "cut" away from the man to look at the waitress who was in another part of the room. Do we in life "cut" from one view to the next, or do we just move our eyes from one part of a scene to another in the form of a long "pan", seeing quickly everything that is in between? This again can be easily checked. Try looking from an object on one side of the room you are now sitting in to an object on the other side. I am sure you will find that you have not really seen all the space that is in between. Using the powers of selection of the eye and brain, you have "cut", in effect, straight from one significant object to the next.

In this simple analysis we have revealed the fundamental grammar of the film. In changing our camera angle and assembling our film afterwards we are merely copying what our eyes and brain do in real-life observation. It is true that in film we may make the changes drastically. Our variety of camera angles may be far greater than we achieve by the use of the eye alone. But I submit that it is only because our camera angles and our cuts from shot to shot are closely related to our everyday manner of observing the world around us that the whole process on the cinema screen is regarded as normal and perfectly acceptable.

Sequence of Shots

From this study of the way we use our eyes we are now able to evolve the basic rules of shooting and editing. Generally speaking it is logical to begin with a long shot to establish a new scene. Having allowed time for the audience to assimilate the essentials, we move

THE SHOOTING PLAN. Camera position I provides an establishing Long Shot enabling the audience to see the whole scene.

The Medium Shot, position 2, satisfies the natural wish of the audience to look more closely at the character sitting at the table.

Position 3 enables the entry of a second character to be seen, while the fact that the first character does not hear him can also be observed.

The interest of the audience now moves to the newcomer and a cut to camera position 4 satisfies their curiosity by enabling them to see him in more detail. He has something in his hand – they will want to know what it is and so a close-up, from 5, provides the answer.

The audience will now want very much to know whether the first character has seen that he is being threatened by a revolver and what his reactions are. The cut to position 6 gives them the answer.

A shooting plan such as this saves a great deal of time since the crew and the actors know precisely what their positions are to be, shot by shot.

to medium shot. From medium shot we proceed to a close-up, centring on the point of interest. This logical progression from the general to the particular 'can be applied to a great deal of our film making, both the development of the theme and the breakdown of scenes into separate shots, and it is a good idea to consider each new location with this approach in mind. Of course, the formula need not be followed slavishly. It is not *always* good to begin with a long shot. Sometimes, for example, it is more interesting to proceed straight to a close-up, but there must be a reason for these departures from the normal progression. If we have been led in the previous scene to expect to see some object or person, it is perfectly in order to begin with a close-up of that object or person. But we then have to bear in mind that the location has not yet been "established" in the mind of the audience. If the location is important, it must now be revealed, by moving to medium or long shot.

Other important conventions can be deduced from our analysis of the restaurant scene. When the man looked across the room we turned to see what he was looking at. It has come to be accepted by cinema audiences that if a character is seen looking out of screen, they are shown in the next shot what he was looking at. Often when we show a character in close-up or medium close-up and he is looking at something, we cannot include in the same picture what he is looking at. So we cut and show it in the next shot. If we had filmed our man in the restaurant looking at the waitress we could not have included her in the same picture, because she was on the other side of the room. So we would have followed a close-up of him with a shot of her, and because of the convention that has grown up, everyone in the audience would have been quite satisfied that she was what he was looking at.

This is a most useful convention, not only because it makes possible the breakdown of a scene into separate shots, but also because it opens up the way to a convenient form of cheating. If we show a character looking out of screen in one shot we can follow with a shot, not of what he is *actually* seeing, but of a scene taken in another place at another time. Provided we ensure that the background of the man in the first shot does not conflict with the subsequent scene, the audience will have no reason to think that anything is amiss. We could take a shot of a man's head against the sky as he gazes into the distance and, even though he may be standing on London Bridge, if we follow with a shot of a South Sea island the audience will be convinced that that was what he was looking at
– provided, of course, that we do not allow any extraneous items to

94

creep into the first picture, and ensure that the sky in both shots is reasonably well matched. This freedom to cheat is frequently useful. It allows us to suggest that characters have been to locations to which, in fact, we would have found it inconvenient to take them. It enables us, sometimes, to assemble material taken in different places and create effects that would have otherwise been impossible.

Planning Camera Angles

In planning our different camera angles, we have to bear in mind that we cannot make random jumps from one viewpoint to another. The whole sequence of shots will only hold together if it appears to be logical. If someone is shown looking very hard in a certain direction, the audience will want to see what he is looking at, so the next shot should enlighten them. The whole art of breaking a sequence down into separate shots lies in appreciating where the audience will wish to look next, shot by shot. The man in the restaurant looks at something in his hand – the audience wants to know what it is, so we follow with a close-up of the bill. He speaks – the audience wants to know to whom he is talking, so we cut to his friend.

This logical approach can almost always be applied. If a craftsman is carrying out some intricate task the audience will want to have a closer look at what he is doing; we therefore go from a medium shot showing both the man and his work to a close-up of the work alone. Even if nobody is in the scene, we can conclude that, having taken in the whole view, the audience would now like to have the opportunity of examining parts of it in more detail.

The question of changing the distance or apparent distance of the camera requires some further consideration. The *amount* of change from shot to shot must be within certain limits. If the change of image size is too small it will appear as an irritating jump. Any change must be substantial and there must be a *reason* for it. A move from a medium close shot into a close-up to reveal some interesting and relevant detail will be accepted as natural by an audience. If there was no reason for a close-up at this instant, the cut will be unacceptable, because it will not appear natural.

This applies to a change of angle as well as to a change of distance. To move the camera only a few degrees in its relationship with the subject will, again, give the appearance of an unpleasant jump in the middle of a scene. A change of, say, 45 degrees will, on the other hand, be sufficient to present the audience with a definitely new viewpoint and – once again provided there is a good reason for it –

95

it will be acceptable. But care must be taken, in changing the angle, that no disturbing change takes place in the relationship of surrounding objects to the subject itself. Such a change may, in itself, give an impression of an error of continuity.

Going to the other extreme, a change of angle that is very great may be confusing. It must be possible for the audience to retain their "bearings" within the scene. If a long shot establishes in their mind the general layout, the ensuing medium shot should proceed to show them a portion of that scene that they can recognize and place in its relationship to the whole. If you jump from the long shot to a close up of some detail that has not previously been clearly visible, your audience will feel momentarily lost and the whole sequence of shots will tend to become meaningless. Retaining a sense of "geography" is a vitally important aspect that must be considered when breaking a scene down into its component shots.

I have emphasized these things under the heading of "shooting" because, whereas in feature film production they are the stock-in-trade of the script-writer and director, in documentary production

CHANGE OF VIEWPOINT. A change of camera position must be neither too great nor too small.

1. If the change is too great it will be difficult for the audience to relate the closer shot with the preceding long shot.

2. If the change is too small the result will appear as a slight but irritating jump on the screen that appears to have no purpose.

3. A shot taken nearer than the preceding one, but along the same axis, may make the subject appear to jump forward. It is safer to change the angle of view as well as the camera distance.

the cameraman should understand them as well. If he is left to capture a sequence by himself, because it is something happening in real life and not under the control of the director, he has to apply these rules himself, as best he can, as he takes his various shots.

For an example of this kind of thing, let's return to the British Transport film *Terminus* that was referred to when we were discussing scripts. You will remember that this film presents a day in the life of Waterloo Station. A series of typical incidents make up the film – a troop train departs, a small child gets lost, relatives say good-bye to members of the family who are emigrating and who may never come back. Edgar Anstey, the producer, described the shooting technique in this way:

"We wanted to get as much realism as possible and we filmed real people wherever we could, using a hand-held camera, newsreel style, most of the time. For such a technique to succeed it is absolutely necessary for the cameraman to enter into the spirit of the thing. Often the director was only able to say: 'You see those people parting – concentrate on them. Get what you can.' Often it's the small detail shots that tell the story most effectively – the close up of two hands holding as the train starts to move, keeping hold as long as they can. This kind of thing the cameraman has to recognize and has to make up his own mind and get it. There may be no time for the director to prompt him. Then, if some unexpected reaction occurs on the part of some other person – something that will add vividness to the scene – the cameraman must be ready to change his viewpoint and capture that, too. The result is live and real. A film shot like this is developing all the time. It is not confined by a detailed script that might only inhibit it."

Continuity Between Shots

To return to our consideration of consecutive shots, there is the important question of continuity between them. If we see a man in medium shot and then take a closer look at him in close up, he must be in the same position in both shots – or, to be more precise, he must be in the same position at the end of the medium shot as when we cut to him at the beginning of the close up. In real life this would automatically be so; when we film him we must somehow ensure that it *is* so despite the fact that, in changing our lens or camera position, there has been a lapse of time. On the face of it, this point appears obvious. It is all the more surprising, therefore, that many beginners fail to appreciate it and assemble their shots with serious continuity errors between them, thinking that the audience will not be bothered by them. This, then, is our next rule, however obvious it may seem: that shots between which there is *supposed* to be no time lapse must obey the rules of continuity and reveal actors and objects in the same position.

97

Condensing Time

This brings us to one of the great problems of film making. It is almost always necessary to condense time in creating a film sequence. We have to present the significant pieces of action and omit the insignificant pieces in between. But we must do this in such a way that the audience is not aware of, or at least not irritated by, obvious jumps in time. If we had filmed our two men discussing the bill in the restaurant we might have found that their discussion took too long. We cannot solve this by cutting the middle out of the shot, which would undoubtedly produce a jump in the action – the men would be in a different position before and after the portion that we had removed. One way out of the difficulty would be to cut from the first man to a close up of the second man listening to him, and then cut back to the first man again. Because we have looked away from him for a moment, it is now permissible to cut back and find him in a different position. We may have cut several seconds, or even minutes, out of the action, but the audience will not be aware of this and will accept the result as natural.

This problem will always be with us. If we are filming a technical or manufacturing process it will almost invariably be too lengthy to

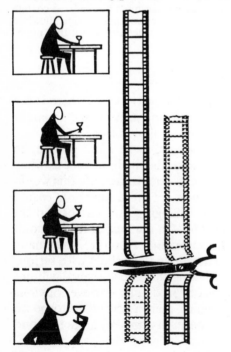

CUTTING ON ACTION. A cut is to be made from medium shot to close-up while the man is lifting the glass. To make such a cut possible the action will have been overlapped – that is, shot twice, once in medium shot and once in close-up, to provide the editor with a choice as to where to make the cut.

To produce a smooth cut the editor would check that the action was slightly more advanced in the first frame of close-up than in the last frame of the medium shot.

Such a cut would be more pleasing if made just after the actor began the action or just before he completed it, rather than half-way through. Every change of camera position should be made for a reason. In this example we will assume that we wish to see the man's expression while he is drinking and so the cut has been made just before the glass reaches his mouth.

show in its entirety. A simple job such as an operator soldering a seam in a tinplate casing will appear endless on the screen although it may only take one minute in real life. Here again, one remedy is to cut to a close up of the operator and cut back to show the job much further advanced. Similarly, if we are filming a packing-case being loaded on to a ship the whole operation would appear tediously slow to the audience. A cut to the crane operator, or a docker signalling to him, and then back to the packing case which is now nearly on board will enable the sequence to be shortened to acceptable proportions. Of course, the cameraman will not be able to take these extra shots in their correct sequence; it would, in most cases, be impossible to switch from the packing-case in mid-air to the crane operator and back to the packing-case while it was still moving. The whole action – or sufficient of it – is shot first, and the interposed close ups afterwards, probably when the operation is repeated with another packing-case. They will be put into correct sequence later.

Shots inserted for this purpose are known as "cut-aways". Every director or cameraman should shoot cut-aways to provide the film editor with additional material to enable him to condense time and assemble the scene to whatever length he considers desirable. If the scene is being acted, the director can stop the actors and ask them to re-start the action at whatever point he requires. If the scene is happening in real life, the cameraman must shoot the significant pieces of action, providing cut-aways as best he can to enable it to be edited without continuity errors afterwards.

Directing People

One of the documentary producer's greatest problems is to make the ordinary people that he films appear natural on the screen. They should look as though they are unaware that a camera is anywhere in the vicinity. If the characters being filmed are not under the control of a director or a cameraman, as in the case of scenes in streets and other public places, this naturalness can usually be achieved only by placing the camera in an unobtrusive place. There are plenty of ruses that can be practised according to the circumstances: filming out of a stationary car; placing someone in front but just to one side of the camera; setting the aperture and focus first, out of sight, and then sneaking shots while you concentrate your gaze in another direction – all these assist in securing candid-camera scenes. The use of a long-focus or medium long-focus lens helps a great deal.

When the characters are co-operating and are under the director's control, on the other hand, much can be achieved by careful handling. Most people are capable of appearing perfectly natural in front of a camera while they are doing their normal job or some everyday action. But they must be given clear instructions. Their instinct is to look at the camera – which is exactly what they should never do. As soon as a character is seen glancing, even momentarily, at the lens all the illusion of naturalness is gone. The camera should be the unseen eye and the audience should have the impression that they are observing the natural world without a mechanical barrier intervening between them and it.

Most people will respond when it is explained to them that they must not look at the camera and that they should try to act as though it was not there at all. It is often astonishing how much co-operation, in this respect, can be obtained by the right approach. We have discussed the technical and filmic qualities that a documentary director and cameraman must possess, but it is just as important that they have a love of people and an intense wish to understand and make contact with them. It is vital to gain the confidence and willing co-operation of people to film them successfully. Actors are paid and they can be given orders (although even here an understanding approach is much more likely to secure good results). But so many of the people who appear in documentaries are doing so without any obligation to co-operate. The director and cameraman have no power to make any demands at all – even if those being photographed are employees of a firm who have commissioned the film, it is doubtful whether they can be ordered to take part if they do not wish to do so. Tact, and understanding of possible shyness and embarrassment at being the centre of a filmed scene for the first time, are the strongest weapons that the film director or cameraman has in these circumstances.

The director who indulges in violent histrionics, miming every part and knowing every gesture he wishes every one of his actors to make, is largely a figment of the popular imagination. Most directors prefer to encourage the actor to make the fullest possible contribution, and to play the part in the way that suits his personality, provided, of course, that it fits the mood of the sequence and the director's overall conception of the mood and style of the film. John Waterhouse says, on this subject:

"With actors, professional or amateur, the important thing is to know when a scene looks and sounds right. Sometimes I give the actor detailed instructions but generally I prefer to let him participate as far as possible in the working out

100

of the scene. The problem of getting one's ideas across to an actor is a very difficult one. It seems to me most important that the actor *understands* the action and his rôle.

"This means that he must understand the circumstances in which the scene takes place and the emotions and feelings of the character he is playing. The director's job is to set the actor's imagination to work and then to act as his audience, correcting him whenever he is not achieving the effect aimed at. If the director understands what is required, if he manages to explain this to the actor, the rest is a question of encouragement and patience.

"The job is usually much more difficult with a non-professional, but the method is the same."

This approach is another example of not letting ideas become crystallized too early. If the actor has a contribution to make within the framework of the script, it will benefit the final result if he is given the opportunity of making it.

Liaison During Production

Filming persons over whom the director has no actual authority becomes a particularly difficult problem in the case of films dealing with industry or involving the recording of scenes in a professional organization. When a film is commissioned and a script agreed upon, the film director and crew are automatically given a mandate to secure the scenes they require, to visit the premises and obtain the co-operation of those members of the staff involved. But the director has no real power to order people to do things that may interrupt their usual routine and possibly hinder the day's work. It is most desirable to secure the services of a member of the administrative staff to accompany the unit throughout the shooting. He can issue orders to those concerned to the effect that they should co-operate with the film director, after which the director takes over and gives his own instructions. The presence of such a liaison officer also helps to ensure accuracy in the presentation of the subject-matter. However detailed the script, it is almost impossible for a film director, dealing as he must with many different subjects, to know exactly how a given process or procedure is carried out. Guidance on the spot is the best guarantee against the eventual film being criticized by observers with expert knowledge, or by the management of the organization concerned.

The documentary director is often in the curious position of calling upon people to co-operate in the production of a film who have no reason, apart from goodwill, to co-operate at all. If a film is being made for a firm on their own premises, the authority of the management is there in the background. It frequently happens, however, that the help of outside organizations is sought to enable a product

101

or a process to be followed through stages outside the sponsoring firm's own works. It is obvious that under these conditions the whole film unit has to proceed with extreme tact. Goodwill is their only weapon. If everyone concerned is handled with charm and understanding all may be well. If patience or tolerance is strained beyond what is reasonable the facilities being offered may be speedily withdrawn. I can remember filming in a large engineering works where I had asked for two big overhead cranes to be brought into position to lower a massive casting slowly into position for an important shot. When we had secured this scene, the works foreman, a most helpful Scot, said to me: "Well, now that ye've just about brought the whole works to a stop, perhaps I can suggest that you take the rest of the morning off and come back this afternoon!" Fortunately this was said with a smile and I knew that we had not quite lost his goodwill. I realized, however, that we were seriously dislocating production – much more than I had imagined. I offered to suspend further work until next day if it suited him better. Our goodwill had to be preserved at any cost or our film was in jeopardy. Undoubtedly, understanding and tact are two of the most important ingredients in the make-up of any documentary film producer.

Conventions of Movement

I have referred to certain conventions of shot assembly and made the point that, although these are primarily the concern of script-writer, director and editor in feature film work, in documentary they must be thoroughly understood by the cameraman as well. Similarly, there are certain conventions of camera movement that are primarily the concern of the cameraman, but which must be equally appreciated by the director.

Whenever a shot involves camera movement, for instance, there is a basic rule that must be observed. Whether it involves panning, tilting (or both), tracking or zooming, the picture must be held still briefly before and after the movement is made. In other words the camera is run static for a moment, then it is moved across the scene, and finally it is run for a moment more after it has come to rest before cutting. This is a universal rule during shooting. Not only does it look right on the screen, but it assists the editor. It is rarely pleasing to cut from a shot in which the camera is moving to one in which it is static. It is equally disturbing to cut from a static shot to one that is moving. There may be occasions to break this rule during editing, just as there are occasions for breaking every other rule in film making. But at least, if the shot begins and ends with the

102

camera at rest, the film editor is left with a *choice* in the matter. And giving the editor the widest possible choice must be the first objective of both director and cameraman.

It is also important for camera movements to begin and end on a point of interest. The cameraman must always know, before he begins to shoot, exactly where he will begin and end his movement. This applies equally when tracking, zooming, panning or tilting – though in the case of tracking or zooming it is, perhaps, not so much a matter of "point" of interest as of an effective composition. A movement towards a subject should begin with a well-composed general view and end close enough to the subject for the detail and emphasis to be brought home to the audience.

Another aspect of camera movement must be borne in mind. It is unpleasant to have a pan one way immediately followed by one in the opposite direction. The same applies to tilting up and tilting down. Tracks and zooms should be used sparingly anyway. There are few faults so irritating as a continual in-and-out movement. Tracking and zooming should be reserved for those carefully planned moments when emphasis is called for.

Movement of the subject within the frame is also governed by rules that it is dangerous to ignore. If a character is seen moving from right to left in one scene it is confusing for him to be seen moving from left to right immediately afterwards, for the audience will naturally draw the wrong conclusion that he has now changed direction. If the camera is following a moving object it is a nice refinement to allow that object to gain ground gradually within the picture frame as it proceeds. This enhances the sense of forward movement. If the camera gains on the object a curious feeling that it is moving backwards, despite its obvious forward progress against the background, will detract from the effectiveness of the shot.

Overlapping Action

Remembering once again the requirements of the editor, it is important to provide at the shooting stage plenty of opportunity for the shots to be assembled smoothly. When scenes are under the director's control it is normal practice, before switching off the camera, to allow the action to proceed somewhat beyond the point at which it is intended to cut. If the action is to continue in the next shot from another angle, the last portion of the action is now repeated at the beginning of the new shot. This allows the editor to select the precise point at which he will cut, and assists him in ensuring that the cut is smooth and the continuity accurate. The

103

smoothest cuts of all are often those made in the course of a move-ment. If a character is seen picking up an object in medium shot and he is then asked to repeat the action in the ensuing close-up, the editor can make his cut during the movement. This calls for care and some skill, but the result is a cut that is scarcely noticed. The best technique is that which passes unnoticed by the audience, who are left completely absorbed in the subject.

This kind of assembly calls for extreme accuracy in the shooting. The continuity from shot to shot must not be spoiled. A careful note of key actions must be kept, so that when the action is repeated and continued in the successive shot the movements are the same. It is surprising how many people will use one hand to carry out an action and then, when asked to repeat it, use the other. This happens even when they are carrying out some process with which they are very familiar. If this kind of inconsistency is not noticed and corrected at the time the film editor may be presented with an insoluble problem.

The "Cut-Away"

I have mentioned the important question of condensing time. So many events have to be presented on the screen in a fraction of the

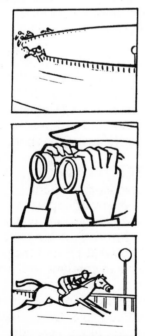

USE OF THE "CUT-AWAY". If we wish to shorten the time taken by a piece of action on the screen a "cut-away" is one way of dealing with the problem.

In the first scene the winning horse is some way from the winning post. If we insert a cut-away of a spectator it is now permissible to cut back to the horse again and find it almost at the post.

To have cut straight from the first scene to the third would have pro-duced a "jump cut" which would not be acceptable to an audience.

time that they take in real life. Here again the editor is in the hands of the director and cameraman. They must shoot in such a way that the action can be condensed smoothly in the assembly. One method already referred to is to provide cut-aways. An operator is, for instance, working on a process. Let us suppose that he is drilling a hole in a panel. The operation takes him, perhaps, half a minute. Now thirty seconds is a very short time in real life; but on the screen it can seem an eternity! There may be a dozen operations that must be presented in, say, a two-minute sequence in a technical film. We must condense time and yet we must see the beginning and end of the operation. The most obvious method to use is the cut-away. We see the drilling begin; we cut to a close-up of the operator's face; we cut back and find the drilling being completed. The audience will accept this without question – provided, of course, the amount we have cut out of the operation is not so great as to appear ridiculous. Or, instead of the close-up of the operator, we can cut away to another operator who is assisting with the job. There may be other alternatives. Perhaps some instrument is involved in the process and we can cut to its dial. But whatever cut-away we use it must be *relevant* to the operation we are watching.

Another method of condensing time is to allow the subject to move out of frame. Suppose an operator in a technical film has to walk across the room to press a switch and this is important to the sequence. If we film him moving the whole distance across the scene the result may be to prolong it excessively. If, on the other hand, we allow him to move out of frame at the end of the first shot, we are free to pick him up at any point in his subsequent action. We can cut to a shot of him already at the other side of the room about to operate the switch. Or we can cut to a close-up of the switch only, and see his hand enter the frame and operate it. This technique can be applied to sequences of all kinds and is a most useful device. It is equally possible to cut from the character to a new view in which he does not appear. Then, he enters the frame and carries out the next action. Once we have broken the continuous view of a piece of action the audience will accept such condensing of time.

All these devices must be at the director's fingertips. And the documentary cameraman, who may be called upon to shoot sequences on his own without direction, must know them too. In a feature film they would be incorporated in the script. In documentary work, even when the shooting is quite detailed, improvisations will frequently be necessary for one reason or another.

There is one more method of condensing time that is most useful,

and that is the use of what is known as "parallel action". If we can find some other aspect of our subject that is proceeding at the same time as the one we are filming, it may be possible to cut away to this and back again, to find the action more advanced. We may, for example, be telling the story of the building of a railway. The operation clearly takes a long time and if we condense it too obviously the result will be absurd. But if we can find two different aspects of the story and intercut them, we shall solve our problem. Suppose that bulldozers are clearing the ground way up ahead, while thirty miles back the platelayers are at work actually laying the rails. These two activities could be intercut very successfully. The start of rail-laying on one particularly interesting section could be shown, followed by a sequence showing the bulldozers smashing their way through the trees thirty miles in advance. Then we could return to find the rail-laying on the first section nearly completed.

Parallel action is, of course, basic movie technique. It was first used many years ago by people like D. W. Griffith in those exciting chase sequences that ended many a silent picture. Cutting from the pursued to the pursuers enabled much ground to be covered and much time to be condensed without any jumps in continuity being apparent to the audience.

We have strayed into the realm of script-writing and editing, whereas our prime consideration at this point is shooting. But the three are so interwoven that it is not really possible to talk of one without referring to the other two.

Breaking the Rules

Having now laid down a number of rules and conventions that should be observed in the directing, shooting and editing of factual films, I am going to repeat that they can, on occasions, all be broken. The aim of documentary films should be to present vividly some aspect of life and the world in which we live, and techniques should never be allowed to become standardized. One of the great joys of this kind of film making is that it embraces so many different kinds of subjects and offers the opportunity for so many entirely different styles of presentation. Every subject should be treated on its merits, and wherever an individual, original approach can be created it should be seized on, developed, and exploited. In doing this every rule in the book may be broken, and sometimes a far stronger, more forceful and imaginative film may result.

Let's consider some instances. An extremely interesting example was the American film *On the Bowery*, which dealt with New York

106

down-and-outs. The director achieved a startling degree of realism by having a loose idea of a story, and then getting the people to express this in front of the camera, using their own language. In other words, he gave them an idea and they expressed it in their own way. The material so created is halfway between the predictable and the unpredictable – the director has, as it were, a "semi-control" of his subjects, but he can obtain the maximum realism. In a film about people, the people should be human; their characters and feelings should get across as strongly as possible.

Another example of handling the unpredictable is the United Nations film *Out*, dealing with Hungarian refugees arriving in Austria at the time of the uprising in 1956. The producer, Thorold Dickinson, describes the treatment of the subject in this way:

"I believed that films like this should have a human, latently emotional content. The people should reveal themselves. The only way you can do this is by directly recording sound as well as image. But what are you going to do with the language when, as in this case, it is not your own, or that of the vast majority of the audience?

"I sent the cameraman with a sound man, as well as a writer to develop the story line, over to Austria. Back came a whole lot of rushes, synchronous, spoken in Hungarian. The various shots did not really fit together – they were intended to but, of course, in the rush of the moment and the fact that the Russians were always closing the frontier just before any sequence of this frontier crossing was finished, we had some pretty hyphenated material. We called it the 'dotted-line technique' – nothing ever joined anywhere. So we devised a system of putting the film together which, nevertheless, worked. It was rather like the sort of idea of the man who made *Breathless*, in which you don't have this exact matching of images from shot to shot because it is thought-continuity rather than a visual continuity.

"We first had to find out what on earth the people were saying in Hungarian. We got it all translated, and then chose the takes in which the Hungarian dialogue would flow. We were cutting without ourselves understanding what was said – merely assembling it on the strength of what the shorthand writers at United Nations had taken down off the screen and translated. In order to make this understandable to people other than Hungarians, we constructed our subject so that for a certain length of the film we were sharing the point of view of one character. We then chose a voice like the voice of this character – a Hungarian voice speaking broken English. He described 'sotto voce' to the audience what was going on in his mind and the minds of the other people, and this was superimposed on the dialogue, which went on in the background.

"And when some other character came in at a properly controlled moment, this other character would begin speaking – perhaps this time a woman, telling what *she* was going through. Then the other one would come back in again. This gave the whole film structure because, unconsciously, the audience changed its viewpoint from that of one character to another. And it was successful; so much so that nobody realized it was an innovation at all."

These examples should make it clear that the rules can be broken, and broken successfully. But it is nevertheless vitally important to know what the rules are. It is one thing to break rules for a carefully

calculated reason; it is quite another thing not to know that there are any rules at all!

Dope Sheets

It is obviously vitally important that a crew shooting on location bring back all the information that can possibly be collected regarding the material secured. This is more than ever necessary when scenes such as those we have been discussing – the kind that cannot be fully planned and are not completely under the director's control – are involved. But even when scenes are being shot that have been fully scripted, so that most of the information required for assembly and commentary is incorporated in the script, there may well be important details that should be recorded at the time of shooting for consideration later.

For this reason it is usual for the cameraman or an assistant to keep what are known as "dope sheets". These, in their simplest form, record what shots have been taken on each roll of film. If material is being shot on scenes where no detailed script has been prepared – as in the case where real-life incidents are being recorded – the more information that can be added the better; it will be invaluable when it comes to editing the scenes and writing the final commentary.

I can remember a particular incident when the subject being filmed was the building of a new railway through the African bush. This was the perfect example of a subject that cannot be scripted in *detail* in advance. The steel sleepers are flung down and manhandled into position. Gangs of men run with rails on their shoulders while others collect fish-plates, nuts and bolts and there is a sense of frenzied activity. Ballast is flung on to the portions of track *already laid* – this in itself seemed surprising to the uninitiated and would have certainly mystified the film editor; unless the whole procedure had been faithfully recorded on the cameraman's dope sheets, how would he have known the correct sequence of events, and how would the commentary writer have learned that this ballast-throwing operation is referred to rather picturesquely, in railway parlance, as "boxing the track"? The information obtained by the cameraman on the spot at the time is often quite impossible to get afterwards. Exactly where the scene was shot; the date on which it was shot; the names of the people appearing – if they are important to the story; technical data. It may be that *no one* can provide these facts – remember where the scene took place or who was in it – at a later date. And some of this information may be vital. Too much information is much better than too little.

108

An example of a cameraman's dope sheet may be of interest:

CAMERAMAN'S DOPE SHEET

2,450 ft. shot between May 15 and May 30, 1959
Film: Dar es Salaam – Gateway to Tanganyika[1]
Locations: Various as designated – Tanganyika (now Tanzania).
Date: May 15 : Kigoma.

Roll 18
 Various shots – activity on quay front. Steam cranes. Offloading cargo from lighters, etc., mostly skins and coffee.

 M/S flag (Belgian) flying over transit shed. Also C/U. Name of company (Belbase) on the side of office building.

 Last ½ roll; a road grader (destined for the Congo) is loaded on to a lighter by means of a large crane. (Belbase is the Customs Base through which goods pass for the Congo, having come without customs formalities through British East Africa from Dar es Salaam – a special arrangement.)

 End with various cut-aways of crew and foreman.

Roll 19
 Subject: Mpanda Minerals Corporation mine. The produce of this mine: lead and copper sulphide concentrate, finds its way to Dar es Salaam via the branch line from Mpanda to Tabora. The Company is a joint Anglo-American affair and likely to become more important as time goes on.

 Scenes: Two aerial views of the mine shot from an East African Airways Dakota.

 Several views of the hoisting gear and head frame.

 View from top of head looking down.

 "Skip" travelling up and down shaft. (The skip is a bucket-type affair which carries the ore from the base of the mine 1,000 feet below ground).

Roll 20. May 16. Location: Tanga.
 Subject: Scenes connected with Tanganyika's sisal industry.

 C/S bronze bust of Dr. Hindorf, founder of the sisal industry in East Africa.

 Sir Arthur Hutchings in his office telephoning (not synchronized).

 A sequence showing a meeting of the Port Committee presided over by the Harbour Master. There are shots (the fourth and fifth) of the Railway Chief in Tanga discussing a graph with the Station Master. This meeting is to plan the transport of the sisal crop from the plantations and its export through the port.

Roll 21. May 17. Location: Sisal Research Station at Mlingano.
 Experiments are shown in the laboratory. These experiments are made chiefly to determine the chemical composition of the soil. In the order in which they were taken, the shots depict the following:

 (1) Nitrogen determination. (Blue flask.)
 (2) Phosphate determination. (Grey box and jars in row.)
 (3) Measuring out red liquid. (For benefit of the cameraman and of no scientific importance!)
 (4) Spectrograph. (Small red flame.)
 (5) Phosphate extraction.

[1] Material for *Dar es Salaam – Gateway to Tanganyika*, a film produced by the East African Railways & Harbours Film Unit.

This dope sheet – which is genuine – is a good example of useful information, collected by a cameraman working single-handed on a varied assignment. He did not simply list his shots, but took quite a penetrating interest in the scenes he recorded, noting the purpose of the operations, the technical descriptions and terms, the names of the important people and the descriptions and ranks of others. Admittedly he did not list each shot separately – time would probably not permit this and, in any case, it is not essential. The editor will have them in front of him and will be quite able to identify them from the information given.

Exposing the Film

I have discussed the conventions of camera movement and other aspects of the cameraman's job that must be equally well understood and appreciated by the director. There are, of course, many aspects of camerawork that are solely the responsibility of the cameraman. Among these are such matters as the choice of filter and the calculation of exposure, both of which were referred to in some detail in Chapter 5. However, the question of exposure, although basically a matter of camera technique, sometimes assumes larger proportions and affects the whole question of camera angle. At this level it does impinge on the director's field of responsibility, because he must be able to appreciate the cameraman's problems when selecting his viewpoint.

For instance, the cameraman has to take into consideration the latitude of his filmstock. He cannot be expected to shoot a scene that is half in bright sunlight and half in deep shadow and achieve a good photographic result. The director must appreciate such a problem and be prepared to accept a camera set-up that keeps the lighting contrast within the latitude of the film being used. If the film is being shot in colour this may be quite a severe limitation. In the case of Eastman Colour (35 mm. and 16 mm.) or 16 mm. Ektachrome, the manufacturer's recommendation is that the lighting contrast should be kept to a maximum ratio of 4:1. That is to say, the brightest area in a scene should not be more than two stops brighter than the darkest area – and if the ratio can be kept down to 3:1 the results will be even better.

It is worth noting in passing that for colour television it is recommended that the contrast ratio should be restricted to as little as 2:1.

In practice, the restricted latitude of colour filmstock means that if a character is called upon to walk from bright sunshine on to a shaded veranda, this action is much better covered by two shots

rather than one. So we find, once again, that even in such matters as exposure we cannot divide the duties of director and cameraman into watertight compartments; each must appreciate the problems of the other. In the case of black-and-white film, the limitations are nothing like so severe. Even so, lighting contrast is something to be carefully studied and kept within the range of the filmstock being used.

Similarly, the direction of the light has to be carefully borne in mind when deciding camera set-ups. In the case of black-and-white, cross-lighting and back-lighting can be extremely pleasant; indeed, filming with the sun directly behind the camera is in most cases best avoided. In the case of colour, the situation is very different. Side-lighting to produce moulding and emphasize contours is very desirable, but safe only if the shadows remain within the range of the film. Once again, the director has to appreciate the problems of the cameraman.

Artificial lights to aid outdoor shooting are commonly employed in the feature film field. In documentary production, speed of work, smaller budgets and frequently more remote locations make such a practice much less common. The use of reflectors, however, for filling in shadows, particularly for colour filming, is very much to be recommended.

Choice of Lens

The choice of lens of a particular focal length is not only a matter of covering, most conveniently, the field of view that is required. Obviously, to embrace a broad view a short-focal length lens is necessary. But lenses of different focal lengths also produce a different perspective effect. It is useful to bear in mind that a wide-angle, short-focal-length lens makes an object that is travelling towards or away from the camera appear to be moving much faster; while a long-focal-length lens makes it appear to be moving more slowly. To secure a dramatic shot of a car or train approaching and passing the camera a greater sensation of speed is obtained by using a wide-angle lens, therefore.

Again, a wide-angle lens has a greater depth of field than a long-focus one. Where a deep-focus effect is required, and objects in the foreground as well as those much farther away must be rendered sharply, a short-focus lens will greatly assist.

Camera Angle and Viewpoint

Composition is something that has to be "felt" rather than taught and to refer to the basic rules of picture composition would be to

111

return to elementary principles. Nevertheless, it is worth emphasizing that the composition of every shot in a film contributes something to the impact and effectiveness of the film as a whole. Filling the frame with significant patterns, taking advantage of an interesting foreground object, varying the angle and looking from below and above; all these help to bring the screen to life. There is an old maxim, "It is the close ups that tell the story", that is worth keeping in mind. Too many long shots and medium close ups that do not come to grips with the subject can make a film seem remote and impersonal.

Of course, when filming for television, a higher proportion of close ups is demanded, even in these days of larger television screens. But in all films, plenty of close-ups of relevant detail and points of interest are desirable.

It is all too easy to get in the habit of taking shots from eye level, and it is certainly much less trouble to do so. But the question of the height of the camera should constantly be considered and if a low or high angle will strengthen the composition or emphasize the subject it should be adopted. For high-angle shots, a vehicle with a platform on top that will accommodate the camera and the cameraman is a most useful asset.

Use of the Tripod

There is one very basic practical question that has not yet been mentioned. When is it permissible to dispense with a tripod and film with camera in the hand? This may sound an elementary matter, but it is, in fact, deserving of considerable thought. Many modern cameras are very well designed for hand holding; 16 mm. cameras are in most cases particularly portable. If a camera can be easily operated in the hand, is there a very great virtue in using a tripod?

The answer is that, however light and manageable a motion-picture camera may be, the use of a tripod on every occasion where it is possible is strongly recommended. When the magnified picture is thrown on the screen the slightest unsteadiness becomes clearly apparent. However steady the camera may appear to be to the operator looking through the viewfinder, movement is almost always apparent to the audience. This is particularly true when static objects are being filmed, or when a large area is included in the field of view. The only exceptions are those comparatively rare occasions when the frame is more or less filled with moving people; a crowd scene, or a group walking quickly, may well disguise any small movements of a hand-held camera.

112

If you feel any doubt on this point, a test will quickly provide the necessary evidence. Shots of the same scene, taken from a tripod and then with a hand-held camera, when compared on the screen, will show how much more pleasant and restful to the eye the former are. Careful analysis will show, too, that definition is better when the camera is operated from a rigid mount.

There is one further argument against the hand-held camera. When a camera is on a tripod, a scene can be much more carefully framed and the composition studied and discussed by director and cameraman. Small adjustments can be made and the best possible viewpoint and angle chosen.

Of course, this is not to say that there are not occasions when the hand-held camera is the best, and perhaps the only, answer. When you are faced with the need to secure a speedy coverage of incidents that are happening around you, and over which you have no control, there is often no option. If the use of a tripod will delay you and prevent your obtaining effective close-ups and a variety of angles, then it is much better to dispense with it.

Camera Jams

Occasionally film may jam in the camera. If there is any possibility that it has been torn or damaged in any way, it is vital that this fact be clearly marked on the box or can and brought to the notice of the processing laboratory. It is important to remember that many hundreds of feet of film are in the processing machine at any one time. Should the film break on its way through, all the film that is following it through the machine will, almost certainly, be ruined. However, if the processing laboratories are put on notice that the roll may be damaged, they will examine it and make any repairs that may be necessary. They will also hold back such a roll until the end of the day's work and put it through the machine last. Should it break, there will then be no subsequent rolls to share in the disaster, as would otherwise be the case. Marking any damaged roll is, therefore, a duty – not only to oneself but to one's fellow cameramen whose material might be next in line and suffer as well.

7

SHOOTING A DOCUMENTARY OVERSEAS

WHEN A FILM has to be produced away from base and in a foreign country a number of additional hazards inevitably arise. I am devoting a complete chapter to them because I have found from experience that they are quite often taken too lightly by those embarking on an overseas production for the first time. I have in mind not an assignment in a nearby country with weather similar to your own, but a trip to somewhere very distant and possibly remote, where the climate is likely to be extreme and the ways of the local people strange. Assignments to record such subjects as expeditions, primitive people and wild game are – particularly for television – by no means rare.

The success of the operation depends upon successfully getting back to base the whole of the footage shot. As the loss of even a small part of it may destroy the continuity – and as there will probably be no chance of retakes – every precaution that can be taken is therefore worthwhile.

If the budget is not too small to permit it, the first essential precaution is to duplicate all basic equipment. Two cameras, two tripods and two exposure meters will halve the chances of equipment failure ruining the project, though whether sound-recording equipment should also be duplicated depends upon how vital to the film live sound will be. I am not suggesting exact duplication, camera for camera. In fact, it may be better to take two different cameras, perhaps one battery driven and one spring driven, one an all-round versatile camera and the other smaller and more portable. In this way, the likelihood of having specially suitable equipment for particular jobs may be added to the security of doubling up.

If the film is of extreme importance and the travelling costs are very high, it may be worth considering doubling up on the filmstock as well. It will then be possible to shoot all the vital key scenes on *both* cameras. I have used this method myself and it has saved the

114

situation when some scenes, without which the whole film would have been incomplete, were spoiled through a defect over which there was no control. To make a difficult and important project as foolproof as possible, this system of duplication can be carried to its logical conclusion. Two *different* batches of filmstock are ordered from the manufacturer, who will usually be quite prepared to co-operate. One batch is then allocated exclusively to each camera. This will guard against the possibility of there being a manufacturing defect in the film – rare but occasionally met with – since it is against all the odds that the same defect will occur in two batches of film manufactured at different times. When a number of scenes have been shot, in duplicate, on the two cameras, a batch of exposed film from *one* camera only is air-freighted home. Not until news is received that this has arrived and been processed is its counterpart from the other camera dispatched. By thus removing the possibility of both batches being in transit at the same time, one greatly reduces the risk of both being lost. Furthermore, one ensures that they are not both in the processing bath at the same time, so reducing the danger of faulty processing ruining both sets of film.

Production Hazards to be Considered

Such extreme safety measures, of course, are taken only when the budget will stand the extra cost and when the importance of the job and expense of travelling to the location warrant it. But a moment's thought on the hazards that are faced in a production will make it clear that precautions will often be worthwhile. Take, for example, the possibility of loss during processing. Laboratories are staffed by careful people who take every practicable step to ensure the safety of the film in their hands. But it has to be remembered that in the average film-processing plant there may be some 700 ft. of film·

FILM PROCESSING. Cinematograph film is processed in a continuous processing plant which accommodates many hundreds of feet. The film passes over rollers from which it hangs down in long loops into the various chemical and rinsing baths 1, 2, 3 and 4 and then into the drying cabinet 5. In the case of reversal and colour film many more than four baths will be involved.

115

passing through at any one moment. It is conveyed over rollers from which it hangs down in long loops into chemical baths, the bottom of each loop being weighted. In this way the film moves up and down through the various baths, passing from the developer, to the hypo, and on to the fixing and washing baths – if it is colour film there will also be baths relating to each of the three colour layers, separated by stages of washing. Finally the film passes to the drying cabinet. If for any reason it breaks, all the film behind the break stops moving. Since one essential of the whole process is a steady, carefully timed movement from bath to bath, most of this film will be ruined – if the break occurs during the final stages, as much as 700 ft. may have to be written off. Although film is examined for damage before it enters the machine, not all damage can be detected, for, it must be remembered, the operators are working in almost complete darkness. For this reason, as we have seen, it is the duty of the cameraman to mark any roll that may have been damaged, by jamming or faulty loading, in the camera. The laboratory is then put on guard.

When you remember that all the film you ever expose is subject to these processing hazards, it is food for thought. Moreover, successful processing also depends upon chemicals being kept up to strength within very small margins, on the maintaining of a constant temperature within very narrow limits, on an absolutely steady speed of progress through the baths and on a high degree of cleanliness and freedom from dust. Laboratories of repute do a fine job in minimizing the risks inherent in their difficult job. Nevertheless, things must, on rare occasions, go wrong. And if you have travelled 10,000 miles to obtain your shots and you are the unlucky one, duplication on the lines I have suggested will certainly pay off.

In addition to risks during transit and processing, small blemishes at the time of shooting may ruin your film. It requires only a hair or a large piece of dirt or emulsion to stick in the camera gate for scenes to be quite unusable in a professional production. It is possible for lenses to fail to focus properly after being knocked in the course of travel, or for gate pressure plates to fail to maintain the right tension, so allowing the film to take up the wrong position in the focal plane. All these things have happened to me at one time or another during many years of filming in innumerable distant places! And then, not to be altogether discounted, there is the occasional lapse on the part of the cameraman who, however experienced, is only human and may be working under difficulties in strange surroundings in a severe climate.

116

I have painted a rather grim picture, but it is important to realize the many things that *can* go wrong and then arrange matters so that none of them do or, if they do, that you have something to fall back on.

Customs Requirements

Sometimes overlooked is the important question of making sure that your equipment and filmstock will be cleared by Customs whenever you cross a frontier. Amateurs on holiday are usually allowed to proceed with a minimum of formalities, provided that the amount of photographic gear that they are carrying is not abnormal. Few professional units will be so fortunate. It is almost impossible to do without the services of a shipping agent to prepare the necessary documents and make the necessary Customs entries. When you return to your country of origin you will be required, by Customs, to produce evidence that you took your equipment and filmstock out, particularly if much of it is of foreign manufacture. If you cannot produce such evidence you may be called upon to produce proof of purchase and payment of import duty – or pay duty again.

There is also the question of getting into and out of the countries you are visiting. Regulations differ greatly in different places. Some countries insist on the payment of a duty deposit equal to the duty that would have been charged on your equipment had it been a normal import, or some fraction of that duty. This deposit may be refundable in full when the equipment is taken out again – in some countries it is returned less a percentage. Other countries, again, will not refund the duty on any film that you have exposed within their frontiers. Yet another requirement met with is a request for a guarantee, backed by cash or the signature of a bank within that country, that the equipment will be re-exported at the end of your stay. If it is not re-exported for any reason – such as the theft of a camera, for instance – this sum of money or a proportion of it may be forfeited.

Your shipping agent will know about these regulations and warn you in advance what steps you must take, what funds you must be prepared to put down, and what documents you will require. As a proof that these hazards are real, I will mention that I still have a sum of some hundreds of pounds in "refundable" duty deposit owed to me by a certain eastern country, although it is five years since I went there to make a film. I am assured that it will be forthcoming – no doubt my heirs will benefit and wonder where the windfall came from!

117

To assist the shipping agent in his work it will be necessary to supply him with lists of all equipment and filmstock that is being taken. Whether he will require these lists in duplicate, triplicate, or by the dozen will depend upon the regulations of the countries you are visiting. Generally speaking, the further east you go the greater the number!

Health Considerations

Insurance cover requires careful thought. If your equipment is insured for use anywhere in your own country, as is usually the case, an extension to cover overseas territories can easily be arranged. Consideration should be given to the losses that might arise from the incapacity of one member of the crew as a result, say, of illness or accident; it may be worthwhile to take out a policy covering the fares involved in sending out a replacement. Cover will also be desirable for personal accident and for sickness, personal baggage and so on. A policy covering the production as a whole, relating to the countries in which shooting will take place and including cover for loss of exposed film in transit, will be most desirable.

But prevention is better than compensation. Injections and vaccinations for the members of the crew should be checked up on in good time. If the destination is the tropics the injections called for by the country concerned, or by your own country upon your return, may be numerous. There are certain prophylactics against common tropical diseases that are worth inquiring about. Malaria and dysentery are two common complaints and both can be guarded against by taking tablets at regular intervals. If the schedule is a tight one it may be disastrous to have a key member of the crew laid up with such a thing as dysentery even for a few days. I can remember leaving my cameraman behind in a remote village in India, with an attack of dysentery, while I dashed on to our next location, wondering when and how he would catch me up again. He did, in fact, join me a few days later a hundred miles farther on, clutching a large bottle of tablets that he assured me would ward off all future attacks. Fortunately they seemed to work!

Dispatching Rushes

It is always advisable to get exposed stock home for processing as soon as possible. If airports will be encountered en route, batches can be sent quite easily – the shipping agent will have provided RUSH labels for affixing to the exposed rushes, clearly marked UNPROCESSED EXPOSED FILM. Such batches will be taken care of by

118

his agents on arrival at the home airport, where he will no doubt have a regular arrangement for clearing them through Customs on your behalf. They may have to be sent to the laboratory "under bond", to be examined after processing by a Customs Officer before they are released. This procedure is necessary because Customs are unable to look inside the can when it arrives at the airport to ensure that it does not, in fact, contain dutiable wristwatches instead of film. Of course, exposed cans of film *do* occasionally get opened and fogged by zealous Customs officials. This is just another hazard of overseas shooting which has, like everything else, happened to me!

It is a good idea to cable your shipping agent to advise him that a consignment is on the way, quoting the footage and type of film so that he can prepare the necessary documents and have knowledge of the amount of film inside the package to facilitate speedy clearance. Naturally, arrangements should be made for the film, after processing, to be examined as soon as possible by technicians at home; they will then cable you a report giving an O.K. or advice concerning the defects to guide you in further shooting.

Safeguards Against Tropical Conditions

If you are shooting in the tropics, precautions are necessary as regards both film and equipment. The following is a summary of the advice given by manufacturers:

Tropical climatic conditions are of two main types; the first is characterized by high and widely varying temperatures accompanied by low humidity, in the case of dry seasons or desert regions; the second occurs in rainy seasons and is characterized by very high humidity with temperatures which do not rise often above 95°F.

Equipment. Keep apparatus dry and as clean as possible.

Treat leather parts with wax polish, keep metal parts lightly greased and clean the lens surfaces frequently.

Avoid leaving apparatus in the sun unnecessarily, especially if it contains sensitized material.

Film. If sensitized materials are ordered from suppliers in temperate climates, specify that they are for tropical use so that they can be chosen and packed suitably, preferably in as small units as possible.

Keep in the manufacturers' containers as long as possible. Once open, use the contents quickly or, alternatively, dry out the residue and re-seal the container.

At all times keep the film as cool and dry as possible and avoid sudden temperature variations. Where cooling facilities are available, keep below 60°F – ideal relative humidity 40 to 60 per cent. Under difficult conditions, at least try to keep storage temperature below 90°F if possible and avoid damp. Prolonged holding at 100°F is very undesirable.

If the temperature is continually as high as 120°F, film cannot be depended

119

upon to survive more than a few weeks. In general the higher the humidity the more rapid the deterioration.

Develop as soon after exposure as possible. If delay is unavoidable, take just as much care of the exposed material as of the unexposed – keep in dry containers and keep it cool.

There are some other points to be borne in mind. Allowing a camera to become very hot may not only spoil any film it contains, but also tend to soften the lens cement. Rapid cooling, or jarring, may cause what is known as "starring" of the lens and this can be cured only by the manufacturer. The best remedy is to keep the camera in its case, as far as possible, whenever it is not in use. A white slip-over cover for the camera case, with non-corrodible metal fastenings, is helpful when working in places where there is very little shade.

Lenses are more likely to be contaminated with airborne grit under tropical conditions. Their surfaces should be kept covered by a lens cap when they are not in use; in use, they should be protected by a filter, or by a piece of plain optical glass when no filter is called for.

Fine dust, silt or sand will penetrate through any small openings there may be in the camera. This is particularly harmful to the shutter and diaphragm mechanisms. One way of minimizing this is to cover any cracks or openings, where this is practicable, with pressure-sensitive tape.

Problems of Extreme Humidity

As regards film, it is clear that the greatest danger is after the airtight seals have been broken. Film that has been exposed in conditions of great humidity can be dried by repacking it in *dried* black photographic paper and re-sealing it in its metal can with two turns of adhesive tape around the lid joint. Only *black photographic* paper should be allowed to come into direct contact with the film, since ordinary papers contain chemicals that may attack the emulsion. This black paper should be dried in an oven or over a fire, used at once, and re-dried on subsequent days if conditions continue to be bad. Packing around the film as large a mass of dried-out cellulose material as possible will help to keep it dry. Readily available cellulose materials include newspapers, hay and straw, which will do the job perfectly well.

But a much more effective drying agent is a crystalline chemical desiccant known as silica gel. One or two pounds are necessary to dry 1,000 ft. of 35 mm. film (or 2,500 ft. of 16 mm. film) completely satur-

ated with water. This is an extreme case, however, and generally speaking a lesser quantity will suffice. Silica gel should be dried before use by heating to 400°F, and then cooled in a closed container. A convenient device to use it in can be made up by soldering two film cans bottom to bottom and then making perforations between them. The silica gel can be dried and re-dried and used repeatedly. In cases of emergency, where conditions of extreme humidity occur and silica gel has not been provided, it is worth remembering that there are other common substances that will serve as quite good desiccating agents. Rice, dried by heating to a faint brown, or dried tea leaves, are two useful substitutes worth keeping in mind.

One more point should be remembered. Film that has become moist should never be sealed, or even partially sealed, in cans. This may cause worse damage than leaving it unsealed. A sudden drop in temperature may result in the condensation of droplets of moisture, which may cause a mottle to develop.

While heat and humidity are the worst enemies, cold climates can also present problems. Generally, however, the cold has to be extreme to call for special precautions. When filming at high altitudes or in Arctic regions, temperatures may be encountered that are sufficiently low to interfere with the proper running of the camera. The film transport mechanism may falter due to thickening or even freezing of lubricants. The advice of the camera manufacturer as to the best method of lubrication should be sought before visiting such locations. Film may become brittle. Manufacturers of both equipment and filmstock will be ready to offer advice and, if extreme conditions are expected to be met, whether they are hot or cold, such advice should be sought well before the time of departure.

Budgeting a Film Overseas

When it comes to costing a film that is to be produced abroad there is a little more to it than merely adding to the usual items the anticipated cost of travel. Additional insurance cover has to be provided; the charges of your shipping agent have to be met; if you are flying, it is probable that you will incur quite heavy charges for excess baggage. The possibility of Customs duties being levied on some or all of your filmstock, and perhaps on your equipment as well, has to be borne in mind. There will be the cost of sending home "rushes" – your exposed camera film – probably by air. There may be numerous cables; the crew may require special clothing. You will probably expose more stock than on a comparable film at home, either because you duplicate essential scenes as a precaution

121

or merely because you are conscious of the fact that you have much further to come should retakes be necessary. By and large, the risks are greater and the hazards more numerous and therefore the item in the budget for contingencies should be higher.

If the film is for a client, it may be better to quote him separately for travel costs. If you quote a lump sum, travel included, you will have to allow yourself quite a large margin to make sure that all the possible travel costs are covered, including those items – such as excess baggage and freight charges – that you cannot easily estimate in advance. In quoting a lump sum high enough to cover yourself, you may price yourself out of the market. Most clients take the view that a charge for the production of the film, plus a separate charge for travel, freight and living expenses at net cost, is a very fair way to approach the matter. Naturally they will expect you to provide them with an estimate of the travel costs to guide them and the figure you quote must be reasonably accurate. It is psychologically better to quote slightly high so that the final figure is likely to be less rather than more.

One of the most difficult aspects of costing films to be shot overseas is that of estimating the time likely to be required for shooting. How long will the work take on this location or that? How long will the travel from one place to another really take? How long will it take to make contact with the local people and get the co-operation of the particular types that the script calls for? How much will unfavourable weather delay you? There are so many imponderables, difficult enough to answer if the budget and timetable allows you to visit the locations first to reconnoitre and plan, almost impossible to answer if not. Yet time is usually the most costly item in the budget. Some sort of reasonably accurate answer must be arrived at; experience is the best guide. If you have, as yet, no experience to fall back on, think of every likely contingency, allow time for every item that comes to mind, and then add a sizeable percentage for unseen delays of all kinds. Discuss your results with the crew assigned to the job. Unless they feel from the start that the programme is realistic you will not obtain their willing co-operation – and without this, success is one large step further removed. Good films can be made only by dedicated and personally involved crews. You cannot *order* a man to go away and make a good film. You must arouse and retain his enthusiasm for the project on hand.

8

LIGHTING ON LOCATION

THE FEATURE FILM PRODUCER shoots the majority of his interiors in a studio equipped with lighting systems designed to meet all his requirements. A considerable proportion of the lighting is placed high up on galleries and suspended from the roof. Such systems are flexible. Large amounts of electric power are available, so that even when colour is being used it is possible to light a large scene with a margin to spare. The documentary producer is often in a very different position. Shooting as he so often is on location, inside buildings that do not lend themselves to the placing of numbers of large lamps where they are most required, and with problems of obtaining adequate power supplies, he may have many serious difficulties to contend with. The snags inherent in lighting buildings already crowded with fixtures, machinery or furniture, perhaps with low ceilings and no means of raising lamps above floor-level, will be with him whatever his budget.

Four Types of Lighting

There are four basic types of lighting in use for photographic purposes today. The first is the normal tungsten lamp – ordinary filament-type electric lamps which may be anything between 250 watts and 10,000 watts. The second type is the overrun filament lamp. This has been on the market for amateur use for many years as the Photoflood, small but emitting a very bright light for a few hours only – after which it burns out. A variation of this has been evolved for professional use whereby overrun lamps of a more powerful kind are fed through a transformer with a number of tappings which enable a progressively higher voltage to be applied. Because the lamps are brought up to full intensity in stages they last longer. The third type is the arc, producing an intense light by passing a current across the gap between two carbon rods. This type of lighting is very powerful, but it requires a high amperage of

123

BASIC LIGHTING PRINCIPLES. A subject should normally be lit from three directions: The subject 1 is being filmed from a camera positioned at 2. He is being lit from the front by a general flood 3, from one side by means of a strong key light 4 to cast shadows and add moulding, and by a backlight, 5 placed high up, to make him appear to stand out from the background.

To produce a normal effect, the three lights should all fall upon the subject from above, at an angle of roughly 45 degrees. In everdyay life we see people illuminated from this angle much more often than not.

Lamps should not be below the level of the subject unless a special effect is required.

the direct-current type at a comparatively low voltage. In other words, it cannot be run direct from the normal electric mains and a special generator is usually called for. The fourth type is the tungsten-halogen lamp, an extremely bright but very small unit providing more light for a given bulk than any other kind of lighting.

Which of the four types is used for a particular job depends upon the area to be lit, the manpower available, the budget and whether there is a need for portability.

One of the greatest difficulties encountered when working with lights on location is how to place the lights where they will be most effective. The art of lighting consists, basically speaking, in illuminating the subject from three directions:

(1) Light from the front to provide an overall level of flat light.

(2) A strong light from *one* side (often referred to as a key light) to cast shadows and thereby emphasize shape and moulding.

(3) Light from behind the subject (back-lighting). This tends to make the subject stand out from the background and, by emphasizing the various planes, suggests the third dimension. In other words, back-lighting gives a scene depth.

124

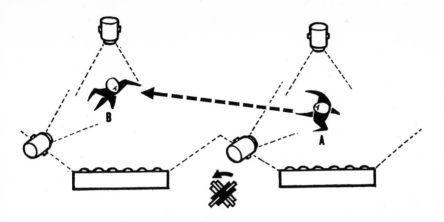

LIGHTING THE MOVING SUBJECT. In motion-picture-work the subject will, of course, frequently be called upon to move about. It is almost impossible to arrange the lighting so that it will be equally pleasing all over the scene. The most practical answer is to compromise by providing certain areas, A and B in this example, within which the lighting is effective, and plan the action so that the subject carries out as much of the business as possible in one or other of these areas. Only when passing briefly from one to the other is the subject not properly lit.

It is usually fairly simple, even on quite small and crowded interiors, to provide (1) and (2), i.e. frontal and side lighting. The great problem is to provide the third ingredient, back-lighting. It is fortunate indeed if there is a means of placing lamps high up at the rear of the scene. Even if this can be done there may be a further difficulty in keeping them out of view of the camera. In most studios it is possible, by means of a gallery or suspension from the roof, to have lamps that direct light from high above the back wall of the set. On location, however, back lighting must usually be limited to placing lamps just outside the field of view at either side, as high as circumstances permit. If the area to be filmed is a small one and the amount of light required, therefore, not too great, lighting units that will extend to a considerable height may solve the problem quite well. But the larger the scene to be lit the greater the problem. The power of the back lights must be quite large in proportion to the front and side lights and this may mean that several units are called for if the back lighting is to have any appreciable effect.

This brings us to how much light is required to illuminate a given area. There is no simple answer to this question, because it obviously depends upon the speed of the film being used and the reflective properties of the walls and ceiling. But while the total light

power required cannot be quoted, it is possible to suggest the relative power required for the three types of lighting. As a very rough guide, the amount of light required for adequate back lighting will probably be at least half the power of that being used for frontal lighting. The side, or accent, light also must be at least half the power of the frontal lighting to be effective. In other words, if 20 kilowatts are required to provide a frontal lighting that will give an adequate exposure, at least 10 kilowatts will be needed for back lighting and a further 10 kilowatts for side lighting. This is a very rough guide only, because it naturally depends upon the effect to be obtained.

Lighting Contrast

Closely related to the question of how much light is required for a given interior is that of lighting contrast. Just as, when filming out of doors, the range between the brightest area of a scene and the darkest must not be too great for the latitude of the film, so must the same precaution be taken with artificial light. Sufficient light must obviously reach the darkest areas to enable important detail there to be recorded.

With colour film this becomes a major problem. As we have seen, for 35 mm. and 16 mm. Eastman Colour and 16 mm. Ektachrome Commercial, the maximum contrast ratio recommended is 4 : 1, except where a special effect is desired. If the ratio can be kept as low as 3 : 1 or even 2 : 1, the quality of the colour prints that we shall obtain will be better still – and it is our end product, a colour *print*, that we must always have in mind.

This means, in practice, going carefully over the scene with an exposure meter and moving the lights until the darkest area does not give a reading less than about $1\frac{1}{2}$ stops lower than the brightest area. To give an example, with a normal motion-picture camera running at the sound speed of twenty-four frames per second, and with a shutter speed of approximately 1/50th of a second, a meter reading of 800 foot-candles will suggest an aperture of f5.6 with Eastman Colour. If this is the reading obtained from the brightest area in the picture, the darkest area should give a reading of not less than 300 foot-candles. These 300 foot-candles will be equivalent to an aperture setting of f3.5 – and the range between f3.5 and f5.6 is approximately 3 : 1.

In practice this is quite difficult to achieve, for it calls for a very consistent level of illumination over the whole scene. This is one of the reasons why so much more light is required to illuminate a scene adequately for colour than for black-and-white. Naturally, in the

126

case of black-and-white film, with its far greater latitude, a considerably greater contrast range is permissible – 30:1 or more would be quite acceptable.

Use of Reflectors

Reflectors can be used to assist the even spread of the light required for colour filming. As in the case of exterior work, white or aluminium-surfaced reflectors can be extremely helpful. Indoors, however, the best reflectors of all are often the walls and ceiling. If the set or interior is being specially prepared for the film, light walls and ceiling will help very considerably in the even distribution of the light. Strong colours should be avoided, as these may produce a colour cast over the whole scene.

Unfortunately, the documentary producer frequently has no choice and must film in whatever surroundings he finds himself. I can remember the feeling of despair that descended upon me and my crew when we found that a large training school in which we had to shoot the greater proportion of a colour film had just been newly painted, with walls of a deep and gloomy green! Nothing we could do would persuade those responsible to start all over again with some pleasant pastel shade.

Light Units and Their Use

Light units can be divided into three main classifications:

1. FLOODS: providing non-directional light.
2. SPOTLIGHTS: highly directional, providing a narrow focused beam to pick out and illuminate a small area.
3. FOCUSING FLOODS: a compromise between floods and spotlights. These lamps are directional and the beam can be varied – at its widest it will flood a fairly large area. At its narrowest it will illuminate quite a small area.

For much documentary work the most useful and versatile of these three is the focusing flood. Because it is directional the light can be placed where it is required. It is one thing to illuminate the subject or centre of interest properly, but it is often more difficult on location to make sure that the area behind it is not underlit. The focusing floods will throw light to the back of the scene. And not only is the width of beam variable; these lamps can be fitted with what is known as a "barn door" – two hinged flaps, one each side of the projecting lens, which allow the light to be masked off from either side, thus limiting when desirable the area that is illuminated.

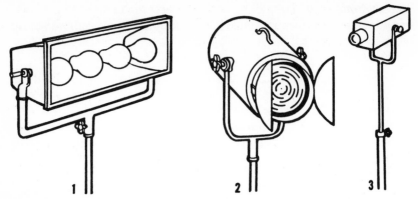

THE THREE BASIC TYPES OF LIGHTING UNIT.
1. Floods: non-directional units consisting of one or more lamps giving a flat light over a broad area.
2. Focusing floods: directional lighting units fitted with a focusing device enabling the width of the beam to be varied to flood a fairly wide area or concentrate on a small portion of the scene only. Normally available in 500 Watt, 2kW., 5kW, or 10kW sizes, they may be fitted with hinged flaps known as "barn doors" to cut off part of the beam when required. Perhaps the most popular and versatile of all standard type lighting units.
3. Spot-lamps: highly directional units providing a thin pencil of light for picking out shadow details and illuminating very small areas.

Ordinary floods have their uses, of course, but as they are non-directional their main function is frontal lighting. Not being focused, the light falls off in intensity more quickly, obeying the "square law": at twice the distance the intensity is only one quarter, and so on. It is essential to use focusing floods as well, to throw light on to those parts of the scene not reached adequately by the floods. In practice, both the side lighting and the back lighting are normally provided by focusing floods. Spotlights have only a limited use in documentary work.

Unfortunately, the focusing flood is a fairly large and heavy piece of equipment. The 2,000-watt type is reasonably portable, but the 5- and 10-kilowatt versions are not very easy pieces of equipment to manoeuvre around a location. But manufacturers are now introducing light alloys into their construction and so the type of unit that requires two men to handle it may become a thing of the past.

With this type of lighting, the power required for a big area is comparatively large. For instance, 25 kilowatts of ordinary tungsten filament lighting will not go very far on an industrial location. For such a set of lamps you may well find current available on the premises. But once you reach 50 or 100 kilowatts the problem of getting sufficient power from the local supply becomes considerable.

Factories and other large plants may be able to cope, but there are many locations on which the factual film maker may find himself – living-rooms, offices, laboratories, schools, museums, for instance – where real difficulty may be encountered.

Overrun Photographic Lamps

For this reason the overrun types of lamp are very useful. A power of 25 kilowatts applied to overrun lamps may well produce the equivalent in light value of two to two and half times as much power in ordinary lamps. However, the smaller Photoflood types so popular in amateur photography have a limitation. Most of them are non-directional, so that while they illuminate the area immediately in front of them very brightly the brilliance falls off rapidly for subjects further from the camera. The types with built-in reflectors are better in this respect, but their power is still rather low for most motion-picture work. Fortunately, the new units now available, such as Colortran, give a light output equivalent to 5,000 watts from a single bulb. Moreover, built-in reflectors project the light where it is required in much the same way as the focusing floods we have already discussed. So far these units are not made with variable focusing, it being necessary to change the bulb to produce a beam of a different angle.

Tungsten-halogen Lamps

Tungsten-halogen lamps are available in a variety of wattages. Most have a colour temperature similar to that of overrun lamps and somewhat higher than normal tungsten lamps. Care must be taken not to touch the lamps themselves even when cold as perspiration from the fingers will cause damage when the lamp is switched on. Models are available with reflectors and in some cases the width of the beam can be varied.

The Problems of Mixed Light

Daylight entering through windows, skylights and doors often creates a problem on location for, though present, it is not strong enough to film by. Artificial light must therefore be brought in, but the daylight cannot be excluded, perhaps because windows are visible in the picture or skylights are too high or too numerous to be blacked out. With black-and-white film the problem is not so serious as with colour. The best answer, in the case of black-and-white, is to accept the daylight and balance it with artificial light.

129

Daylight coming in from a window and illuminating one side of a scene can be balanced by using artificial lights to produce an equal or proportionate brilliance over the rest of the scene. If the window is in the back wall of the scene the problem is rather greater, but it may still be possible to use a lot of light near the camera to balance it and make use of the daylight as a form of back light.

In colour work, coping with mixed light is much more difficult. Daylight calls for colour film that is balanced for it and artificial light calls for a film with an altogether different colour balance. When the two forms of light are present in a location, what is the cameraman to do?

The simple answer is that he must try to shoot by one kind only. If the daylight is insufficient he must seek ways of excluding it and shoot by artificial light alone. But this may not always be possible. It may not be practicable to black out all the windows; if the location is the interior of a very large building there may be many skylights that cannot be covered. One remedy is to use arc lights to supplement the daylight. Arcs give out a light that is not far removed in colour balance from daylight and the two can be mixed to give quite satisfactory results. But arcs, as we have seen, are large

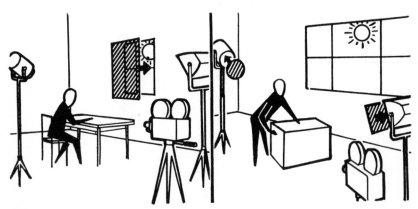

DEALING WITH MIXED DAYLIGHT AND ARTIFICIAL LIGHT IN COLOUR FILMING.
When daylight is present on an interior scene it is rarely strong enough to permit filming without the addition of artificial light as well. This creates a serious problem since colour film may be balanced for one or the other, but will not produce a natural rendering of both in the same picture. There are two possible solutions.
 Left: If the windows are covered with large sheets of gelatin (such as Kodak W.F. Orange Filter) enough of the blue in the daylight will be filtered out to make it blend with the artificial light.
 Right: If the windows are too large or inaccessible for this treatment, blue filters may be placed over the lamps to make them blend with the daylight. Daylight-type film (or film filtered for daylight) must, of course, be used. Another alternative is to use arc lighting, but this is likely to be expensive.

130

and unwieldy. They call for more manpower to move and operate and they require heavy direct current at a comparatively low voltage, which usually involves a special generator. Lighting a large scene with arcs can be an expensive business. It is quite possible for the costs of providing adequate illumination for shooting one large scene in colour to reach several hundred pounds. This may be feasible in some large-budget documentaries, but for many films it cannot be considered.

Unfortunately, there is no wholly satisfactory alternative. Blue filters can be placed over filament lamps (and over tungsten-halogen lamps) to make them blend, more or less, with the daylight. But this appreciably reduces the effective light they emit. Large sheets of gelatine are available for fixing over windows to colour the daylight so that it will blend with the artificial light. This avoids the need for filters on the lamps, so preserving their efficiency, and where it can be done it is a very effective answer indeed. Kodak manufacture sheet material for this purpose, known as Kodak W.F. Orange Filter (Non-Photographic No. 558/13). It is supplied in large sheets up to 50 ft. \times 3½ ft. and converts daylight to approximately the same colour quality as a 3,200°K. tungsten lamp. But the physical problems involved in covering a large number of windows, and perhaps skylights as well, may rule out this solution on many locations.

Filming with Very Limited Light

At present, in fact, the lighting of large interiors for colour filming is full of difficulties. One fairly obvious way of dealing with the situation where the light available is less than the minimum needed to obtain an acceptable picture is to resort to "under-cranking". This term has persisted since the days when motion-picture cameras were hand cranked, and refers to the trick of running the camera slower than normal to increase the exposure time of each frame. Naturally, this is only permissible if there is no action in the scene, or if the speeding up of the action will be acceptable. If the camera will run at a speed as slow as twelve frames per second the equivalent of one extra stop will be obtained; if six frames can be attained this will be increased to two stops – equal to increasing the light power by four times. If there is no movement there is no reason why single frames should not be exposed if the camera has that facility, and a longer exposure can be obtained that way. Clearly this method has its limitations, but many a cameraman has got himself out of a tight corner by using it.

Occasionally it may be possible to provide another answer to the problem. If no movement is required in the scene one can take a colour transparency with a still camera and then film it. It is preferable to take something larger than 35 mm. – such as a 5 in. by 4 in. or even a 10 in. by 8 in. transparency. This can be placed over a piece of white translucent glass or Perspex, illuminated from behind, and then filmed for the time required. If the transparency is sufficiently large it may even be possible to pan or tilt the camera, so introducing a degree of movement that will often conceal the fact that a still has been used.

Today, fast colour films are available. While these greatly facilitate the shooting of large interiors or scenes in poor light, their grain tends to be noticeable, for the law that "the faster the film the coarser the grain" still applies. It is as well to bear in mind that both normal and fast colour films can be boosted in processing to produce results equivalent to a one-stop, or even a two-stop increase of speed. The grain is frequently less offensive after boosting a normal film than is the case with a fast film processed normally. The cameraman must be guided by experience here and must bear in mind that the results of boosting cannot be forecast with quite the same degree of certainty as with normal processing.

There are occasions when it is possible to muster only a restricted amount of light on a difficult location. It is surprising how much work can be done with a small unit held by the cameraman himself or by an assistant. Two tungsten-halogen lamps mounted side by side on a bar to make a single, light and portable unit will illuminate a group of two or three people quite adequately, even for colour filming. Such an outfit, provided with a long mains lead that can be trailed behind, can be used to secure close-up material quite effectively when manpower, time or available electricity supplies are limited.

Working on Remote Locations

For work on remote locations it is possible to get results with a bank of car headlamps. There are black-and-white films so fast today that quite a lot of work can be done with only a pair of headlamps. The modern very fast colour films make it possible to achieve some surprisingly good results this way in colour too. Such a lighting set-up is a last resort with colour, however, because it is unlikely that colour film can be easily balanced for it; for one thing, the colour temperature of the lamps will vary with the state of the batteries.

132

Unfortunately, batteries with a capacity large enough to supply several headlamps for more than a few minutes will be bulky and heavy – six 48-watt headlamps running off a 12-volt battery will draw 24 amps. Of course, if a vehicle can be brought to the location the engine can be left running to drive the dynamo and keep the batteries charged. But I have in mind those really remote locations which no vehicle can reach. There is a type of battery known as a "Nife" battery which, not being as heavy as a normal lead-acid accumulator, it may be possible to transport without a vehicle. With the aid of such batteries and a bank of four headlamps it has been possible to film for a few minutes scenes that could have been secured in no other way. I have in mind such things as ritual performed only at night by primitive people in a bush village. Sometimes scenes of this kind are so rare and interesting as to warrant these very special and rather desperate improvisations to secure them. What we need, perhaps, is a powerful repeating flashgun, coming on twenty-four times a second in synchronism with the motion-picture camera shutter. Even then, a large battery will still be required to provide the necessary power!

Happily, we can look forward to a steady increase in film speed to aid us in adequately lighting those scenes we have to secure on difficult and distant locations. It has been observed that the average speed of photographic emulsions has increased roughly one stop per decade. There are signs that this rate of progress is being increased in these days of intense technical progress. Nevertheless, for a long time yet, getting enough of the right kind of light in the right place will remain one of the challenges that the documentary cameraman has to meet.

Achieving Colour Balance with Artificial Lighting

I have referred to the problem of getting enough light assembled for interior shooting on location and to the problem of a mixture of artificial light and daylight. There are, of course, other problems to be contended with in attempting to secure interior scenes with a natural rendering of colour. The various types of lighting so far discussed do not all emit light of the same colour temperature. Artificial-light colour film is balanced for light of a particular colour temperature and if it is exposed under light differing from that temperature the colours will be distorted.

Both Eastman Colour negative and Ektachrome Commercial are balanced for use with tungsten lamps operating at a colour temperature of 3,200°K. This is the temperature of normal studio

133

tungsten lamps, and also of Photopearl or pearl photographic lamps. If either of these films are exposed by Photoflood lamps, which have a colour temperature of 3,400°K., a Wratten 81A filter is recommended. Arcs, on the other hand, give out light of a higher colour temperature, white flame carbon arcs being rated at 5,000°K. A Wratten 85 or 86A filter is recommended in the case of both Eastman Colour and Ektachrome motion-picture films.

A reasonable amount of latitude is permissible in practice and it is worth remembering that rather more latitude may be allowed in the case of Eastman Colour. This is because the final colour balancing can be done in the printing. Some correction for colour balance can be done in the case of Ektachrome, particularly if "colour corrected" prints are ordered, but since this is a reversal stock the amount of correction must be rather less than can be achieved in the case of a negative filmstock such as Eastman Colour.

As a general statement it can be said that it is usually more pleasing, if a deviation from the ideal is to be permitted, to produce a picture that is warmer in tone than the normal, rather than one that is colder.

9

SOUND RECORDING

ON STANDARD projection prints the sound recording appears as a very narrow track running the length of the reel and positioned alongside the picture. This sound track is produced photographically by printing from a negative and processing is done in the same way as, and simultaneously with, the picture. The negative image from which the sound track is made is known as a MASTER TRACK. This master track may be made from a direct recording, or from two or more recordings suitably mixed.

The master track is itself produced by an optical and photographic process, and hence this type of sound record is known as an OPTICAL TRACK. Making it involves the exposure of the photographic emulsion, on that part of the film allocated to the sound track, to a beam of light which is caused to fluctuate in accordance with the modulations of the sound being recorded. Several means can be adopted to make the light beam vary in this way. Sometimes the variations of sound-track exposure are effected by varying the intensity of a lamp, the rays of which are directed by an optical system on to the film as it passes through a gate; more often they are caused by varying the width of a slit through which the beam of a constant light source is made to pass, or by reflecting a light beam on to the film from an oscillating mirror, through a narrow constant-width slit.

But we need not concern ourselves with the precise technical details of these systems, but only with the practical applications of sound-recording methods. Some years ago the master track was made from one or more optical tracks. Today the initial sound recordings are almost invariably made on magnetic tracks from which, after mixing with other sound records, a final master magnetic track is produced. From this final magnetic track, an optical master is made, because, despite the widespread adoption of magnetic recording, the majority of 35 mm. and 16 mm. release

135

prints in circulation still have optical sound tracks. The principal reason for this is one of economics: optical tracks can be photographically transferred on to the projection print at the same time and in the same way as the picture. Thus the sound recording is both easily and cheaply duplicated in a single operation.

To provide magnetic tracks on projection prints, on the other hand, two additional processes are involved: that of "striping" the film with a band of magnetic recording medium, and then transferring the sound to the stripe. Magnetic sound recording and reproduction lend themselves well to amateur use, particularly in view of the fact that the amateur generally uses reversal filmstock; and for this reason there are a number of manufacturers who produce 16 mm. and 8 mm. projectors with facilities for both recording on and reproducing sound from magnetically striped film. It is also interesting to note that the British film industry proposes to discontinue the use of optical tracks on 35 mm. release prints during the next few years and to adopt magnetic tracks exclusively.

Although it is unlikely that optical tracks will be discarded on 16 mm. projection prints for a very long time, the introduction of magnetic systems has nevertheless revolutionized all sound-recording techniques in recent years. These new techniques have been an inestimable boon to the film producer – and particularly to the maker of documentaries.

Development of Sound-Recording Methods

Until the beginning of the 1950s portable sound-on-film recording equipment was costly, heavy and cumbersome, and had to be transported with great care to avoid damage to its delicate mechanism. Sound recorded optically on film, because it involved a photographic process, could not be played back until the film had been developed – the facility of hearing what had had been recorded immediately afterwards and thus having the opportunity to correct faults at once did not exist. Furthermore, every recording involved an expenditure in filmstock and processing – and mistakes or unsatisfactory recordings were thereby a dead loss. Recording on location was a luxury conferred only upon those fortunate producers who were favoured with liberal budgets. Stories are told of the famous documentary director, Humphrey Jennings, who was entrusted with the production of many wartime Ministry of Information films in Britain. His morale-boosting films, such as *Diary for Timothy*, were made at a very great expense and two complete

136

sound units in their mobile vans were kept continuously occupied recording those exciting natural sounds of Britain at war. The cost of these sound tracks must have been phenomenal. Few documentary units can have been allowed such expensive facilities for location work.

For the less-fortunate producer making his films on a restricted budget, the only alternative in those days was to record on discs. Considerable use was made of them and the quality of sound so obtained was surprisingly good. With suitable kinds of equipment it was possible to record dialogue synchronously with the camera. Such recordings were subsequently transferred to an optical track for laying, as the fitting of track to picture is called. But disc recordings – except, of course, for music, certain sound effects and "archival" material – find no place in professional film making today.

Magnetic Sound Recording

All these former methods of sound recording have been displaced by magnetic systems. To the film producer these offer the great advantage that he can immediately play back what he has recorded – and, if the recording is unsatisfactory, re-record at once, while the equipment, personnel, etc., are still on hand. The recording medium is not wasted: it can be used again and again without noticeable deterioration.

Both optical and magnetic equipments are, however, similar inasmuch as they require an electrical power source to operate them. In a studio or dubbing-room, this source can be obtained readily from the mains, but on location a portable generating set or some alternative power source is necessary. Manufacturers now produce extremely portable magnetic recorders, both the driving motors and transistorized recording and playback amplifiers being operated from small dry batteries or rechargeable cells. Some of these equipments are so small that they can be transported in a case no larger than a lady's handbag and in use they can be hung from a strap over the shoulder.

Problems of Synchronizing Magnetic Tape

One of the early objections to using magnetic tape for motion-picture work was the inaccurate synchronization of picture and sound. Mechanical and electrical interlocking devices between camera and recorder were designed, but these were partially

137

ineffective, because they could not always maintain the tape and picture film in exact register – partly because of slippage when the tape passed between the capstan and pinch roller, partly because of dimensional changes in the tape itself. Both slip and stretch could cause sufficient deviations to destroy satisfactory synchronization.

These difficulties were, however, overcome by the introduction of a pulse system, whereby electrical pulses created by the camera at short intervals of time are recorded on the tape. Standard types of

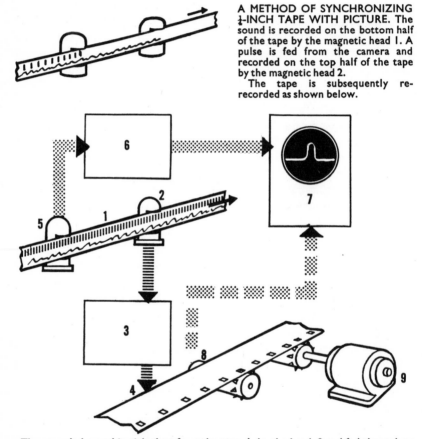

A METHOD OF SYNCHRONIZING ½-INCH TAPE WITH PICTURE. The sound is recorded on the bottom half of the tape by the magnetic head I. A pulse is fed from the camera and recorded on the top half of the tape by the magnetic head 2.
The tape is subsequently re-recorded as shown below.

The recorded sound is picked up from the tape, I, by the head, 2 and fed through an amplifier, 3 to be re-recorded on the magnetic film at 4.
The pulse is picked up by the head 5 and fed through an amplifier 6 to an oscilloscope 7. The frequency of this pulse is compared on the screen of the oscilloscope with another pulse produced by the movement of the film at 8. The speed of the electric motor, 9, driving the film, has merely to be varied until the two pulses are in step with one another for the re-recorded sound to be in step with the picture film to which it relates.
Certain systems based upon this principle are covered by patents.

magnetic tape are sufficiently wide to accommodate satisfactorily two (or more) tracks, and therefore it is possible to record sound on one track simultaneously with electrical pulses on the other. Subsequently these pulses can be used as a control to keep the magnetic tape strictly in step with the picture when the sound record is being transferred to the master track. Of course, when the popular, commercial type of tape recorder is used, it is necessary to have modifications made to provide for an additional head to record the pulses, but these modifications can easily be carried out by a competent sound engineer.

Where this form of pulse recording is used it is not necessary that the speeds of the film and of the tape shall be the same. For instance, whilst 16 mm. film speed is 7.2 in. per second, you can record the accompanying sound at the standard speed of $7\frac{1}{2}$ in. – or, indeed, 15 in. per second. The picture and sound can be reconciled subsequently by means of the pulses. Another useful point is that with camera-originating pulses, the speed of the camera need not be precisely constant, and thus spring-driven cameras can be used – at least for shots of short duration. A spring-driven camera inevitably slows down slightly as the spring unwinds, however well the governor may be designed. If this pulse system is employed, any camera-speed variation is recorded as a variation of the time intervals between the pulses, although there is a limit to the amount of change of speed that is acceptable. With speech and some sound effects an appreciable change, provided it is gradual and in one direction only during the shot, is not readily noticeable, but with music an unpleasant flattening or sharpening of tone (according to whether the sound track is running slower or quicker) is immediately discernible and is objectionable.

Another pulse-control system is based upon the use of an alternating electrical supply both to provide the pulses for the control track and to run a synchronous motor driving the camera. A mains A.C. supply is generally conveniently at hand for this purpose in studios and dubbing-rooms, but, of course, on location an A.C. generator or an equivalent power source has to be specially provided.

Pulse systems in one form or another are widely used today, and they have proved themselves to be both a ready and accurate means for securing synchronization, even when very portable equipment is used on location. But there has been a further and important forward step in the introduction of perforated film base which is entirely coated on one side with ferrous oxide similar to the coating on magnetic tape.

Perforated Magnetic Film

This magnetic film is perforated to the same dimensional standards as its equivalent motion-picture film. Consequently, by using in the camera and recorder sprockets turning at the same speed, the picture and sound are kept in accurate synchronism. The use of perforated magnetic film is being widely expanded, and standards already exist for such films in 35 mm., 16 mm. and 17.5 mm. widths (the latter being 35 mm. stock slit down the middle). Standards are now being prepared for 65 mm. and 70 mm. film, and at the other extreme for 8 mm.

When perforated magnetic film is used it is important that the camera and recorder sprockets shall turn at exactly the same speed. This can be achieved by using synchronous motors for each equipment. Thus a source of alternating current is required, because it is by means of the frequency of the alternations that the motors are kept in step. One must make sure that the motors are, in fact, synchronous: some manufacturers loosely and incorrectly use this term for induction motors which are unsuitable for synchronous and constant-speed operation.

The most satisfactory method of electrically locking the camera and recorder and of attaining a constant speed from the moment of switching on, is to use a Selsyn system by which the rotations of the shafts of the motors are kept in precise step with rotating magnetic fluxes set up in the stator windings. These windings require a three-phase alternating current to energize them; consequently, a three-phase mains supply or a special alternator or rotary convertor are required. Special motors must also be fitted to both camera and recorder. This system is somewhat costly and, because of its weight and bulk, is inconvenient for use on location.

Mixing Sound Tracks

The advantages of magnetic recording are not confined to those that have already been discussed; above all, perhaps, the outstanding advantage is its great flexibility combined with its high fidelity. With magnetic recordings many tracks can be mixed together to secure the desired results without any apparent degradation of the sound quality. The mixing of optical sound recordings, on the other hand, has severe limitations. When sound is recorded on a photographic film it is necessarily impaired by a high proportion of background noise, due in large measure to the size of the silver grains of which the photographic image of the sound is composed.

140

The average area of these grains is over thirty times that of the ferrous oxide elements of which the magnetic tape is made. The proportion of background noise present, compared with the level of the sound recorded, is known as the "signal-to-noise" ratio, and it is obviously desirable that this ratio shall be as high as possible; in other words, the sound reproduced should be heard without the background noise being disturbing.

When one track is being mixed with another the background noise of the first is added to that of the second; and thus when several tracks are mixed this cumulative effect can quickly become objectionable. In the case of 35 mm. films, optical tracks can be produced with a high enough signal-to-noise ratio for the mixing of a few tracks to be acceptable – indeed, the mixing of tracks to make a final master has been done successfully since the earliest days of the talkies. But optical tracks on 16 mm. film are an entirely different matter. The track on 16 mm. is narrower than on 35 mm., the area scanned by the reproducer head at any one instant of time is smaller, and the speed of the film past the head is much slower. Consequently, the signal-to-noise ratio is so low as to preclude the same degree of mixing if objectionable background noise is to be avoided.

The slower speed of travel of 16 mm. film past the scanning head – it is $2\frac{1}{2}$ times slower – produces another effect. Whereas with 35 mm. optical tracks it is possible to accommodate frequencies up to 7,000 or 8,000 cycles per second, it is difficult to record higher than 4,500 to 5,000 cycles per second on 16 mm. optical tracks. This means that the margins of acceptable quality are much narrower and any losses incurred in mixing two or more tracks will have a disproportionately adverse effect upon the master track. As a consequence, the mixing of 16 mm. optical tracks has never been accepted as a standard recording procedure.

These limitations have been swept away by the introduction of magnetic recording, and it is now possible to mix the sound for 16 mm. tracks with the same facility as with 35 mm., and without appreciable degradation of sound quality, and such mixing has become normal practice. Of course, the speed of the 16 mm. magnetic track past the reproducer head remains lower than that of 35 mm., with a consequent lower frequency response. This, however, need cause no concern, because it is possible to record on 16 mm. magnetic track up to 10,000 cycles per second. Indeed, the current British Standard specification for 16 mm. magnetic sound recording and reproduction corresponds with the C.C.I.R.

specification for recordings on magnetic tape used for programme interchange between broadcasting organizations – which is a very high standard.

Sound-track mixing is done mainly in the studio or dubbing-room, and almost never on location. Most motion-picture sound recording on location is made on equipment separate from the camera and is only linked to it on those occasions when synchronous sound is demanded. Nevertheless, it is good practice and a simplification of subsequent work if, when shooting on 35 mm. filmstock, 35 mm. or 17.5 mm. perforated magnetic film is used for recording, and when shooting on 16 mm. filmstock to use 16 mm. magnetic film.

Recording on Location

To many people approaching for the first time the task of making a sound film, the combined camera and recorder, which produces both the picture and sound on the same film, would seem to offer considerable advantages; but it is important fully to appreciate the limitations of such "single system" equipment. First, it must be realized that very few sound recordings are finally used in their original form. Corrections, cutting and mixing with other sounds are just as necessary as are the cutting and editing of the picture. Furthermore, the sound cannot be recorded immediately adjacent to the picture to which it is related. In the case of 35 mm. filmstock, the optical sound record is $19\frac{2}{3}$ frames in advance of the picture, and with 16 mm. stock the optical sound is twenty-six frames in advance. With magnetic recording on 35 mm. release prints, the sound record is twenty-eight frames behind the picture, but twenty-eight frames ahead on 16 mm. magnetic prints.

This picture-sound displacement arises because, even if there were room to fit the sound head alongside the picture gate, a length of film is necessary to absorb the intermittent movement of the film through the picture gate and permit a constant-speed travel of the film past the sound head.

But this displacement means that when we cut a film at the correct place as regards the picture, we are cutting it at the wrong place as regards the sound. There may be occasions when this does not matter – but there will certainly be very many when it does. In addition to this cutting difficulty, there is the frequent requirement of mixing this live recording with other sounds. We may wish to add background music, to add sound effects, or to superimpose the voice of a commentator. We may wish to mix to adjacent sections

142

of sound. None of these things can we do to a track as it stands alongside the picture. We can, of course, transfer the recording on to a separate magnetic track and then cut and mix as we wish, but in so doing we nullify the advantages we sought to gain in the first place. Such single-system cameras have their use only in special applications where speed is a primary requirement.

A useful compromise is available: for certain cameras small magnetic film recorders are available which can be mounted beneath or on the side of the camera and thus form an integral part of it. Since, however, the sound is recorded on a *separate* magnetic film, it does not suffer from the limitations of the normal single systems.

"Wild Recordings"

Despite the accuracy and flexibility with which cameras and sound recorders can now be linked, it remains far simpler to record non-synchronously – or "wild" as such recording is called. Wherever close synchronism with picture is not called for, therefore – and in many sound effects, for example, it is not – it is far more practical to record separately. Many background sounds, such as wind, sea, rushing water, crowd noise, traffic, etc., are much better recorded "wild" because, being more or less continuous, matching them to picture later presents very few problems. The mere fact that a separate recorder, not linked to the camera, is being used makes it possible to take a variety of recordings from different positions and under different conditions; the best of these can be selected afterwards and, if necessary, mixed to produce the desired effect.

There are many sounds, on the other hand, that are very difficult to record naturally and when they are subsequently played back they sound disappointing and unlike the real thing. Faking later, in the studio, may be the only answer. If there is doubt as to whether to record them on the spot or fake them afterwards, it is better to record the real thing provisionally – it will at least act as a "guide-track" later. Sound recordists are frequently asked why they prefer so often to fake sound rather than to record the real thing. They do it not because they are perverse people or a race naturally given to doing things the hard way. The reason is twofold: firstly, when recording particular sounds there are generally a great many unwanted sounds present that cannot be excluded; and secondly, due to the unsatisfactory acoustic conditions under which most location work is done, reverberation, echo and distortion are present in the sound recording. The consequence is that the sound subsequently

reproduced apparently bears very little relationship with the real thing.

Let me give an example. The sound of a ticking clock was required. The ticking had to be loud, to accompany the picture of the shadow of a pendulum moving across the screen, and there had to be no other sound audible at the same time. When the recordist made his recording the ticking did not sound loud enough. The gain on the amplifier was brought up, but when the clock was loud enough the general background noise and extraneous sounds in the room and outside were too loud. The microphone was then brought very close to the clock mechanism so that sufficient volume could be obtained without so much amplification. This eliminated the unpleasant background noise, but unfortunately, with the microphone now so close, the clock no longer sounded like a clock at all – it produced a metallic clang that was more like a blacksmith's hammer striking on his anvil!

Various other clocks were tried, but all with the same result. Someone then suggested that a metronome would probably provide the right answer, as it has a much louder tick than the average clock. A metronome was duly recorded, but when it was played with the picture someone said, to the sound recordist's extreme annoyance, "That clock sounds just like a metronome!" The reason it was so apparent was that a metronome produces a "tick tick" whereas a clock produces a "tick tock". A most convincing answer was eventually found by recording the metronome again with the recorder running faster than normal, producing a lower tone that sounded like a "tock". All the sound recordist had to do was to cut these "tocks" in to place alternately with the "ticks" he had already obtained to produce a "tick tock". The only trouble was that it was quite a long scene and eighty-six "tocks" were called for, each to be cut accurately in synchronism with the picture! Certainly not an easy answer, but one that produced the right effect in the end.

The Problems of Extraneous Sounds

In everyday life the human brain has the ability to differentiate between the many sounds falling upon the ear, and to select therefrom only those sounds which it wants to hear. Thus, one can follow a conversation in a crowded room or in a noisy bus, by rejecting from the consciousness all the irrelevant sounds. But when these many sounds are faithfully recorded and played back in different circumstances but at an appropriate volume level, it will be found that the brain will be unable to exercise its discriminatory ability.

144

This is a psycho-physiological phenomenon which is not fully understood, but it emphasizes the need for care in the type and quality of sound and sound effects to accompany the picture.

Extraneous noises are simply those which we do not wish to record and the desirable method of eliminating them is to stop them at their source. But this obvious remedy is very seldom practicable, and other steps have to be taken. The first of these is to overcome the ever-present problem of insulating the camera so that the noise of its mechanism is not picked up by the microphone. This is effected by enclosing it in a "blimp" – a box or cover thickly lined with sound-absorbent material. However carefully designed, a blimp makes a camera large and unwieldy and therefore difficult to move around. Fortunately what are known as "self-blimping" cameras are now available that run quietly enough to be used for synchronous recording without the need for the addition of a separate blimp.

Placing the Microphone for Synchronous Shooting

When recording on location it is desirable that the microphone be as near as possible to the person speaking or other source of wanted sound. So placed it will receive the voice at greatest volume, and at a proportionately higher level than the extraneous sounds. The golden rule is, the nearer the better. Unfortunately, one has generally to contend with the problem of keeping the microphone (and its shadow!) out of the field of the camera lens, and this usually results in a position for the microphone appreciably distant from the speaker. Thus the microphone picks up the required sound at a much lower level, and the extraneous sounds at a higher level. Occasionally, the microphone and its cable can, with ingenuity, be hidden behind an object in the scene. Sometimes, too, when the picture shot is comparatively close up, it is possible to erect a pair of screens and place them as near as possible on each side of the source of sound and the microphone. The screens should be six or seven feet in height, and constructed on a wooden frame and covered on both sides with sound-absorbent materials such as acoustic tiles, rock wool, carpeting or woollen blanketing. These screens can be effective in reducing the middle-to-high frequencies, but are ineffectual with low-frequency sounds.

Alternatively, one can collect sound from a more or less parallel beam and concentrate it at a microphone by using a metallic reflector. The reflector is parabolic in shape, about four feet in diameter, and the microphone is placed at its focal point and *facing its centre*.

Reflectors of this type have been used successfully in recording the songs of birds and similar sounds: they have the advantage that, if mounted on a swivel-top tripod, they can be turned to follow a moving source of sound.

A still more modern method of recording speech on location, and one which is now widely used in television, is to provide the speaker with a special sub-miniature microphone which can be secreted under the jacket collar. The microphone is connected to a small transistorized radio transmitter, carried in the breast or hip pocket. The equipment presents some difficulties with women, since their clothes do not usually contain such utilities, but no doubt with some ingenuity the difficulties can be overcome! The transmitter is of very low power and therefore has a small range. The transmitted signal is picked up by a nearby receiver and recorded and the quality of sound so produced is very good. In Britain a transmitting licence can be obtained fairly easily: indeed, the Postmaster-General has recently published a proposed specification for these equipments, to operate in the 174.6 – 175 Mc/s frequency band.

Problems with Acoustics on Location

Bad acoustics generally occur in enclosed spaces: if they occur in open air, they are the result of unwanted reflections from walls or solid surfaces.

Any surface against which a sound wave strikes will absorb some of the energy of the sound wave and will reflect what is left. The proportion of sound energy that is absorbed depends upon the nature of the material of the surface, its thickness and size, and also upon the frequency of the impinging sound. When a sound in an enclosed space is abruptly stopped the sound energy will continue to be reflected from surface to surface until it is entirely dissipated. Ideally, the sound energy in an enclosed space should decay smoothly and exponentially, but this is seldom achieved. Usually the decay is irregular, due to the fact that the lengths of the various paths travelled by the reflected sound waves are not the same. Where the lengths of the paths followed by two or more reflected paths are so different that the ear can differentiate between them, the reflections become echoes.

Except in special cases or for special effects, long reverberation periods should be avoided. They seriously impair the intelligibility of speech. It must be remembered that every cinema or hall in which the film will be shown has its own reverberation period which is additive to that on the sound recording.

The problems of extraneous noises and unsatisfactory acoustic conditions can be illustrated in one and the same example. In a film dealing with building methods it was necessary to introduce the sound of hammer blows as nails were being driven into ceiling board that was being fixed in position. Such percussive sounds are always difficult, and exact synchronism is essential, because the slightest error is instantly apparent when the film is projected. At first thought it would seem to be simpler to record picture and sound together, but this was not so. On a building site a great deal of noise is being made all around, most of it quite irrelevant to the picture being taken. Thus, had the sound been recorded on the site, instead of adding realism to the finished picture, it would merely have confused and annoyed the audience. Furthermore, the acoustic qualities of the half-constructed building, with its many hard reflecting surfaces, were extremely bad. Its reverberation time was probably six or more seconds, and the hammer blows produced a cavernous reverberation and echo which, on being recorded and subsequently played back, sounded rather like heavy thunder.

The only satisfactory answer was subsequently to fake the sound of the hammer blows in the studio. By doing so, no extraneous sounds were recorded. In adopting such methods, it is very important that sounds have what might be called the "same perspective" as the picture they accompany. If you are looking at a close-up of a nail being struck, it is natural to hear the sound as from close to – loudly and clearly – and it would be quite incongruous also to hear, say, the sound of carpenters' feet moving about on the floor, greatly magnified by the resonance of the hard surfaces nearby.

The fact that the one important and relevant sound satisfies an audience whereas the natural conglomeration of extraneous sounds does not, is something that should be borne in mind. In the example that I have given, only hammer blows were recorded on the track, although in real life a multitude of other sounds would also have been heard. But the film appeared quite natural, because it was concerned at the moment only with the insertion of nails. It would be foolish to attempt to lay down a hard-and-fast rule, but in general, and especially in the case of close-ups, the sounds recorded should be only those directly related to the picture being seen at the time and emanating from objects within the view of the camera.

Extraneous noises, if emanating from outside the picture area and *irrelevant*, are bound to be confusing. I said, however, "if irrelevant" – there may frequently be cases where a sound emanating from outside the picture *is* relevant and therefore worth having.

In certain contexts a sound such as wind, sea, or crowd noise may greatly add to the atmosphere and realism of a scene and link it to the mood or theme of the film. But this is rather a different matter and, in any case, such a sound would be better added afterwards, so that it would be under the recordist's control.

Assessing Acoustic Qualities

A rough indication of the acoustic quality of any room or enclosed space can be obtained by a single experiment. Set the microphone in the centre of the room and connect it to the recorder. At a distance of, say, 6 ft. from the microphone fire a toy cap-pistol. Subsequently measure the length of tape used to record the shot, and divide by the speed of the tape. The result will give an indication of the reverberation time;[1] if more than one shot is heard on play-back, objectionable echoes are present. By such a method you would find that at a recording speed of $7\frac{1}{2}$ in. per second, a tape length of about 8 in. is required to record the shot in an unfurnished room or corridor, but less than 3 in. is required in a fully furnished lounge. Generally, the larger the room or the fewer the soft-furnishings and carpeting, the longer will be the reverberation time.

The reverberation times for different kinds of recordings should, in general, be as follows:

Speech and dialogue	0.5 – 0.80 seconds
Solo instruments and duets	0.7 – 1.00 seconds
Quartets and small orchestras	0.8 – 1.25 seconds
Symphony orchestras	1.0 – 2.25 seconds
Organs	1.5 – 3.00 seconds

The reverberation time of an enclosed space can be controlled by suitable treatment. Soft materials such as cotton wool, felt and woollen curtains absorb high frequencies, with little effect on lower frequencies. Large panels of building board or plywood firmly fixed to wooden frames will absorb lower frequencies and, if covered with cotton wool or kapok, will absorb sound over a much wider frequency range. Alternatively, one can use membrane absorbers which consist of lidless boxes with felt stretched over and covering the top. The sound frequencies absorbed depend upon the depth of the boxes (which can vary between 6 in. and 2 ft. for general use) and the total absorption is, of course, dependent upon the number of boxes used.

[1] Reverberation time is the time taken for a sound, on its cessation at its source, to die away to inaudibility (i.e. its attenuation by 60dB.).

Particular difficulties can occur from standing waves and flutter echoes. Both arise from the presence of parallel wall and ceiling/floor surfaces; their intensity is a function of the hardness of the reflecting surfaces, and the frequencies at which they occur are related to the dimensions of the room. As far as possible such surfaces should be made non-parallel by the use of screens, or suitably treated to absorb the widest frequency range practicable. The microphone should be placed diagonally to, and as far as possible from, reflecting surfaces to avoid selective reinforcements of the sound, but at the same time the microphone should not be placed midway between parallel surfaces; otherwise, the recording of particular frequencies will either be abnormally high or abnormally low, according to the type of microphone used.

When Acceptable Results are Impossible to Obtain

Sometimes acoustic conditions on a location may be so bad that it is impossible to obtain an acceptable recording. If it is effects that are required they can probably be faked later. If, on the other hand, dialogue is required and the scene cannot be shot somewhere else where acoustics are better, it may be necessary to go ahead and shoot the picture and add the voices later. It may be a good idea to record the sound, however bad it may be, and use it as a guide to subsequently fitting the words to the lip movements. If no such guide track is recorded, the greatest care must be taken to see that the characters speak their lines exactly in accordance with the script. Fitting words to lip movements post-synchronously is difficult enough when the correct words were used – when something not in the script was said, but nobody knows quite what, life can become impossible!

Choice of Microphone

The choice of a good microphone, and one of proper type for the purpose in hand, is a prerequisite of good recording. Microphones are of three types:

1. Pressure Operated
2. Pressure Gradient Operated; and
3. Double Transducer or Cardioid, which is a mixture of types (1) and (2) in the same enclosure.

In the *Pressure Operated* type, one surface only of the working part of the microphone is exposed to the air pressure of the sound wave. In general, these microphones tend to give a resonant peak at certain frequencies (due to the cavity in front of the diaphragm) and

substantial overemphasis at high frequencies – hence it is often better to speak across rather than into them. Of the kinds of pressure-operated microphones made, the following are most common:

Moving Coil microphones, in which the coil attached to the diaphragm vibrates within a magnetic field and thereby creates a voltage which varies with the air pressure in the diaphragm. They are particularly useful for outdoor work, especially when fitted with wind shields. Wind noise can be particularly troublesome on locations and records as a piercing, high-frequency whistle, but with carefully designed shields the difficulty can be overcome. Speaking too close to a moving coil microphone can cause overemphasis of high frequencies, and sibilants, such as "f" and "s", can reproduce as whistles; nevertheless, they often give a higher quality of sound than other types, and they are not so readily overloaded, although, on the other hand, they are more costly. They have the advantage that their output impedance is low and consequently comparatively long leads can be used.

Crystal microphones, in which the air pressure of the sound wave on a crystal (or on a diaphragm to which a crystal is attached) causes a stress within the crystal structure which, in turn, creates a voltage proportional to the air pressure. Microphones of this type have a good frequency response (but with high-frequency emphasis) and a large output. Because their output impedance is high they cannot be used with long leads, but must be placed comparatively near the recorder. They are very sensitive to extraneous interference and, therefore, the microphone leads must be well screened. Crystal microphones are comparatively cheap; they are robust and are suitable for general use.

Condenser microphones (most types), in which the air pressure of the sound wave impinges on a diaphragm which is one plate of a polarized capacitor. When the diaphragm vibrates a voltage is developed across an internal resistance which is proportional to the initial air pressure. These also have a good frequency response, but suffer from the disadvantage that a pre-amplifier must be fitted close to them because of their very high internal resistance. Often the pre-amplifier is enclosed with the microphone and consequently power leads as well as speech leads must be connected to them.

Pressure Gradient microphones: these depend for their operation upon the difference in the pressure of a sound wave upon the front and back surfaces of the diaphragm or membrane. The difference in pressure is caused by the difference in the distance the sound must

150

travel to reach the two surfaces, the sound wave reaching the rear surface generally being out of phase with that impinging on the front surface. Whilst a pressure operated microphone is usually omnidirectional – that is to say, its sensitivity is practically uniform to sound coming from any direction, the pressure gradient microphone is sensitive to sound approaching from the front and rear, but gives little or no response to sound approaching from the sides.

Ribbon microphones are the most commonly used of this type. They consist of a very thin flat metal strip stretched between the poles of a magnet. The output from these microphones is low, but they have an excellent frequency response, provided the sound arrives at right-angles to the ribbon. Their output impedance is also low, which permits long leads, but a transformer is required to match them to the input impedance of the recording equipment. They are particularly sensitive when placed near to the source of sound; when recording speech they should be at least 30 in. away from the speaker, otherwise the bass frequencies will be unduly emphasized. (Special lip-ribbon microphones are available that do not suffer this disadvantage.) These microphones are generally unsuitable for outdoor use – they are too susceptible to wind and murmuring noises – but very good for indoor recording, particularly of music.

Cardioid microphones combine the characteristics of the other two, but they do not have the same satisfactory response under any condition as either of the other two types. Their only advantage is that if on location one wishes to make both indoor and outdoor recordings one need have only one microphone instead of two. Many microphones of this type contain two elements in the same housing (such as a ribbon and a moving coil) and which, by simple switching, can be made to operate as pressure operated, pressure gradient or cardioidal at will.

All microphones are delicate pieces of equipment and are easily damaged by rough or careless handling. They are very susceptible to dampness and dirt. They should, therefore, always be handled with care and when not in use be well wrapped up and kept in a cool dry store.

Recording Speech

A well-balanced sound recording has, above all, clarity and naturalistic tone, and these are obtained by the careful positioning of the recording microphone. It must be remembered that the microphone is a single-channel, non-discriminating instrument,

151

whereas human listening is done with two ears and a highly selective brain. The first step in recording is to place the microphone in such a position as will achieve the desired aural effect. If it is too near the source of sound, the recording will be out of perspective, compressed and coarse; and if too distant the recording will be hollow and perhaps give undue emphasis to certain frequencies.

When recording a single person speaking in a studio or room, the microphone should be level with the lips, and generally not nearer than two feet (unless the voice is very thin and a ribbon microphone is being used). If the speaker is sitting at a table, see that the table-top is covered by heavy felt or sponge rubber to avoid unwanted reflections. If the room is small, boominess from resonances may be troublesome, in which case place the microphone diagonally in respect to the walls and, if necessary, absorbent screens on each side of the speaker.

When recording two speakers, they can be placed facing one another with a moving coil or cardioid microphone set up between them. Each speaker can be placed at such distance from the microphone that the voices balance suitably. A cardioid microphone can be used satisfactorily in this manner when recording a small group of speakers.

Recording Music

In recording solo artistes, the main consideration is to strike a satisfactory balance between the artiste and the accompaniment. Where a single microphone is used, this balance can be determined only by trial of the relative positions of the singer, the accompanist(s) and the microphone: a straight singer should generally not be less than 3 ft. 6 in. from the microphone, but crooners and lip singers can be placed closer, provided they breathe quietly and avoid teeth whistles. If two ribbon microphones are available, the best balance is often found by placing the singer and accompanist (and, of course, the microphones) at right-angles to each other.

One or two voices with piano accompaniment are usually difficult, and almost always two microphones and a substantial distance between voices and instrument are necessary; when the singer is self-accompanied, an acceptable balance can often be achieved by suspending a ribbon microphone above the head and three or four feet in front of the singer, and tilting it to an angle of 45 deg. to the keyboard.

With several voices and particularly close-harmony groups, the most satisfactory balance is found by very careful placing of the

152

voices and the use of a single microphone. It is often more advantageous to arrange the voices above one another (the front singers being seated, and those in the back row standing on low stools) than to spread them out horizontally.

Single-Microphone and Multi-Microphone Techniques

There are two schools of thought on the use of microphones, and they come into prominent conflict when the assignment is to record an orchestra or a choir – or both. The "single-microphone" school believes in using a highly sensitive omni-directional instrument, suspended some 15 or 20 ft. above floor-level, and well behind the conductor. This school believes that it is the duty of the conductor to so place the members of his orchestra or choir, and to so select and control the balance of sound, that a satisfactory recording will be made.

The "multi-microphone" school approaches the problem from a different standpoint. This school believes that it is the task of the recording technician to control and balance the sound recording. This can be achieved only by using several microphones, strategically positioned, feeding into separate and independent inputs of the mixer panel, where the signals are blended and attenuated to produce a satisfactory result.

The best technique probably lies between these two extremes. It is necessary to pay particular attention to the placing of the performers. Brass instruments should be well removed from the strings; the woodwind from the percussion; large instruments (e.g. cellos) must not obscure small ones (e.g. flutes). A single microphone is usually desirable to obtain the general or main effect of the performance. This should be suspended behind the conductor, but not in line with woodwind or brass instruments. The optimum position of this microphone can be determined only by trial and error. Having found this position, it is possible that some instruments or groups of instruments are still out of balance with the orchestra or choir as a whole. If this lack of balance is in the direction of overemphasis, the only solution is to move the offenders out of the most sensitive field of the microphone. If, as is often the case, the lack of balance is underemphasis, then local microphones become necessary. Great care must be taken in correctly placing and phasing, otherwise there is likely to be undue emphasis of some frequencies and absence of others. These local microphones should always be of a directional type, and invariably their output should be subsidiary to the principal microphone. Remember, a distant

153

technique is always the best, provided the reverberation and other acoustic characteristics of the room or studio are satisfactory.

All recordings should be made at a reasonably high level to secure a satisfactory signal-to-noise ratio, but in determining this level one must at all costs avoid overloading the recorder at loud passages, because the result will be unpleasant distortion. The limitations of the recording system must be explained to the conductor, and he should be requested to reduce the loudness of *fortissimo* and increase the level of the *pianissimo* passages. The dynamic range of an orchestra can exceed 70dB, but the recording must be kept within the limits of about 25dB. This restricted range is acceptable to the ear, providing the adjustments to the gain control of the recorder are made slowly and carefully to anticipate changes in loudness.

Methods of Synchronizing Sound Recorded at the Same Time as Picture

We have considered the problem of extraneous sound, acoustics, selection of the right type of microphone for the job in hand and microphone positioning. All these matters have to be dealt with whether we are recording wild or synchronously with picture. There is one further problem to be overcome, however, when we are filming at the same time as shooting. Whether the sound is recorded using magnetic perforated film or with the aid of a pulse system, some means must be found for the subsequent identification and synchronizing of the sound in relation to picture. It is usual to film a number board, or "slate" as it is called, at the beginning of each picture take, with the shot and take number chalked on it. It is also usual to speak into the microphone the shot and take number at the same time so that the two can be identified and married later. A satisfactory routine for this purpose must be worked out with the crew, so that it can be done quickly and efficiently. Since film is expendable, while magnetic materials can be used again, it is usual to start the recorder first, call out the shot and take number, then start the camera, film the number board, remove it from view and begin the shot.

The number board is fitted with a hinged arm so that it can be banged down to make a sharp sound. This sound is easily located later on the track. When it is placed alongside the picture frame in in which the arm and board can be seen to have just come together, the sound should be in synchronism with the picture. This procedure is important; without it time will be wasted finding the point at which the two are in correct relationship.

154

The complete procedure, including the jargon usually spoken by the various members of the crew, goes like this:

When rehearsals are finished and everything is ready the director says:	"O.K. for sound."
When the recorder is running the recordist says:	"Rolling."
The clapper-boy holds the clapper board in the field of view of the camera and says:	"Shot 23; Take 2" (or whatever it may be).
The cameraman then starts his camera and says:	"Running."
The clapper operator then brings down the hinged flap smartly on to the board to make a loud bang and moves quickly out of camera range.	
After a brief pause to allow the clapper operator to be safely out of view, the actors start to speak their lines.	
When the action is complete the director calls:	"Cut."

This is, of course, the complete procedure when shooting with actors or others whose full co-operation is forthcoming. When shooting on location under less favourable conditions, the procedure will often have to be modified. Time and circumstances may prevent the use of the clapper board or similar means of identification and, in these circumstances, notes recorded on the "dope sheets" provide the only means subsequently of correlating picture and sound.

When using a pulse system on tape, one can dispense with the clapper board. It is possible to identify the moment at which the camera started by locating the first pulse generated by the camera. Alternatively, some modern cameras have what is called an "automatic sync marker light". As the camera is started a lamp fogs the first few frames of the shot. This is synchronized with a buzz tone which is recorded at the same instant on the magnetic tape. Later, the two can be used to establish picture and sound synchronism.

The ability to dispense with the clapper board can be extremely useful. For instance, when a sound and picture recording of an interview with an important person is being taken it may be embarrassing to have to bang a clapper board in front of his face before each shot! There are occasions, too – as in securing candid camera interviews with members of the general public – when the use of the clapper may be very distracting and will destroy spontaneity.

It is sometimes desirable to record and photograph the clapper board at the end of a take as well as at the beginning. This provides two definite marks whereby the camera and recorder can be checked for synchronism. If the speeds of the equipments are different, the precise number of frames of error can be counted and

155

appropriate adjustment can be subsequently made: without two marks one can be aware that picture and sound are drifting out of synchronism without knowing exactly how much the drift is.

Recording Synchronous Sound with an Independent Recorder

The use of clapper front and end opens up the possibility of securing synchronous sound and picture with very simple apparatus.

While it is always desirable in these circumstances to use one of the systems described above whereby camera and recorder are linked together, there may be occasions when, due to a small budget or the inability to get the right apparatus to the right spot at the vital time, there is a need to record synchronous sound without any linkage between camera and recorder. If a clapper is recorded and filmed at the front and end of each sound take it is possible to compensate for any drift at a later stage. Since the camera and recorder are not linked, it is very probable that picture and sound will be out of synchronism. But when the sound is subsequently transferred to magnetic film in the sound department it is a simple matter to compare the distance between the front and end clappers with the distance between them on the picture. These differences in distances can be made good by running the variable speed re-recorder either faster or slower, as the case may be, so that in the master copies synchronization is secured.

This is not so difficult as it sounds, and with normal care and judgment the sound can be "stretched" or "compressed" to match the picture satisfactorily. On occasions the method can be a little troublesome and can call for a certain amount of experiment, but I have known it to be used many times with great success. Naturally, speech and sound effects only would be attempted by this method. Music immediately suffers unpleasant and readily noticeable changes of tone when played back at incorrect speed. However, the recording of music is unlikely to be attempted with such equipment.

It has been said that the art of making films is largely the art of successful improvisation. If this is true, it applies as much to the sound as to the picture. The recording of sound is beset with many problems and difficulties, most of which must be overcome by ingenuity and improvisation if we are to achieve that impact and realism to which we aspire. The documentary film that includes no more than commentary and background music will never compete in effectiveness with the film that contains virile and compelling live sound. How all the ingredients that we have discussed can be welded into one smooth-flowing sound track will be discussed in Chapter 12.

156

10

ARTWORK AND ANIMATION

THE AMOUNT of artwork in documentary films varies very much. In many productions the only item that could be placed under this heading would be the titles. Construed in its broadest sense the term covers the preparation of any lettering, diagrams, animation and the designing of any sets, scenes and models.

Titles

There is more to good titling than might at first be apparent. The titles are usually the first thing that your audience sees. They should be carefully designed to be in keeping with the rest of the film. As a rule, hand-lettered titles are the only kind likely to be suitable and, when selecting an artist, it is advisable to choose one who specializes in film title work. The correct format, the size of letters in relation to the frame, the amount of surround and a sufficiently strong contrast between lettering and background – these things seem obvious enough when good titles are seen on the screen. In fact, they are the result of experience, and an artist who has never before had to consider the particular requirements of titles for films may not produce a suitable type of work at all.

Simple, straightforward titles may be all that is called for, particularly if the film itself is simple and straightforward in style. Educational, instructional and scientific films, for instance, are usually best introduced by plain, clear titles. Flamboyance or an attempt at artiness would be out of place. When there is a case for less austere titles the first embellishment that can make them more interesting is a textured background behind the lettering. Coarse linen, rough stone, basket-work; such everyday things will often provide an answer and in some cases the texture chosen can have a connection with the subject of the film. More elaborate titling, involving motifs, sketches or paintings as a background for the lettering, may be quite expensive. First-class artwork is never cheap

and before planning a set of titles involving original backgrounds it is as well to check up on the probable cost. The job may be made less expensive by having one background prepared on which all the titles can be superimposed one after the other. This can be done by two methods, either by having the lettering drawn on thin sheets of clear acetate – known generally in the trade as "cells" – and laid on top of the background, or by photographing the lettering and background separately and superimposing them photographically.

Filming Titles

Titles are usually photographed on a special bench, similar to an animation bench, but not necessarily so complicated. The camera is mounted on a rostrum so that it looks vertically downwards on to a baseboard on which the title cards are laid. The camera can be moved up or down, nearer or farther from the baseboard, so that titles of varying sizes can be made to fill the screen. Suitable lamps are provided to give an even illumination. Titling can be farmed out to specialists and the filming of title cards will usually be undertaken quite economically at so much per foot of film exposed. If you require a more or less standard article, farming the job out works well enough; if you wish for individualistic titles full of special effects, it may be more economical, in the long run, to shoot them yourself.

It must be remembered, however, that not all camera view-finders have that very high degree of accuracy that is required to photograph titles absolutely horizontal and central in the frame. It may not, therefore, be enough to pin the titles to the wall, look through the viewfinder and shoot. If titling is to be regularly undertaken, even quite a simple set-up, with special lighting and a proper camera mount, will very soon pay for itself. A table giving the correct exposure for the filmstock that you commonly use can be easily evolved, for the light falling on the titles will always have the same intensity if you remember to mount the lights on the baseboard, not on the camera bracket; if the lamps move up and down with the camera, the light reaching the titles will vary and consistent exposure will be much more difficult to maintain.

Superimposing Titles

Superimposing titles on backgrounds photographically is normally done by the laboratory in a film-printing machine. Some types of superimposition are much more simple and hence less

158

expensive than others. It is as well to know what is involved before committing yourself to a particular style of titling, so let us go into this matter rather more fully.

If you wish to superimpose white lettering on a darker background, this can be achieved very easily indeed. In fact, such superimposition can be done without the need for special processes or even resorting to a printer at all; it is just a matter of winding back the film in the camera and exposing it a second time. Whether you expose the background first and the white titles second, or the other way round, is immaterial. Of course, it is sometimes inconvenient to wind back the film and do the double exposure in the camera, but the same effect can be obtained by printing the two pictures one on top of the other in the laboratory. In 35 mm. work this is usually done by combining the background scene and the white titles – which will have been shot on a black background, of course – in what is known as an optical printer. In 16 mm. work a method of printing known as "A and B roll assembly" enables the titles to be overprinted on the background at the time that the release prints are made without even the need for an optical printer. Such superimposition is much cheaper, since optical printing is more expensive than normal printing.

Naturally, care has to be taken to see that the background will be dark enough to make the lettering stand out. If a white area in the picture (or a portion of bright sky) falls behind some portion of the white lettering, the titles may become difficult to read.

Lettering other than white can, of course, be superimposed on a background, but the process called for is no longer the simple printing of one picture on top of another. What is called a "travelling matte" is required. The matte, in the form of a black silhouette of the lettering, has to be prepared in the optical department. This is laid over the background scene during the printing so as to prevent the exposing of those parts of the picture that will be subsequently occupied by the lettering. The lettering is overprinted now on these unexposed areas and is not affected by the background. This is obviously a more lengthy, and therefore more expensive, process than the superimposition of plain white lettering on a scene.

The superimposition of lettering on to actual scenes, by whichever method, is an effective way of providing pleasing titles that will blend in with the subject-matter of the film. It avoids the need for elaborate artwork, since quite simple lettering can be used, the scene itself doing the rest.

159

Adding Fades and Dissolves

There is a further aspect of titling that requires consideration. Titles can be shot "straight" – that is without fades or dissolves between them – and this is frequently done. The result is rather lacking in smoothness, however, and a more polished effect is obtained by fading-in the first title and linking it to the subsequent ones by dissolves, fading out the final title and fading in to the first scene of the film. In 35 mm. work, fades and dissolves are still normally inserted by optical printing. This entails the making of dupe negatives and the passing of these dupe negatives through an optical printer which is equipped with a fading shutter; it is the need for these various stages that makes the process quite expensive.

In 16 mm. work, there are two alternatives to the making of "opticals". The first is to use a camera fitted with a variable shutter and backwinding mechanism, such as the Cine-Kodak Special. The fades and dissolves can be inserted at the time of shooting. This is the most economical and speedy method of all, although it calls for some skill and experience on the part of the operator. The second is to assemble the master of the film by the "A and B" roll method, whereby the fades and dissolves are inserted during the making of the release prints without any extra printing stages. "A and B" roll assembly will be dealt with in detail when we come to film editing in the next chapter.

Stop Action and Animation

Animation is quite frequently called for in factual film work and it varies in complexity so very greatly that it is as well to have a clear idea of the various "degrees" of animation that can be used. Full animation of the cartoon type can be immensely complex and extremely dear. On the other hand, it is possible to create certain types of animation by comparatively simple and economical methods. The first need is to be able to recognize whether a given effect can be obtained in such a way or whether it is going to be necessary to employ full animation.

Generally speaking, whenever continuous movement is called for in diagrams or cartoons – movement of human figures or animals, movements of liquids or gases, continuously moving waveforms – it is a job for the animation specialist. Dozens, if not hundreds, of drawings may be required. Sound films are projected at twenty-four pictures a second. (In the case of some television systems – the British, for instance – the speed is twenty-five a second, but the difference is so slight that it is perfectly possible, and in fact normal

160

practice, to televise film shot at the standard speed of twenty-four frames at twenty-five without any adjustment.) Animation, therefore, calls for twenty-four pictures per second. This does not necessarily mean twenty-four *different pictures*. If the movement of a particular piece of animation is slow it may be quite possible to photograph each different drawing twice and still obtain a smooth effect; in this case only twelve drawings per second will be called for. Whenever the action stops and the subject remains still for a moment, the same drawing can be photographed repeatedly. It may be, therefore, that the *average* number of drawings required per second in a given piece of animation is much less than twenty-four. How expensive an animated sequence is going to be will depend largely upon how far it is possible to cut down the number of different drawings required.

Cartoon-style Animation

The normal procedure is to draw the background of the scene or diagram on paper, and draw the portions that are required to move on transparent cells, which are laid on top. Both the background drawings and the cells are punched so that they will fit in register with one another on pins set in the baseboard of the animation rostrum. If the budget is a tight one every endeavour must be made to reduce the number of cells that have to be drawn. A complicated diagram or cartoon may involve several different movements all taking place at once. This may involve not one cell being overlaid on each background picture but several. After each picture has been exposed these cells are removed, the background picture being allowed to remain, and the new cells are substituted. This is bound to be a lengthy process.

Even with full animation of this kind, however, some types of subject can be much less costly than others. To achieve the greatest economy in the number of cells required the animation artist aims at presenting as much of his movement as possible in the form of a "cycle". A cycle is a series of cells used over and over again to present a piece of action that is repetitive. Suppose we are called upon to present, in animated form, the workings of an internal combustion engine. The movement of the piston up and down in the cylinder is repetitive. If it is decided to break the movement into, say, twelve drawings, twelve different cells are drawn. These are arranged so that when the twelfth has been photographed the piston is almost back where it started. Cell 1 is placed on the background drawings again and the whole cycle repeated as many times as required. If

161

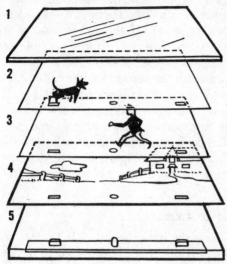

each of the twelve cells is photographed once the piston will move up and down twice a second (since twenty-four frames represent one second); if each cell is photographed twice the piston will move up and down once a second. If the diagram is no more complicated than this we can achieve full animation for as long as we desire for no more than the preparation of one background drawing and twelve cells. The use of a cycle has made this possible and such a job might be quite inexpensive.

In practice, such simplicity is rarely attainable. Most animation is a combination of cycles and continually changing drawings. Let us take an example from a film on the subject of fire risks in factories. The problem was to show by animation a fire starting and smoke building up inside a building from which it could not escape. The onset of the fire obviously could not be a cycle – to show something steadily growing from a small beginning required a considerable number of drawings, each one different, so forty-eight drawings – each on a cell that could be laid on the background drawing of the factory building – were prepared, each showing the fire slightly larger. The flames had not only to grow, but also to vary in shape in each drawing, to produce the flickering effect of a fire. These forty-eight cells were exposed for two frames each, producing a piece of animation ninety-six frames long – lasting, in other words, four seconds.

162

Once the fire had reached sizeable proportions it could, for the purposes of the diagram, remain that size. A cycle of six cells was then drawn, showing the flames in different positions but similar in size. By repeating these six cells for the remainder of the diagram a flickering effect was produced. So fifty-four cells covered the movements of the fire. But the smoke had also to be considered. Accordingly, sixty different smoke drawings were prepared showing the smoke gradually increasing until it filled the building. Photographed for two frames each, these provided 120 frames – five seconds – of smoke build-up. Once the smoke filled the building it could be continued by means of a cycle – four different drawings were found to be sufficient to give the smoke a slightly drifting movement.

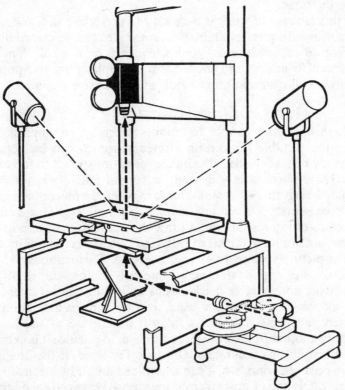

AN ANIMATION ROSTRUM. The camera is mounted vertically and is capable of being moved up or down. The peg-board on which the drawings are placed is capable of being moved in either direction horizontally. In this example an additional feature is provided: frames from a film print can be projected, via a mirror, on to a ground-glass screen on top of which drawings on cells can be placed. This enables live action and cartoon work to be combined.

163

We now had sixty-four cells for the smoke plus fifty-four cells for the fire – a total of 118 drawings plus the background – for one fairly simple piece of animation. And, it must be remembered, the shooting of such a diagram itself is quite a complicated business. Two sets of cells, one for the fire and one for the smoke, have to be laid on top of the background drawing and changed every other frame. Even when both these sets had reached the stage where a cycle only was being used, there was the complication that the length of the two cycles was different. Six cells for the fire and four cells for the smoke meant that the two cycles were out of step. Changing of cells every other frame had to be done with care. The only way an animator can be sure of completing such a job without mistakes occurring is to prepare a detailed chart, setting out the operations frame by frame.

If this amount of work is necessary to produce a fairly short and straightforward piece of animation, some idea can be gained of what is involved to produce a lengthy sequence or a whole film. It is important to understand these basic principles fully to appreciate the reason why animation is a slow and expensive business.

Simple Animation

There are more simple techniques whereby an impression of animation suitable for certain limited purposes can be obtained; these may be useful where the budget does not stretch to full animation. There is frequently a need, in factual film work, for simple animated diagrams – simple sketches in which arrows appear in time with commentary, dotted lines animate themselves in, rings encircle the centre of interest or routes draw themselves across a map.

The basis of a great deal of this kind of work is the ability of the motion-picture camera to shoot in reverse. This, coupled with the fact that paint applied to clear acetate cells can be scraped off without leaving a noticeable mark, opens up a wide field of operations. It is possible, theoretically at least, to draw a line on a diagram piece by piece, shooting a frame, adding a little more of the line and shooting another frame until it is complete. In practice it is extremely difficult to do this accurately. On the other hand, if the line is first drawn on a cell complete, it can be scraped off bit by bit much more accurately. If one or more frames are exposed between each scraping operation *and the whole thing is shot in reverse*, the effect on the screen will be of a line animating itself in. Naturally, the speed at which it appears can be controlled by deciding over how many frames the whole action will occur, in the same way as when using a

164

series of cells. This technique can be applied not only to lines but also to shaded areas; for instance, a portion of a diagram can be made to fill itself in in exactly the same way.

Many motion-picture cameras cannot be operated in reverse, but this does not present any difficulty. If a scene is shot with the camera *upside down* and this length of film is then turned the right way up for projection the action will appear in *reverse*. It is even easier with artwork than with scenes in real life – it is not necessary to invert the camera, but merely the drawing on the bench instead. Any camera can, therefore, be used to film in reverse.

Of course, reverse action is called for only when the "scraping away" technique is being used. The possibilities of ordinary stop-action (that is, one frame at a time) photography, with the camera running forward in the normal way, are worth bearing in mind. The addition of items to diagrams, maps, etc., by adding cut-out sections during filming is a technique that is obvious but useful. In the same way, objects can be added and made to "jump in" a picture by single-frame shooting. For example, in a school film dealing with musical instruments the manner in which the bassoon is made up of four components had to be illustrated. Each one was jumped in, in time with the commentary, by the simple expedient of exposing a number of single frames, starting with a blank screen and then adding each part of the bassoon.

There is a little more to this apparently obvious technique than might be imagined. Why, for instance, go to the trouble of exposing a lot of single frames? Why not run the camera continuously, stopping it and re-starting it again after adding another detail to the picture? The reason is that if the camera is run continuously, stopped and then run continuously again there will be a "flash frame" at the point where shooting was restarted. A flash frame is a lighter frame occurring at the beginning of a shot, and is due to the longer exposure given to this first frame because the camera has not had time to get up to its proper speed. Some cameras, particularly 35 mm., produce several overexposed frames. These can be cut out, but the film join may produce a slight unsteadiness of the picture. It is better technique to expose the required number of frames separately, as a series of single-frame exposures. By shooting the whole scene in this way, one ensures that all the exposures will be equal. This does mean, however, that the precise timing will have to be worked out in advance; in the case of the components of the bassoon, for example, each part of the instrument had to be added with a just sufficient interval in between for the commentator to

name it. The best method is to record the sound track first and count the frames. If the stop action is complicated, a frame-by-frame chart can be prepared indicating the precise frame at which each picture change has to be made.

The technique of recording the sound track first is applied, wherever possible, to full animation. If you cannot wait for the recording of the actual sound track, a mock recording to produce a guide track will be a most useful aid. It is very difficult to decide, even with the most careful use of a stop-watch, the timing that will produce animation that will synchronize exactly with a commentary. If the animation is shot first, it is not easy to record a commentary afterwards that will precisely synchronize with it. Animation is sometimes required to synchronize with music and in this case it is essential to record the music first. As in all things, much depends upon the budget. If time and expenditure permit a "line-test" to be filmed – that is a test-run of the animation – before the final shooting takes place, a great many problems can be ironed out before the whole thing is finalized.

Stop Action

Stop action can, of course, be much more ambitious than merely "jumping" objects in. With careful timing, it enables a useful degree of animation to be introduced. A simple example was called for in a subsequent scene in our film dealing with the bassoon. Having introduced the component parts of the instrument, we now wished to show how they fitted together. The components were animated by stop action, each one approaching and jumping into place over a few frames. It is surprising how few frames are required to suggest a movement of this kind. Five or six frames during which a part of the instrument moved from the edge of the screen into its place were quite sufficient to give an impression of quick movement. Then the whole scene was held static for forty or fifty frames, after which the next component entered and moved, during five or six frames, into position. Naturally, a quick movement is easier to do than a slow one; a slow steady movement calls for precision and the object must be moved exactly the same distance between each frame if a smooth consistent movement is called for.

The possibility of introducing movement into scenes of inanimate objects should never be lost sight of. If it is necessary to film such things as news headlines, notices, blueprints, maps and so on, a zoom-in may help to prevent the film becoming static – whether the zoom is fast or slow will depend on the mood of the film or the

166

sequence. It is surprising how *few* frames of movement are required to produce a really startling zoom-in to close up when a punchy effect is wanted. From a full view of a whole page of a newspaper to a tight close up of one headline, five frames of zoom are all that are required to produce a brisk effect. Increase it to ten frames and the effect is quite lethargic by comparison. While the zoom lens is suitable for slower zooms, quick zooms involving exact framing are better obtained by single-frame shooting on a titling or animation bench.

Filming Stills, Drawings and Paintings

Sometimes sequences or whole films are based on paintings, sketches or photographs. It is possible to string such still pictures together and hold the interest of an audience for long periods if plenty of camera movement is introduced. The basis of this kind of work is to take the picture to be filmed and treat it as though it were a real scene, breaking the subject-matter down into long shot, medium shot and close up and scripting accordingly. Pans, tilting and tracking in and out help greatly to put life into such a sequence, and when the various still pictures are linked by dissolves the whole can be made to flow very smoothly indeed.

This work has almost become a branch of film-making in its own right, and it can be extremely fascinating. An interesting example of the use to which the technique can be put was the filming of ancient tomb paintings for a classroom film on life in ancient Egypt. The vivid and intricate paintings portray with a wealth of detail the everyday lives of the people. By bringing the camera close and breaking the scenes into long shot, medium shot and close up, by introducing camera movement to suggest, for instance, that the boats were gliding along the Nile or the oxen being led by the cowherd, these scenes could be made to tell their story. But the tombs were very remote among the sandy hills of the west bank of the Nile, carved deep into the solid rock, dark and inaccessible. It would have been almost impossible to light them. In many cases it would be extremely difficult to get a motion-picture camera near enough to take close ups – the paintings are sometimes high up at the top of walls or on the ceiling. Filming on the spot would obviously have taken a long time, even if it could have been done at all. Fortunately, copies of the finest examples had already been made and it was possible to collect them together and film them on the animation bench.

Camera movement was introduced wherever possible and the

scenes were broken down into camera angles just as in the case of an ordinary film. Here is a short extract from the script:

Picture	Sound Track
	Commentator:
General scene of activities on a nobleman's estate – from the wall of the Tomb of Nacht, Thebes.	Then, as now, the artists have recorded for us many typical farming scenes. An estate-owner watches his labourers carrying out a variety of tasks.
Track slowly in to centre on estate owner.	He is seated under a shelter of papyrus reed.
Close up of servant.	In front of him stands his servant with napkin and jar, offering refreshment to his lord.
Medium shot of cows drawing a plough, panning to suggest movement.	One of the labourers is tilling the ground, using cows to draw the plough.
Mix to Medium shot of harvesting.	Now the corn is ripe and the harvest is in progress.
Close up of a man with a sickle.	Their sickles are very similar to those we use today.
Medium shot of a young girl. Pan to a man drinking from a jar.	A girl, wearing only a girdle of beads, stoops down to pull up some ears of corn. A thirsty peasant is drinking from a jar, his sickle tucked beneath his arm.
Medium shot of a woman sitting beneath a tree with a child on her lap.	Nearby, a countrywoman sits on a stool and helps herself to fruit while her baby reaches up to pull her hair.
Medium shot of men bringing in the harvest. Pan against the direction of their movement.	Now the harvest is being brought home in panniers of knotted cord suspended from poles.
Close up, panning at same speed, of loin-cloth of the man on the left.	The men are wearing a kind of leather patchwork at the back to protect their linen loincloths.
Medium shot of a group busily at work.	Although there is great activity not everyone is busy.
Close up of a man asleep.	
Close up of water bottle hanging in a tree. Pan down to reveal a man below playing a pipe.	Another man has slung his water bottle from a branch and is playing a tune on a long reed.
Medium shot of two young girls fighting.	Two little girl gleaners are quarrelling. They are pulling one another's hair while their bags of gleanings lie split open between them.
Close up of a pannier of corn. The scene is rotated to suggest the pannier being emptied on the ground.	The corn is emptied on the ground.
Medium long shot of oxen treading the corn.	Now the oxen have arrived. They are driven round in a circle to thresh the corn.

Mix to *Medium long shot* of men using winnowing fans.	When the grain has been separated it is winnowed. It is tossed up in the air with winnowing fans – the heavier grain falling straight down while the chaff is blown away by the wind. The men are wearing white cloths around their heads to protect them from the falling chaff.
Track in to close up of the head of one man.	
Mix to *Medium long shot* of scribes recording the harvest.	Then the scribes arrive to register the harvest – to assess the amount of taxes to be paid to the treasury or the administrators of the gods, for they owned the richest land in Egypt. Each scribe has a palette with black and red inkwells.
Track in to close up to reveal palettes and inkwells.	

The commentary describes the content of the visuals rather more closely than usual, because they call for an explanation if their content is to be clearly understood, for in many cases the paintings have been damaged or defaced.

One of the most fascinating sequences in this film was created by animating the work of an Egyptian artist of 3,000 years ago. On the wall of a famous tomb there are hundreds of line drawings depicting the sports of the time. Athletes are shown throwing the javelin, jumping, running and wrestling, with the wrestlers in dozens of different postures. By making a selection of these drawings and filming them in quick succession it was possible – without doing any additional drawing at all – to animate them. Did the artist think of his many separate drawings as stages in a piece of animation? Almost certainly he did. In another picture, an oarsman in a Nile boat is shown both sitting upright and leaning over to scoop up water to drink from the river, the two bodies stemming, as it were, from the same pair of legs – another example of an attempt at animation. One felt that the bringing to life of the wrestlers by the movie camera would have delighted this artist of long ago – but perhaps not entirely surprised him.

Camera Movement as a Substitute for Animation

It is constantly astonishing, even when a number of examples have been seen, to find how thoroughly effective this technique of re-filming still pictures can be. A most successful series of children's films has been produced in the United States by doing no more than filming the illustrations already provided in the story books. The technique sounds almost crude; in fact, the result is charming and delightful. The camera moves across the pictures, cutting where necessary from scene to scene or character to character, while the story is narrated. By moving the characters past the camera, a most

remarkable impression of movement is produced. Sound effects and occasional music add to the effect. Presented in this way stories such as "Mike Mulligan and his Steam Shovel", "Millions of Cats" and "The Story about Ping" pass the acid test – they hold audiences of children spellbound. Of course, the technique is good; the camera movements are smooth and timed precisely to the words of the story-teller, there are frequent quick changes of camera angles, and the sound effects and musical scores have been most expertly done.

All this suggests that true animation is by no means as necessary as might be thought. Still pictures will take us a long way, and specially prepared drawings can be used to illustrate a sequence most successfully without resort to frame-by-frame work. Provided smooth camera movement is used to bring them alive, plenty of dissolves are used to link picture to picture and the timing of the narration is good, the result, in the case of suitable subjects, can be just as effective. Sometimes it has a charm that animation might have failed to capture.

The following is an example of a specially drawn sequence of stills for a film on the history of tea:

Picture	Commentary
(Drawing 1) Close-up of Emperor's face. Pull back to reveal that he is standing looking at a large pot of water on a fire. There is a tea tree in the background.	According to one legend, tea was first discovered by the Emperor Shen-Nung in the year two thousand seven hundred and thirty-seven, B.C. Seemingly Shen-Nung had ideas on hygiene far in advance of his time because he always used to boil his drinking water.
Close up of tea bush with leaves falling. Tilt down to show leaves falling into the pot. Steam is rising from the water.	One day a few leaves from a nearby tree fell into the boiling water. Music
(Drawing 2) Medium close shot: fire, pot and Emperor standing near. His nose is wrinkling as he detects the aroma.	The aroma that arose so enchanted the Emperor that when the brew had cooled sufficiently
(Drawing 3) Close up: Emperor drinking tea from beaker with a slight smile on his face.	he drank some and found that it not only had a pleasant taste but also a stimulating effect.
(Drawing 4) Medium close shot: Emperor with beaker in hand, looking at the tea tree. Close up of the tea tree.	He noted that the leaves had come from a wild tea tree,
(Drawing 5) Close up: Emperor's face with look of Oriental knowing upon it.	and resolved to pass on the discovery to his subjects so that they might share this new delight.
Long shot: Emperor standing by the tree, holding one of the leaves.	Whatever the truth of this legend the Chinese were certainly confirmed tea drinkers long before the Christian era.[1]

[1] Extract from the film: *East Africa's Expanding Industries – Tea*, produced by the East African Railways & Harbours Film Unit. Animation by Paul Tye.

11

EDITING

FROM THE PRACTICAL point of view, editing may be said to start with obtaining a work-print. The term "work-print", incidentally, is used synonymously with "cutting copy" – both refer to the print that is used for editing purposes. Strictly speaking, a print is a positive image struck from a negative, while a reversal master, being a positive, produces a "copy" and not a "print". We will leave these distinctions to the pedantic and, for the sake of simplicity, refer to the film we are going to edit as the "work-print", whichever its origin.

Obtaining a Work-Print

The work-print is made, as a rule, at the time the camera film is developed. Exposed film, straight from the camera, is often processed overnight, and because it has to be dealt with quickly, ready for screening the next morning, it has become known as "rushes". For the same reason, the first print is also called a "rush-print". The rush-print is usually handed to the film editor as his work-print.

There are work-prints of several types. The first important point is that whereas final projection prints of the finished film (release prints) are "graded" scene by scene, rush- or work-prints often are not. Grading is the process whereby a laboratory technician examines each scene and decides how much light must be passed through it to produce the best picture quality. In the case of a work-print it is not necessary for complete grading to be done; ungraded or partly graded prints save time and money and they are normally quite good enough both for a preliminary viewing and for editing purposes.

In the case of 35 mm. colour film, such as Eastman Colour, there is a choice between a colour or black-and-white work-print. A black-and-white print is cheaper and, since it is usual to shoot several times the length of the finished film, may represent a considerable saving. The difficulty of judging colour is largely overcome

171

by ordering what are known as "colour pilots". These are prints taken from two or three frames *only* of each shot, the frames being repeated using different colour-correction filters. The best colour rendering can be selected and instructions given when the first approval print of the finished production is ordered.

All 35 mm. shooting is done on negative camera stock, but if you are shooting on 16 mm. black-and-white you may be working on either negative or reversal stock. In the case of negative, you will order the laboratory to develop and make a rush-print, exactly as in the case of 35 mm. If you are shooting on reversal it is possible to examine your material without first taking a copy; here it differs from negative, the quality of which cannot be easily judged except from a print. You may therefore prefer to have your reversal film processed but not copied. After examination you will send it for reversal copying, having removed any defective portions.

In the case of 16 mm. colour, if you are shooting on a reversal stock you may prefer to have it processed and examine it before having a work-print made for cutting. You have a choice of a black-and-white reversal work-print made from your colour master, or a colour copy. The black-and-white will be considerably cheaper – less than half the price – and for most working purposes it will be perfectly satisfactory. At the present time there is no colour pilot service available on 16 mm. (in Britain). It is important, when ordering a work-print from a laboratory, to indicate that what you require is, in fact, a *work-print* and not a finished print. Many printers are still in use that cut a notch in the side of the film for grading purposes. Since your copy is for cutting purposes only, it is probable that most of the grading notches will be in the wrong places after you have cut and reassembled the material. This will cause trouble when the laboratory is presented with the task of grading it for making final prints. In any case, many laboratories offer a slightly cheaper rate for cutting copies, since the amount of grading carried out is minimized.

Footage Numbers

For many years 35 mm. camera film has carried footage numbers down the edge. These numbers print through on to the work-print and they are invaluable when the film cutter begins the task, after the work-print has been edited, of matching the negative to it. In 16 mm., the incorporation of footage numbers is more recent, but most filmstocks are now manufactured with them on. However, not all laboratories take the trouble to print them through on to the

172

FOOTAGE NUMBERS. In both 35 mm. and 16 mm. camera stock, numbers are provided along the edge every foot. When these numbers are printed through on to the work-print the task of matching the master to the work-print after it has been edited is greatly facilitated. If the numbers on a given section of work-print are placed exactly against the corresponding numbers in the master the two are in register.

work-print. You will find it safer to give instructions that footage numbers must be printed through on your order. In fairness it must be admitted that film manufacturers are not always consistent and sometimes the footage numbers are on one edge of the film and sometimes on the other. This makes matters more complicated than need be for the laboratories.

It is a pity that some of the footage numbers on 16 mm. filmstocks are very small and, therefore, difficult to read. They are sometimes placed too near the edge of the stock and become partially cut off by the gate plate during printing. One way round this difficulty is to have additional numbers printed in ink on both master and cutting copy, a service that is offered by some laboratories. This ensures that readable numbers are available when the master is matched to the cutting copy later. Without legible numbers this task can be very time-consuming.

Of course, when shooting has been carried out on 16 mm. reversal film, whether colour or black-and-white, it is possible to edit the original film without going to the expense of a work-print. This is not good practice, however, and should only be resorted to when the budget is very small. It is extremely difficult to prevent film from picking up dirt and becoming scratched during editing. Not only must it be handled a great deal; it must also be put through a projector a number of times. Quite apart from the actual editing, it will have to be projected frequently during the sound-recording and mixing stages, and here dirt and scratching are not the only hazards; there is also the danger of damage due to tears and breaks. It is most unwise to risk serious damage to master film in this way. In the case of black-and-white reversal film and Kodachrome, the danger is not quite so acute, because both these types of stock are intended for projection and are given a comparatively hard emulsion which will stand up to a certain amount of handling. In the newer

16 mm. camera stock, Ektachrome Commercial, however, the emulsion is very soft. This film is not intended for projection, but solely for use as a camera master. Using it for all the stages of editing, therefore, will result in its becoming badly marked.

First Assembly

Having obtained our work-print, we are ready to start editing. The first task is to project it. This should be done systematically if time is not to be wasted. You should be prepared to take plenty of notes, and it is better to dictate them to someone to avoid having to take your eyes off the screen while you write; the moment that you glance away some momentary blemish is bound to flash by and you will miss it, to your annoyance later. If you can, at this first viewing, decide which are the best "takes" where scenes have been shot more than once, and get their numbers recorded, you will save the need for a further pre-editing viewing on the projector. You will, of course, see the material many times more on a Moviola or viewer, but it is much less easy to judge quality and action on their smaller screens than it is by projecting.

The basic equipment required for picture editing consists of: scissors, a film joiner, film cement, a Moviola or viewer to enable you to see the picture in motion on the bench, Chinagraph pencils for marking up the work-print, a rack with pegs of some kind on which you can hang lengths of film, and film bins into which you can trail it. You may require a "two-way" or "four-way" synchronizer; these are devices to enable you to run two or more pieces of film through in step with one another. A footage and frame counter may also be useful, and when you come to the sound track you will require a track reader – a device that reproduces the sound recording, whether optical or magnetic, as the film is drawn through it.

Your first task is to break down the footage into separate scenes – it is rare indeed for shots to be taken in anything like the order in which they will finally appear. If the film is longer than two or three hundred feet there will be much too much material to deal with at one time and it will be necessary to separate the various sequences from one another. This is best done by having a large number of film cores in the case of 35 mm., or small spools in the case of 16 mm., and labelling them with numbers or sequence headings. Gradually all the footage is broken down and spooled under these headings. When this has been done, the cores or spools can be shuffled into the order of the script.

The next stage is to produce a rough assembly. Taking the first

174

sequence, the individual shots are cut apart. With the aid of the rough notes made when the work-print was projected, you select the best take of each shot and throw out the others. The selected shots can now be hung up on their appropriate pegs – should you not be able to make up your mind between two takes in some cases, they can both be included for the time being and a final decision made when the material is next projected. But it should be possible to throw out a great deal of surplus and duplicated footage right away. You will have to go through your rough assembly many times, but the more decisions you can make now as to what you will require the less you will have to wade through later. How fast you progress at this stage depends very much upon the kind of film you are editing. If the film has been shot to a tight script, you will know the exact place of almost every scene. If, on the other hand, it is a documentary of the kind that could not be so precisely planned, the sequence of many of the shots can only now be decided.

In any case, it is better to keep all the shots on the long side during rough assembly. Some people prefer to do no trimming at all, but merely to string each shot to the next at its full length. Others prefer to get somewhere near the final length. Sometimes a sequence may have been shot so closely to what the writer of the script had in mind that you can proceed with confidence, cutting the scenes together almost as they will appear at the fine cutting stage.

It is now that the value of a well-planned script becomes vividly apparent. If the script was well written and detailed, and you were able to follow it closely during the shooting, the editing can proceed speedily and surely. If the script was vague, or this was one of those films that simply could not be accurately scripted in advance, editing may take three or four times as long.

Screening the Rough Assembly

A screening of the first rough assembly will give no more than a general impression of the shape of the finished film, though you should be able to judge whether the balance of the film as a whole is likely to work out as planned. It will also be possible to judge how much the scenes and sequences will have to be shortened: this first assembly should, as we have seen, be much longer than the finished film is planned to be.

Now, with the aid of the many notes made during the first run-through, the next of the many stages of trimming can begin.

On this second run-through with the scissors, attention is given to the way in which each shot is linked to the one following. Many

shots can be cut at any point; others will have been so designed that there is only one point at which they will cut smoothly to the next. These cuts are predetermined and there is no longer any reason to delay making them.

Every shot in a film has its best length. When you look at a well-edited film on the screen you do not consciously think about the length of the shots. But this state of affairs is not arrived at by chance. If any shot had been so short that you were not given long enough to see all you wished, you would have been momentarily irritated – as you would if any shot had been so long that you were conscious of waiting, however briefly, for the next. The length of every shot is critical therefore and deciding what it is is one of the film editor's most important tasks. With experience it becomes possible to look at a shot and decide, according to its content, how long it should be within very small limits. However, even the experienced editor approaches the final length with a little caution and he will tend to cut just a little on the long side during the earlier stages of assembly, noting carefully each time the film is projected, and trimming a few more frames off until he is satisfied. Of course, the length of some shots is dictated by the action they contain, and in others the sound track may be the governing factor. If the film has a commentary it may be necessary to leave many of the scenes slightly on the long side until the commentary has been read with the projected picture. Even then the actual commentator may speak at a speed slightly different from that of the person reading the commentary for the purposes of a run-through. It may be necessary to make final trims after the commentary has been recorded, and until then it is not safe to regard the editing as absolutely finalized.

A useful rule to remember when scenes are being cut to a commentary that has been written but not yet recorded is that there are approximately three syllables to the foot of 35 mm. film and seven to the foot of 16 mm. Few commentators vary very much from this rate of speaking.

Assembling Picture and Synchronous Sound

When editing picture and synchronized sound the work must, as a rule, proceed more slowly than with picture alone. Nowadays the sound at the editing stage is usually in the form of magnetic film. The track is laid beside the relevant picture in a two-way synchronizer, so that the two can be wound through in step with one another. If a clapper board has been photographed and recorded on the beginning of each take, as is usually the case, this provides the

indication for obtaining synchronism. The frame of the picture in which the hinged portion of the clapper is seen to meet the board itself is now marked with Chinagraph pencil. It is necessary to play the magnetic track through a track reader and by this means the "bang" of the clapper can be heard and marked similarly. The two pencil marks are then laid side by side in the two-way synchronizer. If a camera equipped with sync marker light was used instead of a clapper board the fogged frames at the beginning of the picture scene are laid side by side with the buzz on the magnetic track and the two are then in synchronism. Two-ways and four-ways are available with magnetic heads that will reproduce the sound on the magnetic track through a small amplifier on the editing bench. This is an easy way to make the first assembly of track and picture.

The track is joined by means of thin Mylar tape which is perforated by the joiner to match the perforations in the film. This is a better method than splicing on a standard film joiner using film cement, for the overlap at a cement join makes the magnetic film imperfect for using again for subsequent recordings – the magnetic surface momentarily leaves the recording head at the point where the overlap occurs and if a sound is being recorded at this instant a click will result. The tape join, on the other hand, is a butt join and should be quite perfect. For the very best results it is a good idea to use a joiner that makes a diagonal join.

Having assembled all the synchronous-sound scenes complete with their clappers, and run them to check that they are in sync., you can cut the clappers out. This operation calls for care. You have to join the scenes together so that there is visual continuity between one scene and the next, but at the same time you have to ensure that the sound also flows smoothly. If the sequence is one containing dialogue, the pauses between scenes will be critical. There is usually very little choice as regards the length of pause between portions of speech; it has got to be right or it will sound odd and artificial. Therefore, if your picture continuity is not correct at the point at which the sound track dictates that you should make your cut, you are going to be in trouble.

Of course, it is not always essential to cut sound and picture at the *same* point. There are occasions, for instance, when you can cut from a character who is speaking to the listener and let the voice continue; or you may be able to get yourself out of a continuity difficulty by cutting momentarily to a third person who is also listening. But you can do these things only if the director and cameraman have provided you with this additional footage, and by

177

no means all directors are so farsighted. Some directors shoot only what is in the script and depend upon accurate continuity being achieved. Others remember that you cannot always be sure that your characters were in the same position in the beginning of the shot as

LAYING SOUND TO PICTURE 1. A simple method of laying a magnetic sound track to picture is to pass both through a two-way synchronizer. A magnetic head is attached so that it will read the track and replay it through a small amplifier. The picture passes through a separate viewer. Allowance will have to be made for the number of frames separating the viewer from the point at which the track is being read.

LAYING SOUND TO PICTURE 2. A machine for running "double-headed" —that is picture and relative sound while they are still separate—at the editing stage. More frequently known by their trade names, such as "Moviola", "Acmiola" and so on. The picture appears on a small ground-glass screen and the sound is reproduced by a built-in speaker.

LAYING SOUND TO PICTURE 3. These are various types of editing machine available today for running separate picture and sound track for editing purposes. Some carry the film horizontally and are known as "editing tables", others are mounted vertically. Many of them will run both optical and magnetic tracks synchronously with picture at a choice of speeds and in reverse.

they were at the end of the last, and shoot a few extra cut-aways for safety's sake, thereby saving the editor a few more grey hairs.

While the picture and sound track are side by side in the two-way synchronizer, and after the clappers have been removed, it is important to place some synchronizing marks on both so that they can be lined up again. It is a good idea to put a Chinagraph sync. mark on the picture and track of every scene. It is very easy for the picture to be trimmed during some later stage of editing without a similar length being taken out of the sound track. This will throw the sound out of sync., but if there are cues on each scene the damage can be rectified in a moment. Trying to re-establish sync. without cues, on the other hand, can be a long and patience-trying job.

Marking Up the Work-Print

So far we have been discussing the editing of the work-print, the print that is taken from the camera rushes for the purposes of assembly. In the course of editing we must not lose sight of the fact that eventually the original negative (or master positive in the case of much 16 mm. work) will have to be matched to our edited work-print. It is true that the work-print has the footage numbers printed through from the master – or added in ink by means of an edge-number printer – and so we can identify the original of each shot and the precise frame at which the cut has to be made. Nevertheless, we may give the cutter who is going to do the master matching some unnecessary trouble if we do not observe certain cutting-room conventions.

For instance, sooner or later you are bound to make a cut and then decide that you don't wish the cut to be at that point after all. You join the work-print together again and make the cut somewhere else. But unless you take some steps to prevent it, the person matching the master will not know that this particular cut is not intended to be made. It is true that if he examined the picture he would see that the scene in fact carried on past the join. But he is not concerned with the subject-matter of the film; he is merely working from join to join mechanically and it is very likely that he will make the cut automatically before he discovers that he should not have done so. For this reason, a conventional sign has been evolved with the meaning "do not cut here": it takes the form of two short parallel lines made with a Chinagraph pencil across the join.

If a work-print becomes torn, as is bound to happen from time to time with all the handling and repeated projection to which it is subjected during the many stages of editing and sound recording, a

179

CONVENTIONAL CUTTING ROOM SIGNS. 1. Unintentional join. 2. Unintentional joins made to insert a patch replacing a damaged portion of work-print. Ignore when matching master. 3. Extended scene. 4. Fade out and fade in. 5. Dissolve. These signs are drawn on the work-print by the editor, usually with a Chinagraph pencil, to guide the person matching the master.

length of blank spacing is inserted with the same number of frames as those that have had to be removed. It goes without saying that if a work-print is damaged it is important *not to cut portions out* and lose frames when repairing it. If there is synchronous sound relating to the picture concerned synchronism will be lost. Even if there is no relative live sound, the cutting of the scenes or the timing of the commentary may be critical. It is a cutting-room rule of first importance, therefore, that work-prints must always be repaired by patching to the original length. When a length of blank leader is inserted for this purpose the join at each end is marked with the two Chinagraph lines conveying the "do not cut here" message.

Sometimes, during the later stages of editing, it is decided that a scene that has been trimmed should be longer after all. A corresponding length of spacing is added and an arrow drawn across it, in the direction in which the scene is to be extended.

Marking Up for Opticals

There are other items of information that must be indicated to the master matcher. Fades, dissolves and wipes will be required from time to time and to obtain them certain action must be taken with the master. Once again conventional marks have been evolved which act as instructions to the person carrying out the matching. The

180

usual signal for a fade-out is two lines starting at the edges of the picture area and converging in the middle of the film at the end of the scene to be faded out. A fade-in is indicated by the same sign in reverse: two lines starting at the join where the fade-in begins and diverging until they reach the edge of the picture area. The lines should be approximately as long as the fades are required to be.

A dissolve is indicated by a diagonal line crossing the picture area from one side to the other, repeated each side of the join. Since a dissolve depends upon the superimposition of the end of one scene on the beginning of the scene following, some frames of the work-print must be cut off to allow for this. A forty-frame dissolve, for instance, involves the overprinting of forty frames of one scene on forty frames of the next. The editor, therefore, removes the last twenty frames of one scene and the first twenty of the other, making his join in the middle of the dissolve. The diagonal line each side of the join indicates to the master matcher that a forty-frame dissolve is required between these scenes.

A wipe is indicated similarly, although, since there are many types of wipe, individual editors evolve their own methods of indicating their requirements. Wipes are very little used today except in "Coming Attractions" trailers, television commercials and advertising filmlets.

These indications for fades, dissolves and wipes not only indicate the action that is required by the master matcher; since they can be seen on the screen when the work-print is projected, they also make it clear to everyone working on the film where these special effects occur.

Master Matching

The task of the master matcher is a very responsible one. The negative or master positive was valuable when it came out of the camera. Now that innumerable hours of work have been put in editing the work-print and generally finishing off the production, it is almost priceless. It goes without saying that the utmost care and cleanliness in handling it at all stages is absolutely vital. Black-and-white negative is a fragile enough material, but the colour negative stocks such as Eastman Colour are even more delicate. The lightest touch on the surface of the emulsion may mark it. Film cutters handling master material always wear soft gloves. Even then, they handle the film by its edges only and keep their editing-rooms as clean and free from dust as is humanly possible. It is difficult to avoid the need for film bins and linen bags into which lengths of film

can be trailed during matching, but their use should be minimized. The damage caused by abrasion when coils of film come into contact with each other in bins and bags is one of the most serious hazards of film handling.

When beginning the matching of the master of a picture it is a good method to break down all the footage, first of all, into rolls of one or two hundred feet, labelling each roll with the footage numbers it carries. When the edge number of a scene in the workprint has been established, it is possible to go quickly to the roll containing the master with the same number. Film joiners used for joining the master should have a narrower overlap than those for print joining. In standard 35 mm. stock there is a small space between the picture area of each frame which will accommodate the whole of the join if a narrow-type splicer is used. In 16 mm., there is hardly any space between the frames, but joins can be made less noticeable by using a joiner that makes a narrow overlap.

For instance, a 3/32 in. overlap is normal for print joins, but for master film, a 1/16 in. overlap is quite common. A further improvement can be made by using what is known as a "frame-line" joiner. Most 16 mm. joiners trim the film in such a way that the overlap is placed equally either side of the frame line. This means that overlapping occurs at the bottom of one frame and at the top of the next. When the overlapping comes at the top of a frame containing a scene with an area of sky or other light subject, it tends to be seen.

The frame-line joiner, on the other hand, trims the film along the frame-line and the whole of the overlap occurs *at the bottom of the frame*; this makes joins much less noticeable.

It is very important to wipe the surplus cement from a join before winding it on to the roll, particularly in the case of colour film. Most film cement bleaches colour film, and not only the area adjacent to the join, but also the portion of the next layer that comes in contact with it will suffer. Non-bleaching cement can be obtained for use with colour film, but even with this wiping is strongly advised.

Film cement is still the most commonly used film-joining medium. Ideally some form of butt join involving no overlapping would be the best answer. The ideal instrument has still to be evolved, in the view of most editors. Butt welding by heating the ends of the two pieces of film electrically is a method in limited use but it is difficult to avoid either heating the film so much that the join becomes brittle or not heating it enough so that the join falls apart. Methods of joining film by means of transparent tape have been evolved and

182

are in limited use for work-prints and sound tracks. Some of these devices have the drawback of being very time-consuming – despite misleading advertisements to the contrary – and this method is not ideal for masters. A considerable picture area has to be covered by the tape the edges of which, it has been found in practice, tend to pick up dirt. In the course of time this dirt may find its way on to the picture area and be printed through. No doubt the ideal device will appear before very much longer, but in the meantime there is very little wrong with film cement, properly used.

Preparing the Master for Opticals

It is normally part of the master matcher's duties to arrange for the fades, dissolves and wipes that have been marked up in the work print to be dealt with by the laboratory. In 35-mm. work it is still customary to obtain these by what is known as "optical" printing. The scenes concerned are cut out of the master and sent separately to the laboratory with detailed instructions. The frames over which the optical effect is required must be indicated. Fades and dissolves are usually twenty-four, thirty, thirty-six, forty or sixty frames in length, and it is usual to have all fades and dissolves the same length throughout a picture. Of course, to obtain a special effect they can be printed longer or shorter in certain instances.

Wipes, since they are available in so many different styles, are the subject of special instructions. Where one scene is required to be superimposed upon another, optical printing is again employed.

By means of the optical printer, the laboratory produces a dupe negative containing the fade, dissolve, wipe or special effect that was required and this is cut into place in the matched master.

There is inevitably a slight loss of quality in printing from a dupe negative, particularly in the case of colour, and it is therefore wise to minimize the length of dupe required. On the other hand, if the fade or dissolve only is duped and not the rest of the shots involved, there will be a change of quality in the middle of a shot. This will be more noticeable than if the whole of the shot were duped. Unfortunately, optical printing is expensive and if the shots are long the cost will be high. The accepted practice is, therefore, to dupe the *whole* shot if the shot is not more than 7–8 ft. long; if it is longer, dupe only the length of the optical. The 16 mm. worker has, during recent years, had a new technique for obtaining fades and dissolves placed at his disposal. The first innovation was the addition to standard printers of a device that would add fades wherever required during the making of release prints. In other words, it was no

longer necessary to cut the scenes concerned out of the master and have an optical made, but merely to indicate where fades were required at the time of ordering prints. A fade shutter incorporated in the printer was triggered off to operate at the right point as the master ran through. Once printers were equipped with fading shutters the possibility existed of inserting dissolves, also, at the time of release printing. A dissolve is, after all, only a fade-in superimposed on a fade-out. But to do this requires two stages of printing.

A and B Roll Assembly

This has been made possible by the introduction of "A and B" roll printing. For this purpose the master is made up into two rolls instead of one. Both rolls start from a common cue marked on the leader. The scenes up to the first dissolve are assembled in roll "A".

THE LAYOUT OF AN EDITOR'S BENCH. For 16 mm. master matching. Through the 4-way he is passing the cutting copy and the master A and B rolls that have been matched to it. As a check, he is running the sound track as well.

In the centre is an illuminated ground glass screen and, on either side of it, wells lined with linen bags into which the film can hang without being damaged.

The scene which is to dissolve is followed with blank leader. The scene *to* which it is to dissolve is placed in the "B" roll which consists of blank leader up to that point. (The two scenes which are to dissolve into one another are overlapped by the length of the dissolve.) Scenes are then added in roll "B" until the next dissolve is reached, roll "A" being padded out with blank leader. This procedure is followed throughout both rolls.

Roll "A" is printed first, a fade-out being inserted on the end of the scene that is to dissolve. The printer shutter remains closed while the blank leader that follows it passes. When the second dissolve is reached the shutter opens again, producing a fade-in and remaining open through the ensuing scene. When the "A" roll has been printed, the copying stock is wound back to the start again and the "B" roll is

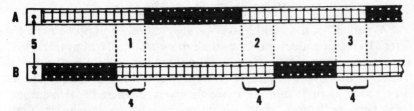

16 mm. "A AND B ROLL" ASSEMBLY. The "A" roll is printed first. The printer fades out at 1 and the shutter remains closed until 2, when it opens to produce a fade-in. At 3 it again fades out.

When the "A" roll has been printed the printing stock is rewound and roll "B" is printed, both "A" and "B" rolls being laced into the printer to start at the same cue-mark 5. This time the shutter remains closed until 1 is reached where it fades in. At 2 it fades out and at 3 it fades in again. A fade-in is thus superimposed on a fade-out at each of 1, 2 and 3, thus producing a dissolve in each case. The length of the dissolves is controlled by the amount of the overlap, usually 30, 36, 40 or 48 frames. For diagrammatic purposes, each frame in this drawing represents ten.

laced up, the starting cue being placed against the same frame of the copying stock as was the starting cue of the "A" roll. The same procedure is followed, but the fade-in on the "B" roll will now be superimposed on the fade-out of the "A" roll and so on.

This method of printing has opened up new fields to the 16 mm. worker. Optical printing, entailing as it does additional stages of duplication, inevitably introduces a slight loss of quality in the portions of the scenes affected. Such losses have been minimized in 35 mm. work, but with the complications of colour it is difficult to avoid the change of quality being detected. "A and B" roll printing does not entail additional duplication, so there is no loss of quality at all. Opticals are costly; "A and B" roll printing is only slightly more expensive than standard printing. It may well be that this useful facility will be extended to 35 mm. work in the future, although it must be borne in mind that the higher cost of blank leader and the longer footages involved may offset some of the advantages.

MATCHING WORK-PRINT AND MASTERS. The work-print 1 is run through a synchronizer and the master film is matched to it. In this case, the master is in the form of A, B and C rolls. The A and B rolls enable dissolves to be added, the C roll may contain titles to be superimposed. Should a foreign-language version be required a C roll with titles in the language required may easily be substituted.

"Chequer-Board" Printing

"A and B" roll assembly has brought another improvement to direct 16 mm. production. One small drawback to 16 mm. work has always been that, due to the fact that there is no space between the frames in this gauge of film, joins tend to show on the screen. There is no room, as in 35 mm., to place the overlap where the two scenes join, *between* frames. Admittedly, with a frame-line joiner that produces a narrow overlap along the bottom of a frame only, very little can be seen on the screen. But a new method of assembly, known as the "chequer-board" system, makes the joins entirely invisible.

The technique is to place scenes in alternate rolls. The space between scenes in each roll is filled in with *black* spacing. It is now possible to overlap each join on to the black spacing where it will not be seen. This involves using a frame-line joiner and reversing

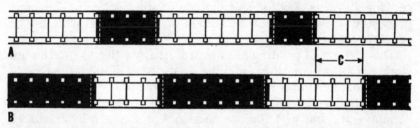

"CHEQUER-BOARD" ASSEMBLY OF 16 mm. MASTERS TO PRODUCE INVISIBLE JOINS. Each consecutive shot is placed in a different roll. *Black* spacing is placed between alternate shots. At "C", however, the shots are overlapped to produce a dissolve just as in normal "A" and B roll assembly. (For purposes of the diagram each frame represents ten.)

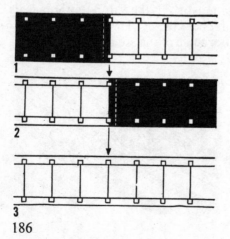

16 mm. joins overlap on to the frame area in normal assembly. By using a frame-line joiner and splicing each shot to a length of black spacing, the overlap can be placed, not on another scene but on black spacing. It is necessary to turn the joiner round between making the joins at 1 and 2.

When the two rolls have been printed on to the copying stock 3 the join is quite invisible.

186

the direction of the overlap at the head and tail of each shot, so that it always occurs, not on the shot at all, but on the black spacing.

Care has to be taken that the spacing used is quite opaque, as the printer light is left on throughout printing (except where a fade or dissolve occurs). Any transparent spots or semi-opaque portions will print through and impair the shot that occurs at that point in the other roll. The result is excellent, however, provided this point is watched and provided the two rolls are exactly matched in relation to one another. In fact, chequer-board printing is now stipulated for high-grade productions in the United States. Dissolves and fades can still be incorporated in the usual way, dissolves being overlapped by the appropriate number of frames as in the case of normal "A and B" roll assembly.

Cueing for Release Printing

Successful "A and B" roll printing depends not only upon accurate assembly of the two rolls, but also upon the provision of accurate printer start-cues. It is usual to punch a hole in the film in the middle of the start frame as well as mark it clearly with blooping ink. The reason for the hole is that the printer operator may be required to lace his machine in the dark and he therefore requires an indication that he can detect by feel. However, most laboratories prefer to punch this hole themselves, because the start position indicated by many film editors is too close to the first scene. A considerable run-up is required by some printers and the grader must, in this case, cut out the hole, extend the leader, and punch a new hole to avoid confusion. A clearly marked cross is therefore preferred – the grader can then place his own punch-hole in the correct position for the printer concerned.

It is advisable to mark up the leaders and trailers of master film with ink and not Chinagraph pencil. Wax-pencil marks introduce fine sticky particles that work their way from layer to layer with most unpleasant results from the cleanliness point of view.

When the masters have been matched it is important that they are very carefully checked before being dispatched to the laboratory for the first print. The error that can most easily pass unnoticed, particularly in 16 mm. work, is a shot inserted upside down. In the case of negative masters many scenes, especially close-ups of detail, are not easily recognized. If a viewer or Moviola is available that is *known not to inflict scratches or marks* the best check is to run the master through this, watching every scene with great care.

187

Leaders

A small point worth mentioning is the provision of leaders. It has become standard practice for cinema and television films to have certain types of leaders on the front of every reel. In the case of cinema films what is called the "Academy" leader is normally used. This carries a frame with the word PICTURE to indicate to the projectionist that, if this is inserted accurately in the picture gate of his projector, the first scene will appear in "rack". In other words, the picture will be correctly framed on the screen. 35 mm. has four perforations down each side of every frame. Without such a guide it would be possible for the projectionist to lace up the projector in such a way that when the first scene appeared it was too high or too low on the screen, revealing part of the adjacent frame also. In 16 mm., where there is only one perforation per frame, it is not possible to be very much out of rack and this procedure is therefore not necessary.

The Academy leader also indicates what point on the sound track should be inserted in the sound gate when the PICTURE frame is in the picture gate. This ensures that the film is laced up in sync. It also carries on the picture a series of frames numbered from 11 to 3 in descending sequence at intervals of one foot. These are *not* intended to be projected, but are to assist the 35 mm. projectionist in making a "change-over" from one projector to the next smoothly. Projectors of different types take a longer or shorter time to run up to speed. A projectionist knows, from experience, what number on the leader he must place in the gate of his second machine, so that when he starts it up he will just reach the first scene of the picture as the other projector comes to the end of the outgoing reel.

It will be seen that these Academy leaders have little purpose in 16 mm. It is strongly recommended that these leaders are *not* used on 16 mm. prints. It is much better to use a specially prepared leader containing four or five feet of a pattern that can be used for focusing. 16 mm. projection often takes place in temporary set-ups and there may be no time to focus beforehand. If the title is the first thing to appear it may well come up out of focus and quite unreadable. A focusing leader, consisting of a pattern of fine lines, will enable focusing to be completed before the actual film begins.

Leaders for films intended for television are somewhat similar to the Academy 35 mm. leader described above. There is a special SMPTE television leader that is most often used today although television networks sometimes have their own designs; inquiries should be made and suitable leaders obtained to suit the station concerned.

188

Marking Up for Printing

Having been checked, had a suitable leader attached and the sound synchronizing cues added, the masters are ready for sending to the laboratory for the first print. Masters should be removed from reels and sent on cores. Leaders should be clearly marked with the name of the film, the reel number (the accepted symbol for "reel" in the trade is #, by the way), the word FRONT or HEAD, and the name of the producing company. The masters may become separated from each other among the many being handled at the laboratory at any one time and clear identification is merely safeguarding your very valuable property.

The laboratory will have to grade your picture master – that is, as I have explained, examine each scene and decide the exposure it is to be given to obtain the best print quality. This is a routine matter, but if there are any unusual scenes in the picture it is advisable to indicate them and issue special instructions. For instance, if the film contains night scenes the laboratory will, quite naturally, try and push enough light through to bring them up to the same density as the rest of the picture, unless you warn them. "Papering up" is the common method of indicating such things if they occur in the middle of a roll – that is, paper is folded round the film at the beginning and end of the sequence concerned. Arrows drawn on the paper and pointing inwards from each end make matters even clearer. Instructions can be written on the papers as well if it is considered advisable. Ball-point pens should *not* be used or any other type of ink or pencil that may imprint itself on the adjacent layers of film. More precise indication of the position of special scenes can be given by quoting the edge numbers at the starting and finishing points.

Opticals (that is, fades, dissolves or wipes) can be indicated in the same way. Quoting the edge number at the *centre* of the dissolve assists in its accurate placing. Dissolves in "A and B" roll printing, however, are usually self-evident by the way in which the film has been assembled and the placing of the spacing. It may, in some cases, be helpful to send the work-print to the laboratory along with the masters to assist them in locating dissolves, fades or any other special requirements.

12

THE SOUND TRACK

SOUND TRACKS contain three main ingredients: speech, music and effects. Combining these into a tightly woven track involves a number of separate stages and a variety of skills. The speech may be in the form of commentary or dialogue, the dialogue having been recorded at the time of shooting or "dubbed in" afterwards. We have discussed the problems of recording dialogue and sound effects on location, so let's turn our attention to the problems of commentary.

The Commentary Script

When a shooting script is written for a film that is to have a commentary, the commentary is referred to as the "shooting script version". In other words, it is accepted that commentary written in advance of shooting is very probably going to undergo change when the picture has been edited. This fact does not make it any less desirable to include the commentary in the script. It is extremely useful as a guide to the length of individual scenes and without it the script would be a very loose and incomplete document.

A well-written script may contain a commentary that requires altering only in detail, but it is rare indeed to find that no alteration has to be made. The fitting of commentary to the edited picture is a two-way process and both picture and sound lean on each other almost equally. The picture is edited to suit the timing of the commentary as far as possible, but inevitably some scenes will refuse to conform. Most often the action takes longer than was anticipated when the commentary was written. This calls for re-writing; often two sentences are required where there was one before, or phrases have to be separated by pauses or put in a different order.

Where there is a conflict between the commentary and the picture, the picture will nearly always win. In other words, what the eye sees will affect the mind of the audience much more strongly than what

190

the ear hears. This can be brought forcefully home to the director if he has mistimed a phrase of commentary or dialogue. I have known cases where an important group of words has been inadvertently made to coincide with a powerful visual which is engaging all the attention of the audience. It is quite clear, when the film is screened and the reaction of the audience is studied, that the point made by the commentary is missed altogether. Such visuals may be dramatic, exciting or comic – the effect is the same. The occasions when the sound track captures attention away from the visuals, on the other hand, are rare. This has to be borne in mind when writing and timing commentary.

Another important fact is that the mind of the audience can easily be saturated with commentary. Commentary should never be continuous, and it is a good rule not to allow it to exceed two-thirds of the running time. On the whole, the less commentary there is the better.

Of course, no rules can be applied rigidly to film making. Much depends upon the type of film that is being produced. A scientific film may be an illustrated lecture and there may be no other method of presenting the subject. But even if the commentary cannot be reduced to the two-thirds of running time limit suggested above, it is at least possible – and most desirable – to introduce some perceptible pauses to break up the continuous flow of words.

If statistics and similar factual data are conveyed solely by the sound track, they are unlikely to stick in the audience's mind. This is too seldom appreciated, particularly by the uninitiated. One hears a client putting a tremendous effort and a great deal of time into discussing an insignificant point of commentary which will be forgotten anyway two minutes after the sequence has gone by.

Writing Commentary to Picture

If the commentary has not been provided in the shooting script because the portion of the film concerned could not be planned in advance, the usual method of commentary writing is to work to a "shot list". This consists of a brief summary of every scene, describing both subject-matter and action, and giving its length. The length is normally quoted in feet and frames, because while all cutting-rooms are equipped with footage counters, very few have measures reading in seconds. Once the commentary writer gets used to it, it is just as easy to work to length as to time. Our old rule of "three syllables to the foot on 35 mm. and seven syllables to the foot on 16 mm." comes into its own again.

191

A detailed shot list is somewhat laborious to prepare. It is possible to dispense with it and write a commentary at the editing bench, with the film running through a viewer. But here again a footage counter is a great help. It is much quicker in the long run to measure each shot and write the commentary to fit accurately right away than to guess it and hope for the best. Trial and error – trying the commentary to the picture, finding it doesn't fit and altering it and trying again – can be very time-consuming. Tapping out syllables with your fingers on the bench may seem a tedious procedure at first, but it soon becomes second nature. With the aid of the syllables-per-foot rule, commentaries can be written that will fit the picture very closely indeed.

Basic Rules of Commentary Writing

There are certain basic commentary rules that should not be ignored. It is bad technique to describe in words exactly what is seen on the screen – yet this rule is broken more than any other. On the other hand, it is nearly as bad to refer to things that have nothing at all to do with what is on the screen. It might seem, from this, that we have not left anything for the commentary to say, since it must neither duplicate the picture nor refer to things not visible! But as soon as we define the purpose of commentary the kind of contribution it should make becomes obvious. *And the purpose of commentary is to amplify and clarify the picture.* If the picture is self-evident, no words are needed. But very frequently there are many things that the audience wants to know that are not clear from the visuals alone. *Where* is the scene; *who* are the people in it; *when* is it taking place; *how* does the technical process work? These are the questions that commentary should answer, subject to one proviso. Does the audience need to know for the purpose of the film? It is possible to spoil a film by telling the audience too much. If they are likely to *want* to know all these things, well and good – if not, silence is golden.

But the precept "silence is golden" needs qualification. In fact, complete silence is often embarrassing. One of the film producer's problems, when he is making a sound film, is that he may *have* to do something with the sound track whether he wants to or not. In scientific, instructional or training films, silence may be quite acceptable. In entertainment films silence often cannot be permitted. The difficulty is that audiences of such films have come to expect to hear dialogue and natural sounds. Complete silence suggests to them that something is lacking. This feeling that some kind of

192

sound is essential has crept into the documentary world as well. Sometimes the problem raises itself in a different form. If we have had a lot of sound in the early scenes, whatever the kind of film, it is going to be very strange if we suddenly have none. The easiest way out is to fill in with music and this accounts for the fact that there is often too much of it in documentary films. If it is really felt that the absence of any sound is going to be quite unacceptable in those portions of a film where there is neither commentary nor dialogue, the best answer as far as documentary is concerned is usually sound effects or live sounds. Unfortunately both can be expensive and time-consuming to provide.

Style in Commentary Writing

In drafting a film commentary, of course, it must be remembered that one is dealing with the spoken and not the written word. Commentaries that read like literature rarely sound well to an audience. On the contrary, some of the most effective are often slightly colloquial and tending towards the conversational in style. If a preposition at the end of a sentence *sounds* natural, let it stay there even if it looks a little odd on paper. No one is going to *see* it but you and the commentator!

Let's examine an example of commentary writing which will bring out these points. Here is an extract from the commentary of *Seawards the Great Ships*, a film which presents a general picture of the shipbuilding industry of the Clyde and handles its subject in a dramatic and forceful way:

> Towers of steel. The traditional system. Ribs rise in the stocks and the skin is fastened to them plate by plate. Great chunks of ship grow ready-made with prefabrication.
>
> Gigantic . . . but most of it is air, enclosed by steel.
>
> A tanker, growing from the inside, outwards.
>
> Curving braces meet curving braces to form chambers of strength.
>
> Internal tanks to hold not only oil but rigidity that will withstand pounding oceans.
>
> A cargo ship grows from the bottom up, and in other ships, all over the yards, mighty pieces of steel assembly find their places in the great jigsaw.
>
> And, as a ship's form becomes clear, the tempo of shipbuilding quickens into a great thundering symphony.
>
> The confusion is stunning, but every man knows his jobs as they swarm over her, and shipbuilding reaches its crescendo of noise and movement.
>
> A ship is ready to be born. Down these greased ways the Clyde prepares to hurl the biggest moving object made by man.
>
> For months the crushing weight of the hull has borne down on its timber supporters. Now the timbers go, leaving the weight to settle on the launching ways.
>
> A complete thing, a ship. Motionless, waiting, today, to be born. The massive bulk, held clear of the earth, is now freed to lower its weight on to the grease on which she will make her first great movement.
>
> Two teams and two rams batter away the last supports. Their going

is synchronized minutely to match the tide and the timetable of the launch, and once they are gone, the launch *must* go on.

Here is a feat both splendid and improbable. A mountain of steel that has never before moved as one will be flung downhill into a strip of water, to become alive.

The men who built the ship are Clydesiders, tough, and cynical, but fierce in their pride. This is their ship. Her day is their day. Their hands made this moment. It is their toil that now reaches fulfilment.

The last daubs of paint where the timbers stood, now only four points are holding her. Time hovers. . . .

A rope to tether a live thing. The giant infant of the Clyde, floating free, feels her first curb, the first of many moorings, in the first rope that ties her to her first tug.

But the men of the Clyde are not finished with her. For she is empty and powerless as she is moved to the fitting-out basin. But mighty power is ready and waiting for her. Power which was fashioned by art and skill in the gleaming metal that brings a ship to life. It has been months in the making, planned and measured to match a great vessel.

There are so many things she needs before she can go. Power for movement and light and heat and cold. Into the shell go plumbing, timber, pots and pans. To her crew, a ship is home, a village, a town, and she needs everything a village needs.

Then the time comes – the time to go, to leave, at last, the hands of her creators, and the place of her creation.

Now slowly, gently, she feels her own strength. Of her own strength at last she moves.

The men who build the ships have looked their last on her.

The Clyde makes ships for many ports, and few of them return to the river of their birth.

They are headed for other, broader horizons. Oceans to cross, waters to plough, voyages to faraway names on mariners' charts. The Pacific, the Indian Ocean, Panama, Madagascar, Bombay, Peru.

Nothing remains but the Clyde. The Clyde, the shipyards, the shipbuilders; and the next ship already growing by the riverside.[1]

(END OF FILM)

Blending the Commentary with Visuals

I have emphasized the need for a commentary to be natural and for the voice to be appropriate to the subject. This blending of the commentary with the visuals and making it an integral part of the story can be carried, with great advantage, a stage further. If it is possible to use a voice to speak the thoughts of one of the characters in the film, telling the story from his point of view, this integrating of commentary and picture can be achieved very effectively. One of the problems, of course, is to identify the voice with the character on the screen. Occasionally, it is possible to begin with a short synchronous sequence in which he is seen and heard speaking, after which – the link having been established – his voice continues. Usually, however, this is not possible, because where non-actors are used they are not capable of speaking a commentary with feeling. Very few untrained voices are pleasing to listen to for any length of time.

[1] Reproduced by courtesy of Films of Scotland. Commentary by Clifford Hanley. Direction by Hilary Harris. From an outline treatment by John Grierson. In charge of production: H. Forsyth Hardy. Production: Templar Films.)

In this case it is essential to have the character on the screen at the moment that his voice begins, and the first sentence, although not synchronized, must make it clear that it is *his* thoughts, or *his* story, that we are listening to. Sometimes the obvious technique of having him say "That's me. My name is John Jones" works. Of course, if it can be done more subtly it is much better, but there must be no failure to establish, in the audience's mind, the link between the story-teller and the character on the screen.

It is important that the character is one who is vitally involved with the story, so that he can speak his feelings and talk as though he is part of what is going on. Sometimes, the identity of the speaker can be established by the commentator, or by the previous speaker. Often, by placing the first few words over a shot of the character concerned, the link is established, as in this example from a film on the subject of child care:

THE TRUST OF A CHILD[1]
Commentary Script

At this point in the film a boy who has just lost his mother in a road accident has arrived at the Children's Home.

Picture Cue	Sound Track
	Commentary continues in voice to represent Sister Edith.
Close up of Sister Edith looking at Robert.	The Superintendent had told me that Robert was coming, so we were ready to welcome him.
Close up of Robert.	
Children looking round the door at the new arrival.	*Music*
Sister Mary motions them to go and they disappear behind the door.	It was quite late by this time and the younger ones were already in bed, so I decided that that was the best place for Robert, too. He'd been unable to bring anything with him, but we found him some pyjamas.
Robert in bed. Sister Edith is buttoning up his pyjama jacket.	
Sister Edith offers Robert some milk. He refuses it.	*Music*
She strokes his head as he lies in bed.	Robert's story wasn't so very different from that of many of the other children in my care.
Close up of Sister Edith looking down at him.	But I wished I could explain that, terrible as things seemed at this moment,
Close up of Robert.	time would heal and one day he would be happy again.
Sister watching him.	
Robert begins to fall asleep.	
Sister goes out of the door quietly.	*Music*
Sitting-room, other children (the older ones) are doing homework.	

[1] Produced for the National Children's Home; script by Brian Tucker and Lindsay Cheyne.

Sister Mary darning. As her voice is heard she looks up in the direction of Sister Edith.	*Commentary continues in a voice to represent Sister Mary:* During her thirty-four years in this very house
Sister Edith sewing.	Sister Edith must have seen many new arrivals like Robert.
Sister Mary again, still darning.	I've seen quite a few myself since I was at Highbury. Highbury! It seems only
Highbury Training College.	the other day that I was here at the Sisters' Training College.
Students listening to a lecture.	During the twelve months' course student Sisters study a wide range of subjects relating to their chosen career.
Medium close shot of the lecturer speaking.	A consultant child psychologist comes once a week to talk to us about problems of child care.

Two characters intimately concerned in the story have spoken in this short extract. No doubt has been left in the audience's mind as to whose voice they were hearing, because each voice began over a picture of the character concerned. The shots were carefully planned so that each of the two characters was seen individually, in close up. It is preferable, as in both these cases, that the character is not seen to be speaking at the moment the voice begins, as then there is no suggestion that he or she is supposed to be *actually* speaking the words. The style both of the phrases and the voice, in such an example as the above, needs to be rather reminiscent. The impression given should be that we are listening to the thoughts of the person concerned as she recollects the incidents and tells them to us.

It will also be noticed that the words are quite carefully placed in relation to the visuals, the scene sometimes changing halfway through a sentence. This careful synchronizing is important if the full effect is to be obtained. The manner in which the commentary links a change of scene and establishes the new location is also worth noting: "Highbury! It seems only the other day that I was here at the Sisters' Training College." The use of the present tense in the word "here" jars slightly as we read the words, but when it is said with the picture it sounds perfectly natural. Tense is something that requires careful consideration in commentary writing. The present tense is frequently useful; it is more vivid than the past. Action taking place on the screen has the appearance of happening *now* – to refer to it in the past tense serves no purpose and tends to divorce the commentary from the picture unless there is some reason for emphasizing that we are dealing with past events.

Integrating the Commentary and Visuals

For this kind of commentary the best readers are actors. They are used to making lines sound natural; they know where to put emphasis and how to make what they are saying sound vital and concerned. Sometimes it is a good idea to change the recording technique slightly and have them speak more closely to the microphone than is usual for normal commentary work. This gives the voice a more intimate sound.

Excellent though this type of commentary may be, and however well integrated with picture it undoubtedly is, there is a danger in it. If we are not careful we are merely telling a story in words and illustrating it by means of the picture. The commentary, that is to say, has become the major partner. Edgar Anstey has something to say about this:

> "A film should communicate primarily through the visuals. Words should be integral, not dominating. What the sound track of any good documentary should do is to carry the mind and the emotions a little further than the visuals – not to say the same thing. It should have the quality of good counterpoint music – it should be oblique, providing another dimension. It should present the other side of the coin as it were.
>
> "There are times when the words can be quite independent of the visuals. In *Terminus*, for instance, we made candid recordings in the booking office so that we could hear passengers asking for tickets to various destinations and the ticket clerk's replies. These words we placed over visuals showing quite different station activities – we retained a perfectly free relationship between sound and picture – and of commentary, in the conventional sense, there is none."

An example of this technique from an early documentary may be remembered. Experimenting in *Song of Ceylon*, Basil Wright laid the sounds of market cries and repetitive phrases of international commerce over scenes of a Buddhist ceremony. There are many ways of using words on the sound track – but however they are used they should complement the picture.

Recording the Commentary to Picture

Having written our commentary, we now have to record it to fit the picture as closely as possible. There are two schools of thought regarding the best method of doing this, and we could call them the "record to picture" school and the "record wild" school.

Recording wild means that the commentary is recorded without projecting the picture – in fact, without any attempt at spacing out sentences to fit the visuals. The complete script is read into a microphone without any pauses other than the natural ones that occur

197

between phrases and sentences in normal speech. Only afterwards is the magnetic film on which the recording has been made cut apart, where necessary, and spaced out to fit.

The argument in favour of this system is that the commentator is not distracted by having to look out for pause marks in his script and, when he reaches one, wait for a cue. And, the argument continues, he is not put off by the mechanics of picture screening or by the movements of whoever is cueing him, and he is not tempted to glance at the screen in the middle of an eloquent passage.

Of the arguments against this method, the most serious is that unless the commentary was timed very accurately when it was written it may not fit. Without the picture you will not know how it is working out. If the commentary is too short it may be possible to correct matters, either by padding out the recording with unmodulated track, or by cutting picture. If, on the other hand, the commentary ends up by being too long you are in a serious difficulty. It may be possible to cut all pauses to their minimum and save a fraction of a second here and there, but the result is liable to sound unnatural and the amount of shortening may be very little. By the time you discover the trouble, the commentator will have long since gone and there is nothing you can do about it short of having another session. Nevertheless there are occasions when a very relaxed style of commentary is particularly desired and then the method may pay off.

The method that is more favoured is to "record to picture". The first problem here is how to keep the commentator in step with the projected film. There must be some means of indicating to him where he must pause in the script. This is easily achieved by inventing a pause sign and probably the one most commonly used for the purpose is the oblique stroke /. Wherever the commentator comes to it he pauses until he is given a cue to resume.

Cueing the Commentator

The cue to resume can be a mechanical one, such as the flash of a light, or it can be nothing more elaborate than a tap on the shoulder. Obviously it must not be audible or it will be recorded. If a flashing lamp is used it is important that it is placed as near to the commentator's script as possible – preferably on the desk in front of him, but not where it is likely to become obscured by discarded pages of the commentary. It is most undesirable for him to have to look away from his script to some other part of the room. If he does so

198

he may lose his place; or he may miss a cue through not looking up quickly enough. The best method is probably the tap on the shoulder, even though it may seem a little crude. The commentator cannot miss it. And mechanical aids such as press switches that operate lights are liable to make a noise.

The next requirement is some means of knowing exactly when to cue the commentator. Of course, if you know your film very well you may feel that you can bring the commentator in precisely where you want him without any aids at all. Much depends on how important you regard a closely synchronized commentary. Personally, I think that far too little attention is given to this. There is no better way to give a film a tight, controlled and smoothly efficient feeling than to have a perfectly matched commentary in which every word and phrase is heard exactly where it should be. Naturally, if the script has not been written tightly to picture in the first place, no amount of juggling with the timing later is likely to improve matters. But if the commentary has been written to fit the visuals closely it is almost impossible to bring the commentator in at the exact split second without some form of cue, however well you know your film.

Cueing the Work-Print

Undoubtedly the best method is to place cues on the film that can be seen on the screen. The most satisfactory of these is an oblique line drawn with a Chinagraph pencil from one side of the film to the other over a dozen or more frames; it produces the effect, when projected, of a line that moves from one side of the screen to the other in the course of half a second or so. This has the advantage over a single mark such as a cross or circle that you are given time in which to react. If you aim at cueing the commentator when the line reaches the far side of the screen you have the interval it takes to get there in which to prepare yourself. Naturally, you place the cue half a second or so ahead of the actual point at which the commentator should speak to allow for *his* reaction time. If your work-print already carries various other pencil marks, such as indications for fades and dissolves – which it probably will by this late stage in production – confusion can be avoided by using a Chinagraph pencil of a distinctive colour.

It might be thought that, having gone to the trouble of putting such clear and elaborate cues on the film itself, the commentator could just as well take his own cues from the screen. This is, in fact, possible, and there are many commentators who regularly do this,

199

particularly in television work and newsreels, where speed is paramount and preparation time has to be cut to a minimum. However, apart from the drawback that the commentator's attention is divided between the script and the screen, so that he may lose his place or be unable to give his best through the inability to concentrate, there is another difficulty. It is very important that the commentator speaks with his mouth at the same distance from the microphone throughout if consistent quality and volume are to be obtained. If he is sometimes looking at the script and sometimes at the screen, this position will be difficult for him to maintain.

Cueing by Footage

An alternative type of cueing that is often used is by footage. Many recording studios are equipped with a footage indicator suitably placed close to the recording desk. If the work-print is run through a measurer beforehand and the relevant footages are marked beside the cue points on the commentary script, it is quite feasable to cue the commentator by this method. It has the advantage that you know, since you are watching the indicator all the time, just how long you have to wait for the next cue. If you are on the 125 ft. mark and your next cue is not until "152", you know that you have plenty of time and can be quite unhurried. On the other hand, if your commentary is one that has to be closely synchronized at very short intervals – suppose, for instance, you have to. synchronize the names of a number of items in a technical film precisely as they appear – you may find it difficult. You have, after all, to read the numbers that are written on your script beside each cue, and watch for them to come up on the indicator. In looking from one to the other with fractions of a second to spare you may well get lost. Another drawback of this system is that, should a cut be made in the picture after the writing of the commentary for some reason, all the cueing footages will be wrong and will have to be altered. Altogether there is a great deal to be said for the method of marking the work-print itself by means of oblique lines.

It may be thought that to divide a commentary up into short phrases, each to be spoken on cue after a pause, would produce a very unnatural effect. In fact, professional commentators are so expert at controlling voice and inflection that perfectly natural results can be obtained. Let's look at an example of this kind of thing from the script of a technical film that called for accurate matching of individual phrases between commentary and picture:

200

Picture	Commentary
Interior: laboratory	
Medium shot of a large mixer operating.	And then, after some further mixing . . ./
Close up of a balance.	the pigments are prepared./
Big close up of pigment.	This is done by mixing a basic shade . . ./
Medium close up of one pan of the balance containing powder. Pigment is added.	with a certain amount of the powder./
Dissolve to	
Medium shot: weighing out materials.	The preparation of the liquid is carried out with the same care. The raw materials are measured out,/
Dissolve to	
Close up of boiling liquid.	dissolved,/
Dissolve to	
Close up, filtering.	and filtered./
	(/ indicates pause.)

Placing of Commentary in Relation to Picture

It is not always merely a matter of positioning individual words so that they are heard the instant something appears on the screen. Often the placing of a whole sentence is important. Frequently it is necessary for a sentence to continue across a change of scene in such a way that a particular word occurs immediately after the change. Take, for instance, the following example:

> On the screen is a map of the Nile Valley. One by one the situation of the various barrages on the Nile is shown. Meanwhile the commentator says:
>
>> Some control of the waters has been obtained by the construction of barrages at Delta,/
>> Nag Hamadi,/
>> Asyut,/
>> and Esna. But the greatest work that modern engineering has so far brought to the Nile in Egypt is the . . .

At that instant a strong upward angle of a large dam is seen. The commentator completes his sentence *without* a pause:

> . . . Aswan Dam./

and the loud roar of water rushing out through the sluices is heard.

It is obvious that the positioning of the words "Aswan Dam" at that precise moment was important, to add to the dramatic effect of a forceful shot. But to achieve it the sentence had to be cued to start some time before the change of shot – about $3\frac{1}{2}$ ft. of 16 mm.

Some scenes require identifying immediately they are seen and some do not. Usually it is the shots that do not follow logically from the one previous that require identifying promptly.

For instance, continuing the above example, after a closer shot

201

of the water rushing through the sluices there followed a shot of a wide expanse of calm water. This scene might appear to have no logical connection with what has just been shown – or, at least, the audience would have no means of knowing whether it was another part of the river, a nearby lake or something quite unrelated. It is not good, in a factual film, for the audience to be puzzled, for however short a time, and unable to follow the logical train of thought that should proceed through each sequence. But as soon as the commentary is closely synchronized with the picture the reason for this shot becomes obvious.

Over the dam the commentator says: "It has created a reservoir . . ." and on the word "reservoir" the expanse of water is seen. The commentator continues: ". . . capable of storing five thousand million cubic metres of water."

Now the connection of the smooth sheet of water with the dam is instantly clear. The sequence progresses logically. Once again, a sentence that bridged two scenes, precisely timed, has served a very useful purpose.

Occasionally, of course, there may be a good reason for keeping an audience guessing. We do not *always* wish to identify everything the moment it is seen. But quite often the failure to do so is loose film-making and the audience is left with a vague feeling that the film does not flow logically and smoothly.

Let's give another example. In this case the following shot has *no* apparent connection with what has gone before. The shots of the dam and the reservoir dissolve to some plans. It cannot be at all obvious what the plans are or why they have been introduced at this moment. If the commentary lagged here, confusion would definitely arise in the audience's minds. But if the commentary is brought in right on cue, the sequence appears smooth enough:

> In 1946 a new page was written in the history of the Nile, for in that year plans were drawn up for a hydro-electric power station to be constructed here at Aswan.

Ideally the word "page" should be synchronized with the shots of the plans – that would produce a slightly smoother effect than synchronizing the word "In . . .". This is another occasion when a sentence bridges a change of scene rather than starts on a new shot.

There are, of course, plenty of occasions when the picture should lead the commentary. Let's take an example once more from the same film. In an earlier sequence there are several scenes of the

202

ancient Egyptian methods of irrigation: the "shadouf" – the crude leather bucket on the end of a pole counter-weighted with mud, the saquia – earthenware pots on a wooden wheel rotated by a circling ox, and what is known as the Archimedean screw. At the *end* of this sequence the commentary comes in:

> Through the ages many ingenious methods of irrigation were developed to make the fullest use of the precious water . . .

In such a case the scenes have been self-explanatory and it is better for the commentator to add his remarks at the end.

The careful placing of commentary contributes greatly to the smooth flow of a film.

We have discussed methods of obtaining synchronism between commentary and picture and its importance at some length. Let's turn now to some of the ordinary, practical problems that are met when the commentary is being recorded.

Avoiding Paper Rustle

There is, for instance, that very basic requirement of ensuring that the turning of pages or the rustling of the script is not picked up by the microphone. This is usually got around by mounting the pages of the script separately on cardboard. There is still the problem of how to attach the sheets to the boards. Rubber bands are commonly used, but they can become caught in the adjacent board and emit a loud "twang"! Paper-clips are an alternative, but there is a great tendency for one board to become attached beneath the clip on the next just at the moment when it is necessary to move quickly to a fresh page. A possibility is to use an adhesive such as Cow gum, but this may take longer. An ingenious alternative is to type the script on blotting paper which will not, of course, rustle. The drawback here is that it is not easy to take a carbon copy when typing on blotting paper – unless the blotting paper *is* the carbon copy, in which event the commentator may not find it clear enough to read. Whatever method is adopted, it is important to type on one side of the paper only, using a large typeface and double spacing. It is not easy, under any conditions, to read for ten minutes without fluffing; nothing is more likely to cause a fluff than a script that is overcrowded, full of last-minute alterations or in very small type.

Dealing with "Fluffs"

And talking of fluffs – a word that describes so well those slips of the tongue made by those whose fate it is to perform before the

microphone – these are bound to occur even when the finest commentator in the business is being employed. Generally speaking, it is best to agree with the commentator beforehand that you will go straight on, after a very brief pause to allow the scissors to be inserted later, and retake the affected sentence afterwards. Retakes should be made as soon after the end of the section to which they relate as possible, both as regards time and position on the magnetic film. Voice quality is a very subtle thing and can be affected by the slightest change, either acoustic, electronic or vocal. It is vital for a sentence or phrase that is to be cut into the middle of a recording to replace a fluff to be recorded at the same speed, in the same tone of voice, at the same strength of voice and at the same distance and angle from the microphone. Naturally, also, the gain control on the recorder will have to be at exactly the same setting. There are, in other words, a great many variables and the task of achieving retakes that will cut in undetectably in place of fluffs is the severest test of the calibre of a commentator.

For similar reasons I emphasized that a retake should be recorded as near as possible, in linear distance on the magnetic film, to the section of commentary to which it relates. Changes of signal characteristics do take place as apparatus warms up. Different rolls of magnetic film may have been manufactured at different times and they, too, may have slightly different characteristics.

It must also be borne in mind that acoustic characteristics can be varied to an audible degree in a recording studio by a change of position of persons other than the commentator. If a retake is recorded with the person who had been cueing missing from his seat beside the commentator, there can be sufficient acoustic change for the recorded signal to be affected. A good commentator speaks with his mouth at a consistent distance from the microphone – another thing that distinguishes the experienced and competent commentator from the novice.

In the case of certain modern equipment the recording of retakes at the end of the session may be eliminated. Magnetic systems now exist in which it is possible to stop both picture and sound track when something goes wrong and reverse, still keeping both in step. The equipment is then re-started at some point before the fluff, the recording being played back until an agreed point is reached. At this instant, a switch is pressed and the machine resumes recording, erasing the previous passage. Such a machine must be capable of being switched from replay to record without making a click on the track.

To be able to correct recordings immediately in this way is a great advantage. Variations of voice level, speed of reading and acoustics can be eliminated and a great deal of time that would otherwise be consumed in cutting in retakes afterwards can be saved.

The Commentator's Style

We have not referred to the problem of getting the commentator to give you the style that you require for a particular film. The commentator often comes straight to a job with no previous knowledge of the film in question. It is obviously desirable, as was suggested earlier under planning, to send a copy of the script to him a day or so beforehand so that he can study it at leisure before he is thrust into the pressure of a recording studio. But even if this has been done, he still hasn't seen the picture. Professional commentators are very quick to recognize the need for a particular style and a few words of explanation, added to what has been gathered from the script, will probably be all that is required. Then, a rehearsal of the first reel will prove whether any further instructions are necessary. If the film is an unusual one and a particular style is called for, it may well be helpful for the director to read the commentary to the picture in a preliminary run-through while the commentator sits back and absorbs the mood and subject-matter of the film. Like most things, this will depend upon the budget, for if you are hiring a recording studio at a not inconsiderable sum per hour, it may add substantially to the bill.

Need for Rehearsal

It is always desirable to rehearse before actually recording. But it may be necessary to rehearse the first reel only of a multi-reel picture. This first rehearsal will iron out many snags; it will become immediately apparent, for instance, whether the pace at which the commentator begins is going to be the right one for the film. Good commentators will quickly get the feel of a picture, find the pace that is correct, and settle down to maintain it for the rest of the session. It may well pay off, after the first reel, to put the trial run of subsequent reels "in the can" – in other words, actually record the rehearsals. Magnetic film is not consumable; it costs nothing to erase a take and record it again, and if you succeed in getting even one reel without the need for a repeat you are in pocket. And occasionally a first take has a freshness and spontaneity that can never be repeated.

Handling the Recorded Commentary Track

It is essential for the sound recordist to label all takes at once and keep accurate log sheets. It is very easy, after a long session in which numerous takes have been recorded, to wonder which of the several reels of magnetic film that are lying beside the recorder are the ones carrying the best performance! And a great deal of time can be consumed in running them through again to find out. Similarly, it is most important to be very methodical regarding the labelling of short retakes of fluffs. Here again, great confusion can result from failure to separate the good takes from the rejects. One of the most desirable attributes in a sound recordist is a methodical mind.

It is very helpful to ask the commentator to record, just before each retake, such identifications as "Retake, page 3, paragraph 4" and, if there are further retakes, "Retake 2" and so on. If the script itself is clearly marked to show exactly where retakes have occurred and where there have been changes of reel, this again will greatly facilitate the assembly of the track later.

Finally, it is good practice to listen to the whole of the recording before the commentator leaves in case there has been a fluff that was not noticed at the time or a "drop out" in the tape – that is to say a portion of tape with reduced sensitivity causing a drop in volume or change of quality. There may have been a momentary mechanical or electronic fault in the recorder – a failure of the tape to maintain consistent pressure against the recording head, for instance – that makes a further retake necessary. Nothing is more annoying than to find that you need a couple more words from a commentator who has just gone out of the door and vanished beyond recall in the crowd outside.

Post-Synchronous Recording of Dialogue to Picture

While we are discussing recording to picture we should not omit a reference to that other aspect of this kind of work, fitting words to lip movements post-synchronously. As we found when discussing recording on location in Chapter 9, some interior locations present difficulties of acoustics that cannot be surmounted, while out of doors, wind may be picked up by the microphone and render good recording impossible. Either outdoors or indoors, extraneous noises over which the producer has no control may penetrate to the sound track. Occasions when dialogue has to be added to picture after shooting are by no means rare, therefore.

206

Fitting words to lip movements is surprisingly difficult. Even when the very person who was filmed is asked to post-synchronize his voice to his own picture, the greatest difficulty is often experienced. I remember asking a parson to speak the first lines of the 23rd Psalm to his own picture on the screen and he found it impossible to say the words in step with his lip movements, although he must have repeated it countless times before.

Recording to Picture Loops

The best method is to divide up the picture and dialogue into very small sections, preferably separate phrases. The picture is then made up into a series of loops and each loop is projected continuously. The speaker then practises until he gets the timing correct. The sound is recorded on to magnetic film, often also in the form of a loop, and as soon as a perfect take is achieved the recorder and projector are stopped.

The task of piecing together both the picture and the sections of sound relating to them afterwards and laying them in synchronism is no small one. Nevertheless, this is the only method likely to produce results that look and sound convincing. If a guide track was recorded at the time of shooting this will help a great deal. It may be possible for the speaker to voice his words in time with the guide track played back to him over headphones. Sometimes a combination of both methods is used.

Recording dialogue to loops has been brought to a fine art in the feature film studios as well as in the dubbing studios who prepare foreign versions. In the latter case the words being spoken are definitely not those that were spoken by the character who was filmed, of course, and there is the added problem of finding words in the new language that will both fit the lip movements as closely as possible and convey the original meaning.

But we must return to the problems of handling the commentary track.

Laying the Commentary

The process of editing the various types of sound track is known as "laying". Laying the commentary track involves cutting retakes in position in place of fluffs and placing the whole thing accurately in synchronism with the picture. Even though the commentator has been cued as precisely as possible, using one of the methods described, there is a limit to the closeness of timing that can be achieved and some degree of correction will probably be called for.

207

Fortunately, with magnetic recording it is possible to replay the commentary at once. There is no longer the stage of sound-track processing, necessary with optical tracks, to delay matters. As soon as the commentator has left the building, laying can begin.

The most useful device for track laying is a track reader. This instrument is small enough to sit on a bench and through it, by means of normal rewinds, the sound track can be drawn. The magnetic film passes a replay head and the signal is reproduced through a small amplifier and loudspeaker. Naturally the quality is poor, because, apart from anything else, good sound depends upon the recording being drawn past the head at a constant speed, something impossible to achieve when winding the film by hand. However, we are not concerned with quality – that was checked in the course of playback on the main amplifier system at the end of the recording session. All we wish to know at this stage is what commentary is carried at any point on the track; we need to be able to find our way about the recording we have just made, in other words. And the reproduction of the track reader will be quite adequate for that.

The first task is to get all the sections on the bench in chronological order, ready for assembly, and to separate out all the retakes so that they are ready to hand for cutting in. The whole of the commentary recording is run through the track reader and the portion relating to each reel of picture carefully labelled with Chinagraph pencil. At the end of each reel, the retakes belonging to it will probably be found. Before cutting these apart it will save time later to mark the first and last words of the retake, exactly where they occur, on the magnetic film: by running it backwards and forwards over the replay head their precise position can be found. Then the retake section is cut and kept separately, after first labelling it. The fact that the commentator recorded the identification before each retake now proves its value, for by listening to his voice you can write down "Retake, page 3, paragraph 5" or whatever he tells you. It is better to leave these identifying words attached until the retake is finally cut in place – just in case you write the wrong number down or the pencil marks get rubbed off.

It is important to make sure that the scissors you use for cutting the track have been de-magnetized. This can be done with the ordinary bulk-eraser that is used to erase whole reels of tape – an accessory with which any well set-up sound studio will be equipped. Similarly, the film joiner used for splicing magnetic film must be non-magnetic. If the model used has been designed for the job, it

will contain the minimum amount of iron and steel; even in such instruments the cutting blades may be capable of becoming magnetized and should be checked from time to time.

If the scissors or joiner do become magnetized, they may introduce clicks on to the magnetic track and these may be a nuisance to remove.

Another point to be watched is that you cut well clear of the beginnings and ends of words. A track reader is not intended to be a high-quality sound reproducer and the letters "h" and "s", and vowels at beginnings and ends of words, may be difficult to hear clearly.

Using the Synchronizer with Track Reader

When you have the reels and the retakes cut apart, labelled and in order on the bench, you are ready to lace up the four-way synchronizer with the track and picture. I suggest that you use a four-way and not a two-way, if you have one handy, because, as you will see in a moment, extra channels are useful when cutting in the retakes. On to the four-way you clip a magnetic head that will reproduce the commentary through the track reader amplifier. It is unlikely that you will have put any START cues on at the recording stage, so your first task is to get picture and track into their correct relationship with one another. This is best done by running the track through the track reader until the first word of commentary is heard. This can then be written on the track at the exact point at which it occurs. Then the picture is placed in the four-way so that the picture where this first word should be heard is beside it. This point is easily found, if you cued the work-print using the Chinagraph line system, because the first cue line will be clearly visible to guide you (another argument for using the Chinagraph pencil system of cueing). If you used some other system, you will have to identify the point in the picture at which you require the commentary to start by viewing the film on a viewer or Moviola and making cue marks. If you used the footage-counter system, many four-ways are fitted with a footage and frame counter and you can lay your commentary to the same footages as you recorded it.

Having laid the first word of commentary against its relative picture, you now run back to the leader and place a START cue on both picture and track. It is a good system to decide, as part of your cutting-room routine, on a standard position for sound cues both at the front and end of reels. The film editor can punch a cue hole the agreed number of feet before the first frame of picture as soon

as he has completed his editing and this cue will serve everyone for all stages of sound laying and mixing afterwards. The START cue on the magnetic track is placed exactly opposite the picture cue and is known as a LEVEL SYNC. cue – for reasons to be discussed later.

Bringing the Commentary and Picture into Precise Synchronism

Now that you have your LEVEL SYNC. and START cues you can wind forward through the reel. If you cued the commentator accurately at the recording session, all the subsequent cues should come up in their correct places. However, it is almost certain that some words whose timing is very critical will come up slightly too early or too late. Adjustment can now be made and the error corrected. If the word is too late, you wind back to the nearest pause immediately before this point and remove the number of frames by which the word was late. This will correct this particular error, but it must be remembered that it will throw out all the commentary that follows. The piece of track that has been removed should be kept to be inserted at the next pause to bring the remaining commentary back into sync. again – and it is as well to keep a note of how many frames you removed just in case this short length gets lost or mixed up with other surplus.

If the word came up too soon, you have to reverse the process and add the necessary number of frames to the previous pause to delay the track by that amount. Once again, all that follows will have been affected and the same number of frames will have to be removed from the next pause to bring the remaining commentary back into synchronism. I am referring to the amount of track to be cut or added as so many "frames" simply because this is a convenient unit of length. Obviously the sound track has no frames, but the picture has and they are the easiest units of length to count. The track has perforations – four per frame in the case of 35 mm. and 17.5 mm. (all that I am saying refers equally well to 17.5 mm. as to the other two sizes of sound track, of course), and one per frame in the case of 16 mm.

A very important point, when adding extra magnetic film to extend pauses in this way, is that the film added should be what is called unmodulated or "buzz track" – that is to say, it must have been passed through the recorder at the time that the recording was made while there was silence. It will then have the same characteristics as regards "background noise". Wherever sound is recorded, even in the most perfectly sound-proofed and damped studio, there

210

is a slight amount of general background noise and to this is added the electronic hiss and minute amount of hum that exist in all recording systems. In a good system this background noise will be at a very low level, but it will always be there. If you merely cut in a piece of virgin film, taken from a reel that has not been through a recorder, it will have no background noise at all and will sound absolutely dead. This short dead section will stand out from the rest of the track – it will sound as though someone has switched the sound off and on again and, electronically speaking, this is exactly what has happened. Of course, if the commentary track has to be mixed with music and effects tracks, this change of background will tend to be covered up and blurred over. But the chances are that it will still be discernible even in the finished optical track. It is not worth taking this risk. Most tracks have a few feet at the front or end, or before or after retakes, that can be robbed for cutting in this way. Nevertheless, it is a good idea to let the recorder run for a few seconds at the end of a session to provide you with a quantity of buzz track for such purposes – it's surprisingly difficult to find buzz track that will match a particular recording if you do run out while track laying.

Cutting in Retakes

So much for synchronizing the commentary. There is also the matter of cutting in retakes. Since you found and labelled your retakes before you started laying, they are there on the bench ready to hand as soon as you come upon a fluff that needs attention. Your aim is, of course, to cut in each retake so that it will exactly replace the section to be removed. You will be working with the marked copy of the commentary script from the recording session in front of you, and so you will know exactly how many words have been repeated. You pause, as the first word of the retake passes the head of the track-reader, and write it on the track so as to indicate its position precisely. You now wind on and do the same with the last word of the retake. It is now that you reap the advantage of having indicated, as I suggested earlier, the first and last words on the retake. And since you are using a four-way and not just a two-way, you have two spare film channels at your disposal. You can now place the retake in the third channel in such a way that the first word is exactly beside the first word of the section to be replaced. Before making any cuts, you run forward to see whether the last words in each case also come up side by side. Having compared the two for length, you now cut the retake in place of the defective

211

section – taking care to put in exactly the same length as you have taken out. You carry out this operation without removing the main part of the track from the four-way synchronizer. Neither picture nor track should be removed until the whole reel has been laid.

When all the retakes have been cut in and the whole commentary has been laid so as to fit the picture exactly, it is a good idea to put an END cue on picture and track in the same way that you put START cues. This enables you to check at any stage later that synchronism throughout the reel has not been lost.

Running Double-Headed

The commentary should now be checked on a sound and picture editor or projector capable of running double-headed – that is, running separate picture and track – to judge the final effect. Commentary laying by means of a track reader is a useful and speedy method, but it is, at best, somewhat mechanical. It is not possible to judge the effect of the timing of the commentary from an artistic point of view. It may be, when you see and hear picture and track under more normal conditions, that you will have second thoughts regarding the timing of some parts of it – in which case you will have to return to the track-laying bench and make adjustments accordingly.

It is also important to listen carefully to the track on a good-quality reproducing system to make sure that everything is in order. As I mentioned, it is very easy to cut off the ends or beginnings of words, using a track reader, particularly words beginning with an aspirate or beginning or ending with a sibilant. Fortunately, proper magnetic film joiners using tape make a butt join and no portions are lost, and so it is usually possible to trace the missing portion and replace it. This is another good reason for discarding nothing at all, picture or sound, until a production is absolutely complete. You must also listen to make sure that no clicks have crept in due to any portion of the joiner or the scissors having become magnetized.

The Music Track

In the film that is to contain music the next step will be to lay the music track. If the budget has permitted a specially composed musical score to be written and recorded, the problems of laying should be minimized. Since the music will have been specially composed to fit the picture, and recorded to the picture while projected, the track, when it is laid to the work-print, should match it. It will now be necessary only to assemble the various music sequences,

212

linking them where necessary with blank film – assuming, as is most likely, that the music is not continuous throughout the picture. We now have a music track that is the same length as the picture and its commentary or dialogue track, and thus they can all be run through in synchronism together. It is not necessary, of course, to use unmodulated track to fill in the silence between sections of music as it was between portions of commentary, because the gain control governing the volume on the music track will be turned to zero between the various musical passages.

Library Music

If a specially recorded musical score has not been provided, ready recorded music will have to be used. The choosing of appropriate music is an art in itself. A feeling for what is suitable can be developed by those with a basic appreciation of music and the fitting of music to film is a very fascinating occupation. Generally speaking, ordinary commercial recordings (i.e. normal gramophone records) may not be used for the purposes of "dubbing" on to film, as in many instances this is precluded by the terms of the contract with the composer, arranger and musicians. Where permission can be obtained, the royalties payable are often high. Similarly, it is not permissible to take recordings from the radio or television and use them, without special permission – and such permission would only rarely be granted.

Fortunately, a wide range of what is often termed "mood music" has been specially recorded for use in films, television and radio shows. Everything depends upon the way in which this music is selected. Since it has not been composed with a particular film in mind, it will rarely follow the mood of a picture for very long. It must not be expected, therefore, that whole pieces can be used. Very often quite short passages have to be selected, frequently not even from the beginning of a composition. The art is to select from any part of a piece of music, fading it in or out, or mixing at the appropriate point to something else. Some care is necessary to avoid mixing orchestras of very different kinds and pieces of music in entirely different keys. The results, however, can be far better than might be at first imagined, probably because in films the music is usually broken up with sound effects, dialogue and commentary. Such interruptions can be used to make changes that might otherwise be unpleasant.

It goes without saying that all music, even when used principally as a background to dialogue or commentary, must be thoroughly

213

appropriate to the visuals. There are all too many films in which this elementary point is overlooked. Another basic rule is that music should not be continuous – any more than commentary should! If music runs without a break through a large part of a film, it has a drug-like effect on the senses and the audience ceases to be aware of it – except, perhaps, as a vague irritation in the background. Music must "do something" for a picture – something more, that is, than fill in awkward pauses between the speech. Music in the right mood introduced at a scene change, or at a moment of climax, will point the visuals most tellingly, and it will do this far more effectively if there has been no music immediately preceding it. Even in the most undramatic and unemotional documentary, music carefully chosen and used selectively can point the film and add greatly to the impact. The important thing is to decide what it is that you wish the music to supply that the film without it might lack.

Pre-recorded music is available in three forms: on magnetic film, magnetic tape or on disc. Which you use depends upon the facilities and the time available to you. Generally speaking, the tendency is for 35 mm. workers to use pre-recorded music on magnetic film and for 16 mm. workers to use it on disc, but this is by no means always so. There is a case for and against both systems. Magnetic recordings do not easily deteriorate due to wear, so that however many times you play and replay the music during laying and rehearsals, quality will not suffer; secondly, a recording on film can be placed exactly where you wish it to be in relation to picture and there is no guesswork or human element to upset matters. The disadvantage is that it is not quite so quick to handle as disc. If you wish to find a particular point in a piece of music you have to run backwards and forwards through a reel to find it. This gives disc its great advantage – you can drop a pick-up at any point, and having found the beginning of the passage you want you can mark it with Chinagraph pencil, or note the position of the pick-up on the dropping arm, and find it again immediately. On the other hand, discs tend to wear and produce surface noise, even when they are carefully handled and regularly cleaned.

Laying Magnetic Music Tracks

To be able to use music on magnetic film you must have several replay channels available, interlocked with one another so that they run in step. You also require the facility to transfer the sound from one piece of magnetic film to another. Having selected your music for a given sequence and timed the sequence, you re-record

214

it, allowing a few seconds extra, on to another length of film. This piece of film is then laid beside the picture in the four-way synchronizer so that it is in the correct relationship with it.

Your aim is to produce not one music track, but two. The reason for this is that you will wish to mix from one piece of music to the next to produce a smooth transition. This can be achieved by placing each piece of consecutive music in alternate tracks. They must overlap for a short distance to enable you to mix one into the other – hence the few extra seconds over and above the length of the relative picture sequence. Naturally, if there is a gap between two pieces of music they can both be in the same track. As before, each should be a little longer than will actually be required, so that the recordist has time to fade down at the end of the first and up over the beginning of the second.

Music laid in this way can be kept exactly in step with the picture. If a certain chord is intended to accompany a certain action in the picture, it can be placed beside it in the four-way synchronizer and it will be heard at that instant. The two music tracks are made up to the full length of the picture reel, the intervals between music on either reel being filled in with blank film. At a later stage these two music tracks will be mixed with the effects track, if there is one, to produce a music and effects track. Finally, the music and effects track will be mixed with the speech track to produce a single master track.

Mixing Music from Discs

Using pre-recorded music from discs, a similar procedure can be followed, although not with quite such split-second accuracy. The

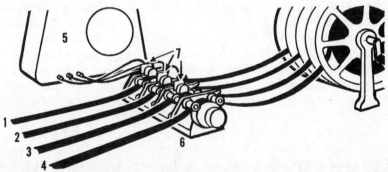

SYNCHRONIZATION. With a 4-way synchronizer, 6, up to three tracks, 1, 2 and 3 can be laid in synchronism with the cutting copy, 4. The amplifier, 5, reproduces the sound picked up by the heads, 7, from the magnetic films. Sound reproduced by drawing the tracks past magnetic heads by hand in this way will be distorted but it will be clear enough to enable it to be identified, which is all that is required at this stage.

215

discs are selected and where a particular passage is required a disc is marked to indicate where the pick-up is to be dropped. At least two turntables and pick-ups are required, and preferably three or more, with provision for mixing the sound from any or all of them. It is usual to have special pick-up droppers fitted to enable the pick-ups to be suspended above any groove on the disc. At the appropriate moment the pick-up can be lowered into the selected groove and will start playing instantly. In fact, with the modern long-playing micro-groove discs it is difficult to mark an individual groove with a wax pencil and, furthermore, particles of wax tend to clog the grooves and introduce background noise. Selecting the appropriate groove with the aid of a dropper carrying a numbered scale is much to be preferred. In the old days of 78 r.p.m. discs the wax pencil method worked quite well.

The transferring of sound from disc to a sound track is known as dubbing. To run a successful dubbing session, in which a number of passages of music from various discs will be woven into one music track, accurately timed to the picture, calls for some organization plus skill on the part of the operators. It is necessary to have an accurate cueing system to indicate where music is to be introduced, mixed or faded out. One good method is to mark the work-print, run it through the projector synchronously with the recorder, and watch for the cues to appear on the screen. A series of cues indicating the point at which the pick-ups have to be dropped and the discs mixed or faded can soon be evolved. They can either be scratched on the work-print or drawn on with Chinagraph pencil. Alternatively, our old friend the footage counter can be pressed into service again. If a careful cue-sheet is prepared, indicating all the music changes and footages at which they occur, the whole operation can be done without the need to project the picture. There is little to choose between the two methods. The preparation of the cue-sheet with the appropriate footage numbers may take longer than placing cues on the film itself and this may be the deciding factor. Also, using the footage-counter system, the sound operators do not have the same "feel" of the picture as when it is there on the screen in front of them.

Using discs in this way is not quite so accurate mechanically as laying magnetic tracks. The human element enters into the dropping of the pick-ups precisely on cue. A double movement is called for because the instant the pick-up has been dropped into the groove, and not before, the knob on the mixer has to be turned up to bring up the volume. And if several different discs are required in the

216

course of a few seconds some smart work is needed to make sure they are on the turntable by the time they are wanted. Even if all the cues are faithfully observed, the pick-up may be one or more grooves either side of the one that was intended. Timing to a split second, therefore, cannot be achieved with certainty.

All the same, such precise timing is not very often called for, and this method, when carried out by an experienced crew, can give excellent results. It is also, in some ways, more flexible than the magnetic film system, because if a change of music, or the timing of a mix or fade, is called for, the discs can be rearranged much more quickly than can the re-laying of magnetic tracks.

It is, of course, quite possible to combine the two systems in order to get some of the advantage of both. After using discs to select the music, the passages required can be transferred to magnetic film which can then be laid on the four-way in the manner described previously.

As a rule, magnetic track laying is carried out where the budget is larger, and discs are used on the more economical jobs.

Music Royalties

A royalty is normally payable on all pre-recorded music incorporated in a film. A music cue-sheet must be compiled giving full particulars of every piece of music used, the duration of each, the name, type and gauge of the film and the kind of distribution for which it is intended, and the territories in which it will be shown. This cue sheet must be submitted to the publishers of the recording or, if they are members of a central body, to that body. (In Britain, for instance, the majority of recorded music publishers belong to the Mechanical – Copyright Protection Society.)

Effects

We have referred to speech and music. There is still the third ingredient of the sound track to be considered, effects. As I mentioned earlier, the decision has always to be made whether to record the effects on location, with or without the camera running, or whether to fake them afterwards in the studio. I referred to the many problems met with when recording on location – extraneous noises, bad acoustics, wind in the microphone, and the need to silence the sound of the camera. For this reason I suggested that many effects are best recorded in the studio. This is another occasion when we think gratefully of the benefits of magnetic film recording over older methods. It is one thing to record an effect and make it

217

sound just like the real thing. It is another matter to synchronize it precisely to picture. But if the sound is recorded straight on to magnetic film, it can be cut, moved forward or backward, and generally adjusted until it fits. An example will show just how useful this can be.

In a classroom film it was desired to show how the vibration of a reed is the means by which the woodwind instruments in the orchestra produce sound. To lead into the subject in an interesting manner, a schoolboy was to be shown plucking a leaf from a hedge and placing it between his fingers and blowing. The question was: Should the resulting squeak be recorded synchronously while shooting, or "wild" afterwards? The arguments against recording it at the time of shooting were quite numerous: (1) It is not easy to make this sound with certainty every time you try; there might be many false takes; (2) It was windy and there was the danger of "wind in the microphone"; (3) The traffic could not be controlled and unwanted traffic noises might mar the recording; (4) The amount of additional apparatus required for sync.-sound shooting is considerable – camera blimp, synchronous drive for camera and recorder (or a linking pulse system), microphone and boom, clapper board, plus extra personnel to operate it all. To this must be added the reduced mobility of a blimped camera over an unblimped one. It was decided to record wild.

When the shooting was complete, a series of squeaks were recorded separately. They were recorded out of doors so that the acoustics would match – there is a noticeable difference between sounds out of doors and sounds indoors. A well-damped studio *can* enable sounds to be recorded that will pass perfectly as exterior sounds, but in this case it was simple to make the recordings out of doors anyway. A different location was chosen where no traffic was likely to intrude.

Obviously the timings of the squeaks so obtained would not match with the picture. They were recorded on magnetic film, however, and so they could be edited easily. When the work-print was available it was put through a viewer and the points at which the boy blew were marked up, a Chinagraph line being drawn to show the duration of each blow. The squeaks on the magnetic film were marked up in the same way. It was then easy to look along the magnetic track and select squeaks of the right duration to match each one in the picture – we had recorded a considerable number to give ourselves plenty of choice. In the one case where a squeak of the precise length was not forthcoming, we chose one slightly longer

218

and cut a piece out of the middle to reduce it to the right length. Cutting the middle out of such sounds, to shorten them, is a good idea – if you cut off the front or the end the result is unnatural.

The effects track that was achieved in this way sounded perfectly natural and the expenditure of time and manpower was considerably less than would have been involved in shooting synchronously. Furthermore, an acceptable result within a given time was assured – by the other method results might not have been good, due to any reasons given above, even after a considerable expenditure of time and filmstock.

The Sound Effects Library

It is not, of course, necessary to record all the effects specially. Many of the more common ones can be obtained ready made, either on magnetic film or disc. The required length can be re-recorded on to magnetic track and cut in place in correct relation to the picture. Continuous sounds, such as wind, sea, traffic, crowd noises and applause present few problems – more or less any part of the recording will fit any part of the picture. Variable noises, such as the sound of a passing train, or percussive noises such as the sound of hammer blows, present much greater difficulties. They have to be laid carefully to synchronize with the picture.

Mixing the Various Sound Tracks

If there are to be many sound effects, it will be necessary to build up a composite effects track in the same way as we did with the music track. If two effects follow one another and have to be mixed one into the next, the best way is to make up two tracks with one of the effects in each, overlapping to allow for them to be mixed at the appropriate point in the picture. Of course, if you already have a commentary track plus two music tracks and you are now adding two effects tracks you will need a system capable of mixing five channels on to a master track. Such systems are available – in fact there are systems capable of handling many more tracks than that. A detailed cue sheet will have to be prepared, indicating exactly where each channel has to be faded up and down, and plenty of time will have to be allowed for rehearsal. Several takes may be necessary to obtain the best possible master track, with all the ingredients from the various individual tracks faded and mixed at exactly the right moment and each at the correct volume-level in relation to the others. Since time is money, and studio hire is not cheap, the budget will have to be consulted and an estimate of the time likely to be involved worked out.

Of course, it is not necessary to mix so many tracks at once. Magnetic recording systems are so flexible and the quality losses in transferring from one channel to another so small that there is no reason why tracks should not be combined before the final mix. For instance, the two effects tracks could be combined to make one and, if the number of channels available was limited, the two music tracks could also be combined. It may, in any case, be very desirable to aim at producing a combined "*music and effects*" *track* that can be mixed with the speech track as a final stage. Foreign-language versions of films are very often required today, particularly in the television market, now that it is expanding to so many parts of the world. It is standard practice, when a film is required for use with a different language from the one it was originally recorded in, to request a separate music and effects track – commonly known as an M. & E. track. This can then be mixed with a commentary or dialogue track in the new language.

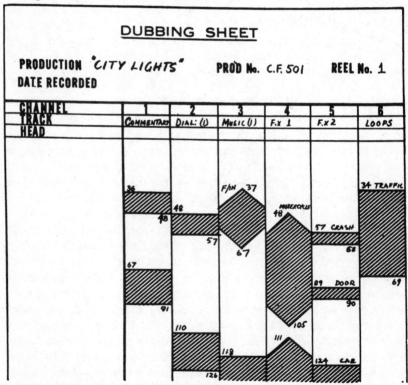

DUBBING CUE-SHEET. A portion of a cue-sheet for mixing 6 tracks. In this case, mixing is done with the aid of a footage counter.

220

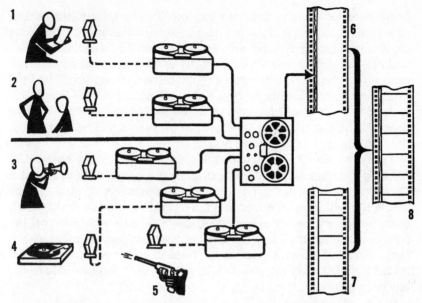

THE INGREDIENTS OF A SOUND TRACK. The commentary 1 and the live dialogue 2 are often combined to form a single speech track, before mixing with the music and effects. The music and effects track may consist of specially recorded music 3, library music re-recorded from disc, magnetic tape or film 4 and sound effects 5. When these five types of sound have been mixed to form a master magnetic this is transcribed to an optical track 6 which is printed with the picture 7 to produce a married sound projection print 8.

Sound Loops

It will be noticed in the example opposite that reference is made to a "loop". If a continuous effect (such as crowd noises, wind, traffic and so on) is required to be added frequently at various points during a reel, it is very useful to make this sound up into an endless loop and run it round and round continuously on one channel. Throughout the session this sound can be faded up whenever it is required. Care must be taken, of course, to see that no very distinctive noise occurs in a short loop or this may be recognized and the repetition at frequent intervals become apparent.

Simpler Methods of Mixing

The example I have given is for a rather complex sound track. It must not be thought that all sound tracks have to be as complicated as this. The track for a simple film may involve no more than background music and commentary, the music may be confined to the opening and the end, or there may be commentary only. The

D.F.P.–P

221

production of sound tracks can be simplified to meet a low budget in a great many ways. It is possible to record the music from discs on to a standard ¼ in. tape recorder. Provided this is of the type that will run at a very constant speed (preferably by means of a synchronous motor) the music can then be replayed on to magnetic film at the same time as the commentary is fed in. Even simpler, it is possible to feed the music off discs on to a single channel of ¼ in. tape or magnetic film at the same time as the commentary is being spoken, the result being a ready-mixed master track.

However, doing so much at one stage involves many chances of error. If the commentator fluffs, or does not come in on cue, or if a disc is not faded in or out at the right moment, all or much of the whole job will have to be repeated. To produce a track that is at all complicated by such methods becomes a feat of virtuosity on the part of all concerned. It is for this very reason that the more elaborate system of using a number of tracks, built up separately and mixed together only when each is as perfect as it can be made to be, has been evolved.

Checking Synchronism During Mixing

There is a practical point regarding the mixing of magnetic tracks that is worth bearing in mind. When several tracks and a work-print are to be run in synchronism, a START cue is necessary on all of them. The tracks and the work-print are laced up in accordance with these cues so that when they are all running they are in step. Should one of them have been laced up wrongly, or one channel not start up at the same instant as the rest, this may not be noticed until some way into the reel. When this happens a lot of time can be wasted in winding tracks and picture back and lacing up again. It is a much better idea to have an audible cue on each of the tracks that synchronizes with a visible cue on the work-print. These cues should be on the leaders, a few seconds after the START marks, so that they occur after tracks and picture have started up, but before the first scene appears. The track cues should be in the form of a short "pip" – in the case of the picture a punched hole will suffice.

It will now be instantly apparent if all the channels have started up in synchronism or not. If all the "pips" occur together at the instant that the punch-hole flashes on the screen, all is well. If one or other does not come up at the right instant it is a false start – no more time will be lost. This idea can be elaborated still further. "Pips" of different frequencies can be inserted in different tracks – a low note for a commentary, a high note for music and so on. It is

then possible to judge which track is out of sync. It is quite easy to produce "pips" of any desired pitch by recording on magnetic film a continuous note from a tuned oscillator set to the desired frequency, and cutting out short lengths of, say, one frame. This single-frame "pip" can then be cut in at an appropriate place in the leader.

These sound cues will serve another purpose later. Since they will be re-recorded on to the master track, the combined "pip" can be used for synchronizing the master track with the picture.

Producing the Optical Track

We have reached the stage where we have a final mixed master magnetic track. In some cases it may be necessary to go no further. Some television authorities – the B.B.C. for instance – often prefer to transmit a magnetic track instead of the optical track normally found on film prints. In this case START cues are marked on the front of the magnetic track to correspond with a START cue on the picture. The two are delivered for use in the telecine machine, which is designed to run them in step. The film print supplied is "mute" – the term used to describe the picture print of a sound film that has been printed without sound.

The time may come when the majority of film prints carry the sound on a magnetic stripe on the print itself. (Such systems as CinemaScope do so already, although this particular system is stereophonic and carries a number of tracks.) Until then, however, for normal film purposes we have to transfer our master magnetic track to an optical track. An optical track is a photographic track of the kind used before magnetic recording was invented, carrying the sound in the form of light and dark areas corresponding to the modulations of the recorded sound. Such tracks have the great advantage of being easily duplicated by ordinary photographic printing processes.

A magnetic track is referred to as being "transcribed" to an optical track. If you have made your own master magnetic track, you will now have to send it away to a studio providing the specialist service of optical transcription. Optical tracks can be made from 35 mm., 17.5 mm. or 16 mm. magnetic film, or from standard $\frac{1}{4}$ in. tape. In the case of the latter, some means of controlling the speed during transcription, such as a pulse, will be desirable to ensure that the resulting optical track will be the correct length for your picture. The speed chosen should preferably be $7\frac{1}{2}$ or 15 in. per second, regarded as professional speeds for this kind of work. The slower speeds now in vogue in domestic recorders do not necessarily

provide a high enough quality, and in any case you will have to discover what speeds the studio can cope with for transcription purposes. The tendency is for magnetic film in any of the three gauges referred to above to supersede tape for transcribing.

Characteristics of Optical Tracks

It is important that the optical sound track produced has the right characteristics to suit the type of filmstock to be used for your film prints. The characteristics required for a particular black-and-white negative stock will be very different from those needed for a colour negative process, for instance. The transcription studio must be notified, therefore, of the type of prints that will be made from the optical track, and of the type and make of stock. Optical tracks can be negative or positive; generally speaking, negative tracks are required where the picture master is a negative. Where a positive picture master has been produced, as in the case of 16 mm. black-and-white reversal, a positive optical track is required. This used also to be true of 16 mm. Kodachrome, but nowadays Kodachrome sound prints are produced from a negative sound track – despite the fact that the picture master, whether it is Kodachrome or Ektachrome, is a positive.

To obtain good-quality tracks, it is advisable to go even further. Every printing laboratory has its own techniques and works to its own standards of track density, exposure and development. For the best results it is as well to inform your transcription studio of the name of the laboratory you are using, as well as the details of the stock. Good transcription studios and laboratories work together and exchange information between themselves to produce the highest quality prints. Your laboratory will wish your transcription studio to give them a track of a certain density for each type of emulsion that they print on to. Only if they get the right kind of track can they be sure of giving you the best-quality sound in your prints.

Just how critical this matter of obtaining good-quality sound prints is will be appreciated when it is realized that there are five distinct stages in producing the printed track. First there is the quality of your master magnetic track – and quality includes the correct frequency range, response curve and volume to suit the characteristics of the transcribing machine. Second, the exposure given to the optical track during transcription is critical. Third, the development given to the optical track is critical – the track must have the density and characteristics called for by the printing laboratory. Four, the exposure given to the track by the printing

224

laboratory is critical. Five, the development given to the print during processing is also critical. Any departure from the precise standards set down for each of these stages will adversely affect the final track. These matters are not primarily the concern of the documentary producer, but if he has some understanding of what is involved he will be in a better position to secure good results in this last but most important stage of his sound-track production.

Cueing for Printing

Having obtained the optical track, there is one last stage to be attended to. The track must be cued up so that it can be printed alongside the picture master to produce prints that are in synchronism. It is a good idea to insert in the magnetic master track some kind of audible cue to facilitate lining up the optical track later (if this has not already been done, as I suggested, at the mixing stage).

This audible cue will be transcribed with the rest of the track. When the optical track is received, this same sound can be found and placed alongside the picture cue to bring them once again into synchronism.

When the synchronizing cue has been marked on the optical track, it is now run with the work-print of the picture to check that everything is in order. If the track is a negative (which it will be except, as I have mentioned, in the case of certain types of 16 mm. work), we must not expect it to sound very pleasing. A negative track that will produce a first-class print will sound noisy and sibilant when it is played, but this does not mean that there is anything wrong with it. The characteristics required to make a good sound print are different from those that are required to reproduce through an optical sound system.

If, allowing for this matter of quality, everything else is in order, we can prepare to send the optical track and the picture masters to the laboratory for the first print. The synchronizing cue that we have already placed on the work-print is transferred to the picture masters. We must now mark up a *printing cue*, as distinct from a synchronizing cue, on the optical track itself – this is the cue that the laboratory must have to enable them to print the track in synchronism with the picture.

One more point has to be borne in mind, however. The sound track is always printed ahead of the relative picture when making sound-prints; 19⅔ frames in the case of 35 mm. and 26 frames inclusive in the case of 16 mm. You can leave it to the laboratory to make this adjustment, or you can do it yourself. But you must

225

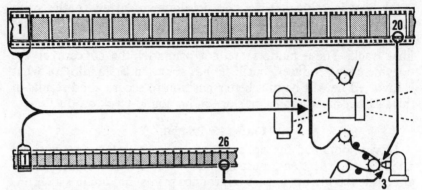

SOUND PRINTS. The picture and the sound that relates to it are not side by side on a print. In the case of optical sound tracks the sound is $19\frac{2}{3}$ frames ahead of picture on 35 mm. prints, 26 frames inclusive on 16 mm. prints.

The reason for this separation of picture and sound is that at the instant that the picture 2 is being projected the sound at 3 is being reproduced.

make it clear which you are doing. If you have made the picture and track cues opposite one another without advancing the sound, you should mark the leader of the track and picture (as well as your printing order) LEVEL SYNC. If you have advanced the sound track your instructions should read PRINT SYNC.

You must remember that to advance the track you move the sound cue the required number of frames back, that is *farther in from the head of the reel.*

Some laboratories may like you to put sound printing cues at the end of the reels as well as at the beginning. This is because, to speed up printing, they print the picture from the head, and then, without wasting time rewinding, they print the sound from the foot. In this, as in other such matters, it is helpful to all concerned to contact your laboratory and ask how they would like picture and sound track marked up to facilitate their own particular methods of working.

Blooping Joins in Optical Tracks

When handling optical tracks it should be remembered that joins should be "blooped". A join will produce a "plop" over the loud-speaker if this is not done. In the case of positive tracks a thick black opaque ink, known as blooping ink, is painted over the join shaped like the segment of a circle or a flat pyramid, with its apex at the join. This interrupts the light from the exciter lamp that passes through the film on to the photo-electric cell more gradually than would the join itself, and reduces the sound produced. Blooping ink is very quick-drying and is specially made for the purpose. In

226

the case of negative sound tracks, a semicircle is punched out of the track by means of a special "blooping punch". This semicircle appears black in the print, having the same effect as the blooping ink applied to a positive.

Having carefully cued your track to enable it to be printed in synchronism with the picture, it is a good idea to provide yourself with a means of checking that it has been correctly printed when you receive the projection prints. If you make a mark on the leader of the track in such a position that it will appear opposite a certain frame in the picture leader, you will be able to check at a glance. For instance, if you are using Academy leaders (the leaders carrying the numbers 11 to 3 in descending order) you can place a small cross, drawn in blooping ink, on the track so that it should appear in the print opposite to a particular number. If the cross appears anywhere else you know immediately that your track has been printed out of sync – and by how much.

Checking Track Quality in the Print

When you receive the projection prints you will also wish to check the quality of the sound track. The cause of poor quality is often difficult to trace. A useful precaution is to insert a length of specially recorded modulations, known as a "cross modulation test", in the trailer (the blank film at the end of the track). You will have to consult a sound engineer for the details regarding the making up of such a test length and how to read it subsequently. Briefly, by superimposing two notes of different frequencies you produce a series of modulations that, when printed, make a pattern that can be studied under a low-power microscope. This pattern will help in tracing at which stage any loss of quality occurred – whether in transcription, exposure or processing.

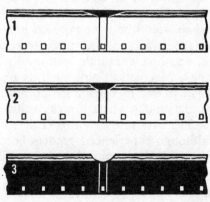

SOUND TRACK JOINS. A join in an optical track is "blooped" to reduce the sound it will make when passing the projector sound gate.

In the case of a positive track an opaque "bloop" is painted on the film with blooping ink. The opaque area can either be in the form of a triangle 1 or a semi-circle 2 placed centrally about the join.

In the case of negative film 3 a suitably shaped segment is punched out of the track. This will produce a black area in the print.

227

13

OBTAINING PRINTS

THE FIRST PRINT obtained is known as the "answer" or "approval" print. Until this has been screened and accepted by the customer, a laboratory is naturally reluctant to run off more. When it is being viewed there are various things to look for. The first and most obvious is whether the sound track is in synchronism with the picture. If the "tell-tale" mark that I suggested was inserted in the leaders this can be detected instantly.

Checking the Grading

The next matter to give your attention to is the grading of the various scenes. As we have seen, every shot in the master of a film, whether negative or positive, has to be examined before printing to decide its density. Printing or copying stock has, like all sensitive photographic material, a limited latitude. That is to say, the range of tones from the lightest to the darkest in any scene must be kept within certain limits if they are to be reproduced properly. However carefully the exposure given to the various scenes may have been calculated by the cameraman, their overall density in the master will vary. If they were all printed with the same intensity of printer light some would be over-exposed and others under-exposed. The light in the printer can be varied to cope with this problem and the job of deciding what light setting to give each shot is known as "grading". Mechanical aids such as photo-electric cells to measure the light passed by each scene do not in fact, prove of much assistance to the grader. There is no substitute, as yet, for the human eye.

The exposure given to each scene is a matter of judgment and although experienced graders become very good at their job, it is probable that some adjustments will have to be made after examination of the first approval print. The laboratory will expect you to give them your reactions and they will be pleased to accept any

228

MAKING A "MARRIED" PRINT. The optical sound track and the master picture remain separate throughout production. They are combined only when the projection prints are made by the printing laboratory.

35 mm. The negative track I and the negative picture 2 are printed side by side in the married print 3.

16 mm. The sound track 4 and the picture 5 may be either negative or positive according to the type of camera stock used. They are combined to produce a sound print 6 with one set of perforations only.

suggestions for changes of grading to particular shots. They will, of course, have viewed this first print themselves, as a routine matter, and made any adjustments to the grading card that they think will improve future prints. Your answer print will probably be perfectly usable. On the other hand, you cannot expect it to be the best possible result that can be obtained from your master. No blame attaches to a laboratory if the approval print is not absolutely up to standard as regards the grading of individual scenes. If you have a very important show, or if your sponsor or client is a very finicky character, you should allow time for a second print to be made, containing any adjustment found to be desirable in the answer print.

Of course, if the answer print is nearly perfect, reprint sections can be made of the portions that call for improvement, so that you have a usable print and do not have to jettison the whole thing.

Checking Colour Quality

If the film is in colour you will be looking to see how the colour has been rendered. There are, of course, losses in any printing or copying process, but fortunately you will not see the copy alongside

229

FILM PRINTERS: FOUR MAIN TYPES:

A. Continuous Printers
B. Step Printers
C. Contact Printers
D. Optical Printers.

In the case of continous printers, A, I and 2 the master film and the printing stock move at a continuous, steady speed through the machine.

In the case of step printers, B, 3 and 4, both master and printing stock move intermittently, stopping momentarily while each frame of picture is exposed individually. The resulting print is steadier but the cost of such prints is usually higher because, generally speaking, the printer runs at a slower speed than the continuous type.

In contact printers, C, I and 3, the master film and the printing stock are in contact with one another, emulsion to emulsion, in the printing gate; no lenses are therefore required.

In optical printers, D, 2 and 4, the two films are not in contact with one another, the images carried by the master film being passed through a lens and focused on the printing stock. Optical printers are normally used only for special purposes such as reducing 35 mm. to 16 mm. 2 or for producing optical effects such as dissolves, fades or wipes 4. In the case of the optical printer 4 provision is made for the master film to remain stationary while the printing stock continues to move so that one frame can be printed repeatedly – a facility sometimes called for. This type of printer can be adapted to print every second frame twice for the purpose of stepping up film shot at silent speed (16 frames per second) to sound speed (24 f.p.s.)

the original, so that, provided the overall quality is good, it is probable that you will not be conscious of these losses. But you may be conscious of an overall colour bias – it is possible, for

instance, that your print may have a slight tendency towards blue, giving a coldness to the colour. On the other hand, it may be noticeably warm in tone, with a bias towards the orange-red end of the spectrum. Every batch of colour-copying stock manufactured differs slightly from every other, however close a check is kept on all the processes involved. The first task of the printing laboratory is to test each new batch of stock and discover its characteristics. Having done so, they then select one or more filters that will tend to correct this bias. These filters will be used the whole time they are printing on this particular stock. In addition, they examine the master of your film and decide whether it, too, has any overall colour characteristic. If it has, a further filter is selected that will tend to correct this particular bias.

It follows, therefore, that if you feel that your answer print shows an *overall* colour bias something can be done about it. But if you feel that the majority of the scenes are perfectly right but that there are one or two that require changing the problem is more difficult. In ordinary colour printing an overall change is all that can be made. If you are prepared to accept a change to all the other scenes in order to improve a few that you are not happy about, well and good. If you feel that this is dangerous, and may adversely affect the bulk of the film, you will have to approach the problem in a different manner.

It is possible today to order what are known as "colour corrected" prints. In fact, in the case of most 35 mm. processes, colour correction throughout is the normal practice. In the case of 16 mm. colour copying, such as on to Kodachrome copying stock, colour correction is a more recent innovation. By a colour corrected print is meant a print in which each individual scene is given any correction that it may require to make it conform to a standard. Correction filters can be introduced for any scene, or sequence of scenes, by means of a special device in the printer. Naturally, colour corrected prints are a little more expensive, as they involve additional labour and time and extra capital outlay in more complex printers.

Joins in Release Prints

A question sometimes asked by a sponsor or client is whether they should be expected to accept projection prints containing joins. (This more often arises in the case of 16 mm. prints; 35 mm. is handled almost entirely by professional projectionists, so that non-technical people rarely have the opportunity of examining the prints and consequently such detailed queries do not occur to

them.) The fact is that, as in so many things in life, you get what you pay for. You can order "no-join" prints, but they will cost a little more. The reason is very simple. Most printing stock has, until recently, been supplied in 1,000 ft. lengths; although there is a tendency for longer lengths to be manufactured today, many emulsions being made in 2,000 ft. and some 16 mm. in 1,200 ft. rolls But there must be a limit, of course, imposed by the problems of bulk when transporting, packaging, and the size which printing machines and laboratory bench apparatus can handle. Whatever length the film may be supplied in there will be the problem of left-over portions – what are known as "short ends". What is the laboratory to do, having been given a 750 ft. reel to print, with the 250 ft. that is left over from a 1,000 ft. roll? It will be coincidence indeed if it is called upon to print a short reel, requiring exactly that 250 ft.! The waste on short ends can be high and if printing costs are to be kept as economical as possible all but the very short ends must find a use. Unless no-join prints are specified, therefore, and the higher price charged for them accepted, an occasional join in prints must be expected. This does not mean that you have to take prints with a join every 40 or 50 feet! There is a happy medium in such things and most laboratories, as a matter of routine, take as much care in making the best use of a roll of printing stock as a good tailor does when cutting cloth.

Sound Quality

We have not quite finished considering our approval print, however. We have checked the synchronism of the sound track, the grading of the scenes and, if it is a colour production, the colour balance overall and of individual shots. One more item remains – the quality of the sound track. As I mentioned earlier, this is dependent upon a number of separate factors quite apart from the quality of the master magnetic from which the optical track was produced. Should there be anything wrong with the sound quality, before blaming the printing laboratory the earlier stages should be re-examined first. Was the track properly transcribed from the magnetic, was the exposure given to the track correct, was it developed to the right density and characteristics? These matters are not easily checked, and the fact that you played the optical track when you received it after transcription may not have proved very much, if the track was a negative. This is the point at which the test length that you added at the end of the reels will provide most useful information.

232

A report on your findings on the approval print as a whole should be speedily passed to the laboratory so that any necessary action can be taken before you place your order for release prints.

Obtaining Release Prints

The term "release print" has come to be used for all those prints subsequent to the first approval or answer print. It applied originally to the prints supplied when a film was released for cinema exhibition and is now generally used whatever the method of distribution. If you require a comparatively small number of prints, the release prints can be made from the original camera master. If you require a considerable number of prints you have to consider whether the camera original may not become worn out before the full number have been run off. In any case, there is always a danger in having only one printing master. All the time and money that has gone into the production is vested in that one strip of film and its associated sound track. Despite all the care and attention to cleanliness that is part of modern laboratory technique, masters *can* become torn or scratched in printing. This might happen, if you are very unlucky, very early in the proceedings when only the first or second print is being run off. It is wise to consider, therefore, right at the start, whether you will take the risk of doing all your printing from the original, or whether you will have duplicate masters made.

Printing from Dupe Negatives

In the case of black-and-white work, very high-quality duplicate negatives (or dupe negatives as they are commonly called) can be made from 35 mm. originals. In the case of a film shot on 16 mm. negative, a dupe negative can be made, but the loss of picture quality may be detectable. It is normally necessary to take a print – a special fine-grain print – and from this to take the dupe negative. Two stages of duplication are therefore necessary, hence the tendency for quality to drop. An alternative technique exists whereby a *reversal* dupe negative is made from the original negative. In other words, the negative is printed on to reversal stock, and by means of the reversal process, this produces a negative directly, cutting out one of the two stages. The results by this method can be extremely good.

If the 16 mm. black-and-white film was shot in the first place on reversal stock, dupe negatives can be struck without any intermediate fine-grain print stage being necessary. If a great many

233

THE VARIOUS METHODS OF MAKING RELEASE PRINTS. All these methods apply both to black-and-white and colour.

1. The master picture negative 1, and the negative sound track 2 are used to produce the release print 3. Used where only a small number of prints are required. Can be applied to 16 mm. as well.

2. Where a large number of prints are required, or it is particularly important to protect the original negative 1, a fine-grain positive 2 is taken from it. From this a duplicate negative 3 is made and used, with the sound track 4 to make the release prints 5. Can be applied to 16 mm. as well as 35 mm.

3. 16 mm. reversal camera stock 1, colour or black-and-white, can be printed with a sound track 2 straight on to reversal stock 3. Used where only a fairly limited number of prints is required.

4. When a 16 mm. film has been shot on colour or black-and-white reversal camera stock and a large number of prints is required, or when it is important to protect the master original 1, an inter-negative 2 can be used with a negative sound track 3 to produce the release prints 4. Note that when a *reversal* camera stock is used, one stage less is involved than with method 2 above.

234

prints are required from a 16 mm. black-and-white production, this is probably the best method to use. The reversal original can be reserved for no other purpose than producing as many dupe negatives as may be required. It should be perfectly possible, for instance, to take thirty dupe negatives from a reversal original and, from each of these, strike fifty positive prints, providing a total of 1,500 release prints. When it is borne in mind that any dirt or dust that may occur on a reversal original is printed *black* in the final print – not as white sparkle as in the case of negative – and that joins are less noticeable, it has to be admitted that the reversal method has a lot to recommend it.

35 mm. Colour Release Prints

In the case of colour, the problem of taking care of the original material so that it does not become worn out before the required number of release prints has been run off is even more acute. Most of the colour films in common use have very soft emulsions that are easily marked by the slightest trace of dust or anything but the most careful handling. The most popular 35 mm. colour film today is undoubtedly Eastman Colour. When this film was first intro-duced great changes in the handling methods in cutting rooms and laboratories had to be made. The slightest touch on the emulsion of the picture area is sufficient to produce a mark that cannot be removed. The laboratories accepted this challenge and today it is possible to obtain nearly as good a run of prints from an Eastman Colour negative as it is off a black-and-white negative. This has been brought about by the introduction of such techniques as "ultrasonic cleaning". One of the problems is that negatives have to be cleaned between every five or six prints when running a batch off. If this was done using the old methods, such as running the negative through moist pads, the Eastman Colour emulsion very quickly became marked. In ultrasonic cleaning, the film is immersed in a liquid solvent which is activated by an ultrasonic oscillator. The oscillator generates intense sound waves which impinge against dirt particles lodged on the film and remove them. There is no possi-bility of damaging a delicate emulsion, since there is no rubbing. This system has brought about a revolution in film cleaning.

Even so, if more than two dozen prints are required, it is a very wise precaution to have a dupe negative taken.

Largely because Eastman Colour is a negative-positive colour process (as distinct from a reversal system giving a direct positive

235

master, like Kodachrome and Ektachrome), a dupe negative can be taken that will produce colour prints of a very high quality, differing very little from those taken from the original negative.

From the orginal negative, the laboratory will make what is known as an "inter-positive", and from this they print the dupe negative, known more precisely as an "*inter*-negative". Since many inter-negatives could be made from the inter-positive, and each inter-negative should be capable of yielding anything between fifty and seventy, or even 100, prints; the number of release prints that can now be made is very large indeed. And since this does not involve going back to the original negative until the inter-positive is worn out, the original can be stored away in complete safety, giving the producer the maximum security.

An alternative is to use the Technicolor system. Technicolor is a dye-transfer process, the prints being produced by a system similar to the multi-colour printing with inks which is used, say, for periodicals. From the colour negative, whether Eastman Colour or any other system, three colour-separation matrices are taken representing the three secondary colours, cyan, yellow and magenta. By means of these matrices, cyan, yellow and magenta dyes are supplied to the print in register with one another, so building up a positive colour image. The resulting colour quality is, as is well known, very good. The initial cost of making these separation matrices is high, however, and although the cost per copy is very competitive the process is economical only if forty or more release prints are required.

16 mm. Colour Release Prints

A great deal of 16 mm. colour production is carried out today on Ektachrome Commercial stock and the most common method of making release prints is to print on to Kodachrome copying stock, unless a large number of prints are required. These two stocks produce very good results when used in conjunction with one another. Although Kodachrome is a reversal colour stock the sound track is printed from a negative, as was mentioned earlier. With the extension of colour television a considerable amount of Eastman Colour negative is used for TV.

Ektachrome Commercial 16 mm. camera stock has the same fragile characteristics as Eastman Colour 35 mm. stock. It is just as important, therefore, to protect the master original if many release prints are required. Both the colour inter-negative process and the Technicolor process can be applied to 16 mm. Since, in both cases,

the camera original is used only for making master duplicates, all the release printing being carried out by means of the duplicates, very large numbers of prints can be obtained safely without the danger of wearing out the original. How many prints can be taken safely *direct from the original* is a difficult question to answer. Different laboratories will vary in their answers to this query. Forty or fifty is a reasonable answer; some laboratories will claim that as many as eighty, ninety or even more can be taken before the original shows distinct signs of wear. It all depends upon the care with which the original is handled, the types of printer used and the method of cleaning between printing.

Even if these claims can be accepted, it is still safer to protect the originals by making duplicate masters. If many prints are required it is probably also cheaper.

Comparative Costs of Different Methods

Prints made by means of an Eastman Colour inter-negative and by the Technicolor process are cheaper than Kodachrome prints, but there are additional expenses in preparing the duplicate masters which have to be taken into consideration. As a general guide it may be said that:

if more than twenty prints are required, the total cost of Eastman Colour prints plus the cost of the inter-negative will be less than the total cost of Kodachrome prints from the original, and

if more than forty prints are required, the total cost of Technicolor prints plus the initial cost of making matrices, etc., will be less than the total cost of Kodachrome prints direct from the original.

The point at which Technicolor becomes cheaper than Eastman Colour is very much more debatable and will depend upon the style of the film, how many opticals, overlay titles and so on it contains. If the film has been assembled by the "A and B" roll method such complications may increase the Technicolor charges much more than the Eastman Colour inter-negative charges. "A and B" roll opticals can be incorporated into an Eastman Colour inter-negative cheaply, since no optical printing is called for. In the case of Technicolor, optical printing is involved and the cost of a lot of dissolves, fades and overlay printing will quickly mount up to a sizeable sum. A direct comparison between the costs of these two systems cannot,

therefore, be made. All this concerns 16 mm. printing and the same factors do not necessarily apply to 35 mm.

Fragile Emulsions

Reverting to the question of fragile emulsions, it may be as well to supply the answer to one question that is bound to be asked. Why is not something done by stock manufacturers to counteract the fragility of such colour films as Eastman Colour and Ektachrome? After all, Kodachrome is a colour film with a tough enough emulsion to stand up to repeated projection, so why not give the same toughness to these other emulsions? The answer is that in the case of Eastman Colour and Ektachrome, the dye coupler is carried in the emulsion layers. Couplers coated directly in the emulsion layers have some tendency to wander through the gelatine. To prevent this, they are carried in microscopic globules of organic materials which are dispersed throughout the layers. The organic materials protect the couplers from the gelatine and at the same time protect them from any chemical reactions with the silver halide.

It is these globules of organic materials that make the emulsion so fragile. Kodachrome, on the other hand, carries no dye-couplers in its emulsion at all and the emulsion is, therefore, harder.

Ektachrome Commercial camera films intended to produce copies should never, in any circumstances, be projected.

One point has to be borne in mind when the decision is made as to what method shall be used to produce the release prints: this is that a suitable optical sound track must be provided. As I mentioned earlier, different types of printing stocks require sound tracks with different characteristics. In the case of 16 mm., a further complication arises. Not all prints have the emulsion on the same side. Prints made direct from the camera master carry the emulsion away from the screen during projection; prints made from a dupe master (in other words from an inter-negative) carry the emulsion on the side facing the screen. This means that the sound track from which they are printed must carry its emulsion on the appropriate side – a sound track suitable for printing with a camera original will have the emulsion on the wrong side for making prints from an inter-negative. One further complication: Technicolor require a 17.5 mm. optical track (in other words, 35 mm. split down the middle) from which to make 16 mm. prints.

It is clear that a final decision as to what method is to be used for release printing must be made before the magnetic track is transcribed to optical.

Release Prints on Both 35 mm. and 16 mm.

There is one further question that frequently arises when planning the release printing. If *both* 35 mm. and 16 mm. prints will be required, what are the problems involved? In the case of black-and-white 35 mm. production, no difficulty arises. Reduction prints on 16 mm. can be printed from the 35 mm. picture and sound negatives. In the case of an Eastman Colour production the same thing applies – 16 mm. reduction prints can be made from the 35 mm. Eastman Colour negative and the negative track. The sound tracks on 16 mm. prints made by this method, however, will leave much to be desired. A 35 mm. track made for cinema reproduction will have a much greater dynamic range than a 16 mm. track can handle. When we discussed sound recording the point was made that 35 mm. optical sound tracks can accommodate frequencies up to 7,000 or 8,000 cycles per second, while it is difficult to record higher than 4,500 or 5,000 cycles per second on 16 mm. – at least, it is difficult to get higher frequencies than this on to a print. In attempting, by reduction printing, to transfer frequencies up to 3,000 cycles more than the film can accept, distortion will be introduced. Quite apart from

MAKING 16 mm. PRINTS FROM A 35 mm. MASTER. The 35 mm. picture negative 1 can be printed through an optical reduction printer to produce a 16 mm. print 2. It is not good practice to reduce a 35 mm. negative track to 16 mm. in this way, however. To produce the best sound quality on the 16 mm. prints, a 16 mm. negative track 3 should be produced direct from the magnetic master.

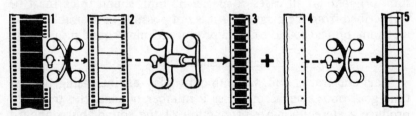

If many 16 mm. prints will be required it may be preferable to produce a 16 mm. reduction negative for the purpose. From the 35 mm. negative picture 1 and fine-grain duping positive 2 is made. From this, by reduction printing, the 16 mm. negative is made and used with a 16 mm. negative track 4 to produce, by normal contact printing, the release prints 5.

239

this, the overall characteristics called for by 16 mm. tracks are very different from those required by 35 mm.

Unfortunately, reduction printing from 35 mm. tracks is still quite a common practice, but it is to be most strongly deprecated. The correct method is to have a 16 mm. optical track prepared which can be contact printed. This can be re-recorded from the 35 mm. but, ideally, it should be made direct from the master magnetic. It can then be given the characteristics most suitable for obtaining the best-quality reproduction under typical 16 mm. playback conditions.

In the case of Technicolor, the special 17.5 mm. track referred to will have to be transcribed from the magnetic master. A separate set of 16 mm. colour separation matrices will also have to be made, although the cost will not be as great as it would be if no 35 mm. version had been produced. This is because some of the 35 mm. procedure – the making of the three-colour separation negatives – applies to both gauges.

It is quite feasible to produce 35 mm. prints from a film shot on 16 mm. stock, whether in black-and-white or colour. There cannot, of course, be quite the same picture quality as in a film shot direct on to 35 mm. Nevertheless, if the 16 mm. original is up to standard an acceptable result can be expected. Many films of a documentary nature appearing in cinemas are shot on 16 mm. and "blown-up", to use the trade term, to 35 mm. for release purposes. There are, after all, many cases where the greater portability of the 16 mm. camera, and the vastly reduced bulk of 16 mm. film, make the use of this gauge almost the only answer, particularly in films of wild-life, exploration or expeditions in remote regions.

The procedure is for the 16 mm. original to be "blown-up" on to a black-and-white or colour inter-negative. The Technicolor process, too, can be used to produce 35 mm. release prints from a 16 mm. original. In all cases, a special 35 mm. sound track must be transcribed from the magnetic – it is not possible or desirable to use a 16 mm. optical sound track to produce 35 mm. sound prints.

Magnetic Sound Prints

Magnetic tracks will, undoubtedly, play an increasing part as time goes on. Cinemascope uses a number of magnetic tracks to produce a stereophonic reproduction of the sound, but standard 35 mm. release prints still carry optical tracks. The position may change before very long. In the case of 16 mm., striped prints (carrying a band of magnetic oxide which will carry a magnetic

240

track) can be obtained. At one time it was thought that this type of sound track would become very popular and perhaps supersede the optical type because it is capable of handling a much higher frequency range and producing better-quality sound. Strangely enough, 16 mm. magnetic stripe has not gained a very great popularity. Perhaps the considerably higher cost of the projector is the principal cause. Additional factors are the increased cost of prints and the extra number of stages involved in adding a magnetic stripe and then transferring the sound on to it. Optical sound prints are made much more conveniently by standard laboratory processes.

Because magnetic projectors are expensive, there are far fewer in use than optical ones. A film released with a magnetic stripe track, therefore, has a much more limited scope. Nevertheless, for the producers of low-budget films who cannot afford the expense of making an optical track and who require only one or two prints it can be most useful. The sound can be recorded on the projector itself, eliminating all studio and laboratory expenses. Magnetic stripe also has a special application where foreign-language versions are required or in areas where many different languages are spoken. Versions of the commentary can be recorded locally with very little expense.

It is as well for the film sponsor to know that a magnetic stripe can be applied that is only *half* the width of the sound track. This "half-track", as it is called, can be laid over one half of the optical track only. The optical track can still be played for the benefit of those audiences for whom it is intended, while another version for local consumption can be recorded on the half-stripe. Either can be played at will.

8 mm. Sound Prints

The latest arrival is 8 mm. sound. Magnetic striped sound arrived first, the narrowness of the film and the slow speed of travel past the sound head making good quality optical sound difficult to achieve on 8 mm. These problems have been overcome and 8 mm. optical sound is now available on the newer format, Super-8, in which the perforations are smaller, leaving more room for both picture and sound. Magnetic sound is also available on Super-8. Films produced commercially on either 35 mm. or 16 mm. can be reduced to either optical or magnetic 8 mm. prints.

Spooling Up

There is one interesting difference when it comes to sending out 35 mm. and 16 mm prints; 35 mm. prints are always sent out un-

spooled, on the plastic cores on which they come from the printing laboratory. There are two reasons for this; firstly, 35 mm. spools are bulky and heavy; and, secondly, there is no standard type of spool, each projectionist mounting his programmes on his own spools. In earlier days most 35 mm. projectors could accommodate only 1,000 ft. of film, with a running time of just over ten minutes, and it is still common practice to issue 35 mm. films in reels not exceeding this length. The majority of machines today can accommodate 2,000 ft. and so the projectionist joins up each pair of reels and mounts them on one spool, breaking them down again before returning them. In the case of 16 mm. film it is standard practice to send out prints already spooled. Almost all 16 mm. sound projectors in use nowadays will accommodate 2,000 ft. of film, but it is not wise to send out a film on a spool larger than 1,600 ft. The projector, unless it is quite an old model, will probably be able to handle it, but few projectionists can be relied on to have a 2,000 ft. take-up spool available. If you *must* send out a film on spools of this size, in preference to breaking it down on to two smaller spools, it is advisable to send an empty 2,000 ft. spool along also.

The lengthy and involved process of producing a film, from the germ of an idea to the finished release print, is complete. There is one last, but vitally important stage – to ensure that it reaches your audience.

14

DISTRIBUTION

FACTUAL AND DOCUMENTARY films are produced either because they have been commissioned or as a speculation. Films in the first category have been made with an audience in mind; it is merely a matter of organizing the most efficient distribution. To those who have just produced, or are about to embark on producing, a film as a speculation a few words concerning the possible channels of distribution may be useful.

No one can tell you how to sell a film. Whether a film finds a market depends upon many factors such as whether it is a really good film, whether it suits the market it is aimed at, whether it is the right length for that market, and whether it is offered to the market at a time when there is a demand for that kind of subject. In other words, artistic merit, good workmanship and luck all play a part, with luck perhaps the biggest element of the three. The speculative market can often be depressing. I can remember trying to sell an excellent film on mountaineering to a television network and receiving the laconic answer "Sorry, we've had too much snow lately!" – and that was final, without even viewing the film.

There are three channels of distribution, the cinema, television and what is known as the non-theatrical market, which virtually means 16 mm.

Cinema Distribution

Producing speculatively for the cinema is a hazardous business. Obtaining a release is dependent on several factors. Documentary films for the cinema, known as domestic shorts, come into the category of supporting material. This limits the demand to begin with, because where a cinema is running a double-feature programme there is seldom time for a short. The rarer features that are longer than average, however, are often accompanied by a supporting short instead of a second feature. There are, of course, pre-release

243

theatres in the big towns where a single feature is shown before its general release to the circuits, and here, too, a short is usually included. The number of such theatres is small in comparison with the general release houses and the financial return on a film shown only on a pre-release run will be small. To cover production costs and make a profit a general release is essential.

To obtain a general release, the short has to become linked with a feature film with which it will be shown round the circuits. This means that its length must be right from the programme-building point of view, and it may help if its subject is related to that of the feature. If it surmounts this hurdle, it does not cease to be a speculation, because it will share the fate of the feature film, whatever that may be. If the feature is popular and gets a wide release and is held for extra weeks in some cinemas, so does the short. If the feature, on the other hand, does not do well and gets taken off before it was expected to be, so does the short again.

The financial return from shorts is not usually high. There are two types of contract that may be offered for a film that is accepted for circuit release. A single payment may be made for the outright purchase of theatrical rights in certain defined territories for a certain period of time. Alternatively, a percentage of net receipts may be offered. In either case, it is usual to place restrictions on the use of the film non-theatrically or on television, in the same territories, during the period of the contracts. Often the percentage of receipts basis is more remunerative in the long run. You are, in fact, sharing some of the risk with the distributor. If he purchases the film outright, he is going to quote a figure that he is very sure he can recoup. On the other hand, if you accept a percentage, while you may get more eventually you will have to wait longer for your money, and in some cases it can be very much longer!

I have stressed the speculative nature of making films for cinema distribution. Of course, as in most other lines of business, if you are successful on more than one occasion and build up a reputation with a particular distributor, your future products may receive sympathetic consideration. You will no doubt have discovered what that particular distributor requires and be able to supply it to him, and the venture will become much less of a gamble.

Selling Films to Television

Television is in many ways an even more speculative market. Outside the U.S.A., there are fewer potential buyers than in the case

244

of cinema distribution. A single film is often at a serious disadvantage, the tendency being towards a series – this is particularly so in America, where a run of thirteen or twenty-six programmes at weekly intervals is the normal thing. Single programmes can be placed sometimes, either with agents in the U.S.A. or with television companies elsewhere, if they happen to fit in with other similar programmes that can be grouped together to form a series.

If it is planned to produce a television series it is usual to complete a "pilot" – that is, either the first programme or a typical sample. However, it must not be assumed that a series will be accepted upon viewing the pilot. Television executives or agents are shrewd people and tangible evidence that the remainder of the series is going to be as good as the pilot will be required. Competition is strong and it is a salutary thought that probably hundreds of pilots of one sort or another are going the rounds of agents and companies at any one time. Furthermore, it is sometimes imagined that production costs can be recouped with one transmission by a major station, but this is rarely so. A wide distribution has to be secured to show a reasonable margin of profit in the case of all but the most economical films, and this often means securing transmissions overseas, as well as at home. Material, in this case, should be capable of being re-commentated in other languages, and for this purpose separate music and effects tracks must be provided.

As with cinema distribution, it may be possible to submit material successfully and build up a connection in the industry to whom repeat programmes can be sold. When this is achieved it is usually done by carefully studying the market and its requirements. Films must contain plenty of close-ups, and they must be the right length. The majority of programmes are 26 or 27 minutes to allow for commercials, with a "natural break" somewhere near the middle. In the case of State networks like the B.B.C., 29 or $29\frac{1}{2}$ minutes is the usual requirement, although films running for the commercial television length of 26 or 27 minutes are accepted, since news summaries, weather forecasts or programme announcements will often fill in the few remaining minutes of the half-hour. It is almost useless to submit films running for such odd times as say, 19 or 20 minutes; the problem of fitting them into a programme schedule based very largely on half-hour units is too great. Yet there are a surprising number of optimists who will submit such non-standard material, without realizing that they have almost certainly condemned themselves to failure, whatever the merits of the film may be.

245

NON-THEATRICAL DISTRIBUTION. Cinemas and television are the outlets that spring to mind first, but it is not always realized that there are many ways of reaching very large and more specialized audiences in what is known as the "non-theatrical" market. Millions are regularly reached through the outlets shown below.

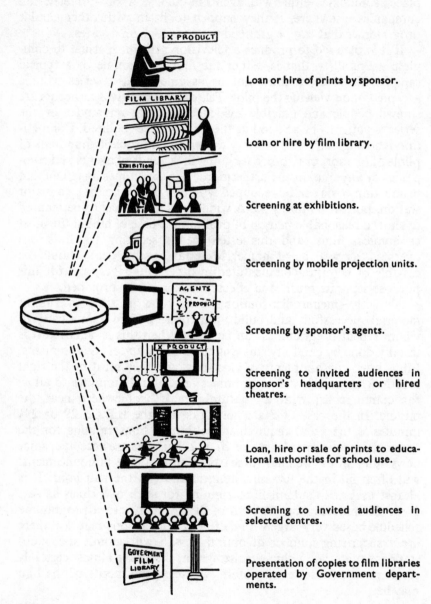

Loan or hire of prints by sponsor.

Loan or hire by film library.

Screening at exhibitions.

Screening by mobile projection units.

Screening by sponsor's agents.

Screening to invited audiences in sponsor's headquarters or hired theatres.

Loan, hire or sale of prints to educational authorities for school use.

Screening to invited audiences in selected centres.

Presentation of copies to film libraries operated by Government departments.

The Non-Theatrical Market

The non-theatrical market is a difficult one for the speculative producer to enter. This is largely a 16 mm. market and consists of films for public relations, sales, staff instruction, classroom films, medical and scientific films and the films of many other kinds that are shown in clubs, institutes, works canteens, hospitals and so on. Occasionally, speculative films on such subjects as road safety, accident prevention in the home or factory, or classroom subjects have a strong enough appeal to be financially profitable. It has to be remembered that hiring out films, apart perhaps from feature films and popular short entertainment films, is not a very lucrative business. The producer of a speculative film for this market has to recoup his costs by the *sale* of copies, and unless his film appeals to the organizers of a wide range of film libraries, including such subsidized libraries as those run by the State or education authorities, he will be unlikely to sell sufficient copies to make his production a commercial proposition. It is unfortunate that the market for classroom films remains comparatively small outside the U.S.A. Only economical productions stand a chance of paying their way, and even then they will have to be produced with an academic approach, aimed at a certain age-group, and with the guidance of an educationist, to find favour. Teachers are as a rule critical consumers and it is right that they should be. The speculative production of classroom films remains, therefore, an enterprise to be approached with great caution.

Distributing the Sponsored Film

The commissioned film, as I have said, is usually aimed at a particular audience. The sales or prestige film may be intended for use at exhibitions, for showing to specially invited audiences, or for screening in showrooms. Nevertheless, the sponsor will often wish to widen his distribution and to seek audiences outside those that he can gather with the aid of his own organization. The most common way to do this is to place copies of his film in libraries that cater for borrowers up and down the country, such as clubs, institutes, churches, hospitals and so on. Such libraries are prepared to offer films on free loan provided the sponsor presents a sufficient number of copies to meet the probable demand, and pays a charge each time it goes out to cover administration and postage. Alternatively the library will issue the film for a hire charge, if the sponsor does not wish to meet this expense. Naturally, there are only certain types of

247

film for which borrowers are prepared to pay a hire charge. They will not normally pay to see a film that tries to sell them something, or otherwise indulges in obvious propaganda. Prestige films presenting some popular event or topic of interest with the very minimum of publicity are the kind that find large audiences in this way.

In the United States a number of large libraries operate in this manner. So highly organized has this form of distribution become that an organization planning a film will frequently consult such libraries before commencing production. The libraries will give advice concerning the number of borrowers that they anticipate will apply for a film on any particular subject, and they will state how many copies they will require to meet this demand. The number of copies for subjects of the more popular kind may be very large indeed and their cost may exceed that of the production of the film.

This type of distribution has not reached the same magnitude in Britain, but nevertheless very substantial audience figures for non-theatrical films are achieved. The number of people who saw free-loan films from one organization alone, Sound-Services Ltd., in 1967, for instance, was 19,814,440. Although one of the largest, this is but one of a number of libraries distributing sponsored films. When others, such as the Central Film Library, Aims of Industry Ltd., Rank Film Library and so on are included it can be seen that the total audience that can be reached by this means is very large indeed.

Setting Up the Sponsor's Own Library

The film sponsor has the alternative of setting up his own library, and many organizations do this. The number of industries, firms, research institutes, travel agents, church organizations, offering films for hire or loan is increasing year by year. Many, such as the churches, have their own audiences and it is logical for them to handle their distribution themselves. Many industrial organizations set up their own libraries and the audiences reached by the larger of these is astonishing. The Petroleum Films Bureau, for instance, which distributes for a number of major oil companies, reached an audience of approximately 7,000,000 in 1961, by means of the free loan of prints.

A sponsor has a number of other ways of reaching an audience. He can send his film around the country to be shown by mobile projection units, either equipping his own or hiring them. He can present his films to invited audiences in selected centres, hiring

248

cinemas, halls or hotel rooms. Alternatively, he can loan copies of his films to his agents at home and abroad and suggest that they invite potential clients to see them in their showrooms or elsewhere. Another important outlet is screening at exhibitions. Normal projection at set times, on exhibition stands or in a special cinema, or by means of continuous-projection cabinets, can reach large numbers. When all these outlets are considered together, the potential audience for non-theatrical films is seen to be a very large one.

The British sponsor interested in an audience overseas can obtain useful help from the Central Office of Information and the Board of Trade.

The Sponsored Film in Education

Films are being increasingly used as visual aids in education. Some organizations consider that it is in their interests to keep their name before the younger element in the population and to that end endeavour to get their films shown in schools. Industry has, in fact, made a significant contribution to the number of educational films available by producing films on science, hygiene, dress sense, the use of cosmetics, sport and many other useful subjects. Naturally there must be no direct advertising and in most cases the sponsor does no more than place his name on the titles. Such films can be very acceptable to teachers, but it is advisable to seek advice from educationists before and during production if one of the principal aims of the film is to secure a distribution in schools.

Finally, it should be remembered that distributing a film in the non-theatrical market calls for the setting up of some organization, if it is not intended to use the services of a library. If, as producer, you have made a film for a client who has not had one before, it is advisable to give him some help and advice on handling his prints. He will require equipment for rewinding, checking and cleaning them when they are returned by borrowers. It will be helpful to instruct the members of his staff in the handling of prints and the repair of minor damage.

15

CONCLUSION

IN ENDEAVOURING to cover as widely as possible in a single book the many and various techniques involved in factual film production I have, of necessity, jumped from practical, mundane matters such as how to join two pieces of film together – for on this simple, basic operation, after all, our whole art is founded – to highly creative matters such as capturing on film the unpredictable, in sound and picture, and welding the captured images and sounds into a harmonious and significant whole. If I have placed more emphasis upon the practical and technical details than upon the creative and artistic, this is because in building our artistic edifice, the solid bricks of technical ability must come first. Only when we have mastered the ABC can we begin to write; a great poem or the novel of the century comes a long time later. Yet it is founded upon that initial mastery of the ABC. So it is with films. It has been said that "Art is a by-product of work well done".

Today, to the true documentary that presents a "creative treatment of actuality" has been added a vast output of "semi-documentary" factual films intended to instruct, educate, sell and entertain. Some of them are utilitarian in subject-matter and the job they have to do. But ours is a creative art. We should never forget the idealism of the documentary pioneers who had, in fact, some quite mundane subjects to deal with themselves. But they brought them alive. They saw the drama and significance of everyday life and wove them into their films and succeeded in giving their audience an exciting new sense of awareness. The same enthusiasm for the job and readiness to experiment applied to even the most utilitarian subject may enable us to make, out of the most unpromising material, a fine and, perhaps, even a great film.

I believe that we factual film makers are privileged people. We have the privilege of going about the world and recording reality. We delve behind the scenes here, we carry out "subject investigation" there, often we are encouraged and invited to see in the

250

course of our work far more than the ordinary traveller or the general public can ever hope to see. And all the time it is real; not for us the tinsel and gilt of the fiction film. Ours is a real world into which we are permitted to delve, explore and record. I believe that this is something to enjoy and get excited about. The pioneers felt rather like this and it is appropriate to end with some quotations from the founder of true documentary, John Grierson:

"I have suggested that we can look for a great development of the documentary film because it is necessary to so many people. The nature of the development of government, the nature of development of business . . . alike suggest a greater use of visual aids to understanding. I add that the nature of the development of education itself gives a new authority to any medium which, like the documentary film, emphasizes the living patterns of modern citizenship.

"They used to ask in the school-books if seven men took twenty-one days to build a house, how long does it take twenty-one men? We have discovered that the answer is not seven, but probably one! We have learned that two and two make five of the corporate and the co-operative.

"But on the other hand, we have become more and more citizens of a community which we do not adequately see. The knob of a radio set switches on the voices of men all over the globe, but not without the thought and work of thousands of people like ourselves, which we have not yet the habit of realizing. Under our feet go wires and pipes leading to complicated supply systems we blindly take for granted. Behind each counter of our modern buying lies a world system of manufacture, choice and conveyance. A simple weather forecast is a daily drama of complicated observation over a large part of the earth's surface, without which men could not safely fly or put to sea. We do not see it. Messages that roll easily from the local Press may have come at 600 words a minute from Moscow or may have been relayed from London to Africa and by complicated steps north through the Americas again. . . . Sleeping or waking, we are concerned each day in an interdependency, one with another, which in fact makes us each our brother's servant and our brother's keeper. This is the fact of modern society. . . .

"The most powerful of all mass media, the mass medium most capable of bringing the disparate elements of the wide world into obvious juxtaposition and association, the medium of all media born to express the living nature of interdependency, documentary film has stuck all too stubbornly to the drama of personal habits and personal achievements. . . . On the other hand, it has done something to open a window on the wider world, and so to widen the stretch of men's eyes. . . . The documentary film has, I believe, outlined the patterns of interdependency more distinctly and more deliberately than any other medium whatsoever."

It is the privilege of those of us who work at this craft to "open a window on the wider world". We shall push that window still wider open if we apply to our creations not only good craftsmanship but also the imagination, vision and inspiration of Grierson and his band of pioneers. They found their work of experimenting with a new medium an exciting adventure, and that excitement and enthusiasm came through on to the screen. The medium is older now, but the excitement should still be there to spur and stimulate us all.

251

GLOSSARY OF TERMS

A ANIMATION. Apparent movement of inanimate objects or drawings.

ANSWER PRINT. The first projection print of a newly completed film. It is submitted by the printing laboratory for the approval or comments of the producer and his client. As a result of examination of the answer print the grading of various scenes may be changed, and in the case of colour the colour balance may be altered in subsequent prints and any other corrections made. Also known as APPROVAL PRINT.

APERTURE. Effective size of the lens opening through which light passes on to the film.

APPROVAL PRINT. See ANSWER PRINT.

ASSEMBLE. To collect together the required shots and join them in provisional order to produce a ROUGH ASSEMBLY or ROUGH CUT.

ANGLE. See CAMERA ANGLE.

B BIG CLOSE UP. (Abbr. B.C.U.) Shot taken very close to a subject, closer than would be necessary for a CLOSE UP. In the case of a human face, part of a face only.

BIN. See FILM BIN.

BLIMP. Sound-absorbent box or cover fitted over a camera to prevent the sound of the mechanism being picked up by the microphone when recording sound with picture.

BLOOP. Opaque area over a splice in positive sound track to eliminate the "click" that would otherwise be produced. See BLOOPING INK.

BLOOPING INK. A black opaque ink which is quick drying. It is used for blacking-out areas on film, particularly for painting over splices in the sound track.

BUZZ TRACK. Sound track that carries background noise but nothing else. Used for spacing or extending pauses when track laying.

C CAMERA ANGLE. Angle from which the camera views the subject: e.g. High-angle, the camera looking down on the subject; Upward angle, the camera looking up at a subject; 45 deg. angle, the camera looking at the subject from an angle of 45 deg.

C.C.I.R. SPECIFICATION. Specification laid down by the Comité Consultatif International des Radiocommunications for standard recording and reproducing characteristics.

CLAPPER BOARD. A board with a hinged flap which is banged against the board itself at the beginning of a synchronous sound take to enable the picture and sound to be brought into synchronism in the cutting room.

CLAPPER BOY. Junior technician who operates the *clapper board*.

252

CLOSE UP. (Abbr. C.U.). Shot taken close to a subject and revealing detail. In the case of a human subject, a shot of the face only, the hands only, etc.

COLOUR TEMPERATURE. A means of expressing the colour quality of light or a source of light. Colour temperature is a measure which defines the colour of a light-source by reference to the visual appearance of the light radiated by a black body heated to incandescence. This measurement is expressed in degrees Kelvin (°K).

COMMENTARY. Spoken words accompanying a film, the speaker usually remaining unseen.

COMPILATION FILM or SEQUENCE. A film or sequence in a film composed entirely of extracts from other films, newsreel extracts or library material.

CONTINUITY. The flow from one shot to another without breaks or discrepancies. Smoothness in the development of subject-matter.

CONTINUITY GIRL. Technician responsible for noting the details of each take during shooting to ensure that no discrepancies or errors of continuity occur between consecutive shots when the material is assembled.

COPY. A reproduction of a reversal or colour film duplicated from the original. In other words, a positive copy of a positive original.

CROSS CUT. To alternate from one scene to another in the course of editing so that two or more subjects are presented in fragments, alternately.

CUT. A cut – the point at which a shot is severed for joining to the next. To cut – to trim and join film shots.

CUT-AWAY. A shot of something other than the main action. A cut-away is inserted between shots of the main action, often to bridge a time lapse or to avoid a jump cut.

CUTTER. Technician who carries out the more mechanical operations of film assembly. In practice, the term "cutter" and "editor" are often used synonymously.

CUTTING PRINT or CUTTING COPY. A print or copy used solely for the purpose of editing.

D DECIBEL (Abbr. dB.). One-tenth of the value of a Bel, the decibel is a measure of power difference. It is a numerical or dimensionless quantity used to express the ratio of one power value to another on a logarithmic scale.

DENSITY. Image blackness. A measure of the light transmitted by film.

DEPTH OF FIELD. Distance from the nearest to the furthest points between which a subject is in focus.

DISSOLVE. Gradual merging of the end of one shot into the beginning of the next. Produced by overlapping a FADE-OUT on to a FADE-IN.

DOLLY. Truck on which the camera can be wheeled during a take.

DOPE SHEETS. List of shots taken, made by a cameraman or his assistant.

DUB. To re-record sound: i.e. to transfer sound from one sound track to another, or from disc or tape to a film sound track. Also, to re-record the sound track of a film, substituting another language for the original.

DUPE. To print a duplicate negative from a master negative, usually via a duping positive.

DUPE NEGATIVE. Negative which is taken from an original negative, usually via a duping print.

DUPING PRINT. Special print of low contrast made from a negative for the purpose of making a dupe negative.

E **EDIT.** To assemble the component shots of a film into their final order and cut them to their final length.

EFFECTS. Recorded noises other than music or speech.

EFFECTS TRACK. Sound track containing sounds other than music or speech.

EMULSION. The substance which is sensitive to light with which one side of the film base is coated. In a processed film this carries the image or picture.

ESTABLISHING SHOT. Shot used to establish a new scene, usually a LONG SHOT, to enable the audience to see the interrelationship of details to be shown subsequently in other shots.

EXPOSURE. The amount of light which is allowed to reach a single frame of film during shooting.

EXTERIOR. A scene filmed out of doors.

F **FADE-IN.** Gradual emergence of a shot out of darkness.

FADE-OUT. A shot that gradually disappears into complete darkness.

FILM CEMENT. Liquid used for joining pieces of film.

FILM BIN. Large receptacle into which film is allowed to fall while assembling shots or when running film through a viewer or projector instead of using a take-up spool.

FILM VIEWER. Machine providing a small moving picture when film is drawn through it, for viewing film material during editing. It may be hand operated or motor driven.

FILTERS. Coloured pieces of gelatine or glass which are mounted in front of the lens or film, to modify tonal rendering or colour balance. Also used in film printers, particularly when printing colour film.

FLASHBACK. Shot or sequence in a film which takes the audience back into the past.

FLASH FRAME. The first frame (or frames) of a shot that are over-exposed due to the time taken for the camera to reach the correct speed.

FOCAL LENGTH. The distance from the centre of a lens to the surface of the film when the lens is focused on a distant object. This distance governs the angle of view of the lens – a short focal length lens has a wide angle of view, a long focal length lens a narrow angle of view.

FRAME. A single picture on a length of cinematograph film.

FRAME LINE. The narrow line, or area, between frames.

G **GATE.** The part of the camera or projector mechanism in which the film is held while each frame is being exposed or projected. Sometimes the term "sound gate" is used to denote the point in the optical sound recorder or projector at which the sound is reproduced.

GRADING. Estimating the amount of light that must be passed through the individual scenes in the master of a film to produce the correct exposure in a print. This operation is carried out by a GRADER and is usually done by eye.

254

H HIGHLIGHT. The brightest lit and lightest coloured parts of a subject. An artificial highlight, such as a card or other matte surface, is often used to take exposure meter readings.

I INCIDENT LIGHT METER. Exposure meter that indicates the intensity of light falling on a subject.

INSERTS. Shots, usually close ups, of articles, such as a clock face, calendar, newspaper headline, etc., and in which no persons appear and which, by their nature, need not be taken in conjunction with other shots in the same sequence.

INTERIOR. A scene filmed indoors.

INTER-NEGATIVE. A negative that is made for the purpose of running off release prints. It is made either from a reversal master (such as 16 mm. Ektachrome) or a print, preferably a special duping print. An inter-negative is also made as one stage in making opticals (mixes, fades, wipes, overlays etc.).

J JOIN. A splice between two shots.

JUMP CUT. Cut which breaks the continuity by omitting an interval of time, revealing persons or objects in a different position in two adjacent shots. Jump cuts should be avoided.

L LAYING SOUND. To place sound in its correct relationship with picture, in other words, to "edit" a sound track.

LEADER. Film at the beginning of a roll that is laced into the projector or camera. In the case of projection prints it may carry a series of numbers, sound and picture start frames or a pattern for focusing.

LIBRARY SHOT. Shot used in a film, but not taken specially for it; shot taken from a film or library source outside the actual unit producing a film.

LONG-FOCUS LENS. Any lens of longer focal length than the normal standard focal length for the gauge of film in use. Such a lens will cover a smaller field of view than will the standard lens. See FOCAL LENGTH.

LONG SHOT. Shot taken with the camera at a considerable distance from the subject. A shot including the whole scene, or, in the case of a human subject, including the whole figure.

LOOP. Short length of film joined at its ends to form an endless loop so that it can be projected repetitively, either to enable actors to fit words to lip movements or to enable sound effects to be fitted. In the case of sound tracks, a loop is frequently made up of continuous sounds such as crowd noises, wind, sea breakers, etc. This loop plays continuously and can be mixed in with the others at any time during a sound session.

M MARRIED PRINT. Print of a sound film carrying both picture and sound track. Normal print of a sound film for projection.

MEDIUM SHOT (Abbr. M.S.). Shot taken with the camera not so far away from the subject as for a LONG SHOT but not so close as for a CLOSE UP.

MIX. Picture – see DISSOLVE. Sound – to combine several sound tracks, as, for instance, dialogue or commentary with music and effects.

MONTAGE. The process of creative editing. Also used to signify a series of dissolved shots suggesting a passage of time, journey, dramatic happening, etc.

255

MOOD MUSIC. Music written in various moods and styles for use in films, radio and television, but not for a specific production. This pre-recorded music is often classified under headings, such as "sad", "gay", "dramatic", "pastoral", etc., to assist the selection of passages suitable for a given film or sequence. Such library music is available on discs, ¼ in. tape or magnetic film.

MOVIOLA. Trade name of an American model of film viewer, reproducing a small moving picture and sound from a separate sound track, for editing purposes.

MULTIPLE EXPOSURE. Two or more pictures exposed on the same series of film frames.

MUTE. A picture negative or positive print without the sound track. The term implies that a track for the picture does exist, as distinct from "silent", which implies that there is no sound track relating to this picture film.

N **NARRATION.** Commentary spoken by one of the characters taking part in the film. Spoken words not synchronous with picture.

NEGATIVE. Original film exposed in the camera in which light tones are reproduced dark and from which positive prints can be made.

NUMBER BOARD. Board photographed at beginning of takes carrying shot number, etc. See also CLAPPER BOARD.

O **OPTICALS.** Fades, mixes, wipes, superimpositions added during the process of printing a film.

P **PAN: PANNING.** Abbreviation of panorama. To rotate the camera, while taking a shot, about its vertical axis.

PARALLAX. The difference between the image seen through the viewfinder and the image recorded by the lens, due to the lens and viewfinder being in different positions.

PARALLEL ACTION. Narrative device in which the development of two pieces of action are represented as taking place simultaneously by showing scenes from one and then the other alternately. See also CROSS CUT.

PLAY-BACK. Reproduction of a sound recording.

POSITIVE. Print from a negative. Normal print suitable for projection.

POST-SYNCHRONIZATION. Recording sound to a picture after the picture has been shot.

R **RELEASE PRINT.** Projection print of a finished film.

REVERBERATION TIME. The time taken for a sound, on its cessation at its source, to die away to inaudibility, i.e. its attenuation by 60 dB.

RE-TAKE. Repetition of a take (film shot).

REVERSAL FILM. A type of filmstock which after exposure and processing produces a positive image instead of a negative.

ROUGH CUT. First assembly of a film in which the selected takes are joined in approximate sequence, but the finer points of editing have not yet been carried out. Also known as ROUGH ASSEMBLY.

RUSHES. Film that has just been exposed by a film camera. In the case of a print, a print of scenes exactly as they were shot in the camera without any cutting or editing having taken place.

S SHOW PRINT. See RELEASE PRINT.

SLOW MOTION. Slowing down of action in a scene caused by running the camera *faster* than normal.

SOUND TRACK. Narrow path on a length of cinematograph film carrying the sound recording. In the case of a projection print it lies to one side, adjacent to the picture frames. If it is an "optical" track the sound is carried as a photographic image. Nowadays the sound track may be carried magnetically on a layer of iron oxide with which the film has been striped or coated.

STOCK SHOT. See LIBRARY SHOT.

SYNCHRONIZER. Usually two-way, or four-way. Apparatus through which two or more lengths of film, either picture or sound track, can be drawn in step with one another, for editing or track-laying purposes.

SYNCHRONOUS SOUND. Sound recorded at the same time as picture, with camera and recorder linked together.

T TAKE. The single recording of a shot. Where a shot is photographed more than once these are referred to as Take 1, Take 2, etc.

TILT. To move the camera up or down about its horizontal axis during the taking of a shot.

TRACK. To move the camera bodily forward or backward during the taking of a shot. Also abbreviation for SOUND TRACK.

TRAILER. Blank film at the end of a reel after the last shot.

TRIM. To cut off the unwanted portions of shots during editing.

TWO-SHOT. Shot taken so as to include two people only, head and shoulders.

W WILD TRACK. Sound recorded without camera, i.e. non-synchronously.

WIPE. Transition from shot to shot in which a line appears to pass across the screen, pushing off the first shot and revealing the second.

WORK-PRINT. A print or copy used solely for editing purposes. (Also known as CUTTING COPY.)

Z ZOOM. To move the camera quickly bodily towards the subject.

ZOOM LENS. A lens with a variable focal length. The focal length can be varied during filming to produce an impression that the camera is moving nearer or farther from the subject – in other words, zooming.

INDEX

A. & B. roll assembly, 159, 160, 184–7, 237
Abrasion, damage by, 182
Absorption of sound by surfaces, 146
Academy leader, 188, 227
Accumulator, 133
Acetate, clear, 158, 164
Acoustics, 143, 146–9, 154, 204, 217
Acoustic qualities, assessing, 148–9
— tiles, 145
Action, in shots, 176
— overlapping, 103–4
Actors, 32, 54–55, 97, 100, 155, 197
— non professional, 100, 194
Advertising filmlets, 181
Aims of Industry, 248
Air freight, filmstock, 115
Alternating current (A.C.) for sound synchronizing, 139
Amateur sound recording, 136
Amplifier, 208
Animation, 160–70
— by stop action, 160, 161, 166–7
— bench or rostrum, 158, 161, 163, 167
— full, 161
— simple, 164–6
Anstey, Edgar, 23, 97, 197
Answer print, 33, 228, 229
Anti-halation backing, 68, 70
Approval print, 172, 228, 229, 232
Archimedean screw, 203
Arc light, 49, 79, 124, 130, 134
Artist, animation, 160–4
— title, 157
Artwork, 157–71
Assembly, of picture and track, 176–9
— of work-print, 174–9
— rough, 174–6
Assistant director, 51
Aswan Dam, 201, 202
Athletics, ancient Egyptian, 169
Attenborough, David, 21
Audible cues, 225
Average subject, 83

Baby legs, 86
Back lighting, 111, 124, 125–6
Background drawings, 161
— noise, 140, 141, 210, 211
Backwinding mechanism, 160
Ball point pens, 189
Barn door, 127, 128
Baseboard, animation, 161
Basketwork backgrounds, 157
Bassoon, 165, 166
Batteries, 133, 137
B.B.C., 35, 223
Beards and moustaches, 55
Bin, film, 174, 181
Black-and-white work print, 171
Blank spacing, 180
Blimp, 145
Blooping, 226
— ink, 226, 227
— punch, 227
Blotting paper, 203
Blow-ups, 240
Blue filters for lights, 131
Blueprints, 166
Bond, importation of film, 119
Boominess, 152
Boom operator, 52
Boosted processing, 132
Brass instruments, recording, 153
Breakdown script, 30–31
"Breathless", 107
"Britain at War", 137
British film industry, 136
British Productivity Council, 23
British Standards specification, 141
British television, 160
British Transport Commission, 23
— — films, 97
Buddhist ceremony, 197
Budget, 15, 32–45, 48, 49, 114, 124, 131, 136, 164, 173, 205
Budgeting overseas, 121–2
Built in reflectors, 129
Bulk eraser, 208

259

Butt joins, 177, 182, 212
— welding, 182

Caltex (Africa) Ltd., 15
Camera,
— angles, 16, 92, 95, 102, 103, 110, 111, 112
— blimp, 145
— dolly, 71
— gate brush, 88
— gate, dirt in, 116
— hand holding, 112
— instructions, 18, 102
— jams, 88, 113
— movement, 102, 167, 169–70
— movement following a moving subject, 103
— pulse systems, 138
— shutter, 68, 69
Cameraman, 52, 97, 102, 110, 112, 113, 130–2
Cameraman's dope sheets, 108–10
— procedure re damaged film, 116
Cameras and equipment, 62–88
Candid camera techniques, 99, 155
Carbon arcs, 79
Car headlamps, 132, 133
Cardioid microphones, 149, 151, 152
Cartoon work, 160, 161–4
Casting, 55
C.C.I.R. Standard for sound, 141
Cells, 158, 161, 162, 163, 164
Central Film Library, 248
Central Office of Information, 23, 249
Changing bag, 88
Changing camera distance, 95
— viewpoint, 91, 95, 96, 102, 103, 110
— viewpoint, amount of change, 95
Change-over, 188
Chart, animator's, 164
Cheating, 94
Checking masters, 187
Chemicals, in film packing paper, 120
— processing, 116
Chequer-board printing, 186
Children's films, 169
Children's Home, 195
Chinagraph pencil, 174, 177, 187, 199, 208, 214, 218
Choirs, recording of, 153
Cine-kodak Special, 68, 160
Cinema circuits, 244
— distribution, 243–4
— exhibition, 233, 249
Cinemascope, 223, 240

Clapper board, 52, 155, 176, 177
— boy, 52, 155
— front and end recording technique, 155, 156
Clappers-loader, 52
Classroom films, 247
Cleanliness in master handling, 181
Clear acetate, 158
Clicks in sound tracks, 177, 209
Clients, 14, 42, 122
Clocks, recording of, 144
Close-up, 18, 91, 95, 104, 112, 132, 167, 196
Coarse linen, 157
Colortran lighting, 129
Colour balance, 37, 76, 77, 129, 130, 133–4, 229–31
— bias, prints, 230
— compensating filters, 77, 172
— conversion filters, 76
— corrected prints, 134, 231
— correction or compensating filters, 77, 172
— film, fast, 132
— master, 172
— negative, 36, 224
— pilots, 172
— printing, 229–31
— prints, 48, 126, 134
— quality, prints, 229–31
— rendering, 76, 172
— television, 48, 110
— temperature, 79, 133, 134
Colour temperature meters, 78
"Coming attractions" trailers, 181
Commentary, 176, 191–8, 207–12
— amount of, 191
— avoiding paper rustle, 203
— bridging scenes, 201, 202
— cutting in retakes, 211–12
— information for, 108
— laying, 207–209, 210, 211, 212
— placing of in relation to visuals, 196, 201–3, 209
— recording fluffs, 203
— recording of, 197–8, 201–5
— rehearsal of, 205
— script, 190–1, 195–6, 198, 199, 200, 201
— script, examples of, 193–4, 195–6, 210
— syllables per foot, 176, 192
— track, handling the, 207–9, 210, 211, 212
— writing of, 190, 191, 192–4
— writing style, 193–7

Commentator(s), 32, 37, 57–58, 165, 176, 195, 198, 199, 200, 201, 202, 204, 205, 206
— choice of, 194
— cueing by footage, 200–1
— cueing the, 198–9, 207
— identifying voice with character on the screen, 195
— reaction time of, 199
— style, 205
Commercial tape recorders, 139
Commissioned films, 101
Composition of shot, 103, 111
Condenser microphones, 150
Condensing time, 98–99, 104, 105
"Conquest of Everest", 36, 64
Consecutive shots, 97
Contact printing, printers, 230
Contingencies, 34
Continuity,
— between shots, 97, 104, 177
— errors, 96, 97, 99
— visual, 107
— girl, 52, 89
— picture and sound, 177
Continuous projection cabinets, 249
Contract, 43, 244
Contrast ratio, 110, 126
Conventions, of camera movement, 102–3
— of film assembly, 90–91
Cores, film, 174, 189, 242
Costing, 32
Costume, 55
Cow gum, 203
Crooners, 152
Cross lighting, 111
Cross modulation test, 227
Crowd noises, 221
— scenes, 112
Crystal microphones, 150
Cue sheet, 216, 219, 220
Cueing the work-print for commentary, 199–200, 209
Cues for printing, 225
— on master film for printing, 184, 185
— on sound tracks, 222, 223, 225
Customs, import and export through, 117, 119, 121
Cut, 92, 95, 103
Cut-aways, 99, 104–6, 179
— relevence of, 105
Cut not intended, 179
Cutter, film, 172
Cutting copy, see Work-print
Cutting on action, 105

Cutting room conventions, 179, 180
Cycle of cells, animation, 161

Damage to work-print, 179, 180
Damaged film, 113
"Dar es Salaam—Gateway to Tanganyika", 109
Daylight loading, 88
Decibels, 154
Depreciation of equipment, 34, 42
Depth of field, 72, 74, 88, 111
Developer, 116
Diagonal joins in sound tracks, 177
Diagrams, 161, 162, 163, 164, 165
Dialogue, assembly of takes, 177
— recording, 149, 151–2, 207
Diaphragm Mechanism, 120
"Diary for Timothy", 136
Dickinson, Thorold, 22, 52, 107
Directing people, 99–101
Directional light, 127
— microphones, 151, 153
Director, 51, 89, 96, 99, 102, 107, 178, 191, 205
Director cameraman, 51, 90
Dirt on film, 173, 181, 183, 235
Disc recording, 137
Disney, Walt, 64
Dissolves, 18, 71, 160, 180, 181, 183, 184, 187, 189
Distortion of sound, 143
Dolly (camera), 71
Dope sheets, 108–10, 155
Dotted lines, animating, 164
Double transducer microphone, 149, 151
Drawings, 160, 167, 170
— Egyptian, 169
Drifting sound, 156
Drying agents in humid conditions, 120
Dubbing, dubbed, 142, 190, 207, 213, 216
Dupe negative, 65, 160, 183, 233–5
Dust on film, 65, 181, 235
Dysentery, 118

"East Africa's Expanding Industries—Tea", 170
East African Railway and Harbours film unit, 109, 170
Eastman Colour film, 76, 79, 110, 126, 134, 171, 181, 235, 236, 237, 238
Echo, 143, 146
— decay, 146
— flutter, 149

261

Edge numbers, 173, 179, 182, 189
Editing, 39, 44, 89, 90–99, 102–6, 171–89, 209, 210
— bench, 174
Editor, 103, 209
Education, sponsored film in, 249
Education films, 157
Effects, 190, 217–219, 221
— recording, 143–4, 217–19
Egyptian irrigation, 203
— tomb paintings, 167, 169
Eight millimetre sound film, 241
Ektachrome Commercial film, 126, 134, 174, 224, 236, 237
Electric drive, 66
Emperor Shen-Nung, 170
Emulsion, photographic, 135, 173, 174, 181, 238
— which side of film, 238
Equipment failure, precautions against, 114, 116
— precautions, in tropics, 119, 121
— hire, 38–39
Erase, erasing, 204, 205, 208
Establishing shot, 93
Exciter lamp, 226
Exhibitions, screening at, 247, 249
Expedition films, 21, 240
Exposing film, 82, 83, 84, 110, 111
— titles, 159
Exposure meters, 82–84, 114, 126
Extraneous sounds, 144–5, 147, 206, 217

Factories, lighting of, 129
Fades, 71, 160, 180, 181, 183, 184, 187, 189
Fading shutter, 160, 184
Faking sound effects, 143, 144, 147, 217, 218
Fast colour films, 132
Feature films, 89, 244, 245
Feature film studios, 207
Film,
— assembly, 90
— breaks, 113, 116
— cement, 174, 177, 182
— cutter, 172, 181
— gauge, 62–64
— grain, 64, 132, 140, 141
— grammar, 92
— joiner, 174, 177, 182
— joiner, magnetic, 206, 207, 212
— joins, 65, 182, 186, 231–2
— latitude, 65, 126, 228
— libraries, 247, 248

Film, manufacturers, 172, 173
— panchromatic, 80
— precautions in tropics, 119–20
— speed, 133
— wastage, 35
Filming non-actors, 100
Films of Scotland, 194
Filmstock, choice of, 64
— latitude, 110
— manufactured batches, 115
Filter factors, 81
— holders, 75
Filters, 75–82
— polaroid, 81–82
— for black-and-white film, 79–81
— for colour film, 76–79
— for lights, 131
Final mix (tracks), 219–23
Fine grain print, 65, 233
Fire in factory, animation of, 162–4
First assembly, 174–5, 177
Flames, animation of, 162–4
Flash frame, 165
Floodlights, 127, 128
Fluffs, 203–5, 207, 222
Fluorescent tubes, 79
Focal length, 72–73
Focusing floods, 127, 128
— leader, 188
Fogging, 88
Foot candles, 126
Footage, cueing by, 200–1
— counter, 174, 191, 192, 209, 216
— numbers, 172, 173, 179, 182, 189
Foreign versions, 207, 220, 241
Format, title, 157
Four-way synchronizer, 174, 209, 211, 215, 217
Fragility of colour stocks, 181
Frame counter, 174
— line, 182, 186
— moving into and out of, 105
Frame-line joiner for 16 mm., 182, 186
Framed, framing (during projection), 188
Frequency range, 141
— response, 150
Front, marking up masters, 189
Furniture, 57

Gate,
— brush, 88
— picture, 188
— sound, 135, 188
Gate plate, printer, 173

General public, 155
Generators, for arcs, 131
Geography of film, 96
Gloves, for editor's use, 181
Grader, 187, 228
Grading, grade, 171, 187, 189, 228–9,
— notch, 172
Grain, film, 64, 132, 140, 141
— in sound film, 140, 141
Grammar of the film, 92
Grierson, John, 194
Griffiths, D. W., 106
Groove selection, discs, 216, 217
Guide-track, 143, 149, 207
Gyro tripod, 85

Half-track, half stripe, 241
Hand-holding of the camera, 112
Hand lettering, 157
Handling film in cutting room, 181
Hanley, Clifford, 194
Hard emulsion, 173
Hardy, H. Forsyth, 194
Harris, Hilary, 194
Headline news, 166
Head of reel, marking, 189
Headphones, 207
Health, when shooting overseas, 118
High angle shots, 112
Hiring films, 247
Humidity, dealing with, 120–21
Hungarian refugees, 107
Hypo, 116

Ideas, not crystallizing too soon, 23,
101
Identification of masters, 189
Impedence of recording equipment, 150,
151
Inanimate objects, animating, 166
Incident light exposure meter, 83
Ink numbers, 173, 179
Insert stage, 57
Instructional films, 157
Insurance, 39–40
— overseas, 118, 121
Intercutting, 106
— negative, 65, 236, 237, 238
— positive, 236
Interior filming, 123–32, 133, 134
Internal combustion engine, 161
Interviews, 155
Jennings, Humphrey, 136
Jewelled styli, 214

Joining film, 177, 181, 182, 183, 186
— magnetic film, 208, 209
Joins in film, 65, 182, 186, 231–2
Jump, in action, 95
Jump-in by stop-action, 165, 166
Jumps in continuity, 106

Kariba Dam, 36
Key light, 124
Kodachrome camera film, 65, 224, 238
— copying stock (sound prints), 66, 224,
231, 236, 237
Kodak W F Orange filter, 131
Kodisk haze filter, 78
Kon-Tiki expedition, 64

Labelling rolls, 182
— sequences, 174
Laboratory, laboratories, 33, 113, 115,
119, 158, 172, 173, 183, 187, 189, 224,
228, 229, 232, 241
— instructions to, 172
Latitude of film, 65, 126, 228
— of filmstock, 110
Laying commentary, 207–9, 210, 211,
212
— sound effects, 217–19
— sound tracks, 40, 176–9, 207–12, 218,
219
Leader(s), 184, 188
Length of shot or scene, 176
Lens aperture, 69, 70, 74, 99
— caps, 120
— cleaning tissues, 88
— turret, 67, 76
Lenses, 71–72, 111
— care in tropics, 120
— long focus, 72, 73, 99, 111
— short focus (wide angle), 73, 111
Lettering, 157
— superimposition, 159
Level sync., 210, 226
Liaison during production, 101–2
Library material, 31, 58–59
— music, 33, 38, 213–14
— of sound effects, 219
"Life in Ancient Egypt", 168–9
Light balancing filter, 79
Lighting, 48–50, 123–34
— back, 111, 124, 125–6
— contrast, 110, 126
— cross, 111
— on location, 123–34
— square-law, 128

Lighting, types of, 123–6
Lights, filters for, 131
— for title shooting, 58
— placing of, 124
— very limited, 131–2
Linen bags, 181
Lines, animating, 164
Line test, 166
Linking shots, 175
Lip movements, 207
Lip-ribbon microphones, 151
Live sound, 51
Living expenses, 122
Location, 53, 66, 93, 95, 109, 206
— lighting on, 123–34
— recording on, 139, 142–3, 206
— remote, 132–3
Long shots, 18, 91
Loops, picture, 207
— sound, 221
Low angles, 86, 112
Lubrication of cameras in cold climates, 121

Magnetic film, perforated, 140, 197, 208, 210
— film, 17.5 mm., 140, 142, 210
— recording, 135, 136, 137, 141, 198, 204, 204–7, 217–19
— sound prints, 240–1
— stripe, 8 mm., 241
— stripe projectors, 136, 241
— striped film, 136, 241
Magnetic tracks, 33, 37, 135, 136, 139, 140, 141, 142, 143, 176, 177, 178, 207–15, 240, 241
— — laying, 207–15
Make-up, 56
Malaria, 118
Maps, animating, 164, 165
— filming, 166
Margin of profit, 34, 42–44
Marking up masters for printing, 189
— — opticals, 180–1
— — work prints, 174, 179–81
Marrying picture and sound, 154–6
Master film, 65, 172, 181, 182, 183, 184, 185, 186, 189, 224, 233
Master, film printing cues, 184, 185
— matcher, 181, 183
— matching, 173, 179, 181–7
— positive, 179, 181, 224
— preparation for opticals, 183–7
— track, 135, 141, 215, 220, 222, 223, 225

Matching negative or master, 179, 181–3
Matte box, 75–76, 82
Measuring tape, 88
Mechanical Copyright Protection Society, 217
Medical photography, 84
Medium shot, 18, 91, 95, 104
Membrane absorbers, 148
"Men at Work", 23
Metronome, 144
Microphone(s), 145–6, 197, 200
— balance, 152, 153
— directional, 151, 153
— distant technique, 153
— leads, 150
— multi versus single techniques, 153
— phasing of, 153
— placing of, 145–6, 151, 152, 153, 204
— single, 153
— sub-miniature, 146
— types of, 149–51
"Mike Mulligan and his Steam Shovel", 170
"Millions of Cats", 170
Ministry of Information, 136
Mixed light, 37, 49, 129–31
Mixer panel, 153
Mixes, picture (see dissolves)
Mixing microphone outputs, 153
— music, 215–17
— sound tracks, 33, 140–2, 215, 216, 217, 219–20
Mobile projection units, 248
Modulations, sound, 135
Mood music, selecting, 213, 214
Movement within the frame, 103
Moving coil microphone, 150, 152
Moviola, 174, 177, 187, 209
Multi-microphone recording, 153
Music, 19, 53, 190, 212–17
— composing for film, 53
— cue sheet, 217
— discs, 213, 214, 215, 216, 217
— for animated sequences, 166
— recording of, 152–4, 214–17
— royalties, 33, 38, 213, 217
— specially composed score, 212, 213
— track, 212–13
Musical instruments, animating, 166
Music and effects track, 215, 220
Mute prints, 223
Mylar tape, 177

Narrators (see Commentators)
Narrow joins in master film, 182

National Children's Home, 196
Negative film, picture, 64, 65, 135, 171, 172, 173, 181, 224, 233–6, 239
— quality, judging, 171
— tracks, 224
News headlines, filming, 166
Newsreel, 90, 200
"Nife" batteries, 133
Night, effects in daylight, 79
— scenes, printing of, 189
Nile boat, 169
Nile river, 167, 201, 202
No-join prints, 232
Non-bleaching film cement, 182
Non-directional lighting, 127, 128
Non-theatrical distribution, 246, 247–9
Notch in film, 172
Number board, 154

Omni-directional microphones, 151
"On the Bowery", 106
Opaque spacing, 187
Opticals, 18, 71, 160, 183, 184, 189, 237
— marking up for, 180–1
— preparing masters for, 183–4
Optical printer, 159, 160
— system (sound), 134
— track, 33, 37, 44, 135, 141, 142, 174, 223, 224–5, 239, 240
Optical track, mixing of, 140, 141
Orange filter for windows, 131
Orchestras, recording, 148, 153
Organs, recording, 148
Original negative, 65, 179
Oscillating mirror, 135
Oscillator, tuned, 223
"Out"—a United Nations Film, 107
Overheads, 34, 41, 44
Overlap at film joins, 177, 182, 186
Overlapping action, 103–4
Overprinting, 181
Overprinting of titles, 159
Overrun filament lamps, 123, 129, 132
Overseas, shooting a film, 114–22
— audiences, 249

Painted backgrounds for titles, 157
Paintings, filming, 167–9
Pan, panning, 85, 92, 102, 103
Pan and tilt head, 84
Panchromatic film, 80
Panning handle, 85
Pans, direction of, 103
Papering-up, 189

Paper rustle, 203
Parallax, 67
Parallel action, 106
Pause sign in commentary scripts, 198
Pauses, length of in speech, 177
— made by commentators, 198, 201
Pearl photographic lamps, 134
Percussion instruments, recording, 153
Percussive sounds, 147
Perforated joining tape, 177
Perforations (in 35 mm. film), 188
"Permanent Way", 15
Personnel, 50–53
Perspex, 132
Petroleum Films Bureau, 248
Phasing microphones, 153
Photoflood lamps, 79, 123, 134
Photographic emulsion, 135
Photopearl lamps, 134
Pick-up droppers, 214, 215
Pick-ups, 214, 216, 217
Picture gate, projectors, 142, 188
— loops, recording to, 207
— quality, 171
Pilot programme, television, 245
Pinewood CT ½B and ½O Lamp filters, 79
Play-back of sound, 137
Point of interest, 94, 103
Polarized capacitor (microphones), 150
Polaroid filters, 81–82
Portable light unit, 132
— sound recorders, 137
Postmaster General, 146
Post synchronizing, 149, 206–7
"Power Among Men", 22, 52
Power leads, microphones, 150
Pre-amplifiers, 150
Pre-recorded music, 214
Pre-release theatres, 244
Pressure gradient operated microphones, 149, 150–1
Pressure operated microphones, 149–50
Print costs, 236, 237–8
Printer, film, 183, 184, 185, 187
— shutter, 184
— start cues, 184, 187
Printing, 189
Prints, 134, 171–2, 183, 228–42
Print-sync. cues, 226
Processing of film, 32, 113, 115
— of sound tracks, 224, 225
Production manager, 51
— time, 40–41
Projected, projection, 173
Projection, double headed, 212
— prints, 135, 171

Projectionist, 188, 242
Projector, 173, 188
Prophylactics, 118
Props, 57
Public relations, 14, 247
Pulse for sound synchronizing, 139, 155, 223
— recording head, 155
Punched cells, 161
— cues, 187, 209

Quality, loss in duping, 183, 185
Quartets, recording, 148
Quartz halogen lamps, 132
Quartz iodine lamps, 132
Quotations, 42–43

Rack (in projection), 188
Rank Film Library, 248
Reaction time of commentator, 199
Realism, 107
Record/Playback head, 155
Recorder, gain control, 154
— overloading, 154
Recording, 135–56, 194, 197–8
— accompanists, 152
— brass instruments, 153
— choirs, 153
— commentary, 197–8
— commentary for animated sequences, 166
— crooners, 152
— effects, 143–4
— level, 154
— music, 152–4
— on location, 139, 142–3, 206
— orchestras, 153
— percussion instruments, 153
— post synchronously, 206–7
— singers, 152
— solo artists, 148, 152
— speech, 148, 151–2, 197–201, 203–5
— synchronously, 137–40, 145, 154–6, 217–19
— technician, 153
— to picture, 197–8
— woodwind instruments, 153
Reduction printing, 239, 240, 241
Reels, 189
Reels of film, 188, 241
Reflected light meter, 83
Reflections, dealing with, 81
Reflectors, 87, 111, 127
— sound, 145, 146
Reflex cameras, 66–70
Release (distribution), 234–9

Release prints, 36, 65, 136, 159, 171, 183, 231–2, 233, 234, 235–7, 240
Remote locations, 132–3
Repetitive action in animation, 161
Replay channels, 214
— head, 208
Resonance, 152
Resonant peak, 149
Response curve, 224
Retakes, commentary, 204, 208
— picture, 114
Reverberation, 143, 146, 147, 154
— time, 148
Reversal copy, 171
— dupe negative, 233
— film or stock, 64, 134, 172, 173, 224, 233
Reversing the camera, 164
Ribbon microphones, 151, 152
Rice, use as drying agent, 121
"Rien que les Heures", 27
Rock wool, 145
Rolling, 155
Rostrum, animation, 158, 161, 163, 167
Rough assembly, 174–6
Routes on maps, 164
Royalties (music), 33, 38, 213, 217
Rush-print, 171
Rushes, film, 118–19, 171, 179
— reporting on, 119

Scanning head, 141
Schlesinger, John, 24
Scientific films, 157
Scissors, 174, 204, 208, 212
Scraping off technique, 164, 165
Scratched film, 173
Screening rough assembly, 175–6
Script, 13–31, 89, 105, 106, 108, 168, 170, 175, 198
— *"Life in Ancient Egypt"*, 168–9
— terminology, 17–19
— writer, 96, 102
"Seawards the Great Ships", 193
S.E.I. Spot Photometer, 84
Selsyn system of synchronous electric motors, 140
Sequence of shots, 95
Sets, 56
Shaded area, animating, 165
Shadouf, 203
Shadows, filling, 87
Sheet gelatine, 131
Shipping agents, 117, 118, 119, 121
Shooting, 89–113

Shooting in reverse, 164
— ratio, 35
— schedule, 59–61
— script, 16–17, 42, 46, 168–9, 190, 191
Short ends, 232
Shot assembly, 90–99, 175–86
— list, 191, 192
Signal-to-noise ratio, 141, 154
Silica gel, 120
Single frame exposure, 164, 165
Single system cameras, 142
Sketches, 157
Sky filters, 80, 82
Skylights, 130
Slate, 154
Slow-running (of camera), 131
Smoke, drawing and animating, 162–4
S.M.P.T.E. Television leaders, 188
Solo artists, recording, 152
Solo instruments, recording, 148
"Song of Ceylon", 197
Sound-absorbent screens, 145, 148, 149, 152
Sound and picture relationship in prints, 142, 225, 226
Sound balance, 152, 153
— compressing, 156
— department, 156
— effects, 143–4, 147, 217–19, 221
— — library, 219
— gate, 188
— intelligibility, 146
— laying to picture, 176–9
— perspective, 147
— prints, 224–33, 238–40
— recording, 135–56, 166, 174, 207, 212, 213, 217–19
— recording on location, 142–3, 146–8, 217, 218
— recording studio, 152, 217, 218
— reflections or reverberations, 146, 147, 148, 149
— reflectors, 145, 156
— relevent, 147
Sound Services Library, 248
— stretching, 156
Sounds, percussive, 147
Sound track(s), 37, 44, 174, 175, 176, 177, 178, 179, 190, 206, 207–15, 219–227, 229, 232, 234
— — losses in reduction printing, 239
— — density, 224
— — development, 224, 225
— — laying (editing), 40, 176, 207–12, 214–15, 218, 219
— — magnetic, 35, 44, 177, 205–23

Sound track(s), problems of silence, 192, 193
— – - quality, prints, 232–3, 239, 240
— — speed, 140
Space between frames, 182, 186
Sparkle, 235
Speech, recording, 148, 149, 151–2, 197–201, 203–5
Speed of film through projector, 160
Spider (for tripods), 87
Splicing, see joining film
Sponge rubber, 152
Sponsor, 14, 42, 58, 229, 246, 247, 248, 249
Sponsor's film library, 248–9
Spontaneity, preserving, 155
Spool loading film, 88
Spools, 242
— small, 174
Spot lights, 127, 128
Spring driven cameras, 139
Squeaks, recording, 218
Stage, 57
Standards for magnetic film, 140
Standing waves, 149
Start frame, 185
Static shot, 102
Statistics in commentaries, 191
Stereophonic, 240
Stills, colour for filming, 132
— filming, 167–9
Stop-action, 31, 160, 161, 166–7
"Story about Ping", 170
Stripe, see magnetic striped film
Striped projectors, see magnetic stripe projectors
Striping film, 136
Studio, hire, 57
— lamps, 79
— lighting, 123
— sound, 152, 200, 217, 218
Subject research, 15, 33, 40
Sub-miniature microphones, 146
Superimposing, in printing, 159, 181
— titles, 158–9
Surplus footage, 175
"Syllables per foot" commentary rate, 176, 191
Synchroniser, 209
Synchronizing marks or cues, 177, 179, 222
Synchronous camera motors, 139, 140
— recording, 137–40, 145, 154–6, 217–19
— recording jargon, 155
— recording with very simple equipment, 156
Take number, 154
Takes, selection of, 174

Takes, sound, 176
Tape, drop-out, 206
— for joining, 177
— joins, 177, 182, 183
— magnetic, 137–9, 222
— recorder, 222, 223
— slippage, 138
Tape speeds, 139
Tea, film on, 170
Tears in film, 173, 179, 180
Technicolor, 36, 236, 237, 240
Telecine machine, 223
Television, 48, 62, 112, 114, 160, 188, 200, 213, 220, 223, 224–45
— colour, 48, 110
— commercials, 181
— programmes, length of, 245
Templar films, 194
"Terminus", 23–28, 97, 197
Textured backgrounds, 157
Theatrical agents, 55
— costumiers, 55
Thought continuity, 107
Three-phase current for recording synchronously, 140
Tilt, tilting, 85, 102, 103
Time lapse, 97
Timing animation, 166
Title bench, 158
— cards, 158
— superimposition, 158–9
Titles, 31, 44, 53, 157–60
— filming, 159
— hand lettering, 157
— textured backgrounds, 157
Tonal rendering, 81
Track, tracking (camera), 71, 102, 103
— density, 224
— laying (see sound track laying)
— reader, 174, 177, 208, 211, 212
Tracks, negative, 224
Transcribe, transcription (of track), 223, 224
Transcribing, 33
Transistorized recorders, 137
— transmitter, 146
Transmitting licence, 146
Travel costs, 122
Travelling, 85
— expenses, 32, 37–38
— matte, 159
Treatment, 13–15, 46
— of film "Out", 107
Triangle, for tripods, 87
Trimming work-print, 174, 175, 176, 179, 180

Tripod(s)
— choice of, 84–87
— feet, 87
— legs, 85
— use of, 112
— use of overseas, 114
Tropical conditions, 119–21
"Trust of a Child", 30, 195
Tungsten lamps, 79, 123, 128, 131, 134
— light, 81
Turntables, 216
Twenty-third Psalm, 207
Two-way synchroniser, 174, 176, 211, 290

Ultrasonic cleaning, 235
Ultra violet filter, 72
Under cranking, 131
Ungraded prints, 171
United Nations films, 107
Unmodulated track, 198, 210

Variable speed recorder, 156
Verticals, distortion of, 73
Viewer, 174, 192, 209
Viewfinders, 66, 67, 68, 69, 70, 86, 158
Viewing, 171, 174, 209
Visual continuity, 107
Voice quality, commentators, 204
— recording, 146, 204

Waterhouse, John, 23, 100
Wax pencil, 187
Wide angle lens, 72, 111
Wigs, 55
Wild recordings, 143–4, 197, 218
— sound, 19, 218
Wind noise, 148, 150, 151, 217, 218, 221
—shields for microphones, 150
Winding back in the camera, 159
Wipes, 18, 180, 181, 183, 189
Woodwind instruments, recording, 153, 218
Work-print, 33, 171–2, 173, 174, 176, 179, 180, 181, 189, 199, 200, 225
— black-and-white reversal, 171
Wratten filters, 76, 77, 134
Wright, Basil, 197
Writing commentary, 33

Zoom, zooming, 18, 102, 103, 166, 167
— by stop action, 167
— lens, 71, 167
"Zoo Quest", 21

268